Digital Restoration from Start to Finish

Paula Butler and Laurie Toby Edison
love and admiration
Now and always

Digital Restoration from Start to Finish

How to repair old and damaged photographs

Second Edition

Ctein

ELSEVIER

AMSTERDAM • BOSTON • HEIDELBERG • LONDON
NEW YORK • OXFORD • PARIS • SAN DIEGO
SAN FRANCISCO • SINGAPORE • SYDNEY • TOKYO

Focal Press is an imprint of Elsevier

Focal Press is an imprint of Elsevier
30 Corporate Drive, Suite 400, Burlington, MA 01803, USA
Linacre House, Jordan Hill, Oxford OX2 8DP, UK

Notices

Knowledge and best practice in this field are constantly changing. As new research and experience broaden our understanding, changes in research methods, professional practices, or medical treatment may become necessary.
Practitioners and researchers must always rely on their own experience and knowledge in evaluating and using any information, methods, compounds, or experiments described herein. In using such information or methods they should be mindful of their own safety and the safety of others, including parties for whom they have a professional responsibility.
To the fullest extent of the law, neither the Publisher nor the authors, contributors, or editors, assume any liability for any injury and/or damage to persons or property as a matter of products liability, negligence or otherwise, or from any use or operation of any methods, products, instructions, or ideas contained in the material herein.

Library of Congress Cataloging-in-Publication Data
Ctein.
 Digital restoration from start to finish / Ctein. — 2nd ed.
 p. cm.
 Includes index.
 ISBN 978-0-240-81208-3 (pbk. : alk. paper) 1. Photographs—Conservation and restoration—Data processing. 2. Photography—Digital techniques. I. Title
TR465.C79 2010
771'.4—dc22

2009038322

British Library Cataloguing-in-Publication Data
A catalogue record for this book is available from the British Library.

ISBN: 978-0-240-81208-3

For information on all Focal Press publications
visit our website at www.elsevierdirect.com

Printed in China

09 10 11 12 13 5 4 3 2 1

Contents

Chapter 4: Getting the Photo into the Computer **81**

Chapter 5: Restoring Tone **121**

Website:
http://photo-repair.com/dr1.htm

How-To's

Chapter 10: Beautification **315**

Preface

What's New in the Second Edition

More than one-third of the text in this second edition of *Digital Restoration* is new material, but none of the information from the first edition has been lost. Older material that I cut out to make room for the new is available online at http://photo-repair.com/dr1.htm in the form of Acrobat files. I extracted these from the PDF proofs of the first edition of the book, so it's really like you're getting a substantially bigger book (for no additional money).

What's new in this edition? Here are the highlights:

Chapter 3, "Software for Restoration," is entirely new. I'm using many new plug-ins and third-party software that really improve my productivity and make it even easier for me to do great restorations, and they're reviewed there (all the old reviews are online). The same is true for Chapter 11, "Examples," with the old examples moved online to make room for a new crop.

There's a brand-new Chapter 10, "Beautification." Making truly attractive prints from a photograph is a whole art form in itself (one of the many hats I wear is that of custom printer for a high-end clientele). This chapter instructs you on many of the techniques that I use to make prints that are considerably better than run-of-the-mill.

Figuring out how to tackle a restoration job is often a challenge, so I've added a "Quick Diagnosis" guide to the end of Chapter 1. If you're not sure how to proceed on a restoration, look at the illustrations on these pages and see if there's a photo there that shows the same problem as yours. Next to that photo you'll find pointers to the pages in the book where I take on that problem.

To further help the reader learn how to solve specific problems, I've reorganized the content of the book to better separate the How-To's from the main text. The instructions are more concise and to the point so that you won't have to read as much narrative to learn how to perform specific kinds of corrections.

Finally, because my current computer is a lot more powerful than the one I had 4 years ago, I'm making a lot more use of adjustment layers and smart filters to do nondestructive corrections, and that's reflected in revised content. Nondestructive editing is the wave of the future, and it's a very good wave to catch.

Enjoy the new and improved *Digital Restoration from Start to Finish.*

pax,
Ctein

Introduction

Why Restore Digitally?

I love reviving old photographs. I get almost as much pleasure from saving someone's cherished, but presumably lost, photograph as from printing a brand-new one of my own. I enjoy it so much that I even started a second business (http://photo-repair.com) just for doing digital photo restoration.

Digital photo restoration is no more magical or mysterious than ordinary photographic printing . . . and no less. It still feels like a minor miracle has occurred when a lovely photographic print, brand-new or restored to life, appears before my eyes. But whether it happens in the darkroom or at the computer, that miracle is based in established routine, using tools and techniques that anyone can learn. Experience and skill count for a lot, which is why I'm a good printer (and restorer), but it's not a secret art. Anyone can learn to restore photographs, just as anyone can learn to print.

Digital restoration recovers and restores a photograph to its proper glory while leaving the original object unaltered. You can restore almost any type of original photograph—color and B&W; slides, negatives, and prints; sheet film, roll film, and glass plates. You can even reconstruct full-color images from color separation films or plates. The restoration process doesn't involve any physical manipulation of the original photograph beyond making a high-quality scan. All the restorative work takes place in the computer, not on the original photograph, which means there's much less risk of damage to the original than with conventional physical photo restoration.

Digital restoration can work wonders; it usually produces much greater improvements in image quality than conventional physical restoration. It's possible to recreate truly beautiful photographs digitally, something that is often impossible with physical restoration. If restoring the image, not the original photograph, is what's important, digital restoration is the safest and the best way to resurrect a photograph.

Digital restoration has one other significant advantage over physical restoration: The results are theoretically permanent. A physical restoration of a photograph is subject to physical deterioration, just as the original photograph was. With modern materials and techniques, physical restorations will probably last longer than the original photographs did, but they won't last indefinitely; no physical artwork does. A digital restoration has a potentially unlimited life. As long as proper procedures and precautions are in place, it can be maintained indefinitely in its pristine and original form.

A physical restoration is a unique object, just as the original photograph was. That rarity may be part of its value, but it's also a curse; the restored artifact is just as prone to loss or destruction as it ever was. A digital restoration can be shared with others as prints or images on a screen, it can be duplicated exactly, and it can be stored in multiple places. Once a photograph is digitally restored, its prospects for remaining part of our culture become vastly improved.

Digital restoration can have many goals (see Chapter 1, "The Big Picture"), but the primary objective is to resurrect the photograph that was originally there. The heart of what I do is not painting, drawing, or hand-tinting. Restoration is never a matter of mere retouching. The only time I "create" parts of a photograph is when that area in the original is so badly damaged that there is nothing of the image to be recovered.

When you are restoring a photo, you're doing much more than simply performing technical manipulation. Your goal may not even be strict restoration; you may also be reinterpreting the original photograph for different sensibilities and times, as you would when printing any photograph. Always think like a photographer, and never forget that you are working on a photograph made by some other photographer. Don't lose sight of this; you want to be "in their head," with the objective of making a beautiful photograph, not just a serviceable rendering.

You won't always know where you're going when you're doing a restoration, because originals are often so badly deteriorated that you can't even get a sense of what the photograph must have looked like until you're halfway done. That's different from most crafts, where the skilled artist can pretty well visualize what the final artwork should look like before ever picking up a tool. Nonetheless, when you start out, you'll have some idea in your head of where you want to take the work. Always maintain an aesthetic sensibility about what you are doing and why, and always remember to take that mental step back from the work, look at it, and ask yourself, "Does this photograph look *good*?"

About This Book

I'm big on workflow. As my friends the Flying Karamazov Brothers put it, "It doesn't matter how you get there if you don't know where you're going." That's why this book is much more than just a compendium of image processing tricks and techniques. I think it's important to understand the entire job of creating a digital restoration from start to finish. The core of restoration is the magic you perform digitally in your favorite image processing program, but that core means little if you don't have a good grasp of the complete work path, from getting the deteriorated photograph into the computer to preserving the restored image for the future. I want to make you aware of the context in which you do restoration and how to set up your working environment to do it.

This book mirrors the workflow as much as possible. The first three chapters set the stage on which you'll work. That's where I talk about your objectives and requirements for a restoration job, what computer hardware will best let you meet those goals, and what software is especially valuable for the restorer. I devote the fourth chapter to the subject of converting the photograph to digital form, because extracting the maximum useful amount of data from the photograph is the key to achieving a good restoration.

The heart of the restoration process (and of this book) is the digital techniques and tools that actually work the magic of restoration. Chapters 5 through 10 will teach you the "moves." You can read this book as an extended single course in restoration (that's kind of how I wrote it) or you can mine it for particular tricks and techniques you need to solve specific problems. Each chapter starts off with a list of "how-to's." Each how-to points to a place in the chapter where you can learn how to accomplish a particular task. All the how-to's are listed in their own table of contents (at the end of the regular table of contents) for easy reference.

What comes next is learning how to put those moves together to create a complete "performance." Chapter 11, "Examples," presents complete step-by-step restorations that start with originals and proceed through to fully restored images. Chapter 11 sets a very high bar; I'm a perfectionist. Chapter 11 demonstrates the ultimate level of quality I can achieve in a restoration, but you don't have to go that far. Most of the time you'll find that considerably less effort will turn out great results. Many of the how-to's and examples in the other chapters are sufficient unto themselves. It doesn't take a lot of work to do a very satisfying restoration.

Once the restoration is complete, you'll need to get it back out of the computer. So, I finish the book with chapters on printing and archiving. It's not enough just to make a good print of the photograph you've restored. You should also take steps to ensure that the restoration file endures.

I could no more write a book about digital restoration that didn't focus on Adobe Photoshop than I could write a book on business planning that omitted Microsoft Excel. Photoshop is the big player in digital photography, and I'll be the first to acknowledge that it offers capabilities nothing else does.

I prepared most of the photographs and restorations for this book using Adobe Photoshop under Windows and Mac OS. Most of the software tools and techniques in this book work just as well under either OS (with a few exceptions); for the most part, the only difference is certain keystrokes.

Most of my methods work with earlier versions of Photoshop, although the farther back you go, the more limitations you'll run into as far as what tools you can use. To prove that a restorer doesn't need the latest and greatest, one

example from Chapter 11, that's now online, is a restoration I did in the 1990s with Photoshop 5.5 running on a 233 MHz Pentium machine.

Photoshop isn't necessary. There are much less costly alternatives that will let you do restoration work efficiently. My goal is to give you skills and knowledge you can apply to do good restorations with any competent image processing program.

A good alternative for the serious worker who wants to spend under $100 instead of more than $500 (and is using a Windows machine or emulator) is Picture Window. I've worked extensively with this program as well as Photoshop. It's entirely capable and eminently affordable, and I talk more about it in Chapter 3, "Software for Restoration."

I use many different third-party plug-ins and software utilities for doing my restoration work. Chapter 3 provides summaries of all of them. If one of these tools catches your interest when you read about how I used it elsewhere in the book, you can learn more about that program there. These tools and the cases to which I've applied them are also indexed in the back under "software."

About Other Books

Can you have too many Photoshop and digital printing books? Absolutely! I have a shelf full of excellent books, every one of which has something of value to impart. The problem is that you could spend your whole life reading books such as these and only two things would happen. The first is that you would never get any photographs made and printed, and the second is that eventually your brain would fill up and your head explode.

Some folks have undeniably proven themselves gurus in this field. I'll read anything by (the late) Bruce Fraser or Andrew Rodney. If you want to understand the underlying principles of Photoshop specifically and digital printing in general, these gentleman have it nailed. But the single book that I would say you absolutely, positively need to have on your shelf is Martin Evening's *Adobe Photoshop CS4 for Photographers* (also from Focal Press, just like the book you're holding in your hands). I can't think of a better book for telling you how to actually use the program.

I read it before sitting down to write this book. Every time I read something pertinent that I didn't know, I'd forgotten to include, or that I'd never had explained to me really clearly before, I flagged that page with a Post-It. I flagged a good 40 pages, and it's not as if I'm a beginner; I've been doing electronic (what we called it in the old days) printing for over 30 years. Point made?

The other book that ought to be on your must-buy list is Katrin Eismann's *Photoshop Restoration & Retouching,* third edition, from New Riders. Katrin is brilliant, even though she modestly claims otherwise. Her retouching skills are

awesome, as is her ability to create entirely missing portions of photographs out of thin air. I'll never be close to her when it comes to wholesale recreation of absent imagery and fine-art retouching.

If you read and assimilate the two books just discussed and mine, you'll know enough to take over the world.

If you are interested in doing accurate restorations of old prints and want to understand better what they should look like and how they have deteriorated, there is no finer book than *Care and Identification of 19th-Century Photographic Prints,* by James M. Reilly. Unfortunately, as of this writing, the book's out of print. Used copies are running at an insane $150. Recommended, nonetheless, for the dedicated restorer.

Keeping in Touch

Long-time readers know that I'm always happy to answer questions and provide helpful advice whenever I can. If you have any questions about the content of this book or need any assistance in matters photographic, feel free to e-mail me at ctein@pobox.com. Should that e-mail address change, you'll still be able to reach me through my Websites, Ctein's Online Gallery (http://ctein.com) and Digital Photo Restoration by Ctein (http://photo-repair.com).

Photo-repair.com has a "hidden" Web page devoted to this book at this URL: http://photo-repair.com/photobook.htm. This section of my site contains sample image files from this book for you to work with. The folks who provided their personal photographs for this book have generously given permission for me to put the files online for your private enjoyment. You can download them to practice restoration techniques. These files are for your personal use on your computer only. Do not redistribute them, publish them, post them on your Website, or link to them.

As mentioned in the Preface, all the content I excised from the first edition to make room for new material is available online on a "public" page at http://photo-repair.com/dr1.htm in the form of Acrobat files, extracted from the proofs for the first edition of this book.

Acknowledgments

First and foremost, I would like to thank my former editor, Diane Heppner, who proposed this book and encouraged me to write it, and my current editor, Cara Anderson, who has demonstrated remarkable and gracious patience and understanding as this second edition slouched its way toward reality. Danielle Monroe, Monica Mendoza, and Kara Race-Moore did a wonderful job of transforming my text and illustrations into this finished book.

Paula Butler, Laurie Toby Edison, and Carol Everhart Roper read every last word of the original manuscript and corrected my grammar, punctuation, logic, and clarity; their assistance was incalculably valuable. A special thanks goes out to David Dyer-Bennet for generously providing the fine cover photograph of me and Elmo.

Finally, I would like to thank those wonderful folks who provided the personal and family photographs that serve as examples throughout this book: Dan Becks, Scott Brock, Grace Butler, Emilio Castrillo, Lloyd Chambers, Tee Corinne, Howard Davidson, Jules Dickinson, Bayla Fine, John Fleshin, Sarah Goodman, Bill Jemison, Ericka Johnson, Stuart Klipper, Scott Lewis, Laura Majerus, Clyde McConnell, Ron Mowry, Myrna Parmentier, Jane Reber, Carol Everhart Roper, Kiril Sinkel, and Steve Schoen.

About the Author

Ctein is the author of several hundred magazine articles on photographic topics and of *Post Exposure: Advanced Techniques for the Photographic Printer* (Focal Press, 2000). He has been doing darkroom printing for 40 years and is one of the few remaining practitioners of the art of dye transfer printing. He has been making electronic and digital prints for over 30 years. Ctein resides in Daly City, California, in a house that overlooks the ocean, with his companion of 25 years, Paula Butler, along with 20,000 books, too many computers and printers, and four demented psittacines.

Quick Diagnosis Guide to Restoration

If your photograph looks like this …	**And you'd like it to look more like this,**	**Then try the methods on pages**
[a] 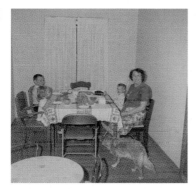	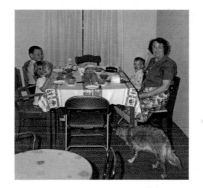	100, 170
[b]		87, 152, 335 (the full restoration workflow is online at http://photo-repair.com/dr1.htm)
[c]		285

If your photograph looks like this …	**And you'd like it to look more like this,**	**Then try the methods on pages**

[d]

100, 111, 170, 331 (the full restoration workflow is online at http://photo-repair. com/dr1.htm)

[e]

103, 299

[f]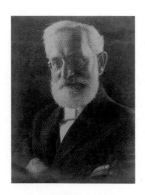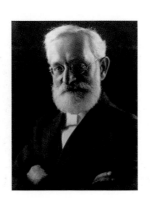

228, 280

If your photograph looks like this ...

And you'd like it to look more like this,

Then try the methods on pages

[g]

73, 252

[h]

87

[i]

97, 100, 170

If your photograph looks like this …	**And you'd like it to look more like this,**	**Then try the methods on pages**
[j] 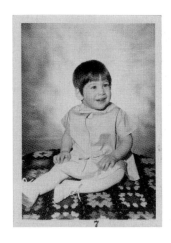	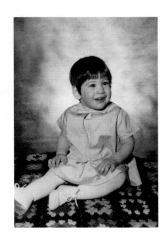	101, 328 (the full restoration workflow is online at http://photo-repair.com/dr1.htm)
[k]		87, 122, 157
[l] 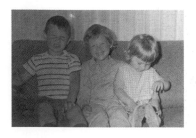	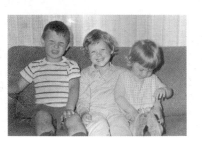	142

If your photograph looks like this …	**And you'd like it to look more like this,**	**Then try the methods on pages**

[m] 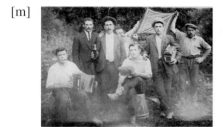 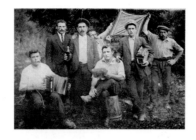 146

[n] 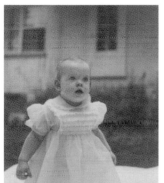 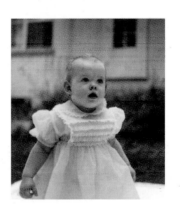 100, 164, 167, 169

[o] 100, 170, 179, 182, 185

If your photograph looks like this …	**And you'd like it to look more like this,**	**Then try the methods on pages**
[p]		100, 194
[q]	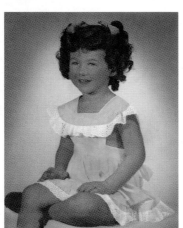	78, 198, 200
[r]		207

If your photograph looks like this …	**And you'd like it to look more like this,**	**Then try the methods on pages**

[s]

290

[t]

231, 235, 260, 265

[u]

221, 268

If your photograph looks like this …	And you'd like it to look more like this,	Then try the methods on pages
[v]	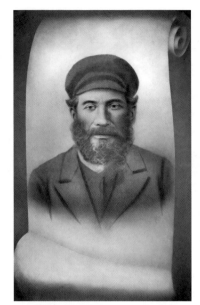	93, 96, 307, 336
[w]		72, 300
[x]	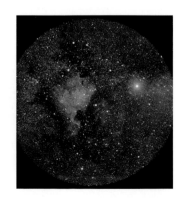	332 (the full restoration workflow is online at http://photo-repair.com/dr1.htm)

If your photograph looks like this …

And you'd like it to look more like this,

Then try the methods on pages

[y]

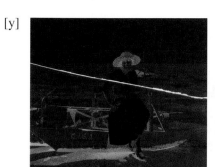

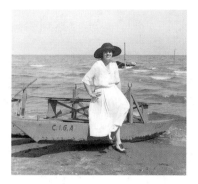

104, 328 (the full restoration workflow is online at http://photo-repair.com/dr1.htm)

[z]

306

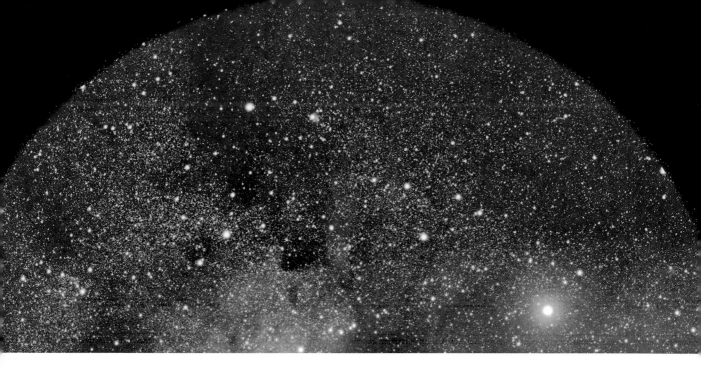

The Big Picture

Where Do You Want to Go Today?

When I sat down to plan this book, I quickly realized that the ideal photo restoration workflow was an elusive and possibly even mythological creature. Oh yes, in the broadest sense there's a clear-cut pattern: Scan the original photograph into your computer, use the image processing program of your choice to correct the defects, print the finished photograph, and archive the restored image's digital file. The organization of this book reflects that flow.

The problem with that facile prescription is that it glosses over the real work that's hidden in the three magic words *correct the defects*. The majority of this book is about satisfying that modest phrase.

Figuring out how to tackle a restoration job can be challenging, which is why I added a "Quick Diagnosis" guide before this chapter. Look for a photo on those pages that illustrates the restoration task you're tackling. Next to that photo you'll find pointers to the pages in the book where I take on that problem.

Hanging over this discussion is the larger and more serious question of just what it is you're after. Photo restoration covers a lot of territory; goals are situational. For example, are you trying to be historically accurate, or are you aiming for the best art? The answer depends on the job.

So, before diving into photo restoration, think about your situation and contemplate the following questions:

- Who are you, and whose expectations matter?
- Who are you trying to make happy?
- Are you trying to recreate an historically accurate photograph?
- How important is the photograph, and how much scrutiny might it be subject to?

Of course, these factors are interrelated, but the answers to these questions provide a framework for organizing your thoughts.

Who Are You, and Whose Expectations Matter?

Are you doing a restoration to please yourself or to please a friend, relative, or client? Are you restoring the photograph as a hobby or favor, or are you doing it professionally?

The difference between a professional and a hobbyist in this case is not one of skill or talent. It's that the professional must satisfy a client whose desires come first. Those needs control the kind of work you do.

Who Are You Trying to Make Happy?

Aunt Sarah and Uncle James will most likely be delighted with anything you do to make that family photo look better (Figure 1-1). Their pleasure is more important than perfection. On the other hand, a professional client who is paying you big bucks for a restoration will likely demand considerably more of your skills.

I've written this book from the point of view of the professional and the perfectionist. When I restore an old photo, I like feeling as though I've waved a magic wand that perfectly and invisibly undid the ravages of age. If I can take it one step further and make that photograph into something that's even nicer than the original (Figure 1-2), it's even better still. Making "the best of all possible prints" from the damaged photograph is what makes me happy.

If you master all the techniques I present in this book, I guarantee you'll be able to do restorations that will please just about anyone. But you may not want or need to go to the extremes I do. Don't slavishly follow my goals. Figure out what will satisfy you in a restoration, and aim for that. I may take a restoration job from A to Z, but you might feel that stopping at K is entirely satisfactory.

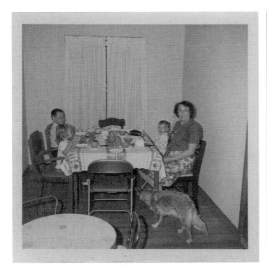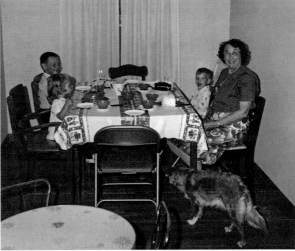

Fig. 1-1 Digital restoration can easily restore a faded family snapshot like the one on the left. Most of the improved tone and color in the restoration on the right result simply from making a good scan, following the principles I present in Chapter 4. A little judicious cropping and burning in produce a photograph that's even better than the original.

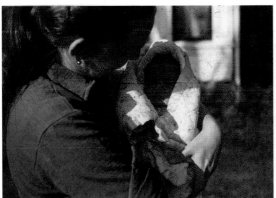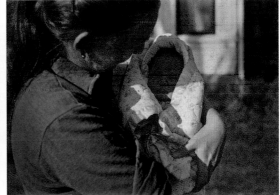

Fig. 1-2 Digital tools can do more than repair damage. The original Kodachrome slide on the left isn't faded at all, although it is badly scratched. Restoration not only removes the scratches, it improves detail in the shadows and highlights. The restoration on the right is a more attractive photograph overall.

My obsession shouldn't drive you. It's possible to spend unlimited amounts of time playing with a digital photograph, trying to make it absolutely pixel-perfect. If that's what tickles your fancy (it does mine), that's great. But if you're doing professional restorations for clients, they're not going to want to spend unlimited amounts of money, and you have to know when to call it

quits. And if you're doing restoration for your own enjoyment, never, ever forget that it's about having fun. If you reach the point where following still one more recommendation of mine feels more like work than play, then don't do it! You can achieve good restorations without it.

Are You Trying to Recreate an Historically Accurate Photograph?

If so, it's of paramount importance not to introduce any extraneous detail that wasn't there or to remove any significant detail from the photograph. That can severely restrict the kinds of gross repairs you can do, especially if entire pieces of the photograph are missing.

In Figure 1-3 no important information would be lost or altered by cropping the photograph or cloning in the lawn to fill in the missing areas. Figure 1-4 is another matter; there's no way to repair the two figures on the right to accurately show what they're doing or even who the rightmost man is. Artistically, we have a free hand in restoring this photograph; historically, most definitely not.

More subtly, does the photo need to be technically accurate? That will rarely be the case, but when I restored this astronomical plate (Figure 1-5) I had to decide whether I wanted a photograph that looked good or one that remained astronomically accurate. I went for "looking good" and invisibly repaired cracks and gaps, with bits of the star field brought in from intact parts of the plate.

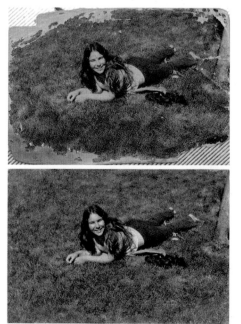

Fig. 1-3 Specialized tools can fill in missing parts of photographs so perfectly that you can't tell where the original leaves off and the reconstruction begins. It's fine to take such liberties when historical accuracy is unimportant.

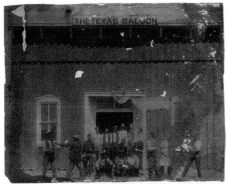

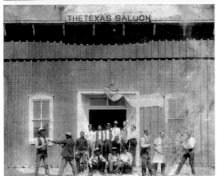

Fig. 1-4 Retouch with caution if historical accuracy matters. Software such as Image Doctor can make quick work of the missing patches in the original upper photograph. But, as the bottom photograph shows, you can't restore detail that doesn't exist. How you "fix" the half-obliterated man on the right depends on whether you want an artistic restoration or an historically accurate one.

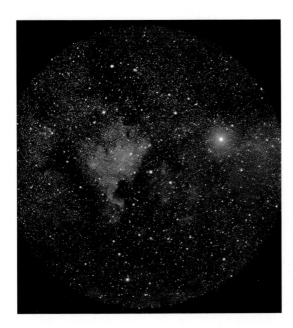

Fig. 1-5 Scientific photographs can be digitally restored. In the online examples I describe, in full detail, how this astronomical plate was recreated from eight broken shards of glass.

Consequently, the "restored" image contains a certain number of stars that don't actually exist! Well, it's my photograph, so it's my call. Were I doing this repair for an astronomer or a scientific collection, I would not do that!

If the restoration requires accuracy, you'll need to know something about what photographs of that type are supposed to look like. James Reilly's book, *Care and Identification of 19th-Century Photographic Prints* (recommended in the introduction), is a fine reference up through the early part of the 20th century. I don't know of any comparable book for modern color images, so be prepared to do some research on what the color photograph is supposed to look like if you're asked to do an accurate restoration.

Most of the time your goal will be artistic—to make the best restoration you can that looks good. This brings me to my next question for you.

How Important Is the Photograph, and How Much Scrutiny Might It Be Subject To?

The ordinary family photograph that Aunt Sarah and Uncle James proudly placed on their mantle is not going to be closely examined or subject to critical analysis. You can take many liberties in your restoration as long as you remain true to the spirit of the photograph. Slight carelessness in technique will never be noticed.

On the other hand, photographs of historic events or famous personages, as in Figure 1-6, may receive closer examination by future viewers. Minor details matter to the historian; for example, a missing button or frayed collar may tell

Fig. 1-6 This Polaroid photograph of a mustachioed Dr. Richard P. Feynman has historical importance, so a proper restoration should not change any details of the subject. In the online examples you'll learn, step-by-step, how much digital restoration can do even when you're subject to such restrictions.

them something about the financial state of the subject when the photograph was made. Historians look at time sequences of famous personages to gauge their health and guess what effect the strains and joys of life and work could have had on them. Even modest cosmetic retouching of the sort you would do to any ordinary portrait to make the person slightly more attractive can have the effect of distorting history.

How Big Will the Restoration Be?

Most restorations are the same size as the originals or only modestly enlarged. You're not likely to need to make repairs down to the single-pixel level of detail. The more the original photograph is to be magnified in the final print, however, the more detailed and extensive your work has to be, because flaws and unrepaired damage that would never be noticed in a life-sized reproduction will be obvious in a 3× enlargement.

These questions are not a quiz. You're not going to be graded on your responses. These are only questions to think about before you embark on a new restoration. They'll help you frame the problem in your head as you contemplate the central matter: What restoration challenges will you face?

The Art (and Craft) of Restoration

Most of the work I do to restore photographs falls into one of the following five categories:

- Restoring tone
- Restoring color
- Fine-detail repairs and cleanup
- Major damage repairs
- Repairing uneven damage

Restoring Tone

Photographs in need of restoration usually don't have very good tonality. Fading and staining will wash out blacks and make whites dingy and dark. A severely faded photograph will have a very narrow tonal range. A big part of restoration is expanding that compressed set of tones back to its original natural brilliance.

You can accomplish a lot simply by making a good scan of the photograph, and I've devoted Chapter 4, "Getting the Photo into the Computer," to that subject. As you'll discover, the process requires some care and attention to detail, but it's a pretty cut-and-dried one.

Beyond merely getting an acceptable tonal range from black to white, one must refine the tonal placement within the photograph so that the highlights

have their sparkle, shadow detail is brought out, and overall the print conveys the feeling of a fresh, new photograph. This is where the art and your talent and skill come in. The Curves tools in your software program are powerful tools for achieving great tonality, and once you master them you'll use them a lot. They're not the only tricks in the bag, though. The Shadow/Highlight adjustment in Photoshop and dodging and burn-in adjustment layers (see Chapter 5, "Restoring Tone") go way beyond simple Curves in their power. In addition, there are some third-party plug-ins (Chapter 3) and specialized techniques (Chapter 10) that go further still in letting you control tone and color rendition.

Restoring Color

Both B&W and color photographs need their color restored. Some B&W photographs will come to you with a pristine, neutral image, but in most of them, what was originally black and white may now be brown and white, brown and yellow, or even dark brown and not-so-dark brown. Part of the restoration job is getting that photograph back to its original hue. Not all photographs started out as true B&W; many of them were sepia or brown in color. Still, it's a pretty safe bet that the deteriorated photo doesn't have the color it did originally.

Color photographs (prints, slides, and negatives) almost always need color restoration. That's by far the most common reason someone will ask to have a color photograph restored. Only occasionally does one turn up where the color is just fine and there's just physical damage.

Just as with B&W photos, a good scan helps a lot; it's a necessary prerequisite to doing good color restoration. Occasionally a scan will accomplish most of the color restoration all by itself, as Figure 1-1 illustrates (I demonstrate this in the online examples at http://photo-repair.com/dr1.htm). Most of the time, unfortunately, a good scan will provide the raw data I need but no more than that.

Curves are my constant companion, just as they are for restoring tones, but they're by no means the only tools I depend on for restoring color. Hue and saturation controls are very important; I also make heavy use of specialized plug-ins such as Digital ROC.

Fine-Detail Repairs and Cleanup

Old photos invariably need to be cleaned up. They will be dirty and scratched and have fine cracks or crazed surfaces or annoying textures. Every photo you restore will have one or more of these defects to some degree.

This kind of fine-structure repair often consumes the majority of the time I spend on a restoration. Much like picking up litter, it's not intellectually or artistically stimulating, and it's tedious to do, but the landscape looks a lot nicer

when I'm done. My way of dealing with this task is to put on some music so I don't get too bored by the repetitive activity and so I can relax and go at it.

I cover many tools in Chapter 8, "Damage Control," that make this work go faster. The right filters and plug-ins attack the noise and "litter" more than the photographic image I'm trying to recover. I have a collection of masking tricks that select for the garbage, so I can work on it more aggressively (and quickly) without messing up the rest of the photograph. All these tools aid the repair efforts, but they're not a replacement for close-in, pixel-by-pixel adjustments. They just make my efforts much more efficient.

Cleanup work is often highly repetitive. For that reason I try not to dwell on it; it's sufficient to tell you, "I painted over the scratches with such-and-such a filter with these settings." That tells you everything you need to know about how I did that bit of repair work. This glosses over the extremely important fact that executing that one cleanup step may have taken more time than all the other stages of the restoration.

Major Damage Repairs

Now I'm talking about the big stuff like tears, missing emulsion, and photos that are in pieces. These types of repairs require very different tools and approaches than the fine-structure cleanup I just talked about. The damaged or obliterated areas are going to be larger than much of the fine detail in the photograph, so I cannot use mechanical fill-in and erasure tools.

Repairing these problems always requires some degree of recreation of detail. Sometimes it's as easy as cloning in material from the surrounding area, as in Figure 1-3. Automated patching tools such as Image Doctor or healing brushes in Photoshop are a big help to me. Often, though, these repairs require serious retouching and illustration creation skills. I'll be honest and admit that major retouching of this type is what I'm worst at. That's a big reason why I recommend Katrin Eismann's book, *Photoshop Restoration & Retouching*, because she is so good at doing that.

Repairing Uneven Damage

I use the same tools for fixing streaks and stains in a print or tarnished and bleached spots that I use for correcting tone and color overall. The difference is that I have to fix those areas of the photograph separately from the rest. One way to do that is with history brushes or cloning between versions, to paint in the corrections just where I want them. A more powerful way to do it, when I can, is to create a special selection or mask that contains only the differently damaged areas.

You'll find that masking crops up a lot in my solutions to restoration problems. That's why I give over all of Chapter 7 to masking techniques. Masking doesn't

let you do much that you couldn't do by hand, but a good mask can save you most of that handwork by automatically placing the corrections where you want them and preventing them from leaking over into other parts of the photograph. Masks are also key to effectively combining layers, both image and adjustment, with the original photograph.

Fooling Around

Figuring out exactly how I'll repair a particular photo is, intellectually, by far the toughest part of the job. Making the corrections can take me a lot of time and work, anywhere from an hour to a day or more, but that part of it doesn't strain my brain. Mapping out the strategy that will get me from A (lousy image) to Z (great photograph) is the tricky bit.

The very first thing I do when I get a new restoration job is to play with it. I scan in a small version of the photograph. It can either be a low-resolution image or a high-resolution scan of a small portion of the entire photograph; often I do one of each. What I'm after is a small file size, so that I can get it into the computer and mess around with it quickly.

These first scans give me the lay of the land, to figure out just what I have to work with and how far I might be able to take it. Many of the photographs I restore come to me as unintelligible (and sometimes nearly blank) pieces of paper, like Figure 1-7. I simply can't tell by looking at such photographs with

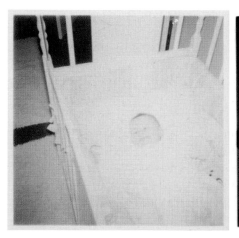 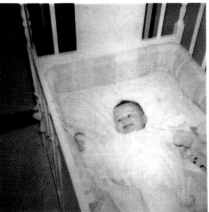

Fig. 1-7 Don't assume that a photograph is unrecoverable until you've tried scanning it! A careful scan, using the procedures in Chapter 4 and some clever enhancement tricks (Chapter 5, pages 152–155), can extract amazing amounts of detail from nearly blank photographs. In the online examples I present all the steps for a complete restoration of this photograph.

the naked eye how much photographic information is hidden in that tabula rasa, let alone how I might fix it.

Even after years of experience, I am frequently surprised by what's possible. I've learned not to tell clients whether I can give them a good restoration based on my visual examination of the photograph. Too often I'm wrong; I underestimate how much quality photographic data is buried in that seemingly hopeless piece of paper or film and how much my hardware and software and skill can mine it.

Scanners excel at extracting the near-invisible. Using the guiding principles from Chapter 4, "Getting the Photo into the Computer," I adjust the curves and levels in my scanner software to pull out and emphasize as much of the real photographic information as I can. Looking at that on my screen gives me a pretty good idea of the potential I have to work with.

Once I can see the photograph more clearly, I decide what its biggest and most obvious problems are. Some photographs have great tone and color but lots of physical damage. Others are physically near-perfect but badly stained or faded. Usually it's a mix.

I don't immediately dive into serious restoration. Even though my time is money when I'm working on a job, I very consciously don't "work" with the photograph from the get-go. Instead I just play, trying out different tools and ideas, noodling around for 30 minutes or so, trying out different approaches to find out what will most effectively fix the photograph's problems. Experience, of course, has given me a good sense of which treatments are likely to be the best remedy for which ills, but every photograph is different and has its little surprises. Hence, the play time.

I try very hard to not be too goal-directed. My objective is to figure out where I want to take this photograph by learning its potential and which of my tools and techniques have the most promise for bringing out that potential, not to drive myself in a pre-judged direction. I try different sharpening or blurring filters, experiment with different masking tools that I have, explore different color-manipulation plug-ins. When I find something that feels like it might take me someplace interesting, I explore it further.

Exploration for the sake of exploration and the adventure of seeing where a photograph might take me: that's the mindset I go into this with, because, paradoxically, treating this work as play makes me more productive by making me more creative. It's valuable because it helps me plan my strategy and approach to that particular restoration.

Once I've settled on a course of action, I make a good scan of the photograph and save a copy of it. As I point out in Chapter 4, the kind of scan I make depends on the tools I want to use and the quality of the photograph. Looking at

the test scan on the screen, I can see how much fine detail there really is in the photograph and how it relates to the physical damage and defects that I'm going to want to eliminate.

If the photograph isn't very sharp to begin with, I might go with a low-resolution scan that yields me a smaller file that's easier to work with. On the other hand, if I think I'm going to do a lot of fine-detail enhancement on the photograph, I scan at higher resolutions than I would if I only wanted to capture the visible detail in the photograph. If a photograph has lots of damage (such as cracks all over the surface) that has much finer detail than the actual photographic image does, I may choose to scan at very high resolutions. Then I can use spatial filters (see pages 218, 276) to pick out the cracks and crevices for repair without also selecting the true image detail (Figure 1-8).

But don't get the impression that I'm starting out blind each time I get a new photo to restore. Every restoration job, like every photograph, is unique, but it's common for photographs of a similar nature to have similar problems. For example, if someone asks you to restore a mid-1960s color Polaroid print that's been in an album, it's likely that the photograph won't be really badly faded, but the colors will be poorly saturated, with dull and veiled highlights.

Another commonality is that the farther you roll back the clock, the more likely it is that the photograph will be physically damaged. There's certainly no shortage of recent photographs that have suffered trauma, and occasionally very old photographs are remarkably well cared for, but the trend is undeniable. Water and mildew damage, even parts of the photograph eaten away by vermin, show up more and more frequently as you go farther into the past.

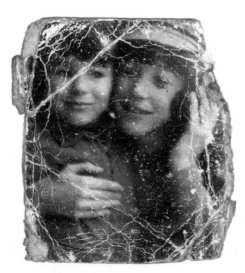

Fig. 1-8 This small photograph is a good candidate for a high-resolution scan, even though the picture isn't very sharp. A scan like that will make it easier to selectively repair the cracks and creases, as demonstrated in Chapter 8.

A Modest Taxonomy of Restoration

This section presents a list of the categories of photographs you'll be most often asked to restore, roughly in order of commonness, based on my experience.

Prints:
 Amateur snapshots, mid-20th century to present
- B&W
- Color

 Commercial and school portraits, mid-20th century to present
- B&W
- Color

 Polaroid
- B&W
- Color
- Peel-apart
- SX-70 style

 Old photographs (pre-1930s)
 Professional photographs
 "Digital" prints

Slides:
 Kodachrome
 Other slide films

Negatives:
 Color
 B&W
 Film
 Glass plate

Newspaper clippings

Prints

B&W Amateur Snapshots, Mid 20th Century to Present

There's a good chance that the photo won't be badly stained or faded, but it will probably be somewhat low in contrast, with grayish blacks, because that's what the B&W photofinishers usually delivered. The color of this era is often nice and neutral, but cheap albums take their toll, so many older photographs are brown or yellow where the silver image has broken down (Figure 1-9).

 Prints from the 1950s and 1960s will likely have some cracks from mishandling. Early resin-coated (RC) prints may have lots of fine cracking and crazing due to deterioration of the plastic layer carrying the image. Displayed RC prints may have severe silvering out and bronzing problems; that is, there will be shiny or yellowish

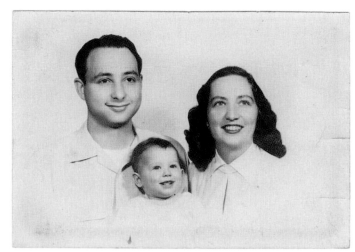

Fig. 1-9 Mid-20th-century B&W photographs may show some yellowing and mild tarnishing, damage that is easy to repair using the techniques from described in Chapter 9.

Fig. 1-10 B&W resin-coated (RC) prints can suffer serious silvering out and bronzing. The masking techniques in Chapter 7 work well for selecting this kind of damage for repair.

patches on the surface of the print (Figure 1-10). Selective masking of the damaged areas (see Chapter 7, "Masking Methods," page 227) works great on this problem.

Color Amateur Snapshots, Mid 20th Century to Present

The more recent the photograph, the better the color will be. If they haven't been on display, prints less than 25 years old won't be too badly faded. They'll have

Fig. 1-11 Color portraits are often printed on textured paper that obscures the scanned image. Chapter 8 shows you how to eliminate that textured surface from the restoration.

lost some density and saturation, but it won't be hard to bring them back with a good scan. If you get prints that young to restore, it's more likely the restoration is needed because of physical damage rather than fading.

Older prints will have faded; prints from the early 1970s will mostly be seriously damaged, and those from the 1950s and 1960s might appear hopeless at first glance, looking almost blank, like Figure 1-7. As you'll learn, it's amazing what good scans and digital techniques can recover even in those "hopeless" cases. Expect to see some uniform highlight stain in all older color prints.

Photographs that have been on display are another problem entirely; by the time they're sent to you, they'll probably be seriously faded. Textured papers, which were very popular in many periods, obscure the image. I discuss some tricks for dealing with them in Chapter 8, "Damage Repair" (Figure 1-11).

B&W Commercial and School Portraits, Mid 20th Century to Present

The situation with commercial and school portraits isn't much different than it is for amateur snapshots, but these prints will have better contrast and tonality than their amateur counterparts. The most likely kind of damage you'll see in younger prints will be physical problems such as cracking, tears, and dirt. The farther back you go, the more the prints will be stained, but the staining is often uniform and so is easy to correct. Unfortunately, the average quality of older print processing was much poorer. Although quite a few are still in good shape, you see many portraits from the 1930s to early 1950s that have stained and turned brown or even yellow.

Color Commercial and School Portraits, Mid 20th Century to Present

The average quality and problems are no different from those you'll encounter with amateur photographs. Low-cost commercial and school portraiture was very

Fig. 1-12 Cheap school portraits come in a variety of (very wrong) colors. Digital restoration, using the methods in Chapter 6, can do a remarkable job of restoring the original color.

variable in quality. Some school photographs from 30 years ago look surprisingly good; others have changed color in all sorts of bizarre ways (Figure 1-12).

Textured paper was very common, almost ubiquitous, for many years. The more faded the color photograph, the more intrusive the texture will be after you restore it; the increases in contrast you make to restore the color also increase the contrast of the texture pattern. Expect to have all the problems you would encounter in restoring an amateur color photograph, plus you'll have the paper texture to contend with.

B&W Polaroids

Most B&W Polaroid prints needed lacquering to keep the silver image from quickly oxidizing. The condition of old B&W Polaroid prints depends on how well the photographer coated the print (Figure 1-13). You'll see prints with streaks where the well-lacquered portions still have good neutral B&W tones and the poorly coated streaks have faded to brown or yellow. Selective masking is one way to isolate those areas, but sometimes clever channel mixing will do the trick (see Chapter 7).

I don't know whether it's because of their small size or stiffer paper, but Polaroid prints are usually less cracked or torn than conventional photographs of the same vintage. You'll need to put in more work correcting uneven fading on these than repairing physical defects.

Fig. 1-13 How much B&W Polaroid prints fade depends on how well they were coated. These two prints both date from the same year in the late 1960s and were found in the same album.

Fig. 1-14 Peel-apart Polacolor prints fade very little when they're kept in albums. The poor color of the original photograph is normal for this type of print; careful scanning and color adjustment can make it look better than new.

Color Peel-Apart Polaroids

The peel-apart Polacolor prints have fairly stable dyes when the prints aren't on display. Prints from the 1960s and 1970s have usually faded much less than their conventional color counterparts. Polacolor color and tonal quality were not very good, though, so you'll almost always want to go the extra step in restoring these photographs to make them look better than they originally did (see Chapters 9, "Tips, Tricks, and Enhancements," and Chapter 10, "Beautification"). Expect older prints to have a greenish cast to them, especially in the highlights and skin tones, and whites will be far from true white (Figure 1-14). Mostly you'll be repairing physical damage and improving the tone and color quality over what

they originally were. Simply making a carefully adjusted scan will often get you pretty good color.

Prints that have been displayed are another matter. If they've been exposed to light, Polacolor prints fade just as badly as conventional ones, and sometimes worse.

Color SX-70-Style Polaroids

Just like the peel-apart prints, SX-70-type prints hold up well in the dark but poorly on display. They acquire a yellowish highlight stain pretty quickly under all conditions, but it's usually uniform. Color improved with each successive generation of these materials, but it was never as good as conventional color prints, so my comments about improving the color of Polaroid prints apply here.

Because of their sturdy protective shell, these photographs usually won't be cracked, torn, or dirty, but they are subject to internal damage. Some older SX-70-style prints develop internal cracks, crazing, or a fine frost-like pattern that obscures the image (Figure 1-15).

Old Photographs (Pre-1930s)

These "vintage" photographs will almost always be B&Ws. The whites invariably darken and turn anywhere from pale tan to dark brown. The image itself may be faded, so the overall contrast can be extremely low. The damage is often very non-uniform, so you'll have to make local corrections to the tones as well as overall ones. Dodging and burning masks (see Chapter 5, "Restoring Tone") are of considerable help.

Fig. 1-15 Some Polaroid SX-70 prints have suffered internal damage. Repair them the same way you would a photograph with fine cracks or scratches on it (see Chapter 8).

All the photos will have some degree of physical damage (Figure 1-16). Restoring the tonal range of a low-contrast photo exaggerates the flaws; in extreme cases you'll be dealing with "noise" that is almost as strong as the "signal." Very old photographs are often missing pieces of the emulsion that will need to be recreated to make the photograph look good again.

Many of the photographs will have "tarnished out"; there will be shiny metallic-looking bronze or silver patches on the surface of the photograph, especially in higher-density areas (Figure 1-17). You'll do best to attack those with selective masking (Chapter 7, "Making Masks," page 227) so that you can correct those problems separately from the rest of the photograph. Chapter 8, "Damage Control" (page 281), tells you how to repair tarnish.

You'll see a fair number of hand-tinted B&W portraits. They will present you with challenging questions, not technical in nature but artistic. If the goal is to produce a good-looking, hand-tinted portrait, modern tastes and sensibilities around such work are very different from those of 50–100 years ago. By today's standards, you may get a more pleasing photograph by eliminating the tinting entirely (not difficult) and turning it into a straight B&W photograph.

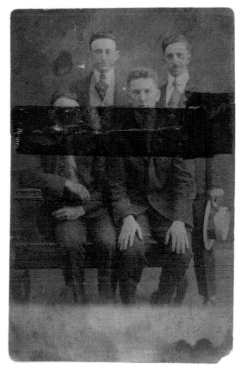

Fig. 1-16 The older the photograph, the more likely it will be physically damaged. At the very least there will be dust, dirt, and scratches; in many cases there will be cracks and tears.

Fig. 1-17 Severe cases of tarnish can be quickly and effectively repaired. Chapter 8 shows you how.

If your objective is to produce an historically accurate restoration, you'll need to know a lot about the tools and techniques, not to mention the aesthetics, of the era in which the photograph was made. The tints you see in the damaged photograph will not be representative of the original hues, and anything that you do to restore proper tone and contrast and eliminate stain and yellowing will alter the colors in ways you can't predict.

Professional Photographs

Professional photographers usually took better care of their photographs than amateurs, and the photographs were usually made with more care and were processed better. Until we get back into the "vintage" era, professional photographs for the most part look better than comparable amateur ones. The most notable exception is that color prints will fade regardless of how well they were processed (although the poor processing used for many cheapo commercial portraits significantly accelerated their fading), so old professional color prints may look just as bad as amateur ones of the same era. Except for color dye fading, though, you're more likely to get a modern professional photograph to restore because it's suffered physical damage than because it's badly in need of tone and color correction.

"Digital" Prints

The overwhelming majority of photographic prints made today are printed with the assistance of a computer. Most of those prints made by mass photofinishers, though computer-driven, are still made on traditional chromogenic color print paper. They don't present any novel restoration problems. In the future, though, that will change because some flavor of inkjet printing will take over.

Small-scale commercial printing and home printing use different media and technology. Inkjet is the most common, with second-place going to dye sublimation, a.k.a. thermal transfer or dye transfer. (This is not to be confused with the traditional darkroom process known as dye transfer printing; they are entirely different beasts.) A very small fraction of prints come off color laser printers or solid-ink printers such as those made by Tektronix/Xerox.

It's easy to distinguish inkjet prints from dye sublimation prints (which we'll discuss in Chapter 2, Figure 2-11). Examine the print with a good 10× loupe. If you see a random pattern of fine dots, it's inkjet. If you see a pattern-free, continuous-tone image or a regular grid of continuous-tone square pixels, it's dye sublimation. In the unlikely event you encounter a laser or solid ink print, what usually sets it apart is that magnified viewing will show a pattern of finely spaced, distinct lines.

Dye sublimation prints, except for the very earliest ones, have an overcoat layer for protection. This gives them a uniform surface finish. It makes it easy to distinguish them from laser or solid ink prints, which will have a pronounced surface relief but usually won't show a giveaway random dot pattern the way inkjets do. Inkjet prints may or may not show a surface relief, depending on the specific printer and paper used.

Incidentally, "giclee" is just a hoity-toity synonym for inkjet. There was a very short period of time about 15 years ago when it denoted a particular kind of inkjet print. Nowadays the term is used by printers simply to make their work sound fancier than the norm; it's functionally equivalent to saying "deluxe" or "acme." It has no significance for us restorers.

Digital prints are subject to the same kinds of damage that traditional color prints are, with a couple of extra "gotchas" thrown in. Some types of inkjet prints were easily damaged by water, which would cause the inks to bleed; that's a problem that traditional and other digital prints won't have.

Though digital prints are subject to light fading just as conventional prints are, many of them were also attacked by airborne chemicals. Light fading is usually proportional, with the areas containing the most colorant fading the most and the ones with the least fading the least. That's why it's possible to do such an excellent job of restoring full color to faded prints; there's almost always some measurable density over the entire tonal scale.

Chemical deterioration, though, is often subtractive. That is, it removes equal amounts of density from all parts of the image, no matter how light or dark the areas were to begin with. That means that low-density areas can completely lose detail in a way that won't be recoverable through simple curve manipulations and contrast enhancement (Figure 1-18).

Digital prints are heir to physical damage, just as traditional prints are. Nothing new there; you'll be dealing with the physical damage the same way regardless of the nature of the print.

Slides
Kodachrome
I've never seen a badly faded Kodachrome slide, and neither will you, unless it's one that has been projected a lot. Kodachrome dyes are extremely stable in the dark, although they fade rapidly in the light. If you get a Kodachrome slide to restore, it will probably need very little tone or color correction (Figure 1-2). More probably you'll be asked to restore it because it is physically damaged. Water and mildew damage repair are common restoration jobs; occasionally you'll come across a slide that's been mishandled and badly scratched.

Fig. 1-18 Early inkjet prints (and those made even today with cheap third-party inks and paper) are widely susceptible to both light fading and chemical attack, causing odd color shifts. Here the black ink has faded to tan. The difference is very evident in the enlarged edge of the print, where a thin strip was shielded from light by an overmatte. The black dots in that strip are much darker.

Other Slide Films

Recent non-Kodachrome slide films are pretty stable. As with Kodachromes, you are more likely to be doing restoration work to correct physical damage than fading. Go back to the 1960s and it's a different matter; just as with color prints, you'll be looking at slides that have faded or stained. Slides from the 1950s will be in extremely poor shape. If they aren't brick-red (Figure 1-19), they will be very badly darkened and stained.

In either case, color correction tools like DIGITAL ROC can work miracles. The hard part will be getting a good scan. Most of the slides will have one or more dye layers that have faded very little, so the overall density range in the slide can be quite high. See Chapter 4, "Getting the Photo into the Computer," and Chapter 9, "Tips, Tricks and Enhancements" for ways to deal with this issue.

Negatives

Even though the majority of photographs made in the past 50 years have been negatives, most of the time you'll work on a deteriorated print. Usually that will be because the client doesn't have the negative, but it never hurts to ask. Original negatives, B&W or color, almost always permit better restoration than the prints made from them.

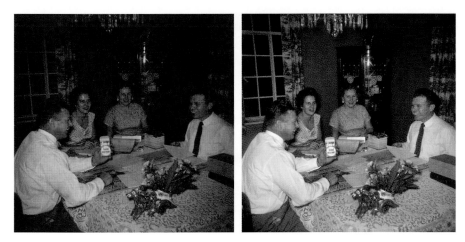

Fig. 1-19 Excellent restorations are possible from severely faded slides, such as this Ektachrome from the early 1950s. The online examples provide step-by-step details of how I completely restored this photograph.

Color Negatives

This is not to say that negatives don't deteriorate. In fact, color negative films are among the least stable of all types of films, and older ones were especially bad. Physically the color negatives are likely to be in pretty good shape; they've probably never come out of their folders and sleeves since they came back from the photofinisher. You won't have unusual numbers of scratches and dirt specks to clean up.

The most common physical damage I see in old color negatives is due to poor processing. There may be long scratches down the film, or water spots; sometimes there are surge or flow marks where the developing chemicals didn't bathe the negative evenly. Mildew damage is a less common occurrence.

Most of the time you will be faced with a clean but uniformly faded negative. Your task will be to figure out the major tone and color adjustments needed to produce a correct-looking print. There will be serious dye loss; the fading will be at least as bad as with very old color slide films. Color correction will be a major challenge.

What makes it possible to do good restorations from old color negatives is that they recorded a lot more information than ever gets conveyed in a print. Most of that information can get lost through fading and still leave you with plenty for producing an excellent photograph. As with slides, special color correction tools can automate a lot of this color and tone restoration for you. Unlike slides, you won't encounter color negatives with extremely high densities, so scanning will be much less tricky than it is with slides and old B&W negatives.

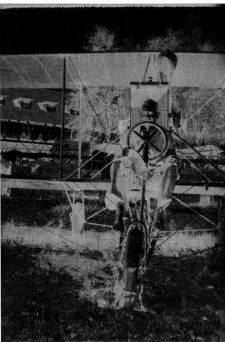

Fig. 1-20 Old B&W negatives, like this cellulose nitrate negative from the early 20th century, are usually very contrasty. That makes them hard to scan, but Chapter 9 tells you how to do it well.

B&W Film Negatives

Modern acetate-based B&W negatives don't usually present a lot of fading problems. Properly processed B&W negatives are extremely stable, but they may not have been stored properly or washed well when they were processed. Physical damage is the most likely reason someone will send you a B&W negative, so you'll mostly be cleaning up dust, scratches, and tears and correcting for a little bit of unevenness in density.

Before acetate "safety" film, there were nitrate-based B&W films. Those negatives will all have some degree of staining and yellowing, from modest to severe. The silver image densities will usually be pretty good, even if they've turned brown (Figure 1-20). In fact, these old films had so much contrast to begin with that scanning them will be difficult. A somewhat faded negative may actually prove easier to work with. (Caution: These negatives can be brittle with age, so handle with care!)

B&W Glass Plate Negatives

Glass plate negatives, like vintage B&W prints, turn up in all kinds of condition, often in pieces! Fortunately, reassembly on the computer is much simpler than in real life. (See the online examples at http://photo-repair.com/dr1.htm.) Really old plates may have bleached out almost to the point of invisibility; others will not have faded at all. In the least-faded photographs, the long density ranges of these old materials will make getting a good scan challenging. Other than fixing broken plates, restoring glass negatives is no different from restoring film ones.

Newspaper Clippings

As long as the paper isn't so brittle and fragile that you dare not handle it, the condition of newspaper clippings and halftone photographs doesn't matter a lot. The nature of the printing inks that were used means that they will rarely be faded even if the paper is badly stained or discolored. You can expect good

Fig. 1-21 Even screened newspaper photographs can be restored and turned into acceptable photographs. Chapter 9 presents several ways to clean them up.

contrast between the halftone ink dots and the paper. Since the paper is supposed to be white and the ink dots are supposed to be black, and there aren't any tones in between, scanning halftones is easy (see Chapter 4, "Getting the Photo into the Computer").

What you will find challenging about working with a halftone is eliminating (or at least minimizing) the screen pattern; a good percentage of your clients will want to know if you can turn the halftone into a "nice photograph." Very often the answer is yes. The trick is to do this without blurring out much of the photographic detail. I've got some software techniques for that (Figure 1-21) in Chapter 9, "Tips, Tricks and Enhancements" (page 299), and an example of such a restoration in the online examples.

Take Your Time

If you're new to photo restoration or even digital print making, don't be in a hurry to do great work. You won't achieve a wonderful result the first time you restore a photo. I don't think it's so much that the learning curve is steep as that doing digital work *well* requires knowing a great deal of information and gathering experience.

That's true of any craft, including wet darkroom printing. But with material crafts it takes a while to physically master the tools and become proficient in their handling. I haven't found printing on the computer to be more conceptually difficult than darkroom printing, but the darkroom forced me to ease into the knowledge because there was so much physicality to get under control. The computer lets you jump right into the deep end of the pool.

For example, you don't have to learn any more about masking to do good tonal control on the computer than you do in the darkroom. But it will take you days or even weeks to master darkroom techniques for making masks, during

which time you mentally assimilate the concepts. On the computer you can learn the technique in a matter of minutes and make technically perfect masks with a couple of mouse clicks. Then you discover it's still going to take you weeks to internalize the knowledge.

Subjectively this makes it seem as though the computer stuff is much harder, but it's only that it takes time to digest the knowledge. Even if you can push the buttons on the computer in 5 seconds, you can't (so to speak) push the buttons in your brain that fast.

One thing I have learned is that it's very difficult to spend "an idle half hour" doing digital photographic work. It's just as hard as spending only 30 minutes doing serious printing in the darkroom. It takes time to get your head into the right place, think about what you're doing, and do it well. Once you're really proficient with the techniques, you can do productive work quickly. While you're learning what you are doing, however, you need to allow yourself several hours at a time so that you can play with the tools and controls and feel comfortable and not be distracted by watching the clock. You need to take the time to experiment enough to get a feel for how different changes have different effects. Don't be utterly goal-directed; investigate different paths and ideas, try different approaches, tools, and settings. That's what Undo commands, nondestructive manipulations, and the original scan file that you saved are for: to let you explore without being committed. Digital restoration is a process of exploration. No two damaged photos are quite alike, and there's no completely fixed routine for handling them. Learn to play.

Chapter 2

Hardware for Restoration Work

The "Bottom" Line

Here's the short form: The most important thing is to have lots of memory, as much as you can afford. Next comes plenty of fast hard disk space and media to archive data off site (external or removable hard drives or CDs and DVDs). Spend your money on these priorities instead of buying a faster computer.

For your display, get either a CRT (TV-type tube) or a *good* liquid crystal display (LCD). Don't get an inexpensive LCD. For scanning prints in and printing out your finished restorations, you don't need to spend more than $250 to $500 apiece on a flatbed scanner or printer.

The rest of this chapter goes into more technical detail about computer hardware—more than most people need to do good restorations. If you're interested in the whys and wherefores of my recommendations, read on. Otherwise, just read the sidebar near the end of the chapter, and you're ready for the next chapter.

The Computer

Just about any computer you're likely to have bought in the 21st century can handle digital restoration. Still, improvements in computer performance and "bang for your buck" should make for big differences in your workflow. When I wrote the first edition of this book, I was working on a single-core Windows machine with 2 GB of RAM, 360 GB of hard drive storage, and a 19-inch Hitachi RasterOps CRT monitor. A better, faster system would cost well under $1000 today. Currently I do my work on a MacBook Pro with an Intel Core Duo CPU, 6 GB of RAM, dual LCD monitors, and much faster and bigger hard drives.

All that extra power doesn't only mean that software runs faster; it changes the way I use the software. In Photoshop, for example, almost every method or technique I write about in this book can be done using masked layers, adjustment layers, and smart objects and smart filters instead of executing it directly on the image file. In fact, Photoshop CS4 has been redesigned to emphasize this kind of workflow. All the old ways of doing things are still available; you don't have to change the way you work. (Consequently, I didn't need to rewrite most of the examples in this book; they'll work just as well under the new workflow as the old.)

But you should think seriously about learning new ways. Adobe is encouraging you to make a lot more use of layers and smart tools in place of irrevocable adjustments and filters, and I agree with them. The big advantage to making corrections this way is that all my work is reversible. If I make a mistake or change my mind later, I can revise and correct my earlier work. That fungibility doesn't disappear when I save and close the file or shut down Photoshop. At any time I can modify earlier decisions. Since photo restoration involves an awful lot of trial and error, even for me, the benefits of this way of working are substantial.

In the first edition of this book, I used a mix of layers, the History Brush (which provided a limited ability to undo bad work that didn't extend beyond one work session), and the direct application of tools and filters (which were reversible only to the extent that History States could be undone within a work session). The reason I did that is because layers and smart tools eat up system resources. File sizes become huge, and on a machine with relatively limited RAM, that would mean I'd be quickly swapping to disk, with all the slowdowns that entails. I'd have to pay an unacceptable penalty in performance to get reversibility. On a fast, modern system, that penalty is nowhere as large, and it doesn't show up anywhere as quickly.

Picture Window also benefits from a lot of RAM. The more RAM you have, the more image windows you can have open without PW having to go to the

scratch disk. As with Photoshop, you can have much more elaborate workflows and sequences going on without your system slowing to a crawl.

While I have my personal preferences, I can't come up with many objective reasons for deciding between a Mac or a Windows machine. I really like Macs; I prefer the interface and the way it handles color management more than Windows. On the other hand, the low-cost image processing program I think the most highly of, Picture Window, only runs under Windows. The Intel-based Macs can run Windows natively or under an emulator; they may offer the best of both worlds in one machine.

If you're running Photoshop, a modest argument can be made for a Windows machine today because the Mac version of Photoshop CS4 cannot directly utilize large amounts of RAM. I'd call it a modest argument because that problem is supposed to be solved with Photoshop CS5, and as I'll explain in the section on "Configuring Photoshop," CS3 and 4 can make indirect use of large amounts of RAM in ways that substantially speed up performance.

Conversely, a modest argument can be made for buying a Mac because a Mac user can still run Windows, either directly under Boot Camp or through an assortment of emulation programs that perform almost as well as a dedicated machine. These days, a Mac can be a pretty powerful Windows platform.

If you're thinking about buying a new computer to replace an older one, keep in mind that many software manufacturers don't offer very good bargains for cross-platform software purchases, if they offer them at all. Switching from Mac to PC, or vice versa, can cost you far more in replacement software than you paid for the computer. Adobe provides cross-grades for Photoshop if you ask.

I strongly recommend getting a machine that includes at least FireWire 800 and preferably eSATA disk interfaces. For desktop machines of either flavor, there are cheap peripheral cards that will perform just fine. If you're getting a laptop, make sure it has an Express 34 slot and you'll be able to use plug-in cards to get you the disk interface of your choice.

Even though it's the most common external interface out there, don't rely on USB 2.0 for external hard disks. They are almost always substantially slower, sometimes three or four times slower. When you're moving large image or scratch files around, you'll really notice this difference. Photoshop in particular doesn't seem to play well with USB drives, so relying on a USB 2 drive as your scratch drive will seriously degrade performance (see "Photoshop Performance Enhancement" in Chapter 3).

A lot of professional digital equipment uses FireWire. For example, my medium-format film scanner, a Minolta DiMAGE Scan Multi Pro, has ultrawide SCSI and FireWire interfaces but no USB interface. These days I don't think you need SCSI ports. Hardly any new devices I know of have only SCSI interfaces.

Ctein
Digital Restoration from Start to Finish

Even fast external hard drive arrays, the last great bastion of SCSI, are being challenged by FireWire and eSATA. If you want to invest in older hardware (charmingly referred to as "legacy" technology), you may need an SCSI card.

Memory

More important than a fast CPU and hard drive is buying as much memory (RAM) as you can afford. Digital scans can get extremely large. A color photograph scanned at 16 bits per channel produces 6 bytes of data per pixel. If you're scanning at 600 pixels per inch (ppi), you're collecting 2 megabytes (MB) of image data per square inch of original print. That's more than 50 MB for a mere 4 × 6-inch print and more than 150 MB for an 8 × 10-inch print.

If you scan your original at 8 bits per channel, that cuts the file size in half, but if your original needs to be scanned at 1200 ppi instead of 600, the file size quadruples! For example, an 8-bit-per-channel scan at 1200 ppi of that 4 × 6-inch print will saddle you with a 100 MB file (Table 2-1).

Programs such as Photoshop and Picture Window eat up memory very, very quickly. The old rule about needing an amount of RAM equal to three to five times the file size doesn't work any longer. If you have less than 10 times the file size in available RAM, Photoshop is going to end up writing scratch files to the hard drive. Doing really fancy work might push that up to a requirement of 20 times the file size.

What does that mean for performance? Everything in the world! Reading and writing data to the fastest hard drive is 10 times slower than handling that same data in RAM. Your image processing program will slow down several-fold the instant that hard drive access light comes on and stays on. When it comes to real-world performance, for a given sum of money you'll almost always be better off buying a machine with a slower processor and more RAM.

It's not easy calculating your total memory requirements. Usually you find out you don't have enough memory when something goes wrong. Figuring out

Table 2-1 File Sizes of Color Scans (in MB)

Print Size (Inches)	300 ppi, 8 bits	300 ppi, 16 bits	600 ppi, 8 bits	600 ppi, 16 bits	1200 ppi, 8 bits	1200 ppi, 16 bits	2400 ppi, 8 bits	2400 ppi, 16 bits
2 × 3	1.6	3.2	6.5	13	26	52	105	205
4 × 5	5.4	11	22	43	85	175	345	690
5 × 8	11	22	43	85	175	345	690	1350
8 × 10	22	43	85	175	345	690	1350	2750

your needs is difficult because different operations may all fight for the same memory, but they're not all operating all the time, so you might not realize you don't have enough RAM to satisfy them all.

For photo restoration work there are four main consumers of memory: the operating system, the image processing software, plug-ins for that software, and the printer driver and print spooler. Those last two categories of memory consumers are what most people don't plan for.

A program such as Photoshop lets you set how much of the available RAM it will use. On my old Win2K machine with 2 GB of RAM, for example, giving Photoshop 80% would leave 400 MB for the operating system. I can check the Task Manager to see what the OS is routinely consuming; it's almost always below 250 MB. It would seem then that I'd be safe with the 80%-for-Photoshop setting and have plenty of RAM left over for momentary demands.

It doesn't work that way. If I tried to print out my largest photographs, which are 20 to 30 million pixels in size, I ran out of memory with Photoshop set for 80% RAM consumption. I didn't get any warning that I was out of memory, but the printer preview window showed a truncated photograph with some lower part of it missing (Figure 2-1). That is not an artifact of the preview; if I print that photograph, it'll be truncated.

Why? The software that converts the photograph to printer data uses a lot of RAM while it's creating that printer file. If it runs out of RAM before it has fully rendered the file, it doesn't abort the process; instead it sends off an incomplete photograph.

The fix is easy: Decrease the amount of RAM that's dedicated to Photoshop so that the operating system has more. Setting it down to 70% usually works; setting it down to 60% always works.

In that case, why not just leave Photoshop using only 60% of RAM or even less, just to be safe? One reason not to do that is that when Photoshop runs out of RAM, it starts swapping to disk. It will keep running, but it runs much more slowly. Worse, third-party plug-ins generally have to use the same RAM that Photoshop does, but they can't use a scratch disk, as Photoshop can. For example, if I open a large file with Photoshop set for only 50% or 60% of RAM, some of my plug-ins will report that they can't function because they've run out of RAM. So, it's back up to 80% for Photoshop, at least until I need to print again. Getting this all to work well on your computer is a trial-and-error process.

Simply adding more RAM to a 32-bit system doesn't necessarily solve such problems. Some software can't take advantage of the extra memory. Some functions need to work in the lower 2 GB of RAM. If there's insufficient memory available to satisfy those functions, additional RAM above the 2-GB limit won't help. That's yet one more reason for upgrading to a 64-bit capable

Fig. 2-1 It takes considerable memory to print large files. If your print preview shows a truncated picture like this one, it means you don't have enough free RAM available to the system. Reduce by 10% the amount of RAM assigned to Photoshop in its memory preferences, and try printing again.

system, if you're not already running one. (You Mac owners don't have to worry; unless your machine is truly ancient, you are running a 64-bit system.)

When you add more RAM to your system, keep an eye out for problems. The quality control on RAM modules is pretty good these days, but every so often a substandard piece will slip through. I added some slightly misbehaving RAM to my Windows system and wound up with an Epson R800 printer problem that drove me nearly crazy (Figure 2-2). It looked like misfiring inkjet nozzles or faulty ink flow; it didn't occur to me for the longest time that it could be a computer problem. When I finally got the notion to run a RAM stress-test diagnostic program (there are tons of free ones available online), it reported a problem. Once I had fully functional RAM, my printing was back to normal. It was a considerable relief to learn that I didn't need to buy a new printer, but I'd have been a lot happier not wasting a couple of days figuring that out.

The reason I'm bringing up such examples is that I've seen many photographers run into these RAM limits on older systems and be confused by the erratic and peculiar behavior of their computers. If you see your program behaving unusually or if it fails to complete an operation or does it only halfway, the first thing to check is the amount of RAM that's available for the program.

Fig. 2-2 The strange red (minus-cyan) and green (minus-magenta) streaks in this print weren't caused by a misbehaving printer or misfiring inkjet nozzles. A defective RAM module proved to be the culprlt.

That's especially true when plug-ins abort or printers fail to print complete photographs.

I have more to say about ways to improve Photoshop's performance. Most of the tricks are software-related, so I've put that information in Chapter 3, "Software for Restoration," after the Photoshop CS4 review.

Hard Drives

So much for the intricacies of real memory. What can we do to improve things when Photoshop has to go to the hard drive, as it inevitably will? The two things you can do to improve Photoshop's hard drive performance are to run very fast hard drives and to have multiple drives running off different data buses. I cut my times for memory-intensive Photoshop operations on my MacBook Pro 25–30% by installing the fastest hard drive I could find (the Hitachi 320 GB 7200 rpm drive) in my MacBook Pro and using the very fast Other World Computing Mercury Elite-AL Pro 750 GB eSATA drive for scratch. I connected that drive with a $39 Apiotek Extreme Dual eSATAII Express Card 34 Adapter—a modest investment for a big performance gain.

Your computer is never doing just one thing. For example, the OS swaps around chunks of program code to optimize performance. That's why a program

like Photoshop starts up so much more quickly the second time you launch it; most of the code is still resident in RAM and doesn't have to load from the hard drive.

And you can bet that Photoshop scratch files are not the only disk access going on. If you have only one hard drive, the bandwidth will get divvied up between competing processes and the drive's heads will spend more time seeking the right data tracks on the drive. For this reason you can be looking at a several-fold loss in performance across your system. If everything is sitting on the same hard drive, even operations as straightforward as saving the file you're working on back to disk will run much more slowly when Photoshop runs out of RAM.

Simply rearranging partitions and workspaces on multidrive systems can make a profound difference. Ideally what you'd like to have are separate drives (and buses) for the OS, programs, documents, and application scratch files. My old PC has two IDE drives on separate buses, plus SATA and FireWire 400 drives. Once I got OS, program, data, and scratch files properly segregated, I saw my sustained DVD write speeds (another disk-intensive operation) jump from 3× to 11×. That's what getting rid of drive contention can do for you.

There are lots of Websites out there, like http://barefeats.com, that benchmark hard drives. If you're serious about tuning up your system, you should get a good disk performance test program of your own. My favorite one for Mac OS X is Lloyd Chambers' DiskTester 2, which you'll find at http://diglloyd.com/diglloyd/software/disktester/index.html.

This is not a free utility, but it is inexpensive and very, very good. I used it for my disk benchmarks and analysis. One warning, though: It is a UNIX command-line program. I am not at all a UNIX geek, but fortunately Lloyd has an excellent user manual with sample commands that you can cut and paste and adapt to your system.

Now that my primary Photoshop system is a Mac, I'm not quite as up on good benchmarking programs for Windows systems, but PassMark (www.passmark.com/products/pt.htm) seems to have a reasonable one that has a free 30-day evaluation period.

Monitor

If you're not a games player, just about any professional-grade video card will be fine for doing photo restoration. If you're heavily into computer games, you'll probably have to spend more money. Today's state-of-the-art games want lots of RAM and powerful hardware graphics rendering. The extra video board power won't necessarily be wasted. Image processing software is increasingly making use of the video RAM and graphics coprocessor to speed up operations.

CRTs aren't dead yet, but they are mighty hard to come by. Unless you are a total diehard CRT fan, your next monitor will be an LCD. The better LCD monitors today are truly superior in quality; unfortunately, there are also a lot of lousy ones out there. Expect to spend $400 and up for a good one. Although you can buy very inexpensive LCD panels, these are not suitable for serious photographic work. Lesser-quality LCDs don't display a uniform image over the entire screen; there are large variations in brightness and gamma with the vertical viewing angle.

You can observe this on the LCD display of any laptop computer by bringing up an image that has a lot of dark tones in it (it's hard to see this problem looking at bright colors and light grays and whites). Tilt the screen toward and then away from you and observe how drastically the darker tones and the blacks change in appearance as the angle of the screen changes (Figure 2-3).

Even if you rigidly fix the angle at which you view a cheap LCD, you will still have viewing-angle problems from the top to the bottom of the screen. This is readily seen by looking at a large and uniform dark gray image. You can create one in your image processing program by opening up a new image window, setting the foreground color to a gray value of about 65, and filling the window with the paint bucket. The image should look uniformly charcoal gray over the entire screen. On a poor LCD monitor, it will look much darker at the top of the screen than at the bottom (Figure 2-4). This variation makes it impossible to do accurate photographic work. The more expensive LCD panels, starting in the mid-hundreds of dollars, don't have this problem.

When you go shopping for an LCD monitor, check it out by viewing a dark image and tilting the screen toward and then away from you, top to bottom. If you see large brightness changes when you do that, don't buy that monitor. Shop around until you find one that looks the same over a wide range of vertical viewing angles. Such a monitor will be good for serious photographic work.

Cheap LCDs don't even display full 24-bit color. They may only display 5 or 6 bits in some channels. Some of them hide this flaw by using clever dithering schemes to simulate a richer tonal scale. The difference may not be noticeable at a casual glance, but it will become obvious when you start doing serious photographic work, and it will mess up color management for you. Don't get sucked into buying a cheap display; it's a penny-wise, pound-foolish strategy.

One Website, www.pchardwarehelp.com/guides/lcd-panel-types.php, has a nice explanation of the various kinds of LCD technologies, should you want to learn more about such arcane matters.

Brand names? Apple Cinema displays are very good, but I'm not at all happy with the new glossy-screen design. A glossy screen produces too many

Fig. 2-3 Don't buy an LCD monitor whose gamma (midrange brightness) changes like this one when you tilt the screen toward or away from you. Cheap desktop monitors (and laptop displays) have this problem; more expensive displays show you a consistent image over a wide range of viewing angles.

Fig. 2-4 This is a photograph of a laptop LCD screen that is displaying a uniform gray image with a value of 65. The difference in brightness from top to bottom is caused by changes in gamma with viewing angle. You can't use a display like this for precision photographic work!

distracting reflections for my taste. I'd lean toward finding a used 23-inch Cinema Display instead of a new 24-inch LED Cinema Display.

For a real step up in quality, take a look at the better NEC displays, the ones advertising "wide gamut." These displays show nearly the entire AdobeRGB color space, which makes them an excellent match for high-quality printers. The NEC MultiSync P221W is a particularly nice "entry-level" display. It's a bit shy on pixel count, with a native resolution of 1680 × 1050, but the image quality can't be beat at a street price of around $450. There are some even nicer 26-inch displays in the $1100 range. A few hundred dollars more gets you integrated color management for any of these monitors via NEC's SpectraView system. If you don't already own a monitor color calibration system, this is an excellent bargain. If you don't know why you should own such a system, read the "Color Management and ColorMunki" section that appears a bit later in this chapter.

Tablets

A graphics tablet and pen aren't strictly necessary for doing restoration work. In truth, I worked solely with a mouse until just a few years ago, and I became quite adept at doing very complicated work with it. You may note that most of the techniques I present in this book don't require extremely precise cursor movements; they allow one to be fairly careless and still get good results. It's also true that you can learn to work pretty well with any input device. It's just a matter of practice.

That said, a good tablet and pen will speed up your work considerably because a great deal of restoration does involve drawing, painting, and dabbing

at the "canvas" with some tool or another. Even with my mousing skills, I am now able to work considerably faster than I could before.

The biggest obstacle when buying a tablet is that it's the kind of product where you would really like to be able to try it out before buying. It's hard to imagine any other computer accessory where personal ergonomics matters half as much. Unfortunately, with the demise of entire retail store chains, you're unlikely to find much physical product to handle.

I finally gave up trying and asked a very experienced and skilled friend what he thought I should buy. He recommended the Wacom Intuos3 6 × 8-inch tablet (Figure 2-5). I blanched a bit when I saw the approximately $300 price tag, but without the chance to test tablets myself I didn't want to gamble on something less expensive.

(*Note:* The Intuos3 series has been replaced by the Intuos4, but as of this writing Intuos3 tablets are still readily available from several sources. Anyway, I have no reason to think the Intuos4 could be a worse tablet.)

Needless to say, the Intuos has worked out very well for me or I wouldn't be mentioning it here, but I'm not going to assert that it's the only good tablet out there. Unfortunately, it is the only one I'm familiar with. My shopping advice to you has to be the same advice I gave myself: If you can't get hands-on experience with some tablets, ask trusted friends what they would recommend.

Specifications don't mean a lot here; I think it's primarily about how the device feels. There are a couple of parameters I would pay attention to. Size, for one: a 6 × 8-inch active area is ideal for me, and I think it would be for most people. A larger area requires a great deal of arm movement that will become tiresome when you're doing lots of spotting work. A 4 × 5-inch area is too small for me to have the precision of movement that I'd like. Be aware that the full size of the tablet will be 4–5 inches larger than the active area; make sure you have enough desk space.

Although pressure sensitivity is a must, I don't think the number of levels of sensitivity is important for this kind of work; 256, 512, 2048, it's really not going to make a perceptible difference. The fanciest tablets also have pen-tilt sensitivity. This is great for the true artist. For folks like us, it's more likely

Fig. 2-5 A good digitizing tablet such as the Wacom Intuos is not required for restoration work, but it makes the work go faster and more comfortably.

a feature you'll disable. I just don't have the hand training or dexterity to simultaneously control pen position, tilt, and pressure.

As I said, a nice graphics tablet is useful but not necessary. Don't feel like you have to get one to be a successful restorer, but if you do you'll likely feel it was money well spent.

Color Management and ColorMunki

Without good color management, everything else becomes much harder. You need to manage your system's color if you want to get quality results.

Why should color management matter? Walk into any consumer electronics store and look at the wall of TVs they have for sale. They're all tuned to the same program, but no two of them look alike. Identical inputs, different outputs: that's the problem. No equipment displays or reproduces color perfectly, and that's true of your computer monitor and printer.

Color management uses data files called *profiles* to fix color-rendering problems. Profiles don't alter your image file. The profile is a little translator that adjusts the electronic data before it goes to your monitor or printer, to cancel out the errors that the monitor or printer introduces. It works behind the scenes to make sure that "What You See" is closer to "What You Get."

Minimize monitor errors and you'll be much closer to seeing your photograph's true tones and colors. You don't absolutely need a calibrated monitor to do good digital printing, but working without one slows the work. You'll have to do more mental translation from what you see into what you think you'll get, and you'll waste more time and money on tests.

Tools such as Mac OS's built-in display calibration only ensure that on average your monitor is operating properly; there will still be errors in how colors and tones are displayed. A monitor profile corrects all those individual color errors.

For example, your monitor may reproduce a middle gray just fine but portray fire-engine red as being a little too bright and a little too yellow. A custom profile won't alter the grays, but it will make the red a little darker and a little bluer to compensate, just enough to balance out the distortion of the monitor.

To profile your monitor, you need special hardware and software that measures and analyzes the colors being displayed. I like the ColorMunki, from X-Rite. The $499 package includes the ColorMunki puck, case, USB cable, and installation CD. It runs under Windows (XP or later) or Mac OS X (10.4 or later, G5 or Intel). ColorMunki makes both monitor and printer profiles for people who loathe color management theory (nothing wrong with that) and who might not even know what a profile's good for (although I hope that I've made it clear to readers why they need them).

39

ColorMunki is incredibly simple to use. The product has veered perhaps too far in the direction of "simple." The substantial-looking 48-page manual contains only the most minimal instructions, and it doesn't explain what you're going to be doing with it or why. Installation was trouble-free, I'm happy to say. ColorMunki requires "activation," and you are allowed to use it on no more than three machines at a time, but activation does not involve any offsite connections or intrusive measures. One mouse click and it's over, instantly and painlessly. Should you wish to move an activation to a different machine, you can deactivate an old one. Nicely done, X-Rite.

The bad news is, after I launched ColorMunki I clicked on the Help menu item. Did that bring up any online help? No; it took me back to the X-Rite Website's online documentation. It's some of the poorest help site design I've seen. I felt like I was playing a text adventure game, and text is an unergonomic gray on gray. I designed better Websites a dozen years ago.

Fortunately, and in marked contrast, ColorMunki's in-program instructions get an A+. The opening screen gives very clear choices. There are short animated movies for each choice and written instruction that are concise and helpful. There is visual on-screen feedback; for example, when the software wants you to switch the ColorMunki to the Calibrate setting, a diagram shows you the current setting of the ColorMunki control dial and indicates how you should turn it. When you turn it, the picture changes in synchrony. The software will not let you make a mistake, and it holds your hand in a way that is not annoying. It more than made up for the unpleasant online experience.

Monitor profiling with ColorMunki in the easy mode requires no decisions whatsoever and calibrates to D65 (6500 Kelvin color temperature, a common industry standard). ColorMunki lacks a CRT monitor choice, but setting it to LCD works just fine. An advanced mode lets you adjust the contrast and brightness of your monitor (if it has such adjustments), take ambient lighting into account when optimizing your display, and choose D50 or D65 color temperature. D65 may be "industry standard" for graphic arts purposes, but D50's better for art photographers and photo restorers. Prints are very rarely viewed under D65 conditions; incandescent light is actually down around D30. Photos that look good on a D65 screen look too warm in prints viewed by daylight and are way off in incandescent-light viewing. D50's a good match to daylight and substantially reduces the visual difference between the screen and in an incandescent-lit print.

ColorMunki runs the show. It instructs you when and how to set the puck to calibrate itself, put it in its padded case, and position it on your computer monitor. The case strap is weighted to help keep the puck in position (although it needs a couple more ounces in the strap). ColorMunki displays a series of

predefined color patches on the screen, measures them, and calculates the adjustments needed to produce correct color.

Profiling your printer is most important for quality results. Reduce printer errors and you'll get better-looking prints than you ever did before, and you'll get them more easily (I cover that topic in Chapter 12, "Printing Tips"). If you don't spend any other money to get into digital restoration, do spend the money for custom printer profiles or buy a ColorMunki. You'll thank yourself for money well spent.

Don't worry about scanner profiling. For normal digital photographic work, you'd also want a good profile for your scanner to ensure that your scans have maximum fidelity. In restoration work this is not even desirable. As I explain in Chapter 4, "Getting the Photo into the Computer," it's unlikely you'll want to make a scan that faithfully reproduces the damaged photograph in its deteriorated state.

Backup and Long-Term Storage

When we contemplate data storage for computers, we normally think in the short term. Our first concern is the immediate one: how much hard drive space to have. Then we think about how we back up our system in case the operating system crashes or a hard drive fails.

The more prudent among us think about off-site backups, ensuring that a copy of the data on our hard drives is stored someplace other than the home or office where our computer is. That way a major disaster at the computer's location loses only hardware, which is easily replaceable. Still, this is thinking about the short term; backups go out of date pretty fast.

Restoring photographs engages us in a whole new concept of time. Months and years are minor matters; it's decades and possibly even centuries that concern us. The photographs we restore may be as young as 15 or as old as 150 years, but we're restoring them because they're important to us and didn't last in their original form. One of the great promises of digital restoration is that in principle the restored photographs can last indefinitely.

The last chapter of this book, Chapter 13, "Archiving and Permanence," covers this subject in detail. As I argue there, currently the two best ways to store your files are DVDs and hard drives. In terms of convenience, durability, and cost per bit, both forms of media are excellent.

One advantage of storing your files on DVDs is that this approach doesn't require much additional money; your machine may already have a DVD burner. High-quality DVD blanks are inexpensive. The (relatively!) small capacity and low unit price of DVDs (or CDs) can be handy, especially if you want to distribute work to several people.

Removable hard drive storage requires a bit more of an investment, but the cost per bit becomes very competitive when your storage requirements mount up into the hundreds of gigabytes. Hard drives have gotten incredibly cheap; they cost about one-third as much per gigabyte as archival DVD blanks. You have to buy your storage in chunks that cost tens of dollars instead of tens of pennies, but it's hard to beat the convenience and compactness of a hard drive.

For a few 10-spots, you can buy a removable hard drive *bay* or *drawer* for your computer that lets you use standard hard drives as removable media (Figure 2-6). A hard drive bay is a hollow shell into which you plug *trays* or *caddies* that contain ordinary internal hard drives. The bay is attached to the data bus of your computer; it has internal connectors that mate with the tray to connect the hard drive to the computer. You install a drive in a caddy, plug the caddy into the bay, and read and write data to it just as though it is a regular hard drive inside your computer. There's no muss or fuss, and you don't need special software, as you do when burning DVDs. Because of the interface circuitry, these bays are sometimes not quite as fast as hard drives installed directly on your machine, but they will still be much, much faster than reading and writing data to DVDs.

With hard drive caddies, a year's worth of work can fit on a single drive and go into your safe deposit box for safekeeping and security. With a hard drive bay, you'll also likely never run out of internal hard disk storage. You can reserve your internal hard drives for the critical stuff such as your applications, scratch files, and those files and documents you really need to have on your machine all the time. Everything else can go on removables.

Look for a hot-swappable caddy. Hot-swappable caddies are more expensive, but they let you treat the hard drive tray like any other removable storage medium. You can insert and remove hard drive cartridges without having to

Fig. 2-6 Ordinary IDE or SATA hard drives, installed in removable hard drive trays, are great for external and offsite file storage. They are as cheap per gigabyte as CDs and DVDs, and they're much faster than those storage media.

power down and reboot. If you're maintaining duplicate backups, as you should when archiving, that's a big convenience factor. (If you try to exchange drives in a non-hot-swappable caddy while the computer is on, the least that will happen is that your operating system will be very confused and unable to recognize the new cartridge until you reboot. The worst is that you can destroy data on your drives.)

Drive bays are also available as external devices, usually for more money. They're good if you don't have a spare slot in your computer case or if you want to move the bay between different computers. Two sources (among many) for bays are OWC (Other World Computing) and Weibetech. Both are very well regarded.

Scanners

Flatbed scanners that cost no more than several hundred dollars will do quite well for print restoration work. They arc limited in their ability to capture very high densities and extremely fine detail. Fortunately, you'll find that 99% of the time the print to be restored isn't very contrasty; sometimes it's so faded as to be almost invisible (Figure 2-7). Being able to capture high densities with the scanner just isn't very important. Similarly, resolution won't be a major worry; you'll hardly ever find an old photo that you need to scan at more than 1200 ppi.

On the other hand, being able to capture at 16-bit depth is critical. You won't always need to scan your originals at 16 bits per channel, but some originals will be so badly faded or distorted in tone and color that you'll need to capture the most subtle differences if you want to get a good-looking restoration. These days my habit is to scan everything at 16-bit depth and decide later whether I need to keep all those bits or down-convert to 8-bit color. Mostly, I hang onto all the data.

Based on these considerations, just about any midrange flatbed scanner you can buy today will do for restoring prints. One feature to consider, if your budget permits, is a film adapter for the flatbed scanner. Usually these take the form of a special lid that includes a light source so that the original can be illuminated from the back instead of from the front, as you would with a reflection print (Figure 2-8). In some scanners there's a separate tray for loading film into the scanner.

The advantage of a flatbed scanner is that it does not cost a great deal of money to get the capability of scanning 5 × 7-inch and 8 × 10-inch films and glass plates. Dedicated film scanners for anything larger than the 120-roll film format are extremely expensive. Old film that is not the same size as modern standard formats (and much of it isn't) is sometimes physically difficult to

Fig. 2-7 Old photographs (top) often look hopelessly faded to the naked eye. A good scanner, used properly (see Chapter 4), can recover an amazing amount of detail that's nearly invisible to us (bottom).

Fig. 2-8 Get a scanner with a film-scanning lid like this one. Then you'll be able scan prints, sheet film, and glass plates for restoration. A dedicated film scanner, though, will serve you better for scanning roll and 35 mm films.

scan with a dedicated film scanner, which may have film carriers that can only accommodate specific formats.

Be aware that older films and glass plates, unlike prints, frequently have extremely high density ranges, even when they are damaged and faded. They can also have lots of fine detail that will require scanning at high resolutions to capture. If you're going to be regularly scanning old B&W sheet film or glass plates, you'll have to spend $500+ on a high-quality flatbed scanner. For occasional use, a lot less'll do you.

A film adapter for a flatbed scanner is not a substitute for a dedicated film scanner for smaller formats; such a scanner will almost always capture the film with much better resolution, more accuracy, and a longer density range. If you plan to work from roll film or 35 mm originals, seriously consider buying a high-quality film scanner. The quality you will get from a film scanner will almost always run rings around flatbed scans.

Make sure you get a film scanner that includes Digital ICE[3]. That scanner software has three tools: Digital ICE, Digital GEM, and Digital ROC. Digital ICE removes scratches and dirt from color scans amazingly well (Figure 2-9). It does not work with silver-based B&W films (although it will work fine with chromogenic ones like Ilford XP2), and usually it won't work on Kodachrome slides. In all the other cases, it does a vastly better job of eliminating dirt and scratches than any post-scanning software can.

Some flatbed scanners include a software-only version of Digital ICE, and it doesn't work very well. Hardware-based Digital ICE performs an infrared scan of the sale. Color film dyes (except Kodachrome's) don't absorb much infrared; dust and scratches do. That gives the software the information needed to subtract dust and scratches from the scan, and it's why Digital ICE won't work with Kodachrome (usually) or with B&W films.

Fig. 2-9 Digital ICE, built into many film scanners as part of the Digital ICE³ package, is the first line of defense against dust and scratches. This Kodachrome slide was scanned without (left) and with (right) Digital ICE. Digital ICE usually doesn't work well on Kodachrome slides, but it worked OK with this one.

Some flatbed scanners have real infrared Digital ICE; most don't. How do you find out what a flatbed scanner really has? Download the full manual for the scanner from the manufacturer's Website. If the instructions for Digital ICE warn that the software won't work with B&W or Kodachrome film, you've got the real deal. Otherwise, I'd be skeptical.

Digital ROC (which restores color) and GEM (which reduces noise and grain) have plug-in counterparts (reviewed online), so it's not absolutely necessary to have them built into your scanner. I still think it's a good idea. The scanner versions work differently from the plug-ins, and the capabilities of the two versions complement each other. In addition, the scanner versions have access to the raw scanner data, which can sometimes make a big difference in the quality of the results.

For example, the scanner's Digital ROC does a really good job with contrasty originals because it works on the raw scanner data before the regular scanner software "corrects" brightness and contrast. In Chapter 11, "Examples," the only way I could capture the entire range of the slide in Example 4 in a single scan was by using Digital ROC (Figure 2-10), and it did the job beautifully.

Printers

At the turn of the century, I would've gone on at some length about just what kind of printer you ought to buy. I'd have discussed the pros and cons of inkjet versus dye sublimation printers and the differing characteristics of the

Fig. 2-10 Digital ROC is available as part of the Digital ICE³ scanner software and as a Photoshop plug-in. (a) This Ektachrome E-1 slide from the early 1950s is badly faded and too dark. (b) Here is the same slide scanned with Digital ROC turned on. Great color and good tonality, automatically! (c) The green channel (magenta dye image) from (a). Without Digital ROC the scanner was unable to pull out any shadow detail. (d) The green channel recovered by Digital ROC, from (b).

pigment-based and dye-based ink sets. I'd have spent a lot of time talking about comparative print longevity, tonality, color gamut, and overall print quality.

My considered opinion is that this is all now water under the bridge. Spend several hundred dollars and you will get a printer capable of making excellent and long-lived prints. It doesn't matter whether you're buying a current, top-tier Epson, Canon, HP, Kodak, or Olympus printer. Prints right out of the box are going to look very good; prints made with a custom profile (see Chapter 12, "Printing Tips") are going to look excellent.

Meaningfully distinguishing between printers requires full-length reviews of each one, just the sort of articles I write for the photography magazines that run several thousand words. I don't think you bought this book to read 20,000 words' worth of printer reviews.

It used to be true that one could make important statements about print longevity and color gamuts that were true across all printers of a particular class. That's not the case any longer. If one has faith in the accelerated tests, on average pigment-based inkjet prints will have a longer life than dye-based inkjet prints, but some brands of dye-based prints have longer lives than some of the pigment-based prints.

Besides, any of these printers produces prints that will last on display for many decades and in albums and storage for considerably longer. Overall, these new digital prints are likely to prove much more stable than the original photographs on which they were based.

Personally, I take published longevity numbers with a big grain of salt; there's still a lot we don't know about these new media. But that doesn't give me any reason to favor one class of print over the other. Uncertainty applies across the board, and all we can do is take the numbers at face value and keep our fingers crossed.

The prints won't all look alike. I definitely have my personal preferences, and so does every other fine printer I know, but those preferences are completely personal and subjective. I can tell you that I use an Epson 2400 printer and like it a lot, but that's no assurance that you would like it is much as I do.

Continuing in this vein, I see less and less difference every year in the kinds of print densities and color gamuts produced by pigment- and dyed-based inks. Again, on average, dye-based ink prints will have higher maximum densities and larger color gamuts than pigment-based prints. But just as with longevity, this is merely an average for which there are notable exceptions; some of the kinds of pigment-based prints are definitely superior in all respects to some of the dye-based prints. Even the average quality difference is becoming less significant; pigment inks have been getting better faster than dye inks.

Another nonissue is printer resolution. By that I mean the dpi that's given in the printer manufacturer's specs. That droplet-per-inch value is now so high that it's been years since I tested any printer where the individual droplets were visible at a normal viewing distance. A greater number of ink drops is only loosely connected to the actual resolution of the printer. (See the sidebar for an explanation of how dpi and ppi have gotten confused.)

I realize this doesn't give you very much specific information to go on when selecting a printer. Sometimes, though, it can be very valuable knowing what *not* to pay attention to.

That's it for hardware shopping. Next you'll need some software to make that hardware useful, so it's on to Chapter 3, "Software for Restoration."

Fig. 2-11 The print on the left is made up of full-color pixels; it's a scan from a dye-sublimation print. The print on the right is made up of ink droplets. It has similar resolution and tonality to the dye sublimation print, but it uses many ink droplets to make a single pixel. Don't get pixels, dots, and ink droplets confused; they're all different!

PPI, DPI, Resolution: What's the Diff?

"Dpi" has become a much misused and overused term. Image processing programs adopted this traditional printing term to make things less confusing for the graphic arts business. It has not quite worked out that way! Originally dpi meant halftone dots per inch when talking press reproduction with screened plates, such as those used for magazines and newspapers.

Today, dpi is also used to mean ink droplets per inch (for inkjet printers) or pixels per inch (for image files and full-color devices like displays, photographic output devices, and dye sublimation printers). In other words, dpi doesn't refer to a single standard unit of measure. This is a seriously confusing situation for lots of people.

To begin with, image files don't come in dots, they come in pixels. Pixels and halftone dots aren't the same thing; most software requires somewhat more than one pixel to generate one sharp halftone dot. The correct measure of digital image resolution is pixels per inch, no matter what your software says. That's why I use "ppi" instead of "dpi" when I'm actually talking about image pixels, and it's a habit you might want to try to get yourself into.

Your inkjet printer is not rated in ppi. In fact, it isn't even rated in dots per inch. An inkjet printer's dpi really means "ink droplets per inch." A droplet isn't a pixel or a halftone dot; it's just a blob of ink. The key difference is that a single pixel or halftone dot can convey the range of tones from black to white. Inkjet printers can make droplets in at most a few different sizes. The printer uses a fine spray of droplets of each color to build up continuous tone, with more droplets to produce higher densities (Figure 2-11). It takes several ink droplets of each color to make up a full-color, full-tone pixel. So the actual resolution of the printer when you're printing out continuous-tone color is considerably less than the printer's official dpi. That's why you need a printer with a much higher dpi than your file's ppi in order to get good tonal reproduction.

How many is "several" drops? It depends on the printer's dpi (droplets per inch) in combination with how it creates the spray pattern of droplets that make continuous tones. The program that

does that (called a dither algorithm) is built into the printer and the driver. Dithers are complicated. There's no easy way to calculate the real resolution (in pixels per inch) that a printer can portray. You find that out by printing a series of real-world images with increasing ppi and seeing when the prints stop getting sharper.

For example, the Epson 2400 can make use of around 500 ppi of image detail (and many printers can do better). You don't have to use that much to get a decent-looking print—300 ppi is enough to look nice and sharp. But if you have the same image in both 300 ppi and 600 ppi and print them out and put them next to each other, the 600 ppi one will look a bit sharper.

Chapter 3

Software for Restoration

The following software products are discussed in this chapter:
Photoshop CS4
Photoshop Elements 6/7
Picture Window Pro v5
ContrastMaster

PhotoLift
Fluid Mask 3
NoiseWare
Noise Ninja
Polaroid Dust & Scratches Removal
FocusFixer v2
PhotoTune 2
AKVIS Coloriage

The following software reviews, from the first edition of this book, can be found at http://photo-repair.com/dr1.htm:
Asiva Selection
Color Mechanic
CurveMeister2
DIGITAL GEM Pro
DIGITAL GEM Airbrush Pro
DIGITAL ROC Pro
Focus Magic
Image Doctor
Mask Pro
Neat Image Pro 1
PixelGenius PhotoKit
PixelGenius PhotoKit Sharpener

Working Around Photoshop

Of necessity this book is oriented toward Photoshop. It's the 500-pound gorilla of image processing programs and cannot be ignored. Photoshop isn't for everyone, however. It's huge, it's complicated, it's horribly expensive, and in many ways it doesn't "think" like a photographer.

Photoshop is what it is, and it's not likely to change. Consequently, you can either live with it or work around it. Fortunately, there are many other image processing programs out there, almost every one of which costs a small fraction of what Photoshop costs. GIMP, the GNU Image Manipulation Program, in fact, is freeware. It's a UNIX program supported entirely by its user base that has been ported over to every major platform out there. You don't need to be a UNIX geek to run GIMP; there are versions that install and run easily under Windows and Mac OS.

My personal favorite among non-Photoshop programs is Picture Window. Unfortunately, there is no Mac OS version of it and there is never likely to be,

but it will run fine on Intel Macs under Windows (installed via Boot Camp or under one of the many PC emulators out there).

I've tried to use a lot of basic and general methods in this book so that the reader can figure out how to implement them in programs other than Photoshop. It's not possible in all cases; I make heavy use of Photoshop's special capabilities. In particular, Photoshop plug-ins are important to my work, and most of the software in this chapter falls into that group. That limits options, but it doesn't entirely eliminate them. There are several ways to take advantage of these programs without owning full-blown Photoshop.

The most obvious is to get a copy of Photoshop Elements 6 or 7. Most plug-ins that will run in the latest version of Photoshop will also run in Elements. The most serious limitation here is that Elements' functions mostly work with only 8-bit-per-channel images. If you can live with the consequences of that (see my comments on Photoshop Elements later in this chapter), you can run most of the software I recommend.

Several of the programs described in this chapter have standalone versions. Typically they can accept TIFFs. You can use them on image files independent of your image processing program, so you can use whichever image processing program you like and still take advantage of these special tools, assuming you can live with some limitations and a little inconvenience.

When you reach the point in your restoration where you'd like to be applying one of these plug-ins, save the image file and close it. Open that image file in the standalone application or in Photoshop Elements (if you're using a plug-in). Once you've worked your magic in the external application, save the file, close it, and reopen it in your usual image processing program.

Sure, this solution is a bit of a kludge, but if one of these third-party apps or plug-ins is just what you need and Photoshop is beyond your reach (or desire), it's a lot better than doing without.

Masks, in particular, are highly portable. As Chapter 7 explains, a mask is just a grayscale image that has the same pixel dimensions as the file you're working on. Image processing applications that let you use masks (which is most of them) don't care where or how you create the mask. You can construct it in a separate application, copy it, and paste it into the appropriate mask channel for your image processing program. Vertus Fluid Mask 3, reviewed on page 66, runs both as a Photoshop plug-in and a standalone app that can create masks for use with any image processing program.

Again, the workflow is a little awkward, but it's much less of a restriction on what you do, because you don't actually have to close out the image you're working on. When you reach the point in your workflow where you need a specialized mask, make a copy of the image file and save and close that

copy. Open the copy in your third-party mask-making program (or Photoshop Elements running your target plug-in), create a mask, select it, copy it, and paste it into the right location back in your image processing program.

Photoshop CS4

www.adobe.com/products/photoshop/photoshop/

There is hardly need for another general review of Photoshop CS4, what with so many of them already in print. Instead, I'm going to emphasize those changes in the program that especially interest me. Here's what's happened to Photoshop since CS2, the version that was current with the first edition of this book.

The big change beneath the hood for Windows users, as I said in Chapter 2, is that Photoshop can now address huge amounts of memory directly, if you're running on a 64-bit machine with 64-bit Windows installed. Mac users will have to wait until CS5 comes along; in the meantime Photoshop can make good use of large amounts of RAM above the 3 GB it can address directly.

A number of tools and functions that I use regularly have been substantially improved. Photomerge, in particular, became really useful with CS3. It's now a part of Auto-Align Layers and it works extremely well. I use it regularly for stitching together sections of scans of originals that are too large for my scanners. The tedious alignment and warping method I presented in the first edition of this book is thoroughly obsolete if you're a Photoshop user. If you tried Photomerge before and were rightly disappointed by it, give it another look. You will be very pleasantly surprised.

A note about Photomerge in CS4: Adobe eliminated the extremely useful "interactive layout" option. You can restore that functionality by installing the legacy plug-in, PhotomergeUI.plugin. And while I'm on the subject of restoring functionality, also install ContactSheetII.plugin to get back the ability to generate contact sheets from within Photoshop.

The Clone Stamp and Healing Brush tools have some new capabilities and improvements. The tools now preview the changes they're going to make as you move them over the photograph. This avoids much of the trial and error of figuring out if you've picked the right source spot. It also makes it much easier to catch yourself when you start cloning beyond the source area you meant to copy (something all of us have done far too many times).

Because the Healing Brush does a complicated blend of the source area with the target area, its preview function isn't anywhere as good, but it's still an improvement over the previous opaque circle. If you can remember that the Healing Brush tends to combine the texture of the source with the brightness and color of the target, you'll be able to do a better job of visualizing its effect from the preview.

Both tools can be set to sample the current layer, the current layer and those below it, or all layers. Furthermore, the Clone Source palette lets you specify five different sources to work from; these can be in different layers. The new palette makes aligned cloning between layers much easier, because you can see the relative position of the source and target in the palette coordinates before you click to set the target.

The Dodge and Burn tools are much better and more realistic looking, especially when they're used in the Highlight or Shadow range. Previously they tended to force very light or dark tones to pure white or pure black and gray out the true whites and blacks. The results were harsh and unnatural and, at the extremes, looked more like applying the Levels tool instead of a graceful tone adjustment. The new versions of the tools preserve a lot more shadow and highlight gradation at the same time that they lighten and darken tones in those areas, and hues don't gray out anything as badly. The improvements in performance are much like the difference between modifying tonal placement poorly with the Curves adjustment described in Chapter 5, Figure 5-9, or well with the one in Figure 5-10.

B&W printing has also gotten a lot better. The Black & White... adjustment not only gives you a lot of control over the precise conversion of colors to tones and includes some very useful presets, it makes it easy to apply a slight tint to the image to emulate classic brown or sepia toned prints. It's not quite as good or as flexible as duotone conversion, but it's good enough for most purposes and it's a heck of a lot easier to do. (It took me six pages to explain how to use duotones in the first edition of this book.)

Photoshop CS4 (and the latest versions of Photoshop Elements) has a new kind of adjustment: Vibrance. Vibrance is similar to saturation but a lot smarter in several ways. Vibrance changes the saturation of colors, but it has its strongest effect in the middle range of color saturation. Its influence gets weaker the closer a color gets to being purely saturated or completely neutral. It also has less effect on the brightest highlight and deepest shadow tones. Finally, Vibrance has less effect in the range of colors corresponding to skin tones. The overall result is that Vibrance produces a more natural-looking change in saturation than the Saturation adjustment does and is less likely to produce garish, artificial-looking results.

Adobe is gradually converting all its filters to Smart Filters, and many third-Party Filters can be used that way. A Smart Filter is a lot like an adjustment layer. It doesn't directly alter the pixels in the underlying layers, and you can change its settings at any time. It's what Adobe calls a "nondestructive" operation. You can revise to your heart's content or even throw away the filter entirely and your original, underlying photograph remains unaltered. If you're

familiar with how useful adjustments layers are, you'll immediately understand how great it is to have filters that work that same way.

If you aren't familiar with adjustment layers, it's time to learn. A lot of this book makes heavy use of adjustment layers, and Adobe is gently nudging all users in that direction. The new Adjustment Panel in Photoshop CS4 integrates this workflow even more firmly into the structure of Photoshop and collects all the kinds of adjustment layers into one easily accessible location. Mind you, all the old-fashioned ways of doing things are still available through the traditional drop-down menus. You don't have to use adjustment layers; you can apply operations directly to your photographs if you must. Adobe isn't forcing you (yet) to take this newer approach to your work, and neither am I. But we both strongly encourage it.

Photoshop Performance Enhancement

Like any large beast, Photoshop can move ponderously slowly. It's a gorilla, after all, not a greyhound. Fortunately, the right hardware and software decisions on your part can perk it up considerably. Unlike real-world performance enhancement, this won't involve the use of semilegal drugs or risk congressional investigation. It's not even very expensive. Lloyd Chambers has a Website (http://macperformanceguide.com) loaded with useful tips for improving Photoshop performance. My experimental results largely agree with his.

To get maximum performance, you may need to install three Adobe Photoshop plug-ins: "DisableScratchCompress," "Bigger Tiles," and "ForceVMBuffering" (http://www.adobe.com/support/downloads/detail .jsp?ftpID=4049). DisableScratchCompress may not make much of a difference if you have a fast hard drive, but it won't hurt. Bigger Tiles instructs Photoshop to process data in larger chunks. On my system, Lloyd's "medium" benchmark clocked in with an abysmal 900 seconds without that plug-in. Adding the plug-in cut the time to a little over 400 seconds.

I shouldn't have needed ForceVMBuffering, according to the technical notes, but my initial test results showed no performance gains from increasing my RAM from 4 GB to 6 GB. This plug-in solved the problem. Install it if you suspect that Photoshop isn't making use of all your RAM. The only disadvantage of running ForceVMBuffering is that other applications will become sluggish after Photoshop's eaten all your RAM, because the OS will have to swap code blocks when other apps need memory space.

All About Memory

Here's why Photoshop seems to plod when you need it to sprint: Photoshop uses RAM for storing the image you're working on, for intermediate results,

for undo and history states, and as workspace for plug-ins and filters to do their calculations. When it runs out of RAM, it uses hard drive space if it can (some functions require real RAM). Then two things happen. The bad news is that using the hard drive as working memory is much, much slower than using RAM, and your performance will plummet as much as $10\times$. The worse news is that those functions that require real RAM could simply seize up.

Great Photoshop performance demands as much RAM as it can handle and really fast hard drive access when it needs it. The former is straightforward; the latter can get tricky.

Buying a modestly faster CPU isn't cost-effective unless you can afford to buy top tier and max out on performance-enhancing accessories. The difference in price between a machine with the fastest CPU you can get and one that is 10% slower is typically around 15%, or several hundred dollars. Unless the other components in the box are also being upgraded to higher-performance ones, the average performance difference you'll see between the two machines is only about 5% overall improvement. Buy as much RAM as you possibly can, even at the expense of other system improvements. It's the best return for your dollar. Then get a faster hard drive.

If you're still running a 32-bit platform, though, it's really time to bite the bullet and upgrade your machine. Regardless of how much physical RAM you have in a 32-bit system, most operations need to take place in the lower 2 GB of RAM. Photoshop will be competing with plug-ins, some OS functions, and print rendering for that precious 2 GB of space.

You may be able to get noticeable improvements in performance at no cost at all by adjusting Photoshop's settings. Check out these Adobe URLs and read all the tips. I bet you will find one or more that you can apply to your system:

Optimize performance in Photoshop CS3 on Mac OS:
 http://tinyurl.com/3bwedw
Optimize performance of Photoshop CS3 on Windows XP and Vista:
 http://tinyurl.com/3xawjy

Your computer already has monitoring tools that will let you see where bottlenecks are. Task Manager in Windows and Activity Monitor in Mac OS X (Figure 3-1) will show you how much real memory your various programs (including the OS) are using and what's consuming CPU cycles that could be better used by Photoshop.

Photoshop itself includes an important monitoring tool, the Info Palette (Figure 3-2). Set the options for that window to display scratch sizes and efficiency. The former tells you how much memory Photoshop is consuming at that moment. It's a good way to track when you're getting close to the point

Fig. 3-1 Activity Monitor (or Task Manager in Windows) is a useful tool for keeping track of how much of your system resources are being consumed by applications like Photoshop.

Process ID	Process Name	User	% CPU	# Threads ▼	Real
1200	Adobe Photos...	Ctein	69.30	14	1,014.95 MB
0	kernel_task	root	9.30	60	278.54 MB
5982	Firefox	Ctein	23.40	18	276.18 MB
81	WindowServer	windowserve	24.60	5	168.46 MB
29881	MacSpeech Dictat	Ctein	0.20	10	155.23 MB
176	Nisus Writer Pro	Ctein	0.00	11	115.71 MB
1223	Eudora	Ctein	0.00	12	101.38 MB
1092	EPSON Scan	Ctein	8.90	3	46.10 MB
422	TiVo Transfer	Ctein	26.10	17	45.55 MB
13412	Finder	Ctein	0.00	4	41.19 MB
63	coreservicesd	root	0.00	3	38.64 MB
1109	seti_enhanced-i3	boinc_projec	8.00	2	38.32 MB
512	seti_enhanced-i3	boinc_projec	8.20	2	38.31 MB

CPU | System Memory | Disk Activity | Disk Usage | Network

Wired: 683.03 MB ■	Free: 694.86 MB ■	
Active: 1.58 GB ■	VM size: 20.07 GB	
Inactive: 3.08 GB ■	Page ins/outs: 244990/8414	
Used : 5.32 GB		6.00 GB

Fig. 3-2 Photoshop's Info Palette lets you track how much memory Photoshop is using and how efficiently it's running.

where Photoshop will start swapping to disk. Efficiency tells you how fast an operation runs. When there are no bottlenecks it will report close to 100%. When you start swapping to disk, that number will plummet. I've seen it get as low as 11%; operations that should take 7 seconds if they could be handled entirely in RAM took a full (boring!) minute.

If you're running Photoshop CS4 on a 64-bit Windows platform, Photoshop can directly use RAM up to a phenomenal amount. Photoshop CS2 and CS3 (Win/Mac) and CS4 (Mac) can use 3 GB of RAM directly and can use 3/4 GB of RAM between 3 GB and 4 GB as additional working space for plug-ins. Free RAM above that gets used as scratch space in preference to the hard drive. Regardless of the version of Photoshop you're running, the more RAM you can put in your system, the less likely it is that Photoshop will have to start using the scratch disk.

With 6 GB of RAM installed, my Lloyd's medium benchmark time dropped to an astonishing 220 seconds from 400 seconds with "only" 4 GB RAM. How could a few GB of RAM make such a difference? Part of the answer lies in the effectiveness of RAM buffering. Without it, Photoshop was doing a high level of scratch drive reads and writes. With it, Photoshop still wrote a 16-GB

scratch file, but reads dropped to zero. All the data that Photoshop actually needed to run the benchmark was being held in RAM. That made scratch drive performance much less important.

Photoshop competes with other software for RAM. Modern operating systems swap around chunks of RAM and code on demand. Don't leave Photoshop idling in the background just for convenience's sake. It becomes a lot more sluggish as other applications and demands on the system nibble away at the blocks of memory that Photoshop was using. Whenever you're doing serious work, start Photoshop fresh.

Use the Edit/Purge command. When you start to get close to the disk-swapping point, you can free up a lot of RAM. Remember that once you purge all, you have no history and no undo state. Make sure you're really happy where you are with your work before you do this. Still, sometimes it's the only way to avoid massive slowdowns in performance.

Be aware, though, that Photoshop isn't 100% perfect about freeing up memory that it doesn't need. Monitor the info palette; if memory seems to be creeping up even when you've purged, it's a good time to shut down Photoshop and restart it to give it a clean slate.

In summary, buy as much RAM as you can afford. Add hard drives, but avoid USB 2; you're going to take a severe performance hit under the best of circumstances. FireWire 400 is okay; FireWire 800 is better. If you want to do it up right from the get-go, add an eSATA interface card and set up a dual-drive array.

My assorted software tweaks and RAM and hard drive upgrades have roughly doubled my speed on the most time-intensive Photoshop operations, at about one-third the cost of the computer.

Photoshop Elements 6 (Mac), 7 (Win)

www.adobe.com/products/photoshopelwin/
I've been a Photoshop user since Version 2.5. Consequently, I've pretty much ignored Photoshop Elements, and I think with good reason. Early versions of Elements lacked even the most basic tools that a serious amateur or a professional photographer needs, like Curves (yes, there were third-party software hacks that would enable Curves). Basically, Elements was a software package for duffers and for the casual snapshooter who needed something more serious than the tools built into Windows and Mac OS.

Things started to change with Elements Version 4, though it still wasn't a package I could recommend. With Elements 6 I think it's a whole different world. This is by no means cheap Photoshop (oh, if only!), but it's well worth the $100 price tag if you can't afford full-blown Photoshop and can't (or won't) use Picture Windows.

Elements 6 includes some serious professional capability. Elements 6 is only semi-16-bit aware—about the level of Photoshop 7. Elements 6 has curves and adjustment layers but no 16-bit or curves adjustment layers. It supports multiple levels of undo, but there's no history brush. It includes the same Photomerge function built into Photoshop CS3 and CS4, although that only operates on 8-bit images (there's that layer limitation again). I am a huge fan of Photomerge; I use it to routinely stitch together scans of film or prints that are too large for my scanners (see pages 307–309).

While I'm strongly recommending a 16-bit workflow as standard in this book, it's not absolutely necessary. If you take care with your scans, making sure you're capturing the information you need and getting a well-populated histogram, you can get by with 8-bit operations just fine. (See Chapter 4, "Getting the Photo into the Computer," pages 87–90, for a proper explanation of what constitutes a good scan.)

Elements 6 even goes one step further, adding a new Photomerge Group command that can combine faces from several different images into one seamless result. Some folks may think that's cheating, but most serious portrait photographers I know long ago decided it made a lot more sense to get a good group portrait by combining faces from multiple photographs than trying by chance to get everyone to have their eyes open at the same time. Although this doesn't fall into the realm of the usual restoration job, I can imagine circumstances where multiple instances of a group photo exist and it would be nice to restore and construct a composite in which everyone has their eyes open (historical accuracy be damned).

Elements 6 incorporates Photoshop's Lens Distortion and Smart Sharpen (called Adjust Sharpness in Elements) tools. Adjust Sharpness is profoundly better than Unsharp Mask. Lens Distortion is, in my opinion, a little bit clunky (Picture Windows does this better), but it's a serviceable way to correct geometric and chromatic aberration in the original photographs you're restoring. The Convert to Black and White function is pretty slick—good and intuitive.

Performance-wise, Elements is not on par with Photoshop. I fed Elements the same stress tests that I use to test Photoshop scratch drives. Elements took about twice as long to run the same tests. On a positive note, Elements didn't choke when thrown those truly massive files. There's probably a file size big enough to kill Elements, but I couldn't find it.

I can't speak to the redesigned interface in Elements 6. It's just enough like Photoshop and just enough different to leave me fumbling for commands. That isn't Elements' fault; it simply means that I'm not competent to evaluate its ease of use. I strongly suspect that it makes it better for the serious amateur photographer or restorer who isn't already Photoshop-savvy. I am no fan of the Photoshop interface; it just happens to be what I know.

One area that could use improvement is the installer. Under Mac OS, on my fast, late-2007 MacBook Pro, it took 25 minutes to run! It was so slow that the first time I tried the installation I thought the program had hung, so I killed the process and rebooted my system. No software glitch; it was just an appallingly slow installer. Don't ask me why.

The new versions of Photoshop Elements will support pretty much the same set of plug-ins that Photoshop CS3 and CS4 do. That provides an alternative way of running many of my favorite tools. Mind you, some of these plug-ins and third-party applications cost more than Photoshop Elements itself. Still, it's a lot less money to be spending than buying full-blown Photoshop.

Photoshop Elements is no longer a trivial or easily dismissible program; it's a really useful image processor.

Picture Window Pro v5

www.dl-c.com

My old review of Picture Window Pro, or PWP (Figure 3-3), is now online. Everything I said there applies to the latest version, PWP 5.0. The program is still

Fig. 3-3 Picture Window, from Digital Light and & Color, works like a real digital darkroom. Each time you change a photograph, you create a new print. This screenshot shows me using the Brightness Curve Transformation to produce four different versions of the original photograph in the upper-left background. I can save as many of these "prints" as I choose. I can also work on each print with other tools and so follow parallel, independent paths of development for the same original photograph.

an incredibly powerful, fully 16-bit native, $90 wonder. Many of its tools are still better than Photoshop CS4's. You really owe it to yourself to check out this amazing program. It runs rings around Photoshop Elements.

The latest version has numerous major improvements; this is not a minor update. At least four of these improvements should be of special interest to restorers:

- *Texture Mask.* PWP 5 has a lovely new kind of masking that selects for textures. It's a lot more controllable than Photoshop's Find Edges or Glowing Edges filters. It should be very useful for selecting various kinds of damage in all photos, such as cracks and paper texture.
- *Multi-Zone Adjustment.* This is a powerful tool for separating highlights, midtones, and shadows so that one can work on them separately. A great deal of damage to old photographs gets localized to one range of tones or another. Dirt or stains on a print, for example, are going to be far more noticeable in highlights and shadows. Cracks, on the other hand, stand out the worst in shadows. Hence, being able to easily work on a selected range of tones can frequently be of real benefit.
- *Bilateral Sharpen.* This is a really interesting approach to sharpening. Instead of just emphasizing the difference between adjacent pixels, this transformation looks for pixels of similar value before deciding what should be sharpened and what shouldn't. Most interesting to restorers is that all the controls are user-adjustable; in particular there is a blur function that is a component of the sharpening analysis that in itself may prove useful for suppressing grain and noise in an image. With the right combination of settings, scaling back the sharpening effect, and emphasizing the blur filter a little more strongly, you can accomplish a lot of the "smooth and sharpen" improvements I describe in Chapter 10, "Beautification," in a single operation.
- *Improved Stack Images.* Even in its old form, I preferred this transformation to Photoshop's HDR for combining different scans to capture a longer density range from the original photograph. The latest version gives you a lot more control over precisely how different tones get assigned when images get blended. There is even a calibration method for producing custom merging curves from test images you generate on your own equipment.

Plug-Ins

Plug-ins let me work much more efficiently, saving me much time and effort. Many plug-ins produce higher-quality results than I could ever achieve by hand, no matter how much time I might spend. In the remainder of this chapter I introduce you to plug-ins that aid my restoration work. These are by no means tutorials or even complete descriptions of their capabilities. Throughout the book I use these plug-ins in my examples of how to fix various kinds of problems.

That will give you some sense of their worth and how to apply them. All of them have trial downloads, so you can check them out thoroughly.

Restorers have very different degrees of image processing skills, not to mention the time and patience for dealing with lots of software fiddly bits (that's a technical term). Various plug-ins recommended in this chapter demand very different levels of technical sophistication from the users. Some are essentially plug-and-play; others won't give you good results until you master a very complex set of controls. Where several plug-ins address the same problem (noise reduction, for instance), concern yourself less with the one that does the "best" job and look for the one that operates at a fiddly level that you're most comfortable with. You'll find that the best tools for your workflow are the ones that are least likely to give you a headache.

You don't necessarily need Photoshop to run plug-ins; most plug-ins will run in Adobe Photoshop Elements, Adobe PhotoDeluxe, and Corel Paint Shop Pro, too, but each plug-in maker decides which programs its plug-ins will be compatible with and what OS they'll run under. A few, for example, might work only under Windows or could require a more recent version of Windows or Mac OS than the one you're running. Check the plug-in publisher's Website to find out in what environment its plug-in will run.

Plug-ins come with a cost, and I don't just mean their purchase price. Plug-ins are frequently memory hogs because they're performing very complicated calculations. See my remarks on RAM usage in Chapter 2, "Hardware for Restoration," page 30. As a rule plug-ins need to use a piece of the RAM that is available to Photoshop. As long as you've got at least twice as much RAM assigned to Photoshop as the size of the file you're opening, bare-bones Photoshop will usually run. It will run *slowly*, because as soon as you start doing anything it will start writing scratch files to the disk, but it will perform.

That is not true for plug-ins. They need to work in real RAM, and sometimes their RAM demands are large. For example, DIGITAL ROC and DIGITAL GEM need additional RAM that's equal to about two and a half times the size of the image file you're working on. DIGITAL GEM Airbrush needs almost seven times the file size!

Some plug-ins perform extraordinarily elaborate computations and take a long time to run, even on a very fast machine. It can truly try one's patience waiting for some of them to finish executing. Still, what I get in return for that time can be incredibly valuable. So, as the seconds (and sometimes minutes) tick away, I try to remind myself that if I were doing this manually, it would take me 10 times as long, and it wouldn't look half as good.

Remember that you can use plug-ins with masks, history brushes, and layers that you can blend into the original image in different ways. Don't just take what a plug-in hands you; shape it to your needs.

ContrastMaster

$69.95; www.thepluginsite.com/products/photowiz/contrastmaster/
I had some misgivings about recommending this plug-in—not because it isn't great but because it's such a powerful and flexible way of altering print appearance that it's going to take a lot of practice to make most effective use of it. For many of you, it will be overkill; a simpler plug-in like PhotoLift (reviewed later in this chapter) is more appropriate for most users, I suspect.

Photoshop's Shadow/Highlight tool and large-radius unsharp masking can bring out details and improve gradation without messing up the overall tonal scale (I explain how to use these on pages 135 and 319). More powerful tools like the PhotoLift plug-in probably provide all the tonal control most of you will need.

But if you find yourself hankering for complete mastery over tone, texture, and contrast, then ContrastMaster goes way beyond those tools, with more controls and dramatic effects on a photograph than you can begin to imagine. What it does isn't central to the task of photo restoration; the purpose of ContrastMaster is to make the prints of your restorations look a lot better (see Chapter 10, "Beautification").

ContrastMaster includes three local and four global contrast adjustment methods as well as various masking, saturation, and brightness options. The three local adjustment methods allow you to dramatically improve contrast in small image details without blowing out highlights or damaging the image. You can apply these three methods separately or use various options to mix them together for even better results.

Complex? You betcha; there's a serious learning curve! ContrastMaster can create very dramatic, even bizarre effects. The real power in ContrastMaster comes from using it more thoughtfully, and that requires a lot of practice. The program's author doesn't provide a detailed explanation of what each of the contrast adjustment methods does, so plan to do considerable experimenting with different settings. I think it's worth it.

Figure 3-4 shows part of the control panel for ContrastMaster. A daunting array of sliders and pushbuttons bring up different sets of contrast controls in combination with a Mode menu at the top that selects the overall approach you're taking. The default setting is Novice. That typically produces awful-looking results at 100% strength; I think of it more as Tutorial mode. It lets you play with the various adjustment methods and is an extremely good place to learn what the different contrast adjustment methods do.

I'm not even going to try to explain my settings in Figure 3-4; that would require a whole article in itself. Figure 3-5 shows you what ContrastMaster did with those settings. The top illustration is the original photograph. The middle illustration shows the improvements to highlight and shadow tonality

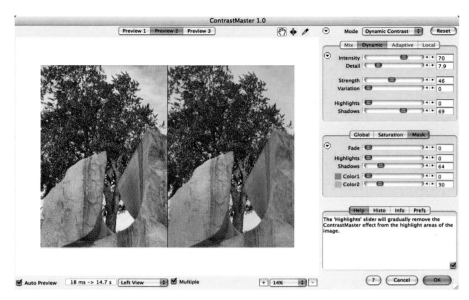

Fig. 3-4 ContrastMaster lets the photographer make elaborate adjustments to local tone, contrast, and detail in a photograph, far beyond Photoshop's abilities. In this split view, the modified photograph on the left shows much more total detail and fine gradation than the original on the right.

and enhancement of detail achieved by Photoshop's Shadow/Highlight tool and large-radius unsharp masking. The bottom illustration shows what ContrastMaster could do with the original photograph. I've made the effect a bit stronger here than I would find attractive so that it will show up well in reproduction. Dial it back in your head by about 25%. In all three photographs the extreme highlight and shadow points and overall contrast grade of the photograph haven't changed very much. The difference is in the details—literally.

I have a few quibbles with the interface. I can't scroll and pan within split view, and repositioning the "focus point" didn't work properly (in the Mac version, anyway). Mostly I stayed in the single-image view and clicked on the image to switch between before and after versions. Also, it would be nice to have the "info" box displayed at all times and show both the before and after channel values. Still, this is one great plug-in; if I hadn't gotten a reviewer's copy, I'd buy it.

PhotoLift
$40; www.pixelvistas.com/photolift/photolift.html
PhotoLift takes a much simpler approach than ContrastMaster, but it's highly effective. There are only seven controls—six sliders and one drop-down menu—that operate in straightforward and intuitive ways. The manual explains clearly what each of the controls is for. It won't take you more than a double handful of minutes to learn how to use all of them well.

Fig. 3-5 A three-way comparison between the original photograph, the photograph enhanced with Photoshop's Shadow/Highlight tool and wide-radius Unsharp Masking, and the photograph enhanced with ContrastMaster.

PhotoLift works best as an interactive program. There are Brush, Eraser, and Paint Bucket tools for applying the contrast adjustments you want to make to the photograph. One common way to use this program is to make an overall modest adjustment to local and global contrast and detail enhancement using the Paint Bucket. Then you can go back and reduce the degree of alteration selectively with the Eraser or change it entirely using the Paintbrush with different settings. As the Paintbrush moves over the plug-in's viewing window, the photograph underneath changes as a preview of what will happen when you apply the brush there, so you're not working blindly. The plug-in also has an unlimited number of undos, should you find yourself somewhere you don't want to be.

It's particularly nice to have a plug-in that combines local and global contrast changes into one easy-to-set tool. Enhancing local contrast frequently pushes tones toward black or white, and clipping can occur if the user isn't careful. By setting the sliders to simultaneously enhance local contrast while slightly decreasing global contrast, you can prevent that from happening.

The interactive brush isn't very speedy. There's a noticeable lag between moving the mouse and the brush following, but changes under the brush are visible almost instantaneously, and the filter works very quickly once you tell it to apply the alterations to the original photograph.

Fluid Mask 3
$149; www.vertus.com/fm_overview.htm
Using masks isn't hard; the trick is creating a good one in the first place. Building a perfect mask by hand is time consuming and tedious. Third-party tools can do very sophisticated masking with fewer clicks of the mouse and strokes of the stylus, saving hours of work on a single photograph.

Photoshop comes with a handful of masking tools, including lassoes, magic wands, and color selections. I've reviewed Asiva Select and Mask Pro 3 (online at http://photo-repair.com/dr1.htm) that each has its own bags of tricks for

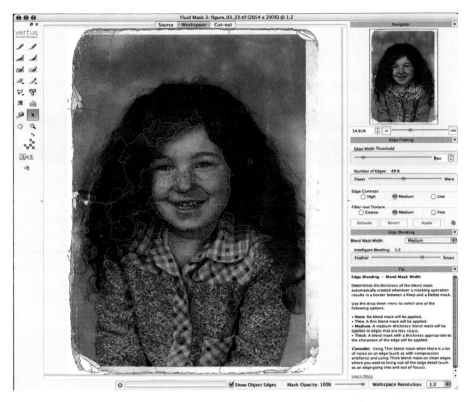

Fig. 3-6 Fluid Mask dissects a photograph into objects bounded by edges (bright blue). Each object can have its own masking and blending criteria, so you can control the selection process locally as well as for the photograph overall.

helping you create masks. What does Fluid Mask offer that the aforementioned tools don't?

Fluid Mask runs as a standalone program as well as a Photoshop plug-in, making it particularly useful to non-Photoshop folk. It's especially good at dealing with ambiguous and messy boundaries between regions, a common situation in badly faded and damaged photographs. Fluid Mask is a complicated and somewhat novel tool, and you are not going to master it quickly. I recommend watching all the online tutorials Vertus has provided for Fluid Mask Versions 2 and 3. They'll do a really good job of helping you understand this new approach to masking.

Fluid Mask divides a photograph into regions called objects—contiguous areas of the photograph that have similar tone, color, and texture characteristics (Figure 3-6). A photograph parsed by Fluid Mask looks a lot like a paint-by-number picture. Fluid Mask masks a photograph, object by object. You can customize the masking criteria for individual objects or groups of them. Part of your photograph might demand a soft, fuzzy mask defined by a very low-contrast edge while another part needs to

be controlled by contrasty, hard edges. When the same colors or tones appear in both foregrounds and backgrounds, it's hard to use global settings and tools to get the selection right. Fluid Mask lets you localize those choices so that, for example, selecting someone's soft white shirt won't also select white fluffy clouds.

Basically it's a four-step process:

1. Use the Edge Finding function to divide the photograph into objects.
2. Use the Keep (green) and Delete (red) brushes to assign those objects to the foreground or background masks.
3. Define a "blending" mask (blue region) that separates the foreground and background masks.
4. Use local patch controls to improve the results wherever the global settings don't produce an ideal mask.

There are many adjustments you can make to optimize the results at each stage, so you'll find yourself trying out different settings and backtracking a lot. Fortunately, Fluid Mask has an unlimited number of undo moves, and you can save your "project" at any point and come back to it later.

This sample photograph (the same one I used in my review of Mask Pro 3, now online) is extremely difficult to mask. The details of the hair are very complex, and there's a great deal of "noise" from the myriad cracks in creases, dust specks, and faded spots.

First, I used the default settings to divvy up the photograph into objects. The goal is to find most of the important edges in the photograph automatically but not create so many objects that they'll be hard to work with. Don't worry about doing a perfect job; you can fix it up later. Figure 3-6 shows the edge-finding results.

Next, I assigned the objects to foreground and background masks by painting over those objects with the local keep and delete brushes. If the areas you're trying to keep and delete are strongly differentiated, a high brush strength setting works well; for a photograph like this, leaving it at zero is better.

The thick blue line between the red and green masks is the all-important blending mask I painted in with the Blend Exact brush to cover all the wispy hair. This is where Fluid Mask will work its magic. The cutout preview shows that the mask isn't perfect, but considering the photo I started with, it's amazing (Figure 3-7). Now it's time for local fine-tuning via patches.

I use the Patch tool to create a small region within which I can custom-tune the blending settings. The yellow-bounded area is the patch. To get a better cutout I moved the Intelligent Blending slider toward the Smart setting, which produced a less blurry selection. I used the color workspace palette to assign individual colors and ranges of colors to the keep, delete, and blend masks, giving Fluid Mask even more information about just what parts of the image

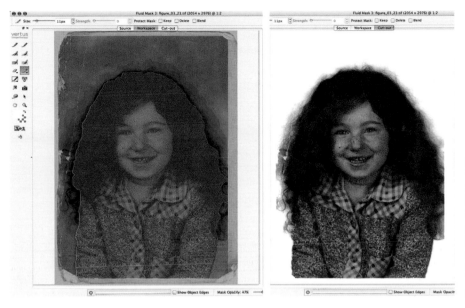

Fig. 3-7 Fluid Mask's "exact" brushes touch up foreground and background selections and define the blending region along the boundaries, where automatic edge detection doesn't do a good job. This makes the automatic cutout much better.

I wanted preserved (Figure 3-8). The strands of hair are now more clearly delineated within the patch, but the selection outside the patch hasn't changed. It's this combination of global controls and local correction that makes Fluid Mask so flexible.

By the way, avoid the Complex Hair Blending Patch Property. This will be an amazing tool when the programmers get the bugs worked out of it, but for me, more often than not, the cutout operation hung, sometimes forcing me to shut down Fluid Mask and losing any unsaved work.

Fluid Mask's impressive capabilities come at a price (and I don't just mean dollars). Fluid Mask is a phenomenal resource hog when you're working on large files. Merely finding the object edges of a 10-megapixel, 16-bit color image at 1:1 resolution took over a minute and consumed a gigabyte of RAM. The brush tool used to select a representative sample of "keep" and "delete" objects was noticeably sluggish on my fairly powerful MacBook Pro, and rendering a sample mask from that took another few minutes. But—and this is what's important—the program makes masks that are nearly perfect, even without any local refinements or patch controls. Although I spent most of my time waiting for Fluid Mask to catch up, it produced a serviceable mask in a small fraction of the time it would have taken me using the Photoshop tools.

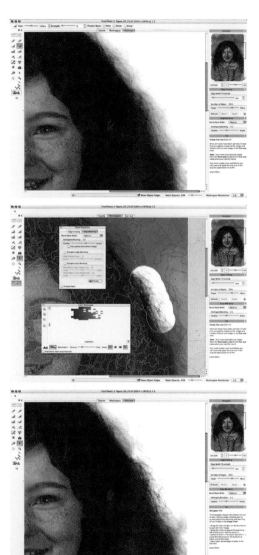

Fig. 3-8 Patches fine-tune Fluid Mask's selections. The upper figure shows a portion of the hair where the background is bleeding through. In the middle figure I've applied a patch to that area and used the patch properties and color selection tools to discriminate the hair from the background. The bottom figure shows Fluid Mask applying those adjustments to the region within the patch and nowhere else.

Noise Reduction

I find myself making increasing use of noise reduction tools in my restoration work. They are valuable in several ways. The first and most obvious way is that restoring faded photographs involves substantial increases in contrast, and that also brings out grain, dust and dirt, paper texture, and any other nonuniformities. That visual noise has to be suppressed in the finished restoration to produce acceptable results.

A second, less obvious reason is that a little bit of noise reduction in combination with sharpening does a lot to bring out the detail in a photograph without also emphasizing its flaws. See Chapter 10, "Beautification," for more on that subject.

The third and most nonobvious reason is that clever use of noise reduction tools, especially if they are over-applied, will strongly suppress both noise and fine image detail but leave visible the gross damage like cracks and crazing. That real detail suppression makes it much easier to use filters and other selection tools to construct masks for use in damage correction, as described in Chapter 7.

In restoration work, the noise you're trying to suppress can be comparable in strength to the image detail you're trying to restore. For that reason sophisticated tools work best. Not only should the software have very smart noise suppression algorithms, it should give you plenty of control over how they get applied.

For this type of work, there doesn't seem to be one ideal program out there. In fact, I find myself using several in different situations (Figure 3-9). They all seem to have their merits, so rather than recommend just one I've provided brief summaries of my favorites and told you what I especially like about each one. They all have trial versions, so you can play with them a bit yourself and decide which ones are worth investing in.

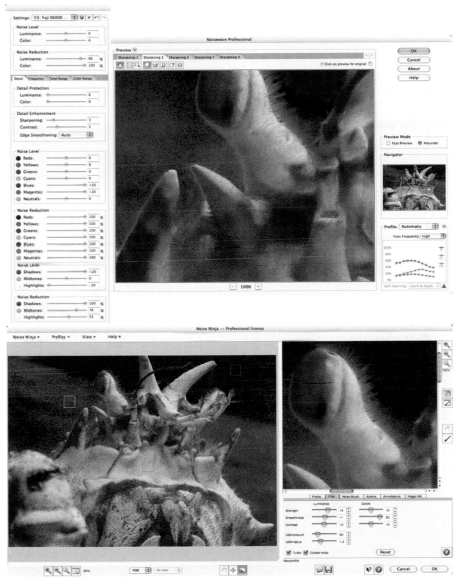

Fig. 3-9 The most important difference between noise reduction programs is in the "knobs" they give you for controlling the way the noise is reduced. Noiseware and Noise Ninja present very different answers to that question. Noiseware (upper) has so many controls that even this expanded view of the left-hand panels shows only half of them. Noise Ninja's simple set (lower) all fit in under the preview window on the right.

All these programs work considerably better than the Reduce Noise filter in Photoshop. I don't find that filter satisfactory for the uses to which I put noise reduction in this book, because it lacks sufficient degrees of control and it isn't nearly aggressive enough about attacking noise while preserving detail.

Noiseware Professional Bundle

$69.95–79.95; www.imagenomic.com/nwpg.aspx

This bundle includes a Photoshop plug-in and a Windows-only standalone app. Since I'm currently doing all my work on a Mac, I can't take advantage of the standalone app, but the Photoshop plug-in suits my needs just fine.

What impresses me most about Noiseware Professional is the huge amount of control it gives me over how noise reduction is applied. I thought Neat Image was good that way (my review for that program is now online), but Noiseware trumps it. It offers many more controls for controlling noise reduction, but what's best of all is a feature called *parameter bracketing.* It lets you select any one of the controls and automatically generate five preview windows with a range of settings for that parameter.

This really speeds up optimizing the settings by eliminating most of my trial-and-error fiddling. Comparing the bracketed previews allows me to quickly decide on the best setting for that parameter. Once I settle the current bracketed setting, I can pick another parameter to bracket around and generate a new set of previews that incorporates the control settings I've established so far. In addition, there seemed to be an unlimited number of undo versions, so if I start fiddling with settings manually, I can backtrack from there to an established working state.

Of all the noise reduction tools I've played with, I feel this one gives me the most direct and flexible influence over the results.

Noise Ninja Pro

$79.95; www.picturecode.com/index.htm

Noise Ninja is available as both a Photoshop plug-in and a standalone application for Macs and PCs. It's something of a standard in the field, especially among digital photographers, because it's very good at creating noise profiles for equipment such as digital cameras and scanners. That isn't particularly of interest to restorers like us. The reason I'm recommending it is that it does a good job of noise reduction "out of the box" . The help manual for the program includes a 30-second guide to using it, and that guide is actually sufficient in many cases. The 5-minute guide will probably tell you more than you need to know, and hardly any of you will ever read the whole manual.

I do recommend that you read the manual's sections on how to manually profile a photograph and use the Brush tool. You'll be making heavy use of both of these features. They're not at all difficult to use, but reading those instructions will teach you how to use them most effectively.

Noise Ninja runs very quickly. It would be my favorite program save for the fact that it doesn't give me all the controls I need over how the noise reduction

is applied. For instance, it lacks controls to let me readily fine-tune noise reduction as a function of tone or spatial frequency. It works very well in conjunction with masks, though.

I mostly use Noise Ninja is in the beautification phase, where I need to make the restoration look prettier and cleaner overall. I rarely use it at the default strength; it's too good at what it does. The results come out so clean and grainless that they look artificial. Real film-based photographs have a bit of "tooth" to them, and Noise Ninja doesn't think twice about wiping that out. Dial it down a couple of notches.

Polaroid Dust & Scratches Removal
Free; www.polaroid.com/service/software/poladsr/poladsr.html
I'm recommending this modest little application because it's a free, standalone app that will run on just about any Windows or Mac platform you're likely to have, no matter how ancient. Polaroid Dust & Scratches Removal doesn't do a perfect job of dust or scratch removal, but it's surprisingly good, getting rid of the majority of the damage. If you need to do quick-and-dirty (no pun intended) cleanups of a large number of originals, it's a handy production tool.

My preferred way of using it is in conjunction with a good image processing program. I first let Polaroid Dust & Scratches Removal do its thing and copy the results into a new layer in Photoshop. Once there I can preserve the areas that the Polaroid program cleaned up well and mask out the areas where it wasn't so good.

Polaroid Dust & Scratches Removal is extremely simple to use (Figure 3-10). It can read and write JPEGs and 8-bit or 16-bit color or B&W TIFFs.

Fig. 3-10 Polaroid Dust & Scratches Removal is a free program with a simple interface. There are only five adjustments in the scratch detection phase (upper screenshot) and one in the scratch removal phase (middle). The results (bottom) aren't perfect, but they're a big improvement, and you can't beat the price or the speed.

The first step after opening an image to be cleaned up is to detect the dust and scratches and create a mask for them. That operation brings up a dialog box where you set the tile size, defect level, and mask size. As a rule, you'll leave the

tile size set to the maximum value of 64, unless the application is failing to pick up a lot of small damage. Set the defect level higher for really dirty originals and lower for relatively clean ones. A value of 30 to 40 is a good starting point. With my scans, which are at fairly high resolutions, I find that a large mask size does a better job of capturing the dust and scratches. Leave Adaptive Filtering off; it does not do a better job of finding the damage, and it runs more than five times more slowly.

After Polaroid Dust & Scratches Removal has created its mask, you can go in and edit that mask with brushes and erasers if you feel that it's missed something important or erroneously selected image detail. Clicking Clean Image... brings up another dialog box in which you choose the amount of feathering for the cleanup. Larger values do a better job of blending the cleaned-up areas into the image but can also degrade fine detail. Save the massaged photograph as a new TIFF file, and that's it.

Polaroid Dust & Scratches Removal is compact and it's speedy; it took about 1 minute to mask a 25-megapixel, 16-bit color file of a badly scratched Kodachrome slide and less than another minute to clean up the scratches. The results are far from perfect, but it's a very respectable start.

Understand that this application is almost obsolete. Since it's an orphaned product, don't look for support or for it to ever be updated to become 64-bit savvy or a Universal Binary on Intel Macs. Although it can be run as a Photoshop plug-in, I don't recommend it; you'll have to make too many other performance compromises to get it to run. But for standalone use, it's acceptable, and you can't beat the price.

FocusFixer v2
$99.95; www.fixerlabs.com/EN/photoshop_plugins/focusfixer.htm
Sharpening tools are important in restoration work. Print scans, no matter how high a resolution they're made at, always seem to lose a bit of sharpness over the original. Edges get softer and fine detail blurs a bit. Many of the restoration tools we use, such as noise reduction and dirt and scratch removal filters, also degrade fine detail slightly.

Sometimes it's the original itself that is a bit fuzzy. It may not be apparent unless the client asks for an enlargement, at which point it becomes clear that the original photograph was just sharp enough to satisfy the original owner, with no fine detail to spare. Other times, it's evident from the get-go that the original was never sharp by anyone's standards. In these situations, sharpening the restoration can make the restored photo look even better and more detailed than the original did.

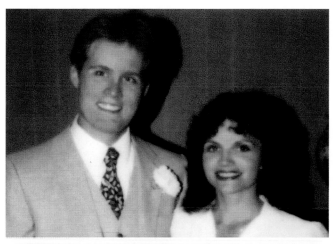

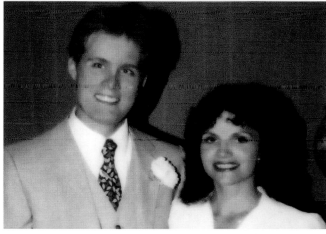

Fig. 3-11 FocusFixer, followed by a dose of Noise Ninja, turned the photo on the top to the one on the bottom. There's a substantial increase in sharpness and fine detail.

FocusFixer is extremely easy to use, yet it's extremely powerful. Without question, it produces the most natural-looking sharpening I've seen. FocusFixer isn't simply an edge-enhancing routine, like unsharp masking, which gives the impression of greater sharpness by making edges more contrasty. No, FocusFixer actually increases the amount of fine detail in the photograph (Figure 3-11).

The calculations necessary to achieve this task are substantial; consequently FocusFixer is not the fastest program you'll ever use. In fact, it may be the slowest! On my system it can process about 1.5 million pixels per minute. Sharpening the halftone photograph in Figure 9-5 took dozens of minutes.

Fig. 3-12 FocusFixer is a slow but extremely effective and powerful image sharpener that increases real detail in a photograph. Like all true sharpening programs, FocusFixer enhances noise as well as detail, as shown in the preview window, so plan to run a noise reduction program after applying it.

Fortunately, FocusFixer is very simple to use and it has a functional and accurate preview window (Figure 3-12). The controls you'll concern yourself with are the Deblur radius and Threshold; the rest of the controls only apply to sharpening camera-made images. In all likelihood you'll be able to get exactly the results you want with this filter on the first try. If you have any doubts, this is a good situation in which to crop out a small sample of the photograph you're working on to experiment with. You don't want to be spending your time on multi-minute trial-and-error efforts.

FocusFixer lacks one important control: strength. There's no difficulty getting less than 100% strength out of the filter; just fade the effect by the desired amount after the filtration operation, or apply the filter to a duplicate layer and reduce the opacity of that layer. Many times, though, I need *more* than 100% strength.

To get greater strengths out of FocusFixer, I apply it twice, fading the effect after each application. The strength seems to be roughly multiplicative rather than additive; applying the filter twice at 50% strength produces an effect that's somewhat stronger than applying it once at 100% strength. This is a situation where you will usually set the Threshold above zero (at least on the second pass) to avoid unwanted amplification of noise.

For many sharpening tasks, Photoshop's Smart Sharpen filter, used with a radius of no more than a few pixels, is good enough. For the most natural-looking sharpening, FocusFixer is the tool I recommend, especially if you can arrange to start your sharpening pass just before you want to take a break.

Focus Magic

Although it's still a very powerful program, I'm no longer recommending Focus Magic (my original review appears at http://photo-repair.com/dr1.htm) because the code hasn't been updated in ages. There is no Universal Binary version available for the Mac, which means it won't run in Photoshop (Mac) unless Photoshop runs under Rosetta. That causes such a huge performance loss that I can't imagine anyone wanting. On the PC side, Focus Magic isn't compatible with 64-bit Windows. If you're running legacy hardware and software, it's a good plug-in. If you're not, I'm afraid it's obsolete.

PhotoTune 2

$159.95; www.ononesoftware.com/detail.php?prodLine_id=27

Good photo restoration involves several disparate skills, some of which are purely artistic. The artistic ones are the hardest ones to teach, which is why I devote so much of this book to discussing restoring tone and restoring color (Chapters 5 and 6). Still, mastering the aesthetic side of restoration is something that many otherwise superbly competent restorers have trouble with. In particular, getting skin tones to come out looking natural demands a high level of skill because we are so sensitive to their appearance.

There's no long learning curve on PhotoTune 2. It has two modules: ColorTune 2 does broad-based color and tone correction, while SkinTune 2 is intended for correcting flesh tones (but I found that it's good for fine-tuning many photos with important colors in that part of the spectrum).

ColorTune 2 takes a comparison approach that is like a game of 20 Questions. You repeatedly tell the plug-in which of two test images looks better, and it homes in on your preferences. You can save the final adjustment settings as snapshots to use on other photos that need similar corrections, and batch process photographs using your saved settings. It's a real timesaver when you need something more akin to high-quality production printing than custom lab work.

I started with the high school portrait at right from Chapter 6, Figure 6-44. ColorTune 2 corrected it using a six-question process (Figure 3-13). The trick is to not overthink the problem. I stumbled a bit at first, because I'd try to decide which test photo looked good, as opposed to merely better. Frequently neither the left nor right versions looked good. Eventually I realized that often the right choice was to leave the intensity slider at its lowest setting, pick whichever

Fig. 3-13 ColorTune 2 does broad-based color and tone correction using a comparison approach that is like a game of 20 Questions. In the final stage, shown here, you can fine-tune the software's best guess, achieving pretty good color correction very quickly and easily.

version struck my fancy, and not worry too much about it. Just as with the 20 Questions, the early answers aren't going to be right. They are only there to help guide the software to a good solution. The final control panel (bottom of Figure 3-13) lets the user modify the settings, which does a lot to improve the software's results.

SkinTune 2 is really great for getting just the right skin tones. It presents you with an array of carefully chosen skin tones from which to choose (Figure 3-14). You can pick the general ethnicity of the subject, which restricts the palette of skin colors to the ones most likely to be correct for that segment of the population. Alternately, you can leave it wide open and select among them all.

Once you've picked a plausible skin tone, you can fine-tune it with sliders that will alter the hue and saturation. It only takes a little trial and error to hit on a result that's entirely pleasing. Honestly, there's not much more to say about this plug-in. That's a feature—no steep learning curve!

Fig. 3-14 SkinTune 2 is a great way to adjust skin tones without a steep learning curve ... or Curves adjustments. It's ideal for folks who find achieving that just-right skin tone an elusive goal.

AKVIS Coloriage
$97; http://akvis.com/en/coloriage/index.php

AKVIS Coloriage makes hand-tinting photographs extremely easy. Launching Coloriage from the Filter menu brings up the Control Panel (Figure 3-15). On the right side of the panel is a color library that includes a standard color palette (bottom) and folders of predefined colors organized by subject matter. Pick the color you want from the palette or the library and set its brightness with the gradient selection. Now you're ready to apply that color to the photograph.

The blue Pencil tool draws in the color you've selected. Sketch it into the area whose color you want to change, as I've done in the illustration. You don't have to be particularly precise; Coloriage automatically finds the edges of the regions you've selected to determine the extent of the color fill. Use the Color Pencil to crudely outline all the areas you want to change, much as I've done. If you make a mistake, you can undo the pencil stroke and back up as many steps as you want. Alternately, you can use the Eraser to wipe out part of a pencil stroke and redraw it.

At any point you can save your pencil strokes and recall them later. That's extremely useful, since doing hand-tinting can take a lot of time, even with an

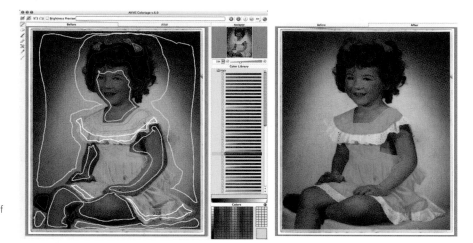

Fig. 3-15 AKVIS Coloriage "hand-tints" photographs based on color outlines you draw. I didn't spend very long on my crude sketch; the results are about 75% of the way there, for just a few minutes of effort.

automated tool like this. You may find that you don't like the results you got after you've applied Coloriage and want to go back and revise them. Being able to reload a previous set of pencil strokes, edit them, and save them anew (or under a different name) makes that easy. Nothing you do with this plug-in need be irreversible. You can change the Color Pencil strokes, refine your selections, and create whole new ones.

Once you've made a cut at hand tinting, click the green arrow and look in the After tab. You'll see a preview of your work (Figure 3-15, right). In these illustrations, my work isn't especially good. My first choice of colors is less than ideal, and I didn't get some of the edges right. All that's okay; I can go back to the Before tab and correct my errors, or I can load my pencil strokes at a later time and work on it some more after thinking about it. I can even apply these changes to the photograph and save the tinted version for reference, knowing I can go back to an untinted copy of it and pick up where I left off.

I work with this particular photo more in Chapter 6, "Restoring Color," starting on page 200. There I show you how to use Coloriage to best advantage in a layer and refine what it creates to make it look even more like realistic hand tinting.

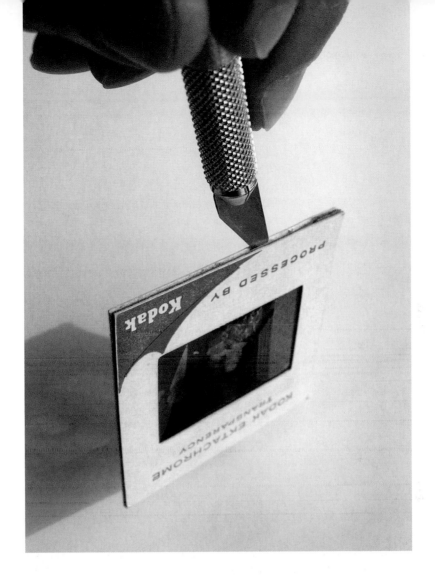

Getting the Photo into
the Computer

How-To's in This Chapter
How to unmount a slide
How to scan a faded B&W print
How to scan a dark B&W print

How to convert an RGB scan to grayscale
How to scan a magazine or newspaper illustration
How to improve color with a good scan
How to inspect very dark parts of a scan
How to scan color negatives
How to determine the resolution at which to scan
How to photograph tarnished or textured prints

Introduction

Before you can digitally restore a photograph, you must get it into the computer. Most likely you'll be doing this by scanning the photograph on a flatbed or film scanner (although, as I explain on page 117, sometimes you're better off rephotographing it).

The closer you can come to working with the original source photograph, the better your restoration will be. You often have no choice in this matter, but when you do, exercise it. When a client sends you a print for restoration, ask if the original negative or transparency is available. In almost every circumstance you'll be able to do a better restoration by scanning the original film than scanning a print derived from it (Figure 4-1).

It is possible for the original film to be so badly deteriorated or the print so heavily retouched that restoring from a scan of the print is the better option, but it's very unusual. Don't let having to recreate modest amounts of print

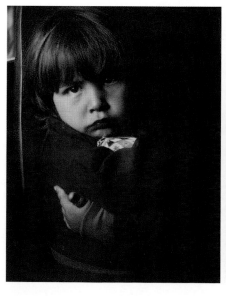

Fig. 4-1 The photograph on the left is a print made from the slide on the right. The print has faded substantially, but the slide is in nearly pristine condition. It's usually true that original film will be less deteriorated than any prints that have been made from it.

retouching dissuade you. Physical retouching is, frankly, cruder than what you can do on the computer; you can almost always recreate the retouching work better than the original. Read Katrin Eismann's book, *Photoshop Restoration & Retouching,* which I recommended in the Introduction. She's a retouching wizard.

Half the job of doing a good restoration is making a good scan. Scanning a deteriorated original is not the same as scanning a high-quality photograph. Usually you won't want to make a scan that faithfully reproduces the photograph in its damaged state. As you'll learn, that is more likely to lead to inferior results; at best it will require you to do much more work in your image processing program to produce a good restoration.

Getting a good scan for restoration is not difficult if you follow the guidelines in this chapter, but this is not knowledge that any of us was born with. Making a good scan for restoration is a learned skill, and for that reason you're better off doing the restoration from a scan you do yourself than one provided by the client unless that client is *very* good at this kind of work. If you have no choice, you can create a good restoration from a scan sent to you, but if the client provides you with poor scans it will make your life harder.

Some originals are so valuable or fragile that the owners will very sensibly not let them out of their possession. In that situation the best you can do is carefully instruct the owner about what constitutes a good scan and hope for the best. Don't be discouraged if you can't get original source material. Although the results get better the closer to the original you can get, I've done good restorations from lousy scans and mediocre, highly compressed JPEG files that people have emailed me (Figure 4-2).

No matter what the source of your image file, never work on the original file when doing your restoration. Save it, and set the saved file's permission to read-only. Work only on duplicates of the file; that way if you need to start over, you don't have to rescan the photograph (or ask the client for replacement scans). Save intermediate results often in case you decide to backtrack and try a different approach.

Preparation and Cleaning

One very important way that scanning damaged photographs differs from scanning ones in good condition is the way you prepare the photographs for scanning. Old photographs are often fragile, so you want to stress them as little as possible. If the print you are going to scan is taped or glued to an album page or mounting board, do not attempt to remove it or peel the tape away from the photograph. You will surely damage the photograph. Leave it where it is, and scan it on the page.

Be careful with photographs that are in those horrid "magic" adhesive photo albums. The gum on the page that is supposed to let you easily remove or reposition the photograph hardens with time into a rigid adhesive. Don't try to pry the photograph away from the adhesive board; you'll crack the print. Fold back the page's plastic cover sheet, and scan the photograph on the album page.

On the other hand, 35-mm slides ought to be removed from their mounts before scanning (see the sidebar). I recommend that you do this because most film scanners will not produce tack-sharp results unless the film is sandwiched between glass to hold it flat. Even though many scanners are sold without a glass

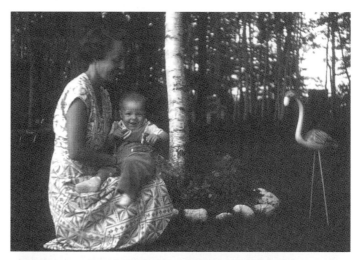

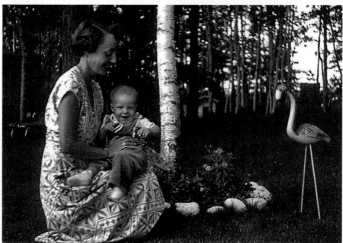

Fig. 4-2 This is a restoration done from a JPEG (top) the clients sent to me of a scan they did. It's better to get the original photograph and scan it yourself, but don't give up hope if all you can get is a mediocre JPEG. You still may be able to produce great results (bottom).

film carrier as standard equipment, you need it for getting good scans of slides or negatives. Even if the carrier is deep enough to accommodate the mount, leaving the slide in its mount just prevents the glass from doing its job.

How to unmount a slide

Plastic slide mounts open pretty easily. Many are designed to be opened, and the rest can be snapped apart by prying up on one face of the mount at the edge with a blade until the spot welds that hold the two halves together break. It won't take a lot of force.

Cardboard mounts require a sharp thin blade, like a single-edge razor blade or X-Acto knife, and a steady hand. Don't try to cut directly through the cardboard near the slide to free it; unless you are very experienced at this, there's too much of a risk that your hand will slip and you will cut the slide. There's a safer way.

Look closely at the edges of the mount, and you will usually see fine perforations along one edge. Carefully cut through those perforations and try to peel the cardboard apart. If there aren't any perforations, cut the edge where the seam is most obvious (Figure 4-3). The cardboard is glued together, but don't worry about damaging it. Do make sure it's the cardboard that you're bending, though, and not the slide when you do this.

If you're fortunate, the mount will split right along the center window, and you'll be able to lift the slide out of the mount. If the mount didn't split at exactly the right point, there will be only a thin layer of paper covering the edges of the slide and preventing you from removing it. You can easily cut away that paper to get to the slide. Sometimes the slide is spot-glued along one or both perforated edges to the cardboard. Slip the tip of the blade (carefully!) between the slide and the cardboard to break those glue points (Figure 4-4).

Fig. 4-3 To split open a cardboard slide mount, carefully slice around the edges with a sharp, narrow blade. Observe the position of the blade here between the two halves of the cardboard sandwich.

Fig. 4-4 The slide might be glued to one half of the mount along one or both edges. Carefully slip the blade of the knife between the slide and the cardboard to slice through.

Scanners are notoriously good at exaggerating every little defect and flaw; it's virtually impossible to produce a perfectly clean scan, regardless of the state of the original. If we start with a dirty original, the time and effort involved in cleaning it up on the computer is horrendous. Normally we take fairly aggressive steps to eliminate every bit of dirt and dust before we make the scan, to reduce the time and tedium of retouching an inordinate number of spots and specks in the computer.

I always clean my regular photographs (that is, the ones in good condition) with PEC-12 and PEC Pads, dust them off with an antistatic brush and give them a solid blast of compressed air to remove any lingering specks. I've become almost obsessive about cleanliness. It's a kind of conditioned response; whenever I slack off, I end up with a scan that takes me hours to tidy up, and that shock to my system provides powerful negative reinforcement for any sloppy cleaning techniques.

But this is not the approach you want to take when performing a restoration. Deteriorated images are frequently in a very fragile physical state. Bits of emulsion may just be waiting to flake off at a too-firm touch. Any kind of wet cleaning is an especially bad idea. Water is an absolute no-no. In the case of prints, it can wash away important retouching or cause it to bleed and leave you with a complete mess on your hands. Water may also mobilize damaging chemicals locked in the paper base and actually hasten the deterioration of the photograph. In the case of color films and older prints, the final processing step usually involved a stabilizing chemical; dilute that and you compromise image permanence even more.

Mold or mildew actually makes emulsions soluble in water! The little bugs gobbling away at the photo damage the gelatin enough so that it will dissolve if you get it wet. Inorganic chemicals can attack emulsions in similar ways; spots and stains on the photograph could turn out to be places where the image can dissolve. If you apply a water-based cleaner, you'll remove the entire image in those areas.

Even solvent-based cleaners such as PEC-12 are not to be trusted with older originals. PEC-12, for example, will dissolve unhardened gelatin and albumen emulsions, and it should not be used on photographs that have suffered biological or chemical damage. The manufacturer, Photographic Solutions (www.photosol.com), makes no secret of this and warns that PEC-12 should never be applied to a photograph of unknown characteristics.

Many cleaners carry no such warnings; that does not make them safer. You can do irreparable harm by attempting any sort of wet cleaning of deteriorated photographs. Because deterioration is often not uniform over the entire photograph (chemical spots and mildew stains being prime examples), a spot test at one corner of a photograph that goes well is no assurance that the entire image will survive cleaners.

This is not even considering the other kinds of physical damage you might easily do. If the photograph's surface is delicate, even the most careful wet cleaning runs the serious risk of scratching the surface with bits of dust and dirt picked up by the cleaning pad as it's wiping down the photograph.

Wet cleaning should be left to knowledgeable professionals. It's a very risky process, one never to be undertaken by amateur conservators. The only wet cleaning I ever do is to the glass side of a glass plate. Glass is hard and inert enough that it's safe to clean dirt and grime from it. Be careful not to use so much cleaning solution that any can leak onto the emulsion side of the plate. Just dampen the cleaning pad; don't saturate it.

Never use cotton swabs such as Q-tips. I mention this because they're a common tool used by photographers and retouchers, but they are really very abrasive. In my tests of several different cleaning aids, cotton swabs scratched even worse than ordinary kitchen paper towels or facial tissues. They will mar an original more readily than just about anything else you might use.

The least abrasive materials I've tested are the PEC Pads made by Photographic Solutions, the folks who make PEC-12. But even PEC Pads are not perfectly nonabrasive; nothing is. That's why I recommend avoiding as much physical contact with the original as possible.

So, how do I clean originals before restoration? Minimally. A very light and delicate dusting with a very soft antistatic brush. Then careful bursts of compressed air. If a dust speck or bit of lint doesn't want to move, I leave it. I do everything in my power to stifle my justifiably obsessive cleaning impulses. It is simply not worth the risk of damaging an irreplaceable original to save myself some spotting time on the computer.

Scanning Prints: Maximize Your Information by Getting the Tones Right

A good photograph almost always has a full range of tones, from black (or nearly black) to white (or nearly white). See Chapter 5, "Restoring Tone," for more elaboration on this point, but for the time being take it as gospel.

Correspondingly, a good scan of a deteriorated photograph spans most of the range of values from near-black to near-white. It doesn't throw away any of the intermediate tones in the photograph by forcing them to pure white or pure black. This is true for color as well as B&W photographs. A good scan's histogram looks like the middle one in Figure 4-5; you don't want it to look like the top or bottom histograms. The former makes poor use of the range of available values; the latter clips some of the near-whites and near-blacks.

It's usually a bad idea to make a scan that faithfully reproduces a deteriorated photograph. The upper photo in Figure 4-6 is a straight, uncorrected 8-bit scan from

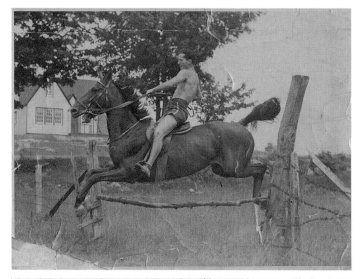

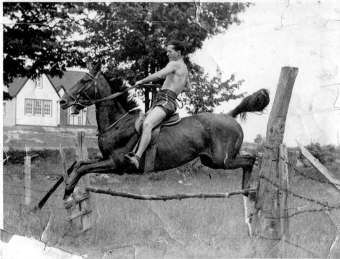

Fig. 4-5 A good scan uses most of the range of available tonal values. The histogram at the top is from a scan that is too low in contrast; barely half the full range of 256 values is being used. The middle histogram shows an ideal scan; most of the values have some data, but no information is being clipped off. The histogram at the bottom shows a scan that is too contrasty. There are big spikes at values of 0 and 255, which means that some light and dark tones have been forced to pure B&W. That highlight and shadow information is lost forever; avoid that in your scans.

Fig. 4-6 A good scan is vitally important to doing a good restoration. The upper photo is a straight 8-bit scan from a badly faded original, similar in appearance to the original photograph. It is a very poor place to start from because it doesn't take advantage of the full range of tonal values that are available in the scan. I adjusted the scanner software's Curves and Levels controls in each color channel in the scanner software to produce a good range of tones for all three colors. (I desaturated the image in Photoshop to eliminate a small amount of lingering color cast.) That produced the good 8-bit scan in the bottom photograph; it has a histogram like the middle one in Figure 4-5.

a faded B&W print. This is not a good basis for a restoration. The upper histogram in Figure 4-7 shows why. Only half the total range of available values is actually being used in this scan. I can expand the tonal range of the scan in Photoshop to restore the photograph to a full-valued, neutral-colored image, but if I do that I get one of those unwelcome "picket fence" histograms (Figure 4-7, bottom).

There are many gaps in the tonal scale that will show up as discontinuous-tone steps in the print (Figure 4-8, left). The bottom photo in Figure 4-6 is from

Fig. 4-7 These histograms show the problems that a poor 8-bit scan will cause. The top histogram is from the top scan in Figure 4-6. The bottom histogram shows what happens when I attempt to restore that scan in Photoshop to produce a photograph with a full range of tones from black to white. There are many gaps in the histogram because there aren't enough distinct gray levels to fill them in. This "picket fence" problem degrades the quality of the restoration.

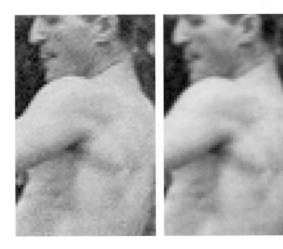

Fig. 4-8 Enlarged portions of finished restorations from the straight (left) and optimized scans (right) in Figure 4-6. The "picket fence" effect degrades the tonal quality of the left restoration. Only about half the normal number of gray levels are available in the scan. The skin tones look sandy instead of smooth because there are intermediates tones missing. The restoration from the good scan shows very smooth tonality because it uses almost all the available tonal levels.

a good scan, one where I adjusted the Curves and Levels controls in the scanner software to produce an image that had a much more complete and neutral range of tones. When I use that as the basis for my restoration, I get results like those in Figure 4-8, right; here there is good, continuous tonal quality.

Don't be obsessed by the histogram. Some folks feel that if there are any gaps at all in their photograph's histogram, the quality of the output will be terribly compromised. That's an extreme exaggeration; a moderate number of gaps are almost never visible in the print. The examples I'm presenting here are extreme so that I can make it clear that many gaps are not a good thing, but you can have a pretty ratty-looking histogram and still see excellent tonality in the final print. Unless I'll be expanding or compressing the tonal scale by more than 25% when I work on the file, I don't worry about gaps.

How to scan a faded B&W print

Any time you use your image processing software to expand the range of tones that you have in the scan, you're going to get some gaps in the gray scale. That's normal, and a few gaps in the histograms really won't be visible in a print. What you want to avoid, though, are lots of gaps in the histogram, as in the lower portion of Figure 4-7, or a histogram that doesn't make good use of the entire value range, as shown on the left in Chapter 5, Figure 5-2. The more data you have to work with in your restoration, the better off you'll be.

There are two routes to better, fuller histograms. The first is to do all your scanning in 16-bit mode; that's my habit. Even when the original has a very narrow tonal range, as in Figure 4-6, a 16-bit scan will usually capture enough gray levels to produce a fully populated histogram when the tonal scale is expanded to produce a normal range of densities from black to white. That produces much better tonality in the finished restoration.

The second solution is to adjust the Levels and Curves controls in the scanner software to produce a good range of data in the scan. Make adjustments to each of the individual RGB channel's Levels controls in the scanner software, as in Figure 4-21. Your goal is to use the majority of the value range in each RGB channel.

Best of all, though, is to use both approaches: Scan in 16-bit mode and adjust levels to optimize your scans. You'll be amazed how much easier it makes the restoration process.

By the way, it's true that most scanners (and digital cameras, for that matter) don't produce true 16-bit files. That is, they don't actually produce 2^{16} (65,000) distinct gray levels for each color channel. More commonly they produce 10 or 12 bits' worth of clean and distinct tonal information. The really good ones may produce 14. But that's plenty! Even 10 bits of clean data is 1000 gray levels—there will be four gray levels in that file for every one that you'd have in an 8-bit scan. That means you could expand portions of the tonal range by a

factor of four before you would start to see gaps in the histogram. I expanded the range of tones in Figure 4-7 by only half that much (a factor of two), and that was a major adjustment. Expanding the tonal scale by a factor of four is enough to correct the most seriously faded photograph. So, even a few extra bits of data in each pixel are sufficient to give you full histograms with few gaps, no matter how much you manipulate the photograph.

All scanners collect data internally to more than 8 bits, even if you've set the controls to output an 8-bit scan. The scanner has plenty of extra value levels available to fill in any holes, just as you do when you work on a 16-bit file in the computer. You can greatly expand or compress parts of the tonal range in the scanner settings without producing tonal gaps in an 8-bit output. This is why you should try to get the levels approximately right in the scam, especially if you're going to be working with 8-bit files.

How to scan a dark B&W print

Here's how making the scanner adjustment works in practice: The B&W print in Figure 4-9 has a very limited range of tones because of fading and staining. A straight 8-bit scan with no special corrections produces the upper histogram in Figure 4-10. You can see that this doesn't come close to taking advantage of the full number of levels available in Photoshop.

Figure 4-11 shows the Levels adjustments I made in my scanner software. Observe how I've pulled in the white and black sliders so that they more closely bracket the range of tones in the print. Allow yourself some safety margin. Keep the darkest pixels in the scan at values of 10 to 20 and the lightest pixels around 240. That way you'll avoid accidentally clipping the highlights or shadows. If you need a pure white or a pure black in the finished restoration, you can adjust the range in your computer without visibly compromising tonal quality.

The results of this adjusted scan are clearly much better both visually and data-wise (Figure 4-12). The histogram looks much fuller (Figure 4-10, lower). This would be a good starting point for restoration in either an 8-bit or a 16-bit scan.

Even when I'm working with a "B&W" original, I still scan in full-color mode. A scanner's B&W mode usually uses only one channel of data (green). That yields noisier scans than scanning in full-color mode and combining the channels in your image processing program. It's easy enough to convert the image to monochrome once it's in your computer, and the quality will be much better.

Don't worry about the exact image color when you're scanning monochrome originals. Once you've got the scan in the computer, you'll desaturate it and neutralize any color casts. When you print the restored image, you can

Fig. 4-9 This photograph is very dark and low in contrast. In all probability it was printed poorly to begin with, but that's fixable with digital restoration.

Fig. 4-10 The top histogram shows how little tonal information there is in Figure 4-9. Hardly even one-third of the histogram bins contain any data. The bottom histogram represents Figure 4-11, which was made using the scanner Levels settings shown in Figure 4-12.

adjust the color to replicate the look of an original, pristine print. I tell you several ways to do that in Chapter 12, "Printing Tips."

Color is a valuable tool for restoring B&W photographs. Differences in color in different parts of the photograph are evidence of damage or deterioration. Color is a distinguishing factor you can use to create masks that select especially damaged areas for restorative work (see Chapter 7, "Making Masks," page 226). You can also use that differential color information to fix the damaged parts of the photograph (Chapter 8, "Damage Control," page 266). There are even advantages to scanning monochrome photographs with exaggerated and unrealistic color. Exaggerated hues in the photograph can be most useful for creating masks that isolate areas of tarnish, tape marks, and stains (Figure 4-13). Once the areas are selectively masked, you can apply corrections to those areas, separately from the rest of the image. This is an extremely effective way of eliminating surface tarnish and silvering-out. (You can read about a full restoration of the photo from Figure 4-13 in Chapter 8, starting on page 280.)

Here's another reason for not scanning your prints in B&W mode: The color channel the scanner uses for B&W scanning is not necessarily the best one to use for a restoration. That's a choice you, not an unthinking piece of hardware, need to make. In Figure 4-14 the red channel is by far the most useful for performing a clean restoration. The damage to the original photograph is substantially less visible in this channel because the stains are primarily orange-yellow in color.

Fig. 4-11 These scanner Levels settings turned Figure 4-9 into Figure 4-12. Observe how the B&W set points are positioned just outside the range of populated bins In the histogram. That insures that no shadow or highlight detail gets clipped.

Fig. 4-12 This is a much better scan of the photograph in Figure 4-9, looking more normal and attractive (and revealing a great deal of physical damage in the photograph).

Fig. 4-13 The figure on the left is the original, tarnished photograph. I exaggerated the color saturation in the scan I made (middle) so that the tarnish would stand out clearly. I used that exaggerated color difference to make a mask that selected for the tarnish, making it much easier to correct the damage and restore the photograph (right).

Fig. 4-14 Most B&W photographs will show less damage in one color channel than in the others. This photograph is very badly stained and faded (left). Most of the stains, though, are orange-yellow in color, which means that they hardly show up at all in the red channel of the scan (right). That's the channel to use as the basis for a good B&W restoration.

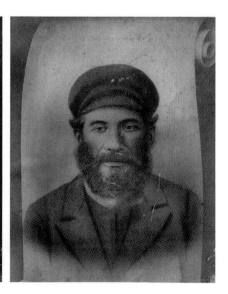

(By the way, there's more to this photo than meets the eye here. The original was so large that I had to scan it in three parts and stitch it together. See Chapter 9, "Tips, Tricks, and Enhancements," for instructions on how to do that, and Chapter 11, "Examples," for a complete description of how I restored this photograph.)

When I'm ready to convert the scan of a monochrome photograph to grayscale, I almost never use the Desaturate adjustment or grayscale mode conversion. Instead, I use the Channel Mixer with the monochrome option selected.

Why? It's about control. Desaturate simply mixes equal amounts of all three color channels. It's a good choice when all three channels in your scan are of equal quality, with none significantly noisier or showing more dirt and stains than the others. Torn or cracked photographs that otherwise are clean and unfaded may have these qualities, but badly deteriorated B&W photographs usually don't.

Automatic grayscale conversion does a weighted mix of the three channels, about 60% green, 30% red, and 10% blue. This will hardly ever be the optimum mix for converting a scan. Channel Mixer, however, lets me specify how much of each color channel goes into the grayscale version of the photograph. Sometimes one channel is obviously superior to the others, such as in Figure 4-14, in which case I might use 100% of that channel. At other times one channel may be significantly worse than the other two, so I'll use none of that channel and some weighted mix of the other two (it doesn't have to be 50/50%).

On occasion I'll even use a negative percentage in one or more of the channels! That's allowed, and useful (Figure 4-15), so long as all three channels still add up to about 100%. As I explain on page 267 in Chapter 8, "Damage Control," applying a negative value in the channel that most strongly shows the damage to the original photograph can markedly suppress that damage by subtracting it out of the converted image.

How to convert an RGB scan to grayscale

In Photoshop, click Image/Adjustments/Channel Mixer.... That opens up a control panel that displays the conversion options (Figure 4-16). Click the Monochrome option at the bottom of the panel. Although the file stays in RGB mode, it turns gray. The controls default to a mixture of 40% red, 40% green, and 20% blue channels to determine the gray value of each pixel, but it's not likely you'll want to use that for restoration work.

Adjust the channel sliders to emphasize the color(s) you want to most retain and deemphasize the one(s) you want to get rid of. Usually you'll want the sum of all three channels to add up to 100%, and negative values are allowed. Pay attention to the histogram display to make sure you're not accidentally clipping shadows or highlights. When you're happy with the results, click OK, and the image will be converted to gray. (It's still an RGB file; it's just that all the channels have the same values.)

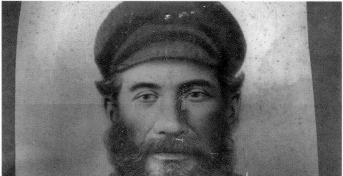

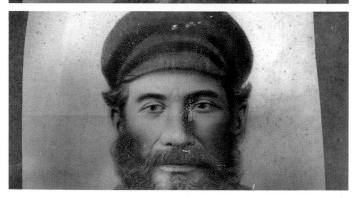

Fig. 4-15 The original photograph (upper) is faded and stained. Examining the individual color channels shows that the red channel (middle) is the most free of damage, while the blue channel shows it the worst. The bottom photograph shows what happens when I use Channel Mixer to subtract the dirty blue channel from the cleaner red channel. The result has clearer subject detail and is cleaner than the pure red channel.

How you do the conversion to monochrome (assuming that's what you want to do) depends on the characteristics of the photograph and exactly how you plan to restore it. A conversion that eliminates one or more color channels of data because they emphasize defects is a good place to start a restoration. Conversely, a conversion that emphasizes the channels that show damage most

clearly will be useful for constructing selections and masks to isolate the damaged areas for repair (Chapter 7, page 230).

For these reasons, don't gratuitously throw away information. Even if you're sure that the final photograph will be reconstructed from only one color channel, save the file with all three channels. You might find that the other two channels contain information that's going to help you in other ways.

Is 16-Bit Mode Really Necessary?

I prefer to scan in 16-bit mode. I've found that the ideal way to produce scans and extract maximum formation from the original photograph is to optimize the Curves and Levels settings in the scanner software and do a 16-bit scan. I usually do this because ultimately it saves me work time. Truth be told, in 16-bit mode I can be rather sloppy about the Levels and Curves in the scanner settings, just not so much that I'm likely to lose any data by overdoing it. I can scan batches of photographs in 16-bit mode using similar scanner settings with less trial and error and fewer repeated scans that otherwise eat up considerable time. None of the scans will be perfect when done this way, but with 16 bits of tonal depth to play with, there's plenty of data for me to fix everything in the computer.

Figures 4-17 through 4-19 show how flexible 16-bit data is. The left-hand photograph (Figure 4-17) and histograms (Figure 4-18) come from a straight scan of a snapshot with no corrections. Because the photograph is so faded, less than half the range of tonal values is actually used; the spikes at the right side of the histograms are just from the white paper border. I crudely corrected the range of tones and colors with the Curves settings shown in Figure 4-19 to get the much better-looking photograph on the right side of Figure 4-17.

These are very extreme corrections! Even so, the histograms on the right side of Figure 4-18 show that I did not get the dreaded "picket fence" effect that is so obvious in Figure 4-7. I have a well-populated histogram that will produce good continuous-tone quality in the finished restoration. I would never recommend accepting a scan this bad, even in 16-bit mode. It demonstrates, though, the considerable robustness of a 16-bit scan.

You may find that a practical limitation on doing 16-bit scans will be the power of your computer. It's not merely that computations take twice as

Fig. 4-16 Channel Mixer combines the original RGB channels to make a grayscale image when Monochrome is checked. I combined 150% of red with –50% of blue, which subtracted some of the damage because the damage was much stronger in the blue channel than the red.

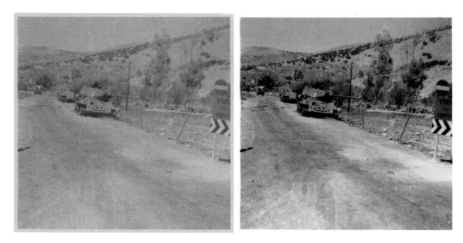

Fig. 4-17 The figure on the left shows the original photograph, captured as a 16-bit scan, with no effort made to correct the tonal color during scanning. This is an accurate representation of the original photograph. On the right is the same scan after I crudely corrected the color using the curves in Figure 4-19. Having 16 bits of data per color channel makes it possible to do extreme corrections like this and still get a photograph of good quality.

Fig. 4-18 The histogram on the left belongs to the left-hand photograph in Figure 4-17. There is only a narrow range of tones in each color channel in the scan. (The big spike in each histogram channel at the right corresponds to the "white" paper border.) The histogram on the right shows what the tones look like after applying the curves in Figure 4-19, producing Figure 4-17, right. Notice that there is no "picket-fence" effect with gaps in the histogram, as we saw in Figure 4-7.

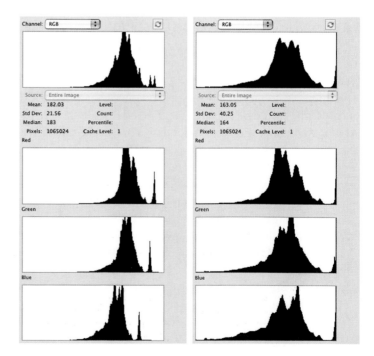

long. I pointed out in Chapter 2, page 30, that an 8 × 10-inch print scanned at 600 ppi in 16-bit mode produces a 175-MB file. Start adding layers to that in Photoshop or working with multiple generations in Picture Window and in short order you're swapping scratch files to disk. Your performance crashes dramatically. It's something to keep in mind when you're deciding on your scan depth. It may seem that scanning in 8-bit mode and consequently having to really fine-tune your scanner settings will slow down your work, but that's not going to be the case if doing a 16-bit scan means that your image processing program goes running to the hard drive every time you perform an operation on the file. Back when I only had 512 MB or 1 GB of RAM in my computer, I did my best to avoid working on 16-bit files unless the originals were quite small.

Sometimes 16-bit data is going to be a must. When the condition of the original is so uneven that no overall set of corrections in scanning is going to produce good results, you'll need those extra bits. The severely degraded glass plate in Figure 4-20 is almost entirely bleached out, and the scanned density isn't anything close to even. Until you manipulate the file into a uniform-looking image, you'd need to work in 16 bits so that you could do different strong corrections on different parts of the scan and still have well-filled histograms of data.

If your computer really isn't up to working on 16-bit files for the whole restoration process, I recommend a compromise: Do your scans and as much of the gross color and tone correction as you can in 16-bit mode. Then convert the file to 8-bit mode. That will minimize the image-quality problems of working with 8-bit files. Don't worry about doing damage repair and cleaning up dust, scratches, and cracks before you convert. You can do that work as invisibly in 8-bit mode as in 16-bit mode.

The closer you get to the finished restoration, the less having 16-bit data will matter. When you get to the output stage, 16-bit color may not make any difference. Most printer drivers don't take advantage of 16-bit data, although that's gradually changing. Photoshop and TIFF file formats preserve 16-bit data, but JPEG

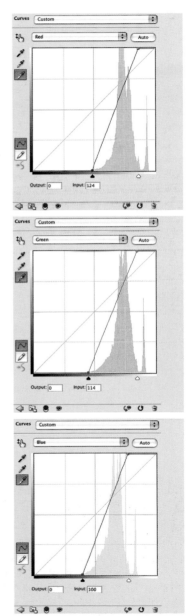

Fig. 4-19 These are the curves I used to correct Figure 4-17. The contrast change in each channel is extreme, expanding the tonal range by a factor of two to three. This would have produced visible image degradation in an 8-bit scan; a 16-bit scan has enough extra data to handle it.

Fig. 4-20 The upper figure shows a very badly faded glass plate. I scanned it and inverted the tones, producing the photograph in the lower figure. There's plenty of information here to do a restoration from, but the density and contrast vary so much in different parts of the plate that it would be impossible to do a good restoration from an 8-bit scan, even with carefully adjusted scanner software settings. This is a case where 16-bit scans are a must for good results.

doesn't. If your client wants the finished image in JPEG form, you will be sending them 8-bit color, no matter what you were working on in the computer.

Pulling in the Color

The same principles that work for scanning B&W prints apply to scanning color prints (and for that matter, slides, but not color negatives). It's usually a safe bet to assume that the print originally had a complete range of tones, from paper-white to maximum black. Unless you know that the original had a limited range of tones in one or more channels, strive for a scan that makes best use of the full range of values available and looks similar in overall color balance to your desired result.

Frequently this will give you a very good start on a proper restoration. In the Examples online at http://photo-repair.com/dr1.htm, I take the scan from

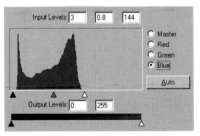

Fig. 4-21 The rules for making a good color scan are no different from those for making a good B&W one. The only difference is that you have three channels to correct instead of one. In each of the three color channels, I adjusted the black and white endpoints so that they bracketed the full range of tonal information in that channel without clipping any of it. I made a slight overall color correction by adjusting the gray midpoint for the blue channel from 1.0 to 0.8 (that is, I moved the gray slider triangle to the right). That made the scan a bit more yellow, eliminating a blue cast.

Figure 4-22 and turn it into a fully restored photograph by making just a handful of further corrections.

How to improve color with a good scan

Adjust the Levels or Curves in the scanner software the same way you would if you were scanning B&W prints (Figure 4-21). You may find that even when you make these adjustments, the resulting scan has an overall color cast. You can correct much of that in the scan by shifting the midtone sliders in each channel's Levels adjustment until the average color looks good. This can make a substantial difference in the quality of the scan and get you well on the way to a complete restoration. The "corrected" scan of the photograph in Figure 4-22 originally had a blue color cast. I adjusted the midpoint in the Levels control for the blue channel (bottom histogram in Figure 4-21) to make the scan more yellow.

It can take a while to become proficient at scanning, and some trial-and-error time will always be involved. Scanning badly deteriorated prints is a bit of an interpretive art. I find that I usually make three or four different scans of a print before I settle on the one that I'm happiest with.

If you plan on using tools like the DIGITAL ROC Photoshop plug-in to restore the photograph's color, don't go overboard on messing with the scanner curves. DIGITAL ROC is surprisingly insensitive to the quality of a scan. It produces almost as good results from a straight scan that looks just like the faded photograph as from one with the B&W levels carefully normalized to produce a full range of tones.

Moreover, if you distort the curve shapes substantially in trying to fine-tune the color by eye, it can confuse DIGITAL ROC, which works its magic by analyzing the distribution of tones and colors in the photograph. The recovered color in that case may actually be worse than it would be if you didn't refine the scan as much—yet another reason why I usually fiddle with several different scans before settling on the one that will work best for my restoration.

Not so incidentally, don't worry about profiling your scanner (or camera) for accurate color and tonal rendition. The originals you're scanning will have badly

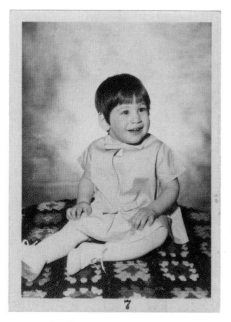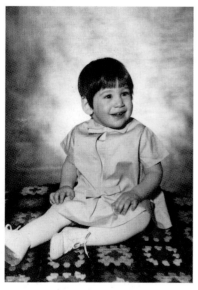

Fig. 4-22 The left-hand figure is the original photograph. I scanned it using the scanner software Levels settings shown in Figure 4-21 to produce the right-hand photo.

distorted colors and tones, and you're going to end up substantially modifying those. As I've said for B&W, capturing values exactly the way they are in the original not only doesn't matter—it's often counterproductive.

Scanning Halftones

You may not know the term *halftone*, but most of the photographs you see are halftone reproductions. Newspaper and magazine reproductions are halftones. The photograph is made up of a pattern of black (or colored) dots on white paper (Figure 4-23). The illusion of continuous tone is created by variations in the size of the dots to produce more or less ink coverage of the paper, but there really aren't any intermediate tones.

Consequently, a good scan of a halftone print has very different characteristics from a good scan of a regular, continuous-tone photograph. When scanning a regular photograph, it's important not to push the extreme tones all the way to pure white or pure black, lest you accidentally lose some highlight or shadow detail. With a halftone, you want blacks and whites, within reason.

Fig. 4-23 This is a highly magnified view of a B&W newspaper print. There are no intermediate tones in the image, just black dots of varying size that simulate the appearance of different shades of gray.

How to scan a magazine or newspaper illustration

The best scan of a halftone, though, will almost always be one that makes the majority of the ink dots come out close to a true black and most of the un-inked paper close to true white. That means setting the white and black level points in your scanner software (Figure 4-24) well within the range of tones in the photograph. The correct white and black level points are the ones that come closest to achieving this without obliterating the very smallest dots. The histogram you see in the finished scan should look something like that of Figure 4-25.

Figure 4-25 is very different from a good histogram for a continuous-tone photograph, where you don't want the scan to force any of the tones in the photograph to pure white and pure black. Also, because you don't care about having lots of continuous-tone information in a halftone scan, there's no need to scan in 16-bit mode; 8-bit mode works just as well, and you'll get files that will be only half as big and will process twice as quickly.

In Chapter 9, "Tips, Tricks, and Enhancements," page 299, I show you some ways to get rid of the dot pattern (a process known as *descreening*). A high-resolution scan, which shows the size and shapes of the dots clearly, works best for this task. I scan a halftone at four to eight times the dot spacing. Newspaper photographs are reproduced with somewhere between 65 and 100 dots per inch (this, by the way, is the actual and correct use of dpi as a unit of measurement). Magazine illustrations can be anywhere between 125 and 200 dpi. I never scan at less than 600 ppi and sometimes I go to 1200.

How to Scan B&W Film and Glass Plates

If you're working from roll film originals, a high-quality film scanner is in order; if you're trying to scan old B&W sheet film or glass plates, a very good flatbed scanner is going to be necessary. Old glass plates and sheet film are especially challenging to scan well. Old-style photographic emulsions were typically much more contrasty than modern films. The older the photograph, the more likely it is to place severe demands on your scanner's ability to capture detail in the highlights, the densest parts of the negative (Figure 4-26). In the Examples

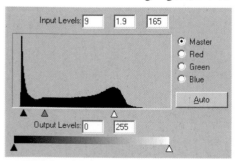

Fig. 4-24 These are the scanner software Levels settings I used to create Figure 4-23. I set the black and white endpoints inside the range of tones seen by the scanner. That makes the ink blacker and the paper whiter, minimizing or eliminating stains and faded spots in the halftone and making it much easier to restore this photograph.

online at http://photo-repair.com/dr1.htm, I do a complete repair and restoration on this photograph.

The situation is made worse because the grains of silver that make up the image are more likely to scatter light out of the optical path than back into it. Consequently, most scanners read B&W silver emulsion densities as being much higher than what you would measure on a densitometer and higher than the equivalent density in a dye-based (color or B&W chromogenic) photographic image. For example, my Minolta DiMAGE MultiPro film scanner can handle about 4.2 density units (du) in color film and chromogenic B&W film like Ilford XP2, but it's limited to silver-based B&W densities of 2.7 to 3.0 du.

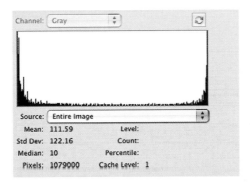

Fig. 4-25 This is the histogram for the halftone scan in Figure 4-23.

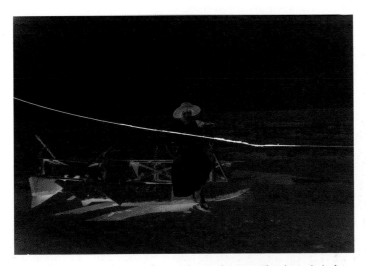

Fig. 4-26 Old B&W films and glass plates are often very dense and contrasty. They demand a lot from your scanner. I was just barely able to capture a good scan of this cracked glass plate negative on my professional flatbed scanner.

That's a lot by modern darkroom standards, but unfortunately it's not by early photographic standards; the printing materials they used then had extremely long exposure ranges. Adding to the difficulties are early photographers' predilections for generous exposures. Emulsion making and exposure determination were nowhere near the precise crafts that they are today. It was far better to have to "print through" some extra and unneeded density than to underexpose and be saddled with an unprintably thin or mostly blank negative, so the majority of old films and plates are dense.

The only times when you're not likely to see high B&W densities are when the original is severely faded or bleached, as in Figure 4-20. That doesn't make repairs any easier! Such damage is rarely uniform across the photograph, and a very narrow contrast range in the negative only serves to exaggerate the impact of dirt and scratches.

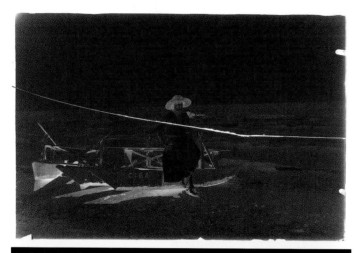

Whenever you scan contrasty and high-density originals, regardless of the film format or type, be sure to mask off the unexposed areas at the edges of the film, film sprocket holes, and the clear parts of the film carrier or platen. The unattenuated white light blasting through those clear areas will cause flare that degrades the quality of the scan if you don't block it (Figures 4-27 and 4-28). Good film scanners come with masks for different formats, so you

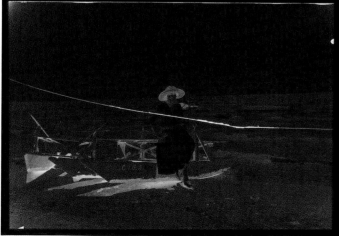

Fig. 4-27 Clear areas around the image must be masked off when scanning a dense negative. The upper figure shows the scan I made of this glass plate on my flatbed scanner when I didn't mask off the clear areas of the platen. The lower figure shows the scan made with exactly the same settings, but this time I used black paper to mask off the region outside the image. Figure 4-26 shows what a difference this made in the quality of the highlights (densest parts) of the negative.

shouldn't have to worry about this. When scanning dense film or plates on my flatbed scanner, I just mask off the surrounding area with strips of black construction paper. It's simple, even primitive, but it's most effective.

Scanning old B&W plates and films is best done in 16-bit mode using whatever scanner settings will let you capture the maximum density range. Finding out what those settings are for your scanner will take some experimentation. In some scanners, 16-bit mode automatically captures a longer density range; in others (my Minolta DiMAGE, for example) there may be a separate mode with a name like "16-bit linear" that captures the longest density range.

Even though you are scanning a B&W negative, you may find that you can capture the longest density range if you tell the scanner software that you're working with a color transparency. Frequently scanner software tries to be "helpful" and scan for normal-contrast results. The software boosts contrast and restricts the range of densities you capture if you scan the film as a negative instead of as a transparency, because modern negatives, B&W and color, have lower density ranges and less contrast than slide films.

Fig. 4-28 Here's an enlarged portion of the unmasked (left) and masked (right) scans. I lightened the scans and increased their contrast to make more visible the highlight detail (the dense parts of the negative). Even though this area is in the very center of the plate, far from the unmasked edges, flare has crept in and lightened the high-density areas. It also reduced contrast; the folds and ripples in the white dress aren't as clear in the unmasked scan as the masked one. The masked scan has much better highlight detail and contrast.

You can use the Curves tool to exaggerate the highlight detail, making it easier to compare quality between the scans. Open the scan files in your image processing program, bring up the Curves tool, and create a Curve like the one in Figure 4-30. If you're using Photoshop, do this in a Curves adjustment layer. That's a better way because you won't be altering the photograph itself, just its presentation. Then if you forget what you're doing and accidentally save the file, you haven't destroyed any information. A Curves adjustment layer also lets you move the control points in the curve around to make it easier to see different aspects of the highlight density.

You will need to run some experiments to find out what combination of these settings works best with your equipment. Don't worry about what gets captured in the shadows (the thin parts of the negative); they will take care of themselves. Concern yourself with how much information you capture in the densest highlight areas (Figure 4-29). Find the scanning mode that gets you the maximum amount of highlight information, and stick with it for all your scans unless the original is severely faded.

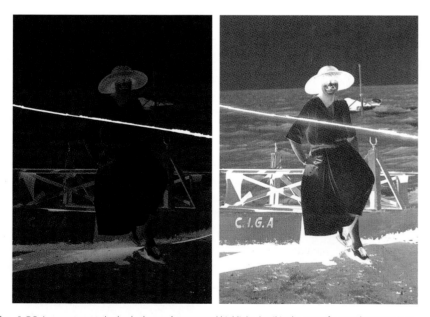

Fig. 4-29 An easy way to check whether you've got good highlight detail in the scan of a very dense neg is to increase its brightness and contrast using the curve in Figure 4-30. The photo on the left shows the scan viewed normally. The photograph on the right shows the same scan after I applied the enhancing curve in Photoshop.

When you are working with extremely contrasty originals, consider making two scans with very different exposures—one for the highlights and one for the shadows. In Photoshop, you can use the Merge to HDR automation to combine several differently exposed 16- or 8-bit files into a single, extended-range image. Picture Window has a simple tutorial explaining how to do this using its Stack Image operation. This operation is a lot more intuitive than Photoshop's automation, and I like Picture Window's results much better. I give you detailed instructions on using it in Chapter 9, on page 298.

Depending on the capabilities of your scanner, combining multiple scans may not capture a longer density range than a single scan could. But it will get you much higher-quality data in the extreme highlights and shadows, with less noise and better tonal separation.

Be aware that, just like point-source enlargers, most film scanners also really exaggerate scratches and dust and dirt. There are software tools that will help reduce that, but using them without compromising sharpness is tricky. Hardware-based scratch and dust suppression, such as the DIGITAL ICE found in dedicated film scanners, won't work with silver-based images. Resign yourself to the fact that a certain amount of "spotting" is necessary with any scan. This is a situation where the Polaroid Dust & Scratches Removal program (see Chapter 3, "Software for Restoration") could help you out considerably.

Fig. 4-30 This curve increases the contrast in a negative's highlights fourfold. It makes it possible to clearly see the quality of the highlight detail in scans of very dark negatives.

Scanning Color Film

Scanning old color negative film is usually more of an aesthetic than a technical challenge. Old color film does not have much higher densities than modern film. Unless you're scanning a relatively recent photograph that has only suffered physical damage that needs repair, you'll be dealing with color emulsions that have faded with time, so their maximum densities are even lower. Most scanners should have no trouble capturing the full range of densities in a negative once you get the settings right.

You want a scan that contains as much information from the negative as possible. Linear mode capture usually accomplishes this task; it's intended to pass on the data collected by the scanner with the minimum amount of software interpretation. That's left up to you, as it should be; these are not decisions you want your software making for you.

I strongly recommend capturing negatives in 16-bit mode, especially 16-bit linear mode if it's available. Because a negative's contrast is naturally low, it gets boosted substantially when it's printed, even more so if the negative is faded. If you start with a mere 8-bit scan, you will run the risk of getting a "picket fence" histogram that's bad enough to degrade the quality of the restored photograph, the same way you would with a straight scan of a badly faded print (Figure 4-8).

If your scanner doesn't offer a linear mode and your negative scans are clipping either the highlight or shadow detail, try scanning the negative as though it were a slide, since scanner software is designed to retain a greater density range when scanning slides. The image you see on your screen will then, of course, be a negative, but a simple inversion operation will give you a positive image.

Don't expect the image you see to look anything like a good photograph. The color will be wrong, the contrast will be flat, and it could appear much lighter or darker than you would want a good-looking photograph to be. That's all correctable. Not correctable are highlights and shadows that are entirely lost because your software threw away some of the detail in the photograph.

I recommend 16-bit linear mode for scanning color negatives, because most scanner software assumes that when you scan a negative you want a positive image of "normal" contrast and color saturation. Usually it will not capture the full density range of the negative, only a partial range that produces what the software thinks will make the best-looking print.

Using 16-bit scanning mode is less critical for scanning slides if they're not severely faded, but it's still a good idea. A lot can be done to improve the quality of chromes, especially old ones. The original slide in Figure 4-31 was a badly scratched Kodachrome that had never been projected. Kodachrome slides are very stable in the dark. Consequently, once the scratches were all repaired, the tone and color were in like-new condition. Typical of slides, this one has very contrasty midrange tones and flat highlights and shadows.

Some photographers intentionally took advantage of the harsh characteristics of their films, but far more often they only tolerated them as being the best that was possible at the time. This may be a look you want to preserve, but more often than not the client will be thrilled if you can do something to improve the tonal quality. Scanning the chrome in 16-bit mode ensures that you have plenty of well-discriminated tonal information in the highlights and shadows so that you won't see posterization and banding when you improve the overall contrast characteristics of the photograph.

Fig. 4-31 This Kodachrome slide (left figure) has like-new tone and color because Kodachrome is very stable in the dark. That does not mean it can't be improved. I produced the photograph in the right-hand figure using Photoshop's Shadow/Highlight, Hue/Saturation, Dodge, and Burn tools. This photograph has better highlight detail and improved color, and it shows the mother and child more clearly and better focuses the viewer's attention on them.

Faded slides can be particularly tricky to scan. Often one dye layer is hardly faded at all, while at the same time there is an overall buildup of stain. The result is that even though the slide looks pale and washed out to the eye (and sometimes to the scanner's exposure control), it may actually have higher-than-normal density in one or more channels. Despite the best efforts of your scanner, the darker areas in that channel may go solid "black" in the scan, eliminating any possibility of good color correction in those portions of the photograph.

Scanning in 16-bit mode may bring in that extra-high-density data. However, you'll often encounter cases in which even that won't be enough (Figure 4-32). When that happens, the first thing to try is scanning the film into a larger color space. Good film scanner software has an option for choosing the color space; Adobe RGB is a common default setting. This is a very good general-purpose color space, but it can't capture the widest range of colors and tones. What you want is a super-large color space, like ProPhoto RGB or Wide Gamut RGB.

If you scan into that kind of color space, you'll find a lot of the extreme density values in the slide that previously went to pure black in one channel or another are now usable. Where there was merely blocked-up tone, you'll get a range of dark values.

When you open up the scan file in Photoshop, the program will alert you that the color space for the file is different from your working color space (unless you happen to be working in ProPhoto RGB or Wide Gamut RGB) and will ask what you want to do about it. Tell Photoshop to assign the file the same color space (ProPhoto RGB or Wide Gamut RGB) as you scanned it in.

Fig. 4-32 This early 1950s E-1 slide is very contrasty. Even after color and tone correction (shown here), a single 16-bit scan can't encompass the full range of detail that was in the slide, from highlights to shadows.

If scanning in a larger color space doesn't do the trick, the answer is to make two or even three scans at very different exposure settings and combine them, as in Figure 4-33. See Chapter 9, "Tips, Tricks, and Enhancements," for complete instructions on how to do that.

Resolution Decisions

Usually you won't have to scan prints at extremely high resolutions. It's rare to find an old print that has 1200 ppi worth of fine detail. For 8 × 10-inch and larger originals there usually won't be even 600 ppi worth of detail in the photograph. Often a mere 300 ppi scan can capture all the real detail that there is to be had. This is true even of contact prints from glass plates and large-format film negatives.

Fig. 4-33 You can create an extended-range scan from several individual scans made with different exposures by using Picture Window's Stack Images Transform. I used that transform to create the large composite photograph here from the three individual scans at the top of the figure. Compare the vastly improved highlight and shadow detail with that of the photograph in Figure 4-32.

How to determine what resolution to scan at

If you believe that a particular photo merits a high-resolution scan, do some test scans of a small section of it at different resolutions: 300, 600, 1200 ppi, and so on (Figure 4-34). Compare the scans on your monitor at 100% scale, at least. If you find that the pixelation in the lower-resolution scans makes it difficult for you to compare the amount of image detail with the higher resolution scans, resample all the files to the same ppi (Figure 4-35). Use this to determine the point where increasing the scan resolution further doesn't get you any more picture detail.

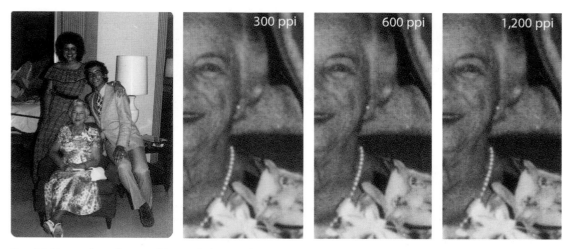

Fig. 4-34 I scanned a small portion of the snapshot on the left at 300, 600, and 1200 ppi resolutions to see how fine a scan was needed to capture all the detail in the photograph. The 600 ppi scan is a little sharper than the 300 ppi one. The pearls and the flowers in the corsage have a little more detail at 600 ppi. There's no difference between the 600 and 1200 ppi scans. This tells me that I don't need to scan this photograph at a higher resolution than 600 ppi.

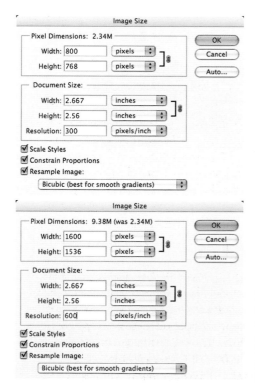

Fig. 4-35 Here's how to resample a lower-resolution scan to higher resolution when you're comparing different scans. The upper control panel shows the settings for the 300 ppi scan. To make it match the 600 ppi scan in scale, change the Resolution to 600 (lower panel) and make sure that Resample Image: Bicubic is selected.

There's no harm in scanning at unnecessarily higher resolutions, but it expands your file size dramatically. The size of the image file you get goes up as the square of the scan resolution: A 600-ppi scan will be four times as large as a 300 ppi scan, and a 1200 ppi scan will be 16 times as large.

High-resolution scans of low-resolution prints can be useful when there's physical damage with sharply defined, clear edges (Figure 4-36). Scanning at higher resolutions spreads out real image detail over many more pixels while the edges of damaged areas remain pixel-sharp. This makes it easier to use edge-finding filters and similar tools in your image processing program to extract the boundaries of the damaged areas. When a damaged region's edges and the finest image details are both only 1 or 2 pixels wide, it's hard for software to distinguish between them. When an edge is 1 or 2 pixels wide but the finest photographic detail is 5 to 10 pixels wide, you can do a pretty good job of masking that selects for the sharp damage. In Chapter 7, "Making Masks," pages 221–224, I apply this technique to the photo in Figure 4-36.

Masks can be resized the same way image files can, so you aren't stuck with a monstrous, ultra-high-resolution file to work with. If you need to scan at, say, 2400 ppi to create a good mask, don't be afraid to do so. Once you've made that mask and saved it, you can resample both the mask and the image file down to something more workable, say, 600 ppi, and perform your restoration on much smaller files.

When you're scanning film, be aware that scanning usually increases grain, no matter what type of film was used. That's because a "grain" in a digital file can be no smaller than a single pixel. Even coarse-grained B&W film has film grains smaller than most scanners' pixels. Consequently grain is magnified in scans. Good software tools exist for reducing the impact of grain, notably DIGITAL GEM, which is part of the DIGITAL ICE[3] software package incorporated in many film scanners and also available as a plug-in for Photoshop, and NoiseWare (see Chapter 3, "Software for Restoration"), but it's hard to make it go away entirely. The best way to minimize grain in a digital scan is to scan at the very highest true (not interpolated) resolution you can. That will make the grain finer and more like it was in the original negative and more like it would be in a wet darkroom print.

Low-resolution scans don't solve the grain problem until you get to very low resolutions. Film grain, unfortunately, acts like random noise, which means it doesn't blur out as much as you'd expect when you make the pixels bigger. (For the mathematically inclined, grain contrast goes down only as the square root of the size of the pixel.) Figure 4-37 shows highly enlarged sections of a photograph scanned, top to bottom, at 4800, 2400, and 1200 ppi. As the resolution drops, the film grain gets larger and mushier, but it still hasn't gone

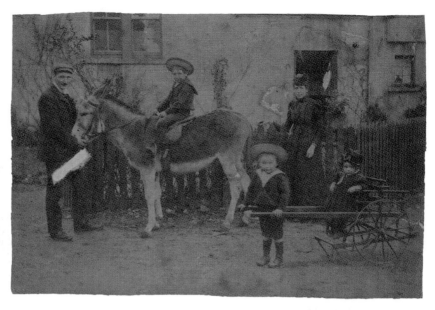

Fig. 4-36 Sometimes it's a good idea to scan at very high resolutions. This photograph is covered with a network of fine cracks. The 600 ppi scan (lower left) records as much photographic detail as the 1200 ppi scan (lower right), but the cracks are much sharper and better defined in the 1200 ppi scan. That will make it easier to create a mask that selects just the cracks for repair (see Chapter 7).

away even at 1200 ppi. The random noise effect of grain leaves its imprint on individual pixels even after fine detail is blurred out.

Putting aside grain problems, the older the original, the less likely you are to need a high-resolution scan of it. By and large, old-time photographs get their wonderful sharpness and rich tonal qualities from the large size of the films and plates of the time. However, although old-style emulsions were often very fine grained and sharp, the same cannot be said for the camera lenses. The techniques of the photographers of the time didn't usually lend themselves to ultra-sharp photographs. On average, a photograph made by a casual 35 mm camera user in the late 20th century has much finer detail than a professional photograph made a century earlier.

One important tip for scanning smaller negatives: Always scan film in a glass carrier! No glassless flat film carrier has been made that holds the film well enough to give you an edge-to-edge sharp scan, no matter what the manufacturers may foist off on you as a standard carrier for your scanner. Pay for a glass carrier when you buy your scanner, even if it costs you extra.

Rephotography

If you're trying to restore prints that have lots of fine cracks or a really heavy surface texture, you may be better off rephotographing the print with a good digital single-lens reflex (DSLR) camera. Flatbed scanners use highly directional light that accentuates surface flaws and brings out textures. Defects that are hardly visible under normal diffuse light viewing can dominate a scan. Taking the more conventional photographic route on a copy stand lets you use all the clever lighting tools that had been developed over the years for minimizing surface blemishes: light tents, double-crossed polarizers, careful off-axis placement of lamps—the whole bag of tricks. Used properly, this approach can save you many hours of work on the computer.

Copy photography is a specialized skill that isn't difficult to learn but does involve techniques you're not likely to have encountered while doing regular photography. In particular, the trick of using crossed polarizers to suppress

Fig. 4-37 Reducing scan resolution is not a good way to suppress noise and grain. This B&W negative was scanned at 4800 ppi, 2400 ppi, and 1200 ppi (top to bottom). The film grain gets mushier as scan resolution drops, but it doesn't go away, and much fine detail is lost.

textures and reflections is something every good copy photographer knows, but there's almost never a reason to have learned it outside that discipline.

A good instructional book on copy photography is the 1984 Eastman Kodak publication *Copying and Duplicating in Black-and-White and Color.* An online search will turn up numerous sources for this book. Even though it's 20 years old and so is entirely film oriented, it's timely. Many of the copying techniques are just as applicable to modern digital photography as they were to film photography. You'll even see some nice examples of photo restorations done using film and filters instead of scanners and computers. Be sure to carefully study the section on the use of polarizers.

How to photograph tarnished or textured prints

Prints that have *silvered out* (developed shiny metallic spots on the surface) can be difficult to scan because the metallic surface of the print bounces light directly into the scanner sensor. This is a problem that you can fix when you restore the image with some more clever masking tricks, as in Figure 4-13, but sometimes it's easier to avoid the problem in the first place. Rephotographing that same photograph with crossed polarizers over the lights and the camera lens suppresses reflections from the tarnish spots and the paper texture to provide a much cleaner image to work with (Figure 4-38).

This technique requires that you have a polarizing filter on your camera and polarizers on your copy lights. It doesn't matter whether the polarizers on the lights are oriented for vertical or horizontal polarization; what's important is that they all need to be oriented the same way. Once you have the lights set up, rotate the polarizer on the camera until specular reflections disappear and the visibility of tarnish or paper texture is minimized.

Recapturing a photograph with a camera has two disadvantages. The first is density range; your digital camera may not capture the full range of the print in a single exposure. In that case you'll need to make two exposures, one for the highlights and one for the shadows, and merge them in your image processing program (see Chapter 9, page 297). Regardless, you will want to do your captures in RAW mode.

The other handicap is resolution. Don't expect digital photography to be as sharp as scanning. The actual resolving power (across the width of the image) of most digital SLRs is in the range of 1500 to 3000 pixels' worth of fine detail. I'm not talking about the file size in pixels but the actual amount of fine detail that is there. Put another way, a sharp 600 ppi scan of a 4 × 6-inch print will record as much fine image detail as a very good digital SLR. In many cases, though, the digital photograph will be more than good enough, especially for the advantages it offers in suppressing cracks, textures, and silvering out.

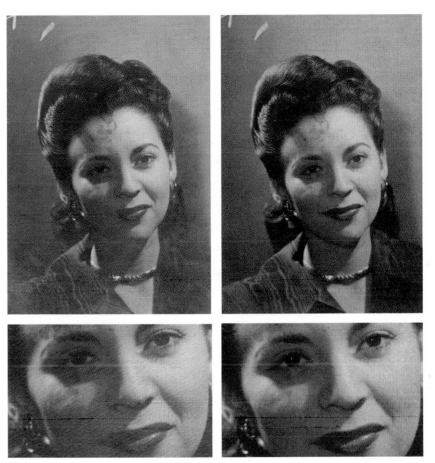

Fig. 4-38 The original photograph on the left has an intrusive paper texture and considerable tarnish. A flatbed scanner captures these flaws along with the underlying image I want to restore. I made the figure on the right by rephotographing the original print on a copy stand using a digital camera. I used two floodlights set at 45-degree angles to the print so that the paper texture wouldn't cast shadows. I covered the floodlights and the camera lens with polarizers rotated at right angles to each other. That killed the specular reflections from the tarnish, making it almost invisible.

Some digital cameras have a problem with lateral chromatic aberration (color fringing toward the edges of the frame). You can fix that in Photoshop, but I much prefer Picture Window's tool for correcting this problem. See Chapter 6, "Restoring Color," page 203, for instructions. Better still, try to fix it when you make the RAW conversion.

Chapter 5

Restoring Tone

How-To's in This Chapter

How to evaluate contrast with a histogram
How to change overall brightness and contrast with Curves
How to use sample points with Curves
How to change black and white points and avoid clipping with Curves

*How to make a print look more brilliant and snappy by adding contrast to
midtones with Curves*

How to lighten or darken a print with Curves

How to bring out shadow tones with Curves

How to improve snapshots with the Shadow/Highlight adjustment

How to improve a copy print with the Shadow/Highlight adjustment

How to improve a copy print with ContrastMaster

How to correct uneven exposure with a Curves adjustment layer

How to do dodging and burning in with masked Curves adjustment layers

*How to improve contrast and highlight detail with a masked Curves
adjustment layer*

How to dodge and burn with a soft-light layer

How to recover a nearly blank photograph with "multiply" blends

How to improve contrast without making colors too saturated

How to fix harsh shadows on faces

How to use the History Brush as a dodging tool

How to retouch faces with a masked Curves adjustment layer

What Makes a Good Print?

Let's talk a bit about what a good print looks like.

The First Rule of Good Tonality is that a good photograph almost always
has a range of tones that run from near-white to near-black. This is true even of
high-key and low-key photographs. This is partly a result of the inherent nature
of real-world subjects, which usually have highlights and shadows, even if they
are a very small part of the photograph. It is also partly a result of the limited
exposure range of most photographic films. Whatever the reason, this dictum
holds so often that the exceptions to the rule are, well, exceptional. If you
assume that the photograph you are restoring is supposed have a full range of
tones, you will almost never be wrong.

Conversely, a good photograph usually doesn't have large areas that are pure
white or solid black without there having been a specific aesthetic reason to
make it that way. This is not as universal a truth as my First Rule, but it's true
more often than not.

The classic error that the neophyte printer makes in the darkroom is getting
the overall contrast wrong. Flat prints with muddy blacks and grayish whites
are what I most commonly see. Occasionally someone will err the other way
and produce prints that are way too contrasty, with lots of solid blacks and pure
whites where there should be continuous tone and delicate gradation (Figure 5-1).
That potential for error still exists when printing digitally.

Fig. 5-1 A good-looking B&W photograph almost always has a full range of tones from black to white. The photograph on the left is too low in contrast; it looks muddy and flat. The photograph on the right has too much contrast; midtones are harsh, and some important highlight and shadow detail has been pushed to pure blacks and whites. The photograph in the middle is just right!

How to evaluate contrast with a histogram

Sometimes it's difficult for novices to tell whether they have good overall contrast in their photographs. Fortunately, we have a tool that makes it easy to evaluate that. It's the *histogram* (Figure 5-2). If your photo's histogram looks like the one on top, with large empty areas at the left or right sides of the scale, the contrast is too low. If it looks like the histogram on the bottom, with many pixels jammed up against the black and white limits, it's too high.

A good-contrast histogram spans most of the range of values from black to white. A smattering of pixels may be pure whites and blacks in the finished photograph, but for restoration work we want to minimize that until we get to the very last stages of image preparation for printing. The histogram in the center, with few or no pixels at the extreme limits, is indicative of a good contrast range in the photograph.

You'll recall from Chapter 4 (and you'll see in later examples) that when scanning a photograph I strive to get tones that fill most of the range of the histogram. I don't do that simply because it maximizes the amount of data I have to work with in the restoration, although that would be reason enough; I do it because it also gets me much closer to a photograph with good tonality.

Fig. 5-2 These are the histograms of the photographs in Figure 5-1. The low-contrast photo doesn't make good use of the full range of available tones; there's no data below a value of about 70. The high-contrast photograph has forced a lot of pixels to pure black or white (values of 0 or 255). Highlight and shadow detail is missing, and the photograph is unattractive. The middle histogram makes good use of the tonal scale without clipping off highlight or shadow detail.

123

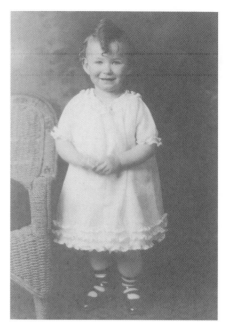

Fig. 5-3 Another flat photograph with grays where there should be blacks and whites. The histogram in Figure 5-4 tells the tale.

Fig. 5-4 This histogram shows why the photograph in Figure 5-3 looks so bad. There are no tones that come anywhere close to black, nothing darker than a dark gray. At the highlight end of the scale, the white dress is being rendered as a dishwater gray.

The First Rule is almost an absolute law for original slides and prints made from slides. Slide film has an extremely short exposure range; hardly ever do slides lack a true white and a true black somewhere in the scene. This is usually, but not always, true for color negatives and prints made from them. Professional portraits may lack a true white and a true black, especially if they were supposed to be soft, "flattering" portraits made with diffusion filters. Amateur portraits are a different matter; the First Rule likely applies. The old color print processes were not as good; while films tended to be contrasty, prints were often low in saturation and lacked a really good black. Almost all color prints from that era are severely faded and stained.

Many old B&W photographs were not black and white to begin with; they were brown or sepia in color. But you should treat them as though they were true B&W. Because of the staining and fading that afflict old photographs, you will normally eliminate all vestiges of hue during the restoration process. At the last stage, once the restoration is complete, you can digitally "tone" the print to give it the hue you want (see Chapter 12, "Printing Tips," page 380).

Moreover, most amateur photographs from the mid-20th century were terrible prints to begin with. Photofinishing back then was poor, and people's expectations were lower. Well-preserved B&W snapshots from that era (Figure 5-1, left) are more often gray and white rather than black and white. Such originals would not qualify as a good photograph by my rules. But we can improve them, unless the goal is a strict historically accurate restoration. As part of the restoration process, we can turn those gray-and-white snapshots and prints with washed-out color into full-toned photographs that will be much lovelier than the original ever was. It's always a good idea to check with the client to make sure this is acceptable; in the majority of cases they will be both delighted and amazed that you can actually improve on the original.

Now that I've laid down some guidelines, how do we get to that good-looking print? Consider the photograph in Figure 5-3 and its histogram in Figure 5-4. It's easy to see what needs to be done; the whites are too dark and

the blacks are very washed out. The photograph needs to be brighter and more contrasty overall.

Well, whatever you do, *don't* use the Brightness/Contrast adjustment to fix this! It is the tool of amateurs and is way too blunt an instrument for doing good work. Furthermore, although I find Levels adjustments useful for controlling the scan quality (see Chapter 4), I don't make much use of the Levels tool in Photoshop itself (Figure 5-5). Levels adjustments lack fine control and subtlety; you're limited to setting the end points for the pure black and white tones and a single midrange point that controls how light or dark the middle grays are (Figure 5-6). Levels definitely improves the photograph, but truly fine control over tonal placement isn't possible with this tool.

Levels' limited flexibility, though, is why I like using such adjustments in my scanner software. As long as I've got a good range of values in the scan, I want the data to be pretty linear and unmassaged. I'd rather do that work myself and not have it locked into the original scan. Some plug-ins I use are happier working with linear tones than with heavily manipulated ones. But what makes Levels just right for scanner settings makes it mostly wrong for real restoration work. If I'm recommending against using the Brightness/Contrast or Levels tools, what's the alternative?

Curves

The Curves tool does everything that the Brightness/Contrast and Levels tools can do for you. What makes Curves the tool of choice is that it also does so much more. You can attach a multitude of control points to a curve and shape it to your liking. This is the secret to getting good tonality in B&W restoration, and it's absolutely essential for color. Careful Curves adjustments in color (see Chapter 6, "Restoring Color") are often the only way to produce exactly the right color corrections. If you want to do great restoration work, you must become completely comfortable with and must master Curves. Read Chapter 11, "Examples," to see how much I depend on manipulating curves to make my color and tone corrections and even to repair damage.

Fig. 5-5 Photoshop's Levels tool can correct the contrast of Figure 5-3. The B&W sliders are positioned just outside the range of tones portrayed in the photograph. The black slider is moved in much farther than the white slider, so the picture will become darker overall. To compensate, the midtone gray slider is shifted slightly to the left (a value of 1.06) to brighten up the middle grays a little bit to compensate.

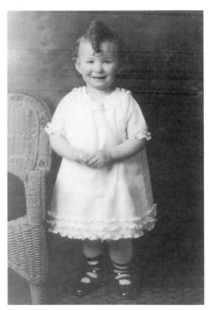

Fig. 5-6 This is the same photograph as Figure 5-3 after the Levels settings in Figure 5-5 are applied. It has more natural-looking and attractive tones and more normal contrast.

How to change overall brightness and contrast with Curves

Curves will do anything that Brightness/Contrast and Levels adjustments can. A Brightness increase of +32, for example, becomes what is shown in Figure 5-7 in the Curves tool. Raising the line by 32 points produces exactly the same results as that brightness change would.

The numerical Contrast changes don't equate so directly to Curves adjustments, but making the line steeper corresponds to a plus Contrast change, while making it shallower corresponds to a minus Contrast change. A Contrast increase of +16 looks like Figure 5-8.

In short, if you want to increase or decrease brightness, raise or lower the curve. If you want to increase or decrease contrast, make the slope of the curve greater (steeper) or lower (more horizontal).

Fig. 5-7 This curve works exactly the same as a Brightness tool change of +32. The whole line has been raised by 32 points.

Fig. 5-8 This curve corresponds to a Contrast tool increase of +16. The black and white endpoints of the curve have been dragged inward, making the curve steeper.

Fig. 5-9 This curve has the same effect as the Levels tool in Figure 5-5. The black and white endpoints of the curve are dragged in to match the positions of the black and white sliders in the Levels tool. The midpoint of the curve is moved slightly upward to make the middle grays lighter.

Levels adjustments translate easily to Curves. Instead of moving the Levels black and white sliders to new values, move the black and white endpoints of the curve to those values. The midpoint on a curve works the same as the midpoint slider in Levels. Move the curve midpoint up and down the way you would move the slider in Levels back and forth. The Curves adjustment in Figure 5-9 has just the same effect as the Levels adjustment in Figure 5-5.

Curves are not the only way to manipulate the tonality of a print; later in this chapter I'll bring up some very powerful techniques that don't depend on the Curves tool at all to greatly improve the tonal qualities of a photograph.

But Curves are going to end up doing most of your heavy lifting, tone-wise. All the clever tricks in this book won't get you a good restoration without the assistance of Curves. Contrariwise, as Example 3 (online at http://photo-repair. com/dr1.htm) demonstrates, you can use primitive tools and ancient software and do fabulous restoration work if you know how to bend (literally!) those curves to your will.

Consequently, I spend most of this chapter talking about ways to use Curves to improve tonality. I appreciate that many newcomers to the world of digital work find Curves a tough row to hoe, so I'll take some time to get you more comfortable with this tool.

In Photoshop CS4, the emphasis is now on adjustment layers. The Curves adjustment layer affects an image exactly the same way the directly applied Curves tool does. The difference is that the adjustment layer remains separate from the image layer, and you can go back and change those Curves settings at any time. I use adjustment layers a lot later in this chapter, so you can appreciate their power, but don't worry about learning this new approach. For now, we'll just use Curves as curves.

Curves are potent tools. As you'll see in the rest of this book, I use them more often than any other adjustment, by themselves, in adjustment layers, and in combination with masks. Unfortunately, many photographers understandably have trouble warming up to the Curves tool. Relating levels of brightness in a photograph to numbers on a graph doesn't always come naturally.

Photoshop's Curves has some features that help make this less forbidding. You can use the eyedropper to figure out which points in the photograph correspond to which points on a curve. You can set control points on the curve this way, and you can assign information readouts to selected points in the photograph so that you can monitor the effects your Curve changes are having. Learn to use these techniques; they will help you internalize the relationship between numerical values and tones in the image. The more that becomes instinctive to you, the easier you will find Curves.

How to use sample points with Curves

When you use the Curves tool, the cursor automatically becomes an eyedropper; clicking the eyedropper anywhere on the photograph overlays an open-circle indicator on the curve at the tonal value of that point in the photograph (Figure 5-10).

Numerical readouts below the graph report the exact value at that point (Input) and what it will change to when the curve is applied (Output). You can move the cursor around with the mouse button held down and watch the indicator slide up and down the curve and the numbers change as you pass over bright and dark parts of the photograph. This is a good way to learn how the

Fig. 5-10 Use the cursor to match tones in a photograph with points on the Curves tool. I sampled the water in the background by clicking the cursor (the eyedropper in the oval) on the photo. That created a corresponding circle in the Curves panel (right) whose input value matches the tone in the photograph.

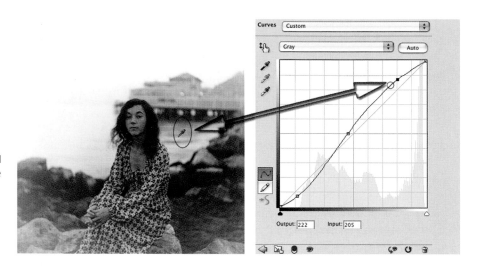

Fig. 5-11 To monitor the values at several points in a photograph, shift-click the Eyedropper tool on the photograph. That will create new RGB readouts in the Info window (upper right). I've placed four monitoring points in the photograph—in the woman's hair, on her face, in the background, and in the sky. Those readouts will report the effects of Curves and other adjustments on those points, no matter where I move the cursor.

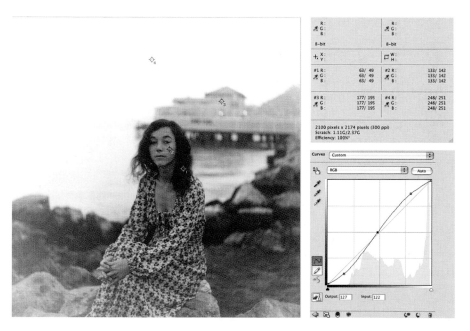

tones in the photograph correspond to values on the curve. Photoshop's Info window, shown in Figure 5-11, will also tell you the numerical values for the photograph under your cursor; that data's available with any tool, not just when you have Curves opened up.

You can use the eyedropper tool to monitor several different points in the photograph while working on it. If you shift-click on a point in the photograph with the eyedropper, it adds a readout

point to the photograph; the numerical values for that point appear in the Info window (Figure 5-11). You can place up to four separate readouts in the photograph that will always tell you the values at those points, regardless of where your cursor is or what you're doing.

You can set adjustment points on the curve by Command-clicking (Control-clicking under Windows) on the tone in the photograph that you want to modify. Once you set a point, you can drag it up or down and to the left or right to alter the tones. That way you don't have to guess what value a particular tone in the photograph corresponds to on the curve or pay attention to the numerical values.

Important notes for Photoshop CS4 users

If you're using a Curves adjustment layer, manipulating the eyedropper has become more complicated. To begin with, you'll have to select the eyedropper tool from the Tools palette, and simply clicking that eyedropper on the photograph doesn't accomplish anything. To get the open-circle indicator, you'll need to hold down the Command key (the Control key under Windows) at the same time that you mouse-click the eyedropper on the photograph. That places a new control point on the curve when you release the mouse click.

If you just want to inspect points in the photograph without laying down control points, you'll need to hold down both the Command and Shift keys and the mouse button while moving the eyedropper over the photograph. That will bring up the open-circle indicator on the curve but won't lay down a new control point when you release the keys and the mouse.

You can do a lot with Curves to improve the tonality of a print without throwing away any of the highlight or shadow detail. The how-tos describe some basic curve manipulations that accomplish this task, explaining how to add midtone contrast, how to make prints look more brilliant and snappy, and how to lighten or darken a print. Usually you'll use these manipulations in combination; think of them as individual seasonings you might add to a dish in different combinations to give it exactly the flavor you want.

How to change black and white points and avoid clipping with Curves

Remember how I told you to pull back a little bit on the scan and not make it too contrasty, so you didn't accidentally clip off tones? That means that initially your blacks won't really be black but will be a very, very dark gray, and your whites will be fogged (Figure 5-12). At some point in the restoration process you'll fix them to place the "blacks" and "whites" where you want them to be for a good-looking print. Curves can take care of that (Figure 5-13).

Fig. 5-12 The photograph on the left is too dark and too dull. The Curves adjustment in Figure 5-13 turned it into the photograph on the right. The histograms for the before and after photographs are also in Figure 5-13, on the right.

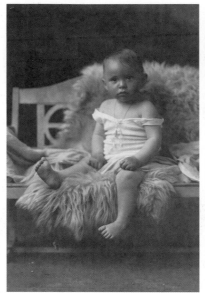 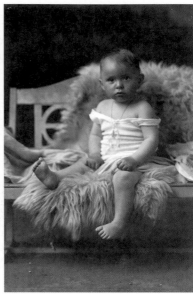

Fig. 5-13 This Curves adjustment increases both contrast and brightness. Moving the endpoints of the curve in raises the contrast. Adjusting those so that the midpoint of the curve is above the center point of the graph makes the photo lighter. Exactly the same result could be obtained with a combination of Brightness and Levels tools. The histograms on the right represent the photograph before and after applying this Curves adjustment. The adjusted photograph makes much better use of the available tonal range than the unadjusted one.

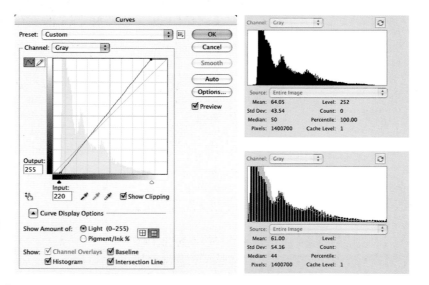

Sneak up on those end points cautiously. You don't want to throw away highlight or shadow detail that you'll need later. It's best to leave the photograph a little too flat and grayish up until just before you want to print it out. Then you can adjust the end points of the curve to place the black and white values exactly where they need to be to give you a full-range print.

To see whether you're accidentally cutting off highlight or shadow detail that you want to retain when you're using the Curves tool, click the Show Clipping box. Clicking the black eyedropper icon will show you what parts of the photograph are being pushed to pure black; clicking the white eyedropper icon shows which pixels will become pure white (Figure 5-14).

If you're working on a color photograph, be aware that Photoshop will indicate clipping when any of the color channels go to 0 or 255. For example, you may get a clipping warning for pixels that are simply highly saturated colors, and that it's often just fine.

There isn't a Show Clipping box in the CS4 Curves adjustment layer control panel. To preview clipping in that mode, select the black or white eyedropper and press the Option key (Alt in Windows).

You'll use the S-shaped curve type of adjustment frequently in restorations. The sense of brilliance in a photograph is primarily controlled by the contrast in the midtones. Snappy midtones keep your final prints from having that flat, "this is a copy" look. A really good restoration doesn't look like a copy; it looks like an original photograph.

Fig. 5-14 The Show Clipping option in the Curves tool displays which pixels will be clipped by that adjustment. Checking this helps you avoid accidentally throwing away shadow or highlight detail.

How to make a print look more brilliant and snappy by adding contrast to midtones with Curves

Figure 5-16 started out with pretty good whites and blacks, so I didn't want to alter those qualities. The simple S-shaped curve in Figure 5-15 markedly increases midrange contrast. It turns Figure 5-16 into Figure 5-17 without altering the values rendered as pure whites and pure blacks and while producing a lot more "snap."

Had I tried to achieve the same level of tonal improvement with the Levels or (worst of all) Brightness/Contrast tool, I would have clipped some of the highlight or shadow tones and entirely eliminated that detail from the photograph (Figures 5-18 and 5-19).

Fig. 5-15 A curve like this one substantially increases contrast and sparkle in midtones without throwing away any highlight or shadow detail. Highlights are lightened and shadows are darkened, but the total tonal range is unchanged.

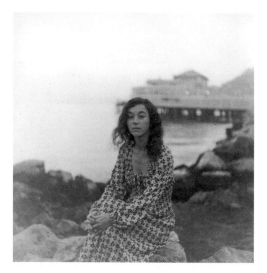

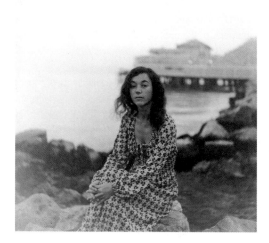

Fig. 5-16 This photograph has a full range of tones from black to white, but it looks dull and lifeless because the midtones lack "snap." The curve in Figure 5-15 fixes this problem.

Fig. 5-17 This is what Figure 5-16 becomes after applying the curve in Figure 5-15. The extreme white and black points haven't changed, but the photograph looks brighter and more alive and contrasty as a result of using that S-shaped curve.

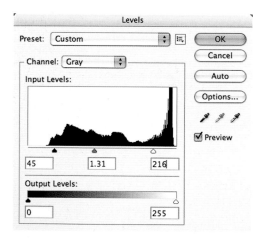

Fig. 5-18 The Levels tool can simulate the tonal changes produced by the curve in Figure 5-15 for the midrange tones, but it can do this only by sacrificing highlight and shadow detail. Curves is much better tool for doing sophisticated adjustments of tonality than Levels.

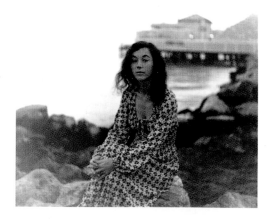

Fig. 5-19 This is the result of applying the Levels adjustment in Figure 5-18 to Figure 5-16. Compare this to Figure 5-17, which was created using Curves. The midtones are not much different in the two photographs, but the Levels adjustment lost highlight detail in the water and shadow detail in the rocks. The seated woman looks similar in both photographs, but the background looks much harsher in this one.

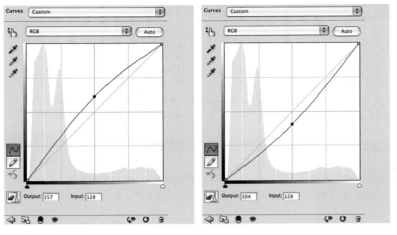

Fig. 5-20 Curves like these don't change the overall contrast or tonal range of a photograph, but they make it look markedly lighter or darker. Raising the midpoint of the curve (top) produces a much lighter, more open-looking photograph. Dropping the midpoint (bottom) makes the photograph darker and more somber in appearance. Figure 5-21 shows how both of these curves affect the original photograph.

Although the woman looks almost identical in Figures 5-17 and 5-19, Curves retains delicate highlight detail in the water and the background that cruder tools wipe out. This one set of tone corrections is enough to make a very satisfactory restoration.

How to lighten or darken a print with Curves

Adding a single midpoint to a curve and raising or lowering it, as in Figure 5-20, will alter the overall brightness or darkness of the photograph. This doesn't change the black or white points, as you can see in Figure 5-21, but it does substantially alter the contrast in the highlights and the shadows. Raising the midpoint compresses the highlights, lowering their contrast and tonal separation. At the same time it increases shadow contrast and makes those tones more clearly visible and distinguishable. Lowering the midpoint has exactly the opposite effect, increasing highlight contrast at the expense of shadow separation.

Fig. 5-21 The original photograph is in the center, between two versions modified by the Curves settings in Figure 5-20. Applying the curves from Figure 5-20, top, opens up midtones and has a more light, airy feel. Applying the curves from Figure 5-20, bottom, instead increases the drama and gives the photograph a more intense and "theatrical" look.

How to bring out shadow tones with Curves

Many faded prints have very poor contrast in the shadows. Even when you restore the overall contrast range of the print (Figure 5-22), you may not have a good tonal separation in the darker areas. The curve in Figure 5-23 fixes that. I restricted the lightening effect by adding adjustment points along the curve to keep it from arcing upward overall. Locking down values near the highlights ensured that they didn't lose any contrast at all. It increases the contrast a lot in the shadows and sacrifices a little contrast in the other tones. It also makes the print appear somewhat lighter overall.

Fig. 5-22 The original photograph (top) has a lot of important subject detail buried in the shadows. The middle to dark tones are a little too contrasty; this is most obvious in the subjects' faces. The Curves adjustment in Figure 5-24 created the lower photograph. A lot more shadow detail is visible, and contrast in the darker midtones is greatly improved.

Fig. 5-23 This Curves adjustment greatly increases the contrast in the deepest shadows and lightens them up to bring out more detail. It does not affect the tonal range of the print, its overall contrast, or the brightness of the highlights. Multiple control points in the middle of the curve keep the midtones and highlights close to their original values.

Now that we've covered some of the basic moves with Curves, let's look at some other tricks for improving tone.

The Shadow/Highlight Adjustment

This could well be the most underrated feature in Photoshop. The Shadow/Highlight adjustment is an amazing (and complicated) control that improves

the contrast and visibility of detail in both highlights and shadows. What makes it amazing is that it can do that without destroying midtone contrast.

Problems can arise when you want to improve both shadows and highlights at the same time. You'd do that with a curve like the one shown in Figure 5-24. This kind of curve shape, called a *reverse-S*, expands the contrast in the highlights and shadows but compresses tones and contrast in the midrange.

Subtle adjustments like this work well. I used a much less aggressive version of this kind of curve to improve Figure 1-2. That photograph is typical of amateur photographs; there's a lot of midrange contrast, and the tones in the highlights and the shadows are pushed toward the black and white. Consequently, highlight and shadow detail is obscured. Almost every amateur photograph suffers this to some degree; somewhat blown-out highlights and blocked-up shadows are practically hallmarks of the snapshot.

Copy photographs also have especially bad tonal separation in the highlights and shadows, where the contrast will be extremely low. It may take strong changes to bring out good shadow and highlight detail. But strong changes like those of Figure 5-24 don't usually produce attractive results. The midtones become so compressed and low in contrast that the print looks flat and lifeless.

By way of example, I applied this Curves adjustment to the slide restoration I did in Example 4 of Chapter 11 (now online at http://photo-repair.com/dr1.htm). When I did that restoration, I chose not to change the overall tonality of the photograph, because I wanted to preserve the original "amateur" quality of on-camera flash in the 1950s (Figure 5-25, left). That was an artistic choice and a completely arbitrary one; I could have just as well decided to give the photograph a more professional look. That would require toning the harsh highlights down and bringing out the details that were lost in the shadows. Curves can do that (Figure 5-25, middle), but look at what happens to the midtones, most obviously in the tablecloth and in the people's faces. They look very flat and artificial, as if someone just painted the tones and colors onto the photograph.

The image on the right in Figure 5-25 shows what miracles Shadow/Highlight can work. The highlights have more details, and the shadows are more open, with better color and saturation than in the Curves-altered version, without destroying the midtones. The faces and the tablecloth look just as lifelike and

Fig. 5-24 This Curves adjustments doesn't alter the total tonal range of the photo, but it increases contrast and separation in both the highlights and the shadows at the same time. In consequence, midtone contrast is reduced. That can make a print look lifeless, as shown in Figure 5-25, so use adjustments like this carefully.

Fig. 5-25 This figure shows how the inverted-S Curves adjustment in Figure 5-24 and the Shadow/Highlight tool improve shadow and highlight detail. The photograph on the left is the unaltered version. The photograph in the middle shows the effect of the Curves adjustment. There's better detail visible in the highlights and shadows, but the midtones look unnaturally flat. The Shadow/Highlight adjustment from Figure 5-26 does a much better job of bringing in highlight and shadow detail without ruining the midtones (right).

natural as they did in the original version, yet somehow the overall contrast of the photograph is moderated. It almost looks like it was lit professionally.

The Shadow/Highlight adjustment can do this because it doesn't blindly apply Curves changes to the entire photograph. It analyzes the tones present in the photograph and selectively works on areas of highlights and of shadows but leaves midtone areas alone. Figure 5-26 shows the adjustment with the settings I used. Separate sets of sliders are used for adjusting the shadows, adjusting the highlights, and maintaining midtone contrast and color saturation.

As I said, this is a complicated control. I'll describe what the sliders do in the next several paragraphs, but don't be surprised if this description is very confusing. The way to understand what this tool does is to play with it and look at how the preview changes when you move the sliders around. The explanation I'll provide will help you figure out why moving a slider has the effect it does, but messing around with this adjustment on your computer is the only way to understand it.

Fig. 5-26 Photoshop's Shadow/Highlight tool does an excellent job of improving tones and enhancing detail in highlights and shadows, almost like dodging and burning in a print in the darkroom. This adjustment was applied to the photograph in Figure 5-25, right. See the main text for an explanation of what the different control settings do.

136

Starting at the top of the Shadows section, there's a slider for Amount. That controls the strength of the adjustment, with 0% being no effect on the shadows at all. In this case I applied a moderate 33% effect to bring out the background detail. The next slider, Tonal Width, controls the range of tones over which the effect is applied. Set it near 0% and only the tones very close to the darkest ones will be affected. Set it near 100% and almost all the tones in the photograph will be lightened.

The last Shadows slider, Radius, controls how wide an area the adjustment samples to determine what range of tones to correct. This is the part that is smart enough to figure out how to leave the midtones alone. The adjustment takes into account all the tones within a radius to find out which ones are the shadow tones that should be adjusted.

The Highlights sliders work the same way. The only difference is that the highlight tone width is measured starting from white and working down, instead of from black and working up. Most often you'll apply only a very small amount of highlight correction. The 13% I used results in a pretty potent effect.

The last set of controls ensures that the shadow and highlight adjustments don't make the image look too dull. The Color Correction slider controls the saturation in the areas being altered. It doesn't have any effect if you're working on a B&W photograph. Midtone Contrast does about what you'd think—it's a way to control how snappy the print looks in the midrange. To some degree, it counteracts the effect of the Shadows and Highlights adjustments, so use it sparingly. If you get good at setting the Shadows and Highlights sliders, you'll need to make only very slight midtone contrast corrections. The Midtone Contrast slider is useful for fine-tuning the look of the photograph after you've set the shadow and highlight corrections.

How to improve snapshots with the Shadow/Highlight adjustment

Figure 5-27 shows a typical use for the Shadow/Highlight adjustment to correct this snapshot from 1970. The settings I used are shown in Figure 5-28, and they would provide a good starting point for many amateur snapshots. I've circled the three settings that are different from Photoshop's default settings. Because I was primarily interested in improving the highlight detail, I pulled back the shadow amount to 17% and turned the highlight amount up to 15%. I boosted the contrast in the midtones by nine points so they have a little more clarity. That's how little it took to produce the marked improvement you can see in this photograph. This level of improvement in family snapshots would make many clients very happy.

Fig. 5-27 Amateur snapshots are often contrasty, with poor detail in the highlights and shadows. The Shadow/Highlight adjustment from Figure 5-30 greatly improves this photo's tonality (bottom).

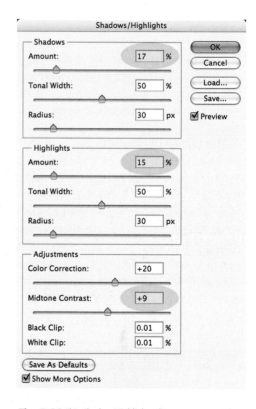

Fig. 5-28 This Shadow/Highlight adjustment was used to improve the photograph in Figure 5-29. All the control settings are the default ones except for those that are circled. Their function is explained in the main text.

How to Improve a Copy Print

Copy photographs like the one in Figure 5-29a usually have poor tone separation (you'll also see that in a very severely faded photograph). Ignoring the matter of repairing the physical damage, what will most improve this photograph? The histogram in Figure 5-30 shows that the print lacks good whites and blacks. Looking at the print itself, it's very clear that tonal separation is weak in both the highlights and the shadows.

The curve in Figure 5-31 is the most straightforward fix. I've pulled in the white and black points so that the photograph has some true whites and blacks. Then I added control points that gave the curve a reverse-S shape that increased contrast in the highlights and shadows in exchange for some midtone contrast. That produced Figure 5-29b, which is much improved over the original.

Fig. 5-29 There are several ways to improve a copy photograph, like the one in (a). You can use Curves (b), the Shadows/Highlight tool (c), or a combination of the two (d). My personal favorite is (d), but they're all good.

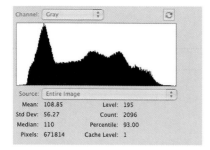

Fig. 5-30 This is the histogram for Figure 5-29a. The blacks should be a little darker, and there's a very pronounced lack of bright highlight detail.

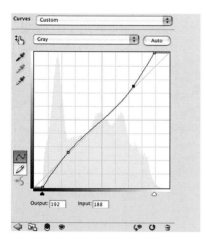

Fig. 5-31 This Curves adjustment produced Figure 5-29b. I pulled in the endpoints of the curve to make the blacks blacker and the whites whiter, increasing the overall contrast of the photograph. The two other control points on the curve increase the contrast of the highlight and shadow detail at the same time that they bring the midrange contrast back to normal. This curve adds a lot of tonal separation to the highlights and shadows without making the print look too harsh overall.

Still, I wouldn't mind opening up the shadows more and restoring some of the lost midtone contrast. That's a job for the Shadow/Highlight adjustment. There are ways in which I like that a lot better, but overall the photograph now feels "busy" to me; it has lost too much visual focus. Maybe I did too good a job of equalizing contrast over the entire tonal range.

How to improve a copy print with the Shadow/Highlight adjustment

Copy prints frequently have poor contrast in the highlights and shadows, which makes Photoshop's Shadow/Highlight adjustment a good choice to revive them (Figure 5-32). Because the shadows in Figure 5-29a needed only a modest boost, I throttled back the shadow amount to 20%. Then I added a 6% highlight amount to keep them from getting blown out. Last I increased the midtone contrast by a substantial 28 points to give the photograph some real snap. That gets me Figure 5-29c, a big improvement.

ContrastMaster, the Photoshop plug-in I reviewed in Chapter 3, "Software for Restoration," seems like a logical tool to try on this photograph. After all, the big problem with copy prints is that they look flat and lifeless; the tonal nuances of the original get lost in the copy process. As you can see in Figure 5-36, it did a pretty good job on this print.

How to improve a copy print with ContrastMaster

This plug-in is good at bringing out local tonality and contrast, and that's where copy prints fall flat (literally). Figure 5-35 shows the control panel settings I used to get the result you see in Figure 5-36. I left the individual settings for the three different contrast effects (Dynamic, Adaptive, and Local) at their default values. I played around with the mix until I got a result that looked pleasing. Not too surprisingly, there is only a little bit of Dynamic adjustment in there; overall, the contrast and tonal placement within the photograph isn't too bad. The Adaptive and Local contrast

changes do a lot more to bring out textures and subtle tonal differences, and that's what most needed improvement, so my mix favored them.

The direct effect of this control panel was way too strong, so I adjusted the Fade slider to reduce the strength by 60%. I could also make such a change by leaving the plug-in at full strength and using the Edit/Edit/Fade... control in Photoshop to reduce the strength of the plug-in.

Not so incidentally, a more flexible and less destructive approach would be to copy the photograph into a new layer, apply the plug-in to that layer, and use the Blend slider in that layer to mix in the amount of the plug-in's alterations that I wanted. This would avoid irrevocably changing the original and preserve the option of changing the strength of ContrastMaster's effect later.

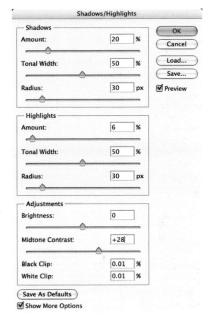

Finally, I tried a mixed tack for equalizing contrast. Starting with the original, I applied the curves from Figure 5-33. This is just a straight overall contrast increase; I pulled in the white and black points to increase the density range in the photograph, but I didn't reshape the curve to alter the relative contrast of the highlights, midtones, and shadows. Then I applied the Shadow/Highlight adjustment shown in Figure 5-34. This opened up the shadows and toned down highlights just a little bit. Since I hadn't flattened out the midtones with the curves, I didn't need to increase their contrast very much. The result is Figure 5-29d. Personally, this is my favorite of the versions. There's room for further refinement, but for many clients you could stop right here; this is a good-looking photograph.

Why did I bother including the other three versions here if this is the one I like best? Because they're all good; they merely appeal to different tastes. This harks back to points I made in Chapter 1: First, good restoration is about art and aesthetics, about constructing the image that looks like a good photograph to you, not just mechanically correcting errors. Second, there's value in playing around. Trying out different settings and controls to see

Fig. 5-32 This Shadow/Highlight adjustment produced Figure 5-29c. The overall tonality is not a lot different, but there's a better sense of separation and detail throughout the tonal range, even in the midtones. Note the hefty boost to Midtone Contrast (+28 points) in the control settings; that's what keeps the snap in the midtones.

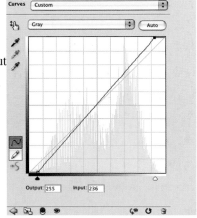

Fig. 5-33 I applied this Curves adjustment to Figure 5-29a as the first stage in producing Figure 5-29d. This curve causes a modest contrast increase and makes the blacks a little darker and the highlights a little whiter.

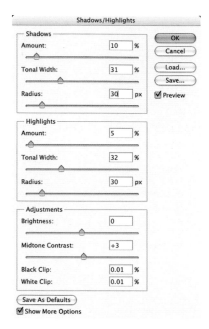

Fig. 5-34 This Shadow/Highlight adjustment takes the photograph that resulted from the Curves adjustments made by Figure 5-33 and yields Figure 5-29d. Notice that there's only a slight Midtone Contrast increase; that's because the previous Curves adjustment took care of most of the overall contrast change needed. The Shadow/Highlight adjustment kicks up the detail in the highlights and shadows just enough to make the resulting photograph look like an original print instead of a copy print.

what they get you is the best way to get to the photograph you really like. Single-mindedness is not a virtue.

How to Correct Uneven Exposure

The photograph in Figure 5-37 is not badly faded, but it was very badly made! Aside from the usual low-contrast printing typical of B&W photofinishing in the mid-20th

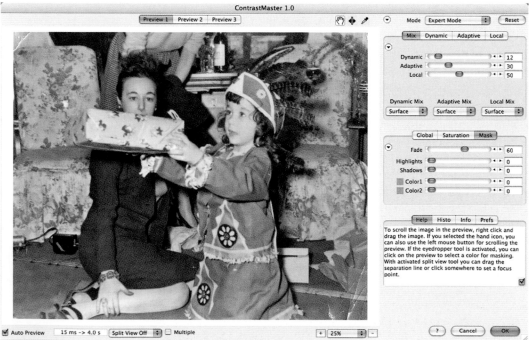

Fig. 5-35 ContrastMaster's elaborate controls will take time to master, but it's worth the trouble.

century, it was improperly exposed. The flash sync on the camera was set incorrectly, so only the right side of the picture got good flash exposure.

The easiest and best way to correct uneven exposure like this is with a Curves adjustment layer combined with a mask to control what parts of the picture are altered.

In older versions of Photoshop, create an adjustment layer by going to the Layer menu, selecting New Adjustment Layer from the drop-down menu, and picking the kind of layer you want to create (Curves, in this case). In Photoshop CS4, you can also do this by clicking the Curves icon in the Adjustments window.

While creating the Curves adjustment layer, I didn't make any curve changes. When the Curves tool opened, I merely clicked OK. I did that because I wanted to first create a mask for that layer so that the properly exposed part of the picture wouldn't be changed. That way, when I experiment with different curve settings to correct the left side of the photograph, I can see how well I'm matching the right side.

The advantage of doing all this with an adjustment layer and a mask is that I don't have to get this correct on the first try; I just have to make a usefully close guess. If I discover that the gradient won't give me the uniform exposure correction I'm after, I can modify or replace the gradient in the Curves mask channel. Similarly, I'm not making irrevocable Curves adjustments; I can fiddle with them until I'm convinced I've really eliminated the exposure problem.

How to correct uneven exposure with a Curves adjustment layer

I set the foreground and background colors to white and black and selected the Gradient tool (Figure 5-38). I chose "Foreground to Background" as the gradient type and checked to make sure that the linear gradient button was pressed, the mode was normal, and the opacity was at 100%.

I created the gradient in the Curves mask channel by drawing a horizontal gradient line from left to right, starting near the boy's arm and extending to under the baby girl's nose. That was my best guess of where the exposure fall-off began and ended (Figure 5-39). The black area on the right side of the gradient is completely masked off (Figure 5-42, top); there the adjustment layer will have no effect. As the gradient fades to white, the effect of the adjustment layer increases until it operates at 100% strength for the left portion of the picture. Now I'm ready to correct the exposure.

I didn't do anything fancy to come up with the adjustment layer's curve in Figure 5-40. I just moved in the white point until the highlights looked about the same at both ends of the photograph in the preview. Then I dragged in the black point until the shadows looked

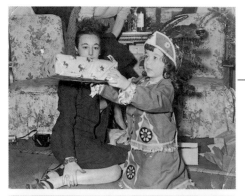

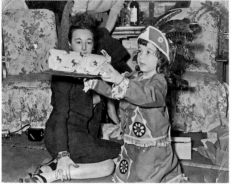

similarly dark. That left the midtones on the left side a little too dark, so I added a center point to the curve and raised it up a bit to lighten those tones so that they matched on both sides of the photograph.

Fig. 5-36 A copy print before (top) and after (bottom) the application of ContrastMaster, using the settings shown in Figure 5-35.

Figure 5-41 shows the results of my efforts. My first attempt at a gradient mask turned out to be pretty good. There's a slightly darkened band between the two girls where the Curves adjustment wasn't quite strong enough. I fixed that by lightening up the mask along a vertical band in that area. I just painted white into the mask with a wide-radius airbrush set to 5% opacity— nothing fancier than that.

It was only a slight correction; Figure 5-42 shows the original gradient mask in the top half and the airbrushed mask in the bottom half. The alteration is so subtle, in fact, that I'm not attempting to reproduce the difference it made to the photograph in the pages of this book. I bring it up only to illustrate the level of refinement that's easily achievable when you use these kinds of masks.

Figure 5-43 isn't anywhere close to being a finished restoration. Overall the tonality is bad, and the huge contrast increase I did to the left side of the photograph

Fig. 5-37 This photograph is an amateur's mistake: The camera's flash synch was incorrect, so only the right side of the photograph got a full flash exposure. I can fix this with a masked Curves adjustment layer.

Fig. 5-38 Making a gradient mask for the adjustment layer for Figure 5-39 isn't difficult. Set the foreground and background colors to white and black, select Foreground to Background from the gradient options, and draw a line with the Gradient tool across the photograph from where you want the gradient to where you want it to end (Figure 5-39).

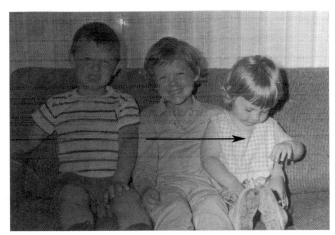

Fig. 5-39 I estimate that the flash fade-out starts just under the littlest girl's nose and ends on the right side of the older girl. Drawing a line with the gradient tool from left to right between those points produces the gradient mask shown underneath the photograph.

Fig. 5-40 This adjustment layer curve turns Figure 5-37 into 5-41. It greatly increases the contrast in the underexposed parts of the photograph and changes the dim grays into light highlights.

Fig. 5-41 With the masked Curves adjustment layer, the illumination is much more even; there is still a bit of a darker band between the two girls.

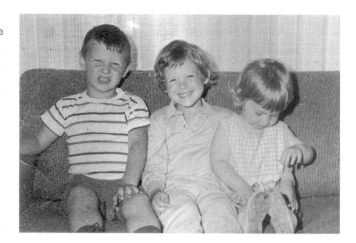

Fig. 5-42 Masks are modifiable! To get rid of the dark band between the two girls in Figure 5-41, I dodged the original mask (top) to lighten it up in that region (bottom). That increased the strength of the adjustment layer there, which eliminated the dark band.

enhanced defects like paper texture and cracks. Considerable work would be needed to turn this into a good restoration, but evening out the exposure was the critical first step.

By the way, this is a good example of a photograph that must be scanned in 16-bit mode. The contrast adjustment I made to the left side of the photograph threw away almost two-thirds of the value range. Expanding an 8-bit image's contrast by a factor of three would have produced very visible and unacceptable contours.

How to Repair Uneven Density: Dodge and Burn with Masked Adjustment Layers

It's not much of a conceptual leap from using gradient masks to control local photograph densities to using any kind of mask, including hand-painted ones.

Hand-painted masks are uniquely valuable because they let you apply correction effects exactly where you want them. The effect can be as broad as half a photograph or as narrow as a single pixel; it's just a matter of what radius brush you use to paint the mask with.

You can apply any kind of Curves alteration you want this way, but I'm going to concentrate on the two most useful ones. I call them *dodging* and *burning-in* masks (and layers) because they produce effects a lot like those of dodging and burning in when doing darkroom printing. Unlike darkroom printing, however, you can have as many different dodge and burn-in effects going on as you want by creating a new adjustment layer for each particular flavor of alteration you want to make.

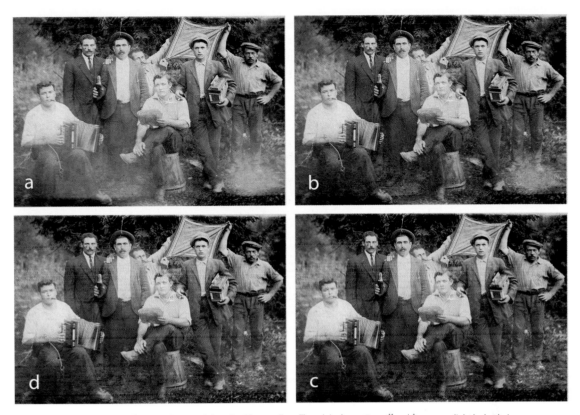

Fig. 5-43 (a) shows a scan of a poor photograph I received from a client. The original negative suffered from some light leaks during exposure, so this photograph has large washed-out spots in the lower half that reduce contrast and ruin the shadows. Dodging and burning in Curves adjustment layers, explained in the main text, are the keys to repairing this damage. (b) was created by a burn-in adjustment layer that used the Curves and mask shown in Figures 5-44 and 5-45. (c) adds a second burn-in adjustment layer that used Figures 5-46 and 5-47. (d) incorporates a dodging adjustment layer using Figures 5-48 and 5-49.

Even better, any dodging or burning in you do is reversible. If you find you've overdone the correction at some point, just paint over that part of the mask with a black brush to reduce or eliminate the change there. In other words, this requires no painterly skills. The better you are with wielding a (digital) brush, the more efficiently you'll be able to do this, but you can erase or rework any mistakes you make, so you'll always be able to get there bit by refined bit.

(There is a common method for doing this that uses a soft-light blended layer. It's convenient and easy to implement. I don't like it as well because it doesn't give me the flexibility and control I get from customizing my own dodging and burning-in effects. Still, that technique has its adherents, so I describe it in the next section. I'm just not recommending it for really sophisticated work.)

Good dodging and burning-in curves are hugely exaggerated versions of the kinds of basic curve corrections I talked about earlier in this chapter. They're intentionally super-strong so that you can paint them into the layer mask with a low-opacity brush, building up the changes you want, stroke by stroke, in a controllable way.

The photograph in Figure 5-43a is a good candidate for burning in and dodging. The original negative was apparently light-fogged. Large parts of the lower half of the photograph are washed out and pale, although low-contrast detail is visible in those areas. I fixed this photograph using a total of four adjustment layers that dodged, burned in, and made local contrast enhancements to the photograph.

How to do dodging and burning in with masked Curves adjustment layers

To burn in the image in Figure 5-43a, I created a Curves adjustment layer with the curve shown in Figure 5-44. This extreme correction greatly increases the contrast and density of any tones below light gray. I designed this curve to produce such a strong change that it could fix the flare problem in all but the worst spots. It doesn't matter that it's too strong for most of the photograph, because I'll be painting in the adjustment only where I want it at the strength I want.

Next, I inverted the layer mask to make it black instead of white. I selected the Brush tool and gave it a radius about two-thirds the size of the largest areas I wanted to burn in. I set the opacity of the brush to 12%; I've found that values between 8% and 15% work best for doing dodging or burning in. I did not turn on the mask layer visibility. There's no need to see what the mask layer looks like, only the effect of the brush on the photograph.

I made a couple of passes at the mask layer with the large-radius brush to dampen the overall flare. Then I switched to a smaller radius brush and started filling in the places the large radius brush had missed. When that was close to correct, I switched to an even smaller-radius brush to touch up the areas that still needed to be toned down. If I went too far and made an area too dark, I switched the brush from white to black and painted some of the mask back in to reduce the overadjustment in that area.

I find that working back and forth between black and white brushes like this and shrinking the radius of the brush as I refine the adjustments is a very efficient way to do this kind of painting. I think this is just my style, though. If you want to take a different approach to painting in the mask, do whatever feels most comfortable and efficient for you.

Only a few minutes' work got the photograph to the point shown in Figure 5-43b. The burn-in mask is shown in Figure 5-45. It looks strange, doesn't it! Still, it does the job and does it well.

I created the first adjustment layer, one designed to burn in the worst of the flare, as I describe in the sidebar. It yielded Figure 5-43b. Following the same general procedures, I created a second burn-in adjustment layer to deal with the flare patches that the first layer didn't entirely fix, mainly a flare spot at the lower-right

Fig. 5-44 This Curves adjustment has little effect on the highlights but substantially darkens everything else. It's strong enough to correct the near-worst of the flare when applied at 100%.

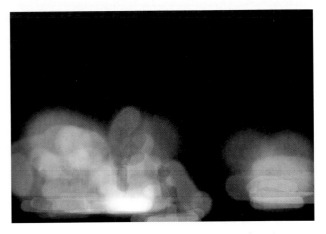

Fig. 5-45 This is what the burn-in mask looks like for the Curves adjustment layer I created from Figure 5-44. It eliminates almost all the flare on the left and about half the flare on the right in Figure 5-43b.

Fig. 5-46 This is the Curves adjustment for the second burn-in layer. It works much like the first burn-in layer except that the lighter tones have been pushed toward white to increase the contrast everywhere in the tonal scale.

Fig. 5-47 This burn-in mask produced Figure 5-43c. It corrects the flare and light leaks that remained after applying the first burn-in layer.

corner of the photograph. I assigned that layer the curve in Figure 5-46. It darkens most of the tones but also greatly increases contrast in the lighter areas, so it could make the flare spots both darker and more contrasty and even improve the whites a bit. The burn-in mask in Figure 5-47 got me to Figure 5-43c.

Next, I needed to do some dodging along the lower edge of the photograph where there was a very dark strip. I created a third adjustment layer with the

Fig. 5-48 This is the Curves adjustment for the dodging layer that I used to correct a band of underexposure at the bottom of the photograph. It increases the brightness of all tones by a factor of three.

Fig. 5-49 I used this dodging mask to touch up small parts of the bottom of the photograph and eliminate the band of darker exposure there. The result is Figure 5-43d.

curve in Figure 5-48. This curve leaves the black point unchanged but extremely lightens everything else. When I was done dodging the dark areas that needed correction, shown in the mask in Figure 5-49, I had Figure 5-43d.

That finished the technical correction I set out to make. I still saw room for improvement. Dodging and burning-in layers are useful for artistic work as well, just as darkroom dodging and burning in are. They're a much better tool for artistic control than the simple, crude Dodge and Burn tools built into Photoshop, as my final corrections demonstrate.

In Figure 5-43, I felt that several of the faces and the white clothing were too washed out. I wanted to increase their contrast and make them darker, but I didn't want the highlights to go gray. In fact, I wanted the highlights to be a little brighter.

How to improve contrast and highlight detail with a masked Curves adjustment layer

I created my final masked correction layer with the curve in Figure 5-50. Although I instinctively tend to think of this as burning in, because overall it makes the faces look darker, it really is unlike ordinary burning in. Most of the tones are darkened, it's true, but the near-whites are substantially brightened because I dragged the white point in from a value of 255 to 227. So, at the same time that I'm burning in the highlights, I'm also improving their contrast and preserving whites. The mask I painted for this layer is shown in Figure 5-51.

Fig. 5-50 This curve controlled the mask adjustment layer I created to produce Figure 5-52. It performs several corrections at once: It increases the contrast in the faces, darkens the shadows on them, and increases separation and modeling in their highlights.

Fig. 5-51 Here's the mask for the final adjustment layer using the Curves adjustment in Figure 5-50.

After another few minutes' work, I had the mask shown in Figure 5-51 and the corrected photograph shown in Figure 5-52. The dodging and burning-in layers have completely corrected all the unevenness in the original photograph. This is not a fully restored photograph by my perfectionist standards. The overall tonal and contrast characteristics are not exactly what I would want in a perfect print. But I can assure you that many clients would be delighted to have a restoration of this quality.

Soft-Light Dodging and Burning-in Layers

You can directly paint dodging and burning-in effects into a simple soft-light blended layer. Personally I don't use this much, because it doesn't give me the level of control I want over just how dodging and burning in is happening to the photograph. That doesn't mean it's a bad approach; I just think mine is better. Soft-light's big advantage is that it's a much simpler approach than mine. If you found the whole business of doing dodging and burning in with adjustment layers, masks, and custom curves somewhat overwhelming, give this method a try. You can't ask for a simpler nondestructive way to do dodging and burning in.

How to dodge and burn with a soft-light layer

Start by clicking Layer/New… to create a new empty layer. In the options panel that appears, give that layer a name, like "dodge & burn." Then select Soft Light as the Mode from the drop-down

list, check Fill with Soft-Light-neutral color, and click OK. There will be a new gray layer above the image layer, but the photograph won't look any different. That's because soft-light blending mixes in the layer in an unusual way: If the layer is middle gray, it has no effect on the underlying photograph. Wherever the layer is lighter than middle gray, it lightens the underlying photograph. Wherever it's darker than middle gray, it darkens it.

To dodge and burn with this layer, use black and white paint brushes. Set the brush opacity to a low level like 10% or 20%. Paint into the soft-light layer with a white brush to dodge and a black brush to burn in the photograph. Build up stronger effects by painting over the same area repeatedly. Painting with middle gray wipes out the effect. Here's a handy trick: The D key sets the foreground and background colors for the brush to black and white, and the X key swaps them whenever you need to switch from dodging to burning in, or vice versa.

Enhancing Almost-Blank Photos

The half-century-old color print shown in Figure 5-53 is the most badly faded photograph I've ever worked on. Although there is considerable shadow density, the midtones and highlights have almost completely disappeared. This is also apparent in the scanner software histograms (Figure 5-54), which show that most of the tones fall into a huge peak near the highlights.

The first step in recovering information from a photograph like this is making the scan. Because I'll need to make truly radical changes to the tonal distribution to produce a good restoration of this photograph, a 16-bit scan is a must. I set the Levels controls in my scanner software to maximize the range of values in the file, which got me Figure 5-55. It's still bad, but now at least I could make out some more detail in the baby and the crib. Because tones were so lacking and

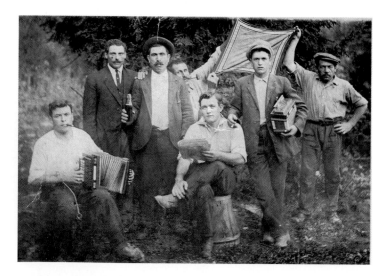

Fig. 5-52 The photograph after complete tonal correction with four dodging and burning-in adjustment layers. The light leak and exposure problems are almost completely repaired; you can hardly tell that the bottom half of the original photograph was badly fogged. This job is nearly ready for damage repair.

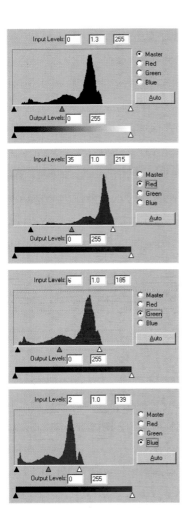

Fig. 5-53 This 55-year-old color snapshot is yellowed and faded to the point of near-invisibility.

Fig. 5-54 The scanner software histograms for Figure 5-53 confirm the overall fading problem but indicate that there is still information in the faded areas, as shown by the broadened peaks to the right in the histograms.

Fig. 5-55 A new scan of the snapshot using the Levels settings from Figure 5-54 shows much more detail in the baby and the crib. This photograph may not be a hopeless case.

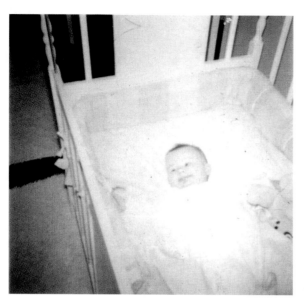

Fig. 5-56 Running the photograph in Figure 5-55 through the Digital ROC plug-in restores even more detail and brings the faint beginnings of correct color to this photograph.

badly distorted, I felt it necessary to do some color correction before I made major changes in the tonal distribution, or I'd risk losing data from the most badly faded red channel. Running the photo through DIGITAL ROC (see Chapter 6, "Restoring Color") got me to Figure 5-56. Neutrality was restored, but the photograph was still extremely faint.

I have two approaches for handling images like this. The first is, as usual, Curves. I created the curve in Figure 5-57 for this photograph. It's an unusual curve for photo restoration; I gave three-quarters of the darker tones very low contrast so that I could greatly exaggerate the density range in highlight tones. I moved the white point in a bit to eliminate the residual highlight stain.

The resulting photograph, Figure 5-58a, could not remotely be considered a good photograph. A lot of work needs to be done to turn this into an acceptable restoration (see the examples online at http://photo-repair.com/dr1.htm for a description of how I completely restored this photo). What's important, though, is that a good scan and a serious dose of Curves were sufficient to turn nearly blank photographic paper into a recognizable, acceptably detailed image.

How to recover a nearly blank photograph with Multiply blends

Good scans and curves are techniques you can use with any image processing software, but Photoshop provides another way to enhance faint images. It's the Multiply blend mode. Take an image, duplicate the layer, and set the new layer's blend mode to Multiply. You'll see a marked increase in contrast and density.

I did this to the photograph from Figure 5-56 and got Figure 5-58b. In some ways it's not quite as good as Figure 5-58a. Multiplication didn't produce as much enhancement of the highlight detail. On the other hand, there is less color distortion in the multiplied version, especially in the midtones and shadows.

For extreme highlight recovery, multiply more than two layers together. I took Figure 5-58b, duplicated the base layer again, and blended it in multiply mode. That produced Figure 5-58c. Now there's a decent range of densities, but color distortions, noise, and defects are similarly amplified. It will take a lot of work to clean up this photograph.

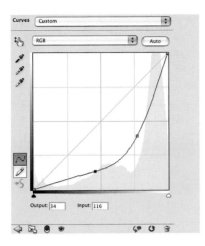

Fig. 5-57 This Curves adjustment turns Figure 5-56 into Figure 5-58a. The curve drastically darkens the highlights and midtones, and it increases contrast in those tones by a factor of four.

Fig. 5-58 There are many ways to intensify detail in a faded photograph. All the photographs here are derived from Figure 5-56. (a) is the result of applying the Curves adjustment in Figure 5-57. To create (b) I took Figure 5-56, duplicated the background layer, and blended it in using the Multiply mode. I produced (c) by making two duplicate layers and blending them both in using Multiply. (d) is the same as (c) except that I desaturated the second duplicate layer, so I was multiplying luminosity but not color.

Here's a very useful variant on the last trick. I kept the new layer as a multiply blend, but I desaturated that layer. In effect, that only multiplied the luminosity. That eliminated some of the color distortions at the cost of reduced saturation (Figure 5-58d). Sometimes this would be an acceptable trade-off. Luminosity multiplication is a good technique to remember when you want to exaggerate or enhance the tonal scale without doing the same to the color values.

Making Extreme Tone Changes Without Distorting Colors

RGB (red-green-blue) color space is the normal working mode for digital photographers and printers. It is so universally used, in fact, that this book takes it for granted that you'll be doing your work in RGB space. Tone corrections in RGB space, though, can have unwanted side effects when you're working on color photographs.

Problems show up because there's no such thing as pure "brightness" in RGB space; light and dark tones are made up of combinations of red, green, and blue. When you alter brightness, contrast, and tonal placements by manipulating the RGB curve, you're really manipulating those individual color values. For that reason, extreme changes in tonal placement and contrast will distort the colors in your photograph. Increases in contrast also increase color saturation; decreases in contrast reduce color saturation.

Figure 5-59a shows a photograph that was very low in contrast but still had reasonable amounts of color. I applied the RGB curve in Figure 5-60 to improve the tonal scale and return some true whites and blacks to the photograph. The result, Figure 5-59b, has good contrast but very unpleasant color. The great increase in contrast I desired resulted in a very undesirable increase in color saturation, to the point of garishness.

How to improve contrast without making colors too saturated

If you convert the photograph to Lab space, you can work on the Lightness channel (that's what the L in Lab stands for; I discuss Lab space in more detail in Chapter 6, "Restoring Color") with Curves and other tools, without altering colors. Unfortunately, that space isn't an intuitive working space for most photographers, so there's not much that you're likely to want to do there, but it's occasionally useful. The CurveMeister2 plug-in (reviewed online at http://photo-repair.com/dr1 .htm) lets you do manipulations in a number of different color spaces, including Lab, and it makes dealing with these nonintuitive spaces easier.

Photoshop offers two ways to get some of the benefit of Lab space without having to deal with it directly. The first way is to do your Curves correction in an adjustment layer and set the blending mode to Luminosity (Figure 5-63). That behaves similarly to making the corrections in Lab space. You can make extreme curve adjustments that radically change brightness and contrast but have little effect on colors.

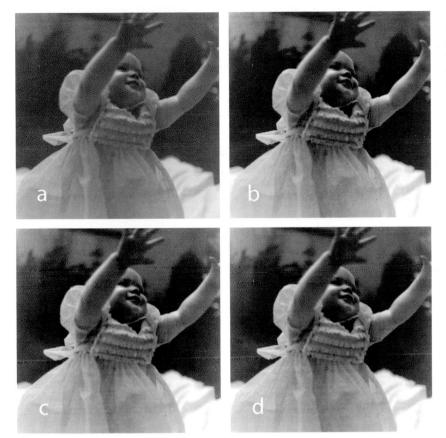

Fig. 5-59 Increased contrast usually means increased color saturation, but there are ways to control it. (a) has pretty good color but very low contrast. (b) The Curves adjustment in Figure 5-60 satisfactorily increases the contrast, but it makes the colors garish. (c) To increase contrast but not saturation, use the Edit/Fade command after applying Curves. Change the Fade Mode to Luminosity, as in Figure 5-61. (d) Use the Hue/Saturation tool to produce the degree of saturation you want, as in Figure 5-62, after you've made a Curves Luminosity Fade adjustment.

The second way to do this is to use the Fade command that's under the Edit menu. The Fade Control Panel contains a Mode box (Figure 5-61) that has a drop-down menu, just like the blending options for adjustment layers. I turned Figure 5-59b into Figure 5-59c by using the Fade command with the Opacity strength left at 100% but the Mode changed to Luminosity. That converted the effect of the curve from its normal one to only affecting brightness.

I created Figure 5-59c by doing a luminosity Fade on the Curves adjustment I made to get to Figure 5-59b (see the sidebar for details). Figure 5-59c had good tonal values, but I felt it was a little bit too undersaturated. I corrected that with the Hue/Saturation control (Figure 5-62), which increased saturation by 14 points. That got me Figure 5-59d, which is a nice combination of greatly improved contrast and moderately increased saturation.

Fig. 5-61 The Edit/Fade command can be used to change the blending mode of adjustments you make. Here I use it to change the Curves adjustment in Figure 5-60 to a pure Luminosity adjustment so that it increases the contrast but doesn't change the saturation of Figure 5-59c.

Fig. 5-60 This Curves adjustment produces good tonality in Figure 5-59b. I've moved the endpoints in to increase overall contrast and create some good whites and blacks. Control points in the middle raise the curve and make the midtones lighter. This curve also undesirably increases the saturation in the photograph.

Fig. 5-62 This Hue/Saturation adjustment adds just the right amount of color emphasis to Figure 5-59d.

Fixing Harsh Shadows on Faces

Most photo restoration requires increasing the contrast of the photograph. Unfortunately, that usually doesn't flatter people's faces. The original photograph, especially if it was an amateur snapshot, may have had pretty harsh contrast to begin with. If it was also printed poorly, as many old photos were, restoring the blacks and whites to their full richness will produce some very harsh skin tones. They will need corrective surgery before you'll be able to make an attractive print.

Figure 5-63a was a commercial portrait that wasn't badly faded; rather, the print was badly made, so it was very low in contrast to begin with. The good news is that, because the print densities were undamaged, all it took to get a full-range photograph was careful scan settings (Figure 5-64) and a small amount of Curves adjustment in Photoshop. That yielded Figure 5-63b, which has a nice range of tones from black to white.

Technically it's quite satisfactory, but it's not particularly attractive. The original lighting in the photograph was too directional and came from too high an angle. When the child leaned forward, the shadows fell harshly on her face. Happily, there are many ways to improve this situation, as the sidebars explain.

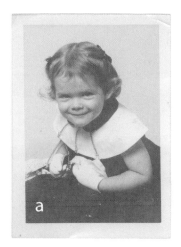
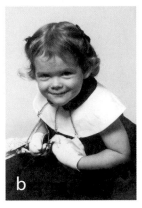

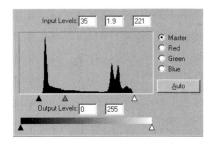

Fig. 5-64 The scanner software histogram and Levels settings for Figure 5-63. I set the black and white endpoint sliders to tightly bracket the range of tones in the histogram, producing good blacks and whites. I adjusted the midtone slider way to the left (a value of 1.9) to lighten up the skin tones and bring out more detail in the shadows.

Fig. 5-63 (a) This early 1960s portrait was printed badly, so it is very flat and lacking in contrast. A good scan (b), using the scanner settings in Figure 5-64, restores a full range of tones to this photograph.

The Shadow/History adjustment, the History Brush, and a masked Curves adjustment layer are all good ways to fix this problem.

How to fix harsh shadows on faces

The Shadow/Highlight adjustment lightens shadows, and that reduces their harshness. I applied the Shadow/Highlight adjustment (Figure 5-65) to the corrected photograph in Figure 5-63b to get Figure 5-66a. Because I didn't increase the midtone contrast in the adjustment, it softened those tones. In combination with slightly opening up the shadows and substantially reining in the highlights, this adjustment improved the face quite a bit.

Another way to fix the face is the good old Dodge tool. It only takes a few strokes to turn Figure 5-63b into Figure 5-66b. I set the radius of the tool to about the width of the child's lips with the hardness at 30% (a fairly soft edge). I set the range for midtones and the exposure to 12%. Anywhere there was a dark shadow on the child's face I dodged it with this brush. Specifically, I ran the brush under her eyebrows and across the bridge of her nose, over her eye sockets, and along the bags under her eyes. I also clicked the brush a couple of times in the whites of her eyes on either side of the pupils to bring them out a bit more.

Next I ran the brush over the "muzzle lines" running from her nose down to the corners of her mouth. I dodged just under her lower lip and along the

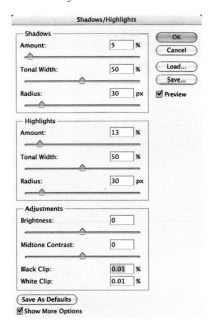

Fig. 5-65 The Shadow/Highlight tool does a great job on Figure 5-63b, producing 5-66a. I set the Shadows Amounts to 5%, which brought out a bit more detail in the hair and the dark dress. I set the Highlights Amount to 13%, which toned down the highlights a lot and created much more detail. I left the Midtone Contrast alone, which softened the skin tones and made the light on the girl's face less harsh.

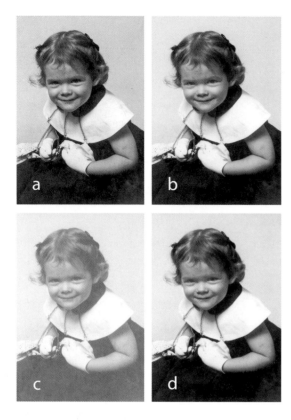

Fig. 5-66 (a) Applying the Shadow/Highlight adjustment in Figure 5-65 to Figure 5-63b produces a much more attractive photograph, with better shadow and highlight detail and more flattering skin tones. (b) The Dodge tool does a good job of removing harsh shadows and lines from faces and opening up eye sockets and brightening eyes. A few minutes' work with that tool turned Figure 5-63b into this photograph. (c) I made this "dodging print" (see the main text for details) using the Curves adjustment in Figure 5-67. (d) I assigned the History Brush to the "dodging print" and used it to paint out the harsh shadows in the photograph. This is a more versatile approach than using the simple Dodge tool.

darkest shadows under her cheeks to soften them up. That's everything; it's not much! You don't have to completely rework a face to soften its look; just tackle the darkest and most contrasty spots, and you'll see a big improvement. A *very* light touch is what keeps the face looking natural.

How to use the History Brush as a dodging tool

When the dodging tool seems too crude and unresponsive, there's a better way: Use the History Brush as a customized dodging tool. I applied the curve shown in Figure 5-67 to the portrait and got Figure 5-66c. All those harsh shadows have been grayed out (along with everything else in the photograph). I assigned that state to the History Brush and reverted to the original portrait. Now I could use the History Brush to paint in that softening effect.

I set the brush to an opacity of 9% so that I could work the effect in controllably, with each stroke of the brush slightly lightening the shadows. I worked over the same areas with the History Brush that I had with the dodging tool to get Figure 5-66d.

The advantage of using the History Brush is that it's easy to customize the effect of the brush to alter tones exactly as you want. For example, if the portrait had also had harsh, blown-out highlights, I could have pulled down the white point on the curve to a light gray and had a brush that would both lighten shadows and darken highlights automatically.

Using the History Brush as a dodging tool also lets you visualize what the effect will be. Before reverting the history state to its pre-Curves condition, you can duplicate the modified image and keep it on your desktop as a reference. That way, when you're working with the History Brush, you can always see which direction it will be pushing the tones and how far it can push them. For maximum control, use a masked dodging layer, as I explain on starting on page 146. This method has the advantages of using the History Brush along with being completely reversible.

How to retouch faces with a masked Curves adjustment layer

Instead of applying the curves in Figure 5-67 directly to the portrait, I used them in a Curves adjustment layer (Figure 5-68). I inverted the layer mask to make it black, which zeroed out the effect of the layer. Now I could paint in the Curves adjustment just where I wanted by using a white brush to paint over the mask. Just as when using the dodging and History Brush tools, I used a small-radius brush set to very low opacity.

Fig. 5-67 This Curves adjustment created the "dodging print" in Figure 5-66c. I also used it in a Curves adjustment layer that I used as a dodging adjustment layer to improve the portrait.

Fig. 5-68 A Curves adjustment layer works well as a customized dodging tool. This layer incorporates the same Curves adjustment as Figure 5-67 and the mask shown in Figure 5-69.

If you make a mistake and dodge somewhere you didn't mean to or you overdo it, simply change the brush from white to black and paint over your mistake. You can switch back and forth between white and black brushes any time you like so that you can rework the mask as much as you need. This is a great method for beginners as well as advanced workers because you never have to worry about doing anything irreversibly wrong. You can see my results, along with the layer mask I ended up with, in Figure 5-69.

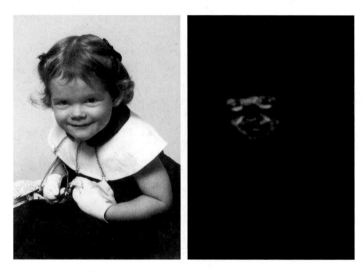

Fig. 5-69 The original portrait, from Figure 5-63b, after correction with the dodging adjustment layer shown in Figure 5-68. The dodging mask I created is shown in the right half of the figure. The lighter the mask, the more dodging gets applied to the portrait at that point.

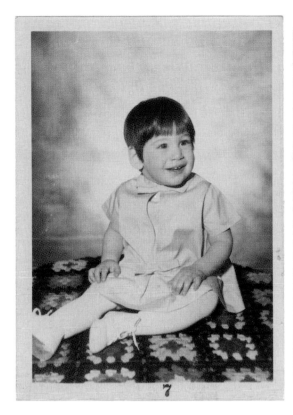 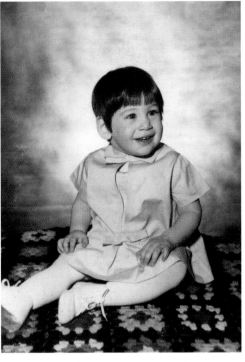

Restoring Color

How-To's in This Chapter
How to make a scan that produces good color
How to correct color with the midtone eyedropper
How to correct color with Picture Window Color Balance
How to correct color using Auto Color options
How to use layers to correct color separately from luminosity
How to improve color with Curves and Vibrance or Hue/Saturation
 adjustment layers

*How to make skin tones smoother with Curves
adjustment layers
How to retouch skin tones with an airbrush layer
How to refine skin tones with a Hue/Saturation
adjustment layer
How to refine skin tones with SkinTune 2
How to fix a faded school portrait with airbrush layers
How to create neutral tones with a Hue/Saturation layer
How to hand-tint a photograph with masked layers
How to hand-tint a photograph with AKVIS Coloriage
How to remove color fringes from a photograph
How to remove developer stains from a color negative
How to improve color with Color Mechanic*

What Makes a Good Print?

After reading Chapters 4 and 5, you've likely figured out that the qualities that make for good color in a photograph are a lot like the ones that give a photograph good tonality. A photograph with good color usually has a rich range of values from near-white to near-black; this is what I called the First Rule of Good Tonality in Chapter 5. Somewhere in that color print you'll find a bit of deep shadow that approaches black and a bit of a highlight glint that approaches white. They aren't necessarily large or important parts of the photograph, but they're usually there.

Look through this book at before and after illustrations of color photo restorations like the one shown in Figure 6-1 and its accompanying histograms (Figure 6-2). Almost always what distinguishes the restored photograph from the degraded original is this richness of tones. The faded-color original won't

Fig. 6-1 The faded photograph on the left has a narrow range of tones, shown in the histogram in Figure 6-2. Each of the three color channels has a restricted tonal scale. In contrast, the photograph on the right with good color has color channel histograms that use most of the tonal range.

have any clean whites or blacks. It's very much the same situation we saw with faded B&W prints. Color is not as different as you might think, but let's now concentrate on the differences that do exist.

B&W has only one channel of tonality: gray. It's easy for people to understand B&W tonality: As the value rises from 0 to 255, the gray tone changes from black to white. Color has three dimensions to it: red values, green values, and blue values (known in shorthand as RGB). Each of those channels behaves like the gray channel in a B&W photograph, but the color we perceive is the combination of all three and not the component values.

To get really good color in a photograph, we have to be able to adjust each of those channels individually with as much finesse as we adjusted the tonality in a B&W photograph. This is much more difficult to do, but fortunately many software tools will help us.

There aren't really any deep secrets to getting good color, but there are some smart rules you may not have thought of. They turn out to be true so often that

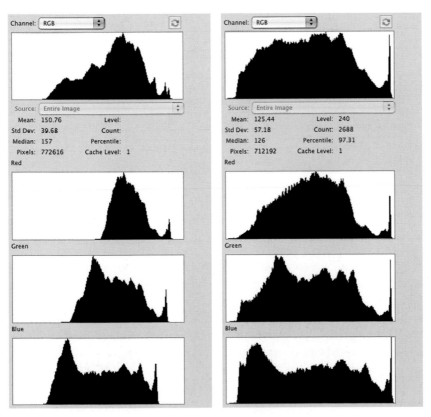

Fig. 6-2 These are the histograms for the faded (left) and color-corrected (right) photographs in Figure 6-1. Each color channel in the faded photograph looks similar to what you'd see in a faded B&W photograph—no clean whites and no tones anywhere near maximum color density. The color-corrected photograph has broad, well-populated histograms in each color channel.

you can consider them to be very reliable guides to good color restoration. Remember the First Rule of Good Tonality that, at the beginning of this chapter, I said only "usually" applies to color photographs? Well, it is much more true when you examine each color channel separately. The photograph may not have any true whites or true blacks, but somewhere in the photograph there will almost always be pixels that will have values near 0 or 255 for one of the individual colors. This is an idea that takes some getting used to, so here's a concrete example. The purest, most saturated yellow will have a blue value of 0 and red and green values of 255. You don't need a white or black pixel to get extreme values in the individual color channels of a color photograph; any pure color will have some color values near black or white.

How to make a scan that produces good color

It's true that some color photographs won't have pure colors in them, just as it's true that some won't have true blacks and true whites. But the number of photographs that have no whites, no blacks, and no fairly saturated colors is awfully small. That means we do have a good general rule for good color photographs: Each of the individual color channels will have a broad set of tones spanning most of the range from black to white. This is not the only requirement for good color, but it is one of them. That's why, when I talked about what made a good scan in Chapter 4, I put such emphasis on adjusting the levels for the color channels to produce histograms that span most of the range from 0 to 255 for each color (Figure 6-3). It's about more than just having a lot of good data to work with; it gets me a lot closer to the color I actually want, as Figure 6-4 shows. Observe the difference in the histograms (Figure 6-5) for the unadjusted and adjusted scans of Figure 6-4. In the examples online at http://photo-repair.com/dr1.htm, I do a complete restoration on this photograph, starting from this adjusted scan.

A second guiding principle is that tone and color are closely connected. Changing the lightness of a photograph changes its color: Rich colors are usually associated with dark values, pastels with light values. You cannot alter tone without altering color, and vice versa.

Most important, contrast and color intensity (saturation) are intimately intertwined. When you increase the contrast of an RGB image, you increase its color saturation; when you decrease its contrast, you decrease the color saturation (Figure 6-6). It's important for you to get the overall contrast of the photograph approximately right before trying to fix the saturation. A common mistake is to look at a photograph that is too low in contrast, decide that the color is undersaturated, and boost the saturation. When you kick up contrast to the proper level, the colors become garish because of the additional increase in saturation.

Consequently, I usually try to correct the tonality and contrast as much as I can before fine-tuning the color. Still, color and tonality are a two-way street. If I have a photograph that is wildly off in color, I can't evaluate and correct its tonality accurately on the first pass. I will crudely correct the tonality and contrast; then I'll approximately correct the color and saturation. Once the color is roughly correct, I can go back and evaluate the tone and contrast much more accurately and fine-tune them. Then it's back to the color to refine it, working back and forth until I've got the tonality and color just where I want them.

Adjustment layers are a really good way of doing this. As I warned, it's easy to overshoot your mark by confusing low contrast with low saturation or the converse. Adjustment layers allow you to adjust the colors and tonal values without locking yourself into a fixed result.

Fig. 6-3 These are the scanner software histogram and Levels settings for the photograph on the left in Figure 6-4. The blacks aren't bad in this photograph, but there's serious staining and loss of midtone dye densities. The Levels settings that produce a good scan closely bracket the range of tones in each channel, just as they would for making a good B&W scan. The blue midtone slider is shifted to the right (a value of 0.8) to eliminate excess blue from the scan.

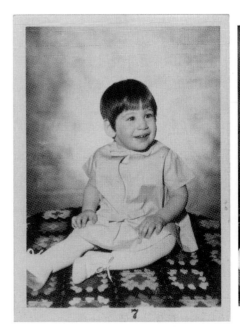

Fig. 6-4 The original photograph (left) is in good physical condition, but it's faded and very badly stained. The vastly improved version on the right is simply the result of making a good scan, using the settings in Figure 6-3.

Fig. 6-5 Here are the histograms for the photographs in Figure 6-4. A good scan, using the Levels settings in Figure 6-3, takes the unevenly balanced histograms in each channel of the faded photograph (left) and normalizes them. All three histograms now cover about the same range of tones and make good use of the available tonal scale.

Fig. 6-6 Contrast and color saturation are closely linked. These three photographs are identical except that I used Curves to increase the contrast from left to right. As the contrast increases, so does the color saturation.

One more guideline: If you get the blacks, whites, and middle grays correct, the rest of the colors will follow. Like the other guiding principles in this section, this is not an absolute law of nature, however. Even when you have the whites, blacks, and grays just where you want them, the color could still be off. But most of the time it's amazing how close it will be to what you want.

How to correct color with the midtone eyedropper

If there is a part of the photograph that you're pretty sure is neutral in tone and isn't too light or dark, you can use the midtone eyedropper to arrive at a good first cut at correct color balance. I've inserted two eyedropper sample points in Figure 6-7 (Chapter 5, page 127 explains how to do this) for illustrative purposes; Point #1 is on the wall of a house that I thought was painted white, so it should be neutral. That's where I clicked with the Curves midtone eyedropper and instantly got the photograph on the right.

Figure 6-8 shows the RGB values at the eyedropper sample point before (Point #1) and after (Point #2) I applied the eyedropper. The red and blue correction curves show how the eyedropper added intermediate points that bent those curves to produce a much better color balance. The color isn't perfect, but it's much closer to being correct.

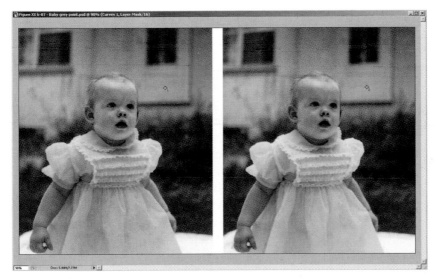

Fig. 6-7 Correcting a single midtone gray using Curves will do a lot to correct the overall color balance of a photograph. On the left is the original color-restored photograph with a sample point (1) added to the background. Figure 6-8 shows the Info window with the values at the sample point and the red and blue curves that I used to color-correct that point and make it neutral (Point 2). That results in the photograph on the right.

A big part of successful color restoration is getting yourself in the neighborhood. RGB color space is a big place; it's a lot easier to fine-tune the aesthetics of your photograph when you're close to having decent color than

Fig. 6-8 Sample Points 1 and 2 in the Info window correspond to a point in the background before and after color correction. I added correction points to the red and blue channels and raised and lowered them, respectively, until the value of the sample point was about the same for all three channels (178). That eliminated the overall bluish-green cast in the photograph.

when you're floundering around out in the hinterlands of RGB space, lost and trying to figure out how to get to where you want to be. The software tools in the next section are no substitute for manually correcting color, but they can get you into the ballpark. It's up to you to polish it up and do the finishing touches.

Getting the Color Right (Semi-)Automatically

Picture Window has a Color Balance tool that lets you do some pretty sophisticated color correction without having to mess directly with Curves or Levels. Much (but not all) of the capability of this tool is also available as a Photoshop plug-in called Color Mechanic. It's a very visually oriented approach to color correction, a simple, intuitive way to get the photograph into the neighborhood of correct color.

Figure 6-9 will give you some idea of what you can do with it. This is a screenshot from Picture Window of color balancing in progress. The photograph in the upper left is the original uncorrected photograph. In the upper right is a preview photograph showing what the color balance settings will do when they are applied. At the lower left is the Color Balance main control panel.

Although the Color Balance tool includes a set of RGB curves that you can manipulate directly, you rarely need to involve yourself with them. You can do what you need to with probes and aimpoint adjustments.

How to correct color with Picture Window Color Balance

On the left side of the Color Balance control panel, you'll see a column labeled Remove and another one labeled Add. The rows in each column correspond to highlight, shadow, and midtone

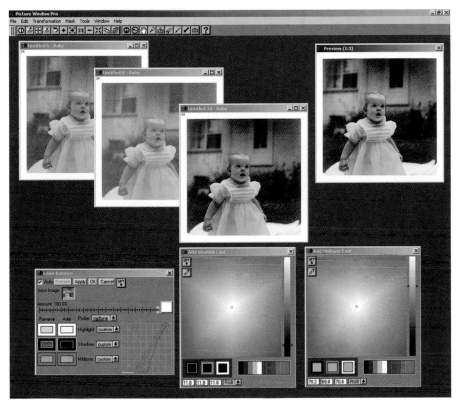

Fig. 6-9 Picture Window's Color Balance transformation is a nice, visually oriented way to do color correction. The original photograph is in the upper left of this screenshot, the Color Balance control panel lower left, and the Preview window upper right. Clicking on points in the photograph assigns them to Highlight, Shadow, or Midtone values. You can correct the colors and values of those points using color picker windows, lower right. Picture Window takes care of manipulating the curves for you. Two color-corrected versions of the original photograph are shown midscreen.

values. The Remove column shows the highlight, shadow, and midtone target points that are going to be corrected. You can change those target points by double-clicking on the color rectangle and opening Picture Window's version of a color picker, but there's an easier way. Set the probe to the value you want to correct (highlight, shadow, or midtone) and then click the cursor on an appropriate point in the original photograph. Picture Window will assign that hue to the Remove box.

Do that for all three values, click Apply, and you'll get a result that looks like the second photograph from the upper left in Figure 6-9. The color balance is pretty good, but the picture is very flat. Why is that? Because the default settings for the Color Balance tool change the color but not the brightness; Color Balance is correcting color but not luminosity.

You have manual control over brightness values. Click one of the boxes in the Add column. That opens up a new window in which you can set the brightness and fine-tune the color (if you need to). I opened windows for the shadows and the midtones. These are the two rainbow-filled windows in the lower right of Figure 6-9. The grayscale slider on the right side of each window changes the brightness of the adjustment point. The little circle in the rainbow field lets you choose the color for that point. For the highlights and shadows, you usually just want to adjust the grayscale slider up or down. You'll often use the color selector to refine the color balance of the midtone point, especially if there isn't a point in your picture that corresponds to a proper neutral gray.

171

The Preview window changes as you move the color point and grayscale slider around, so you can see what your adjustments are accomplishing. I used the color and slider settings seen here to produce the second corrected version of the photograph in the middle of Figure 6-9.

Remember that Picture Window keeps multiple versions of the photographs open; every time you click the Apply button, you generate a new photograph from your color balance settings. If you can't settle on the best version simply by looking at the Preview window, you can create as many variations as you like (I created two in this example) and decide which one you most prefer later.

Even if you work mostly in Photoshop, this is still a great tool for getting your color roughly corrected, because this kind of tone and color adjustment is one of the first things you want to do to your scan. Save your scan file as a TIFF document, open it up in Picture Window, correct it and save it, and do the remainder of your work in Photoshop.

Photoshop's Auto Color adjustment can do a great deal to improve the color of even a very bad original (or scan). In its default mode (the command directly under the Image | Adjustments menu), it's not very good. The trick to making it work well is to call up its semihidden options; then it can turn out some pretty fine results.

Figure 6-10 is an intentionally poor scan. It's very faithful to the original, faded photograph—precisely the kind of scan I said not to make back in Chapter 4. But it could be the kind of scan you'd be stuck working with if your client provided the file to be restored.

How to correct color using Auto Color options

Here's how to semiautomatically correct color. Under Image | Adjustments, click the Levels command. In the Levels control panel, click the Options button. In the Correction Options control panel, select Find Dark & Light Colors and then choose Snap Neutral Midtones (Figure 6-11). That does most of the color correction for us.

We've one more adjustment to make. The default shadow and highlight tones are 0% and 100%, which is likely to clip some highlight or shadow detail that we want to preserve. Click the Shadows (black) box, and the Color Picker window opens. Set B (brightness) to 10% and close the Color Picker (Figure 6-12). Then click the Highlights (white) box and set B to 90%.

Click OK to close the Auto Color Correction Options, click Auto in the Levels control panel, and click OK to close the Levels control panel. When Photoshop asks if you want to save the new target colors as defaults, click Yes. You'll find the 10% and 90% end points much more useful than Photoshop's original 0% and 100% default values.

Auto Color takes us from Figure 6-10 to Figure 6-13. The color is improved, but the tones are very bad because the large white areas threw off the automatic adjustments. I could've made a mask that excluded them; then the Auto Color tool would've done a satisfactory job of restoring tone, but I'll show you a different, better way to handle this with blended layers in the next section, Color Correcting in Layers.

My third and favorite way to do automatic color correction is with the DIGITAL ROC plug-in (Figure 6-14). It gives a lot of control without being excessively time consuming, and the results are usually better than either Picture Window's Color Balance or Photoshop's Auto Color.

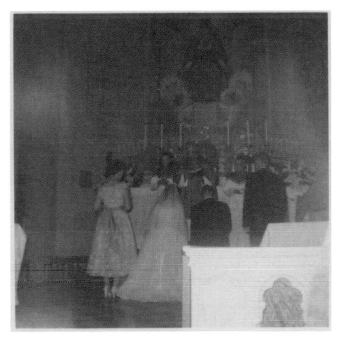

Fig. 6-10 This old wedding photograph has faded to brownish-orange. The Auto-Color settings in Figures 6-11 and 6-12 can restore much of the missing color.

Fig. 6-11 The key to using Auto-Color effectively is taking advantage of the Options. You can use these to tell Auto-Color to find appropriate light and dark colors and to automatically make midtones neutral. Options also let you control the target colors, to avoid forcing intermediate tones to pure black and white (see Figure 6-12).

Figure 6-15 compares all three methods. Starting clockwise from the upper left, it shows the original, badly faded color print, Picture Window's Color Balance transformation, Photoshop's Auto Color correction, and DIGITAL ROC's correction. All three improved versions are good starts on full-color

Fig. 6-12 Avoid clipping important tonal information in the photograph. I always set my black and white points to 10% black and 90% black, respectively. That makes acceptable use of the full tonal range available for working on the photograph, but it ensures that no detail in the photograph is accidentally eliminated.

correction, but DIGITAL ROC did the best job (which is most evident in the color of the clothing, according to the owner of the photograph). All these photos, however, share two problems: low saturation and poor tonality, especially too much contrast. We can fix all that with layers.

Color Correcting in Layers

As Figures 6-13 and 6-15 showed us, automatic color correction often produces undesirable tones. It would be nice to be able to get color improvements without unwanted tonal changes. Photoshop layers are a versatile tool for separating color from tone control. Let's start with Figure 6-13. I like what Auto Color did for the overall color balance, but the main subject area of the photograph is much too dark and too flat.

I was able to turn Figure 6-10 into Figure 6-17 by using a color-blended layer, as described in the sidebar. Figure 6-19 shows the before and after

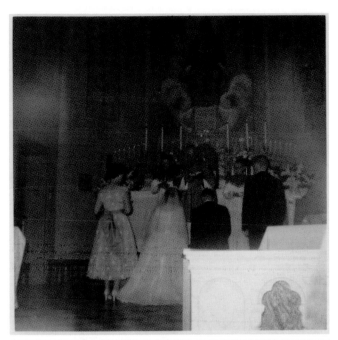

Fig. 6-13 This is what Figure 6-10 looks like after applying Auto-Color. The tones in most of the photograph are too dark because the large overexposed area in the lower right threw off Auto-Color's corrections, but the colors are much improved. This is a big step toward a successful restoration.

Fig. 6-14 Digital ROC is my favorite way to correct color in faded photographs. It does an amazing job of extracting useful color information from badly faded photographs. The plug-in version of this utility has capabilities the version built into scanners lacks; it gives you control over color, brightness, and contrast balance. You can selectively apply color correction with masks, layers, and the History Brush.

histograms for this heavily modified photograph. Even though the photograph has undergone drastic changes, there are no major gaps in the new histograms. That's the benefit of working with 16-bit color files instead of 8-bit ones.

A similar trick works with the photograph I corrected with DIGITAL ROC in Figure 6-15. I suppressed the excessive contrast produced by DIGITAL ROC to get the much-improved photograph on the left in Figure 6-21.

175

Fig. 6-15 Color correction three different ways. The original, faded photograph is at upper left. I used Picture Window's Color Balance transformation to create the photograph at upper right. Photoshop's Auto-Color produced the lower-right photograph. Digital ROC got me the photograph at lower left.

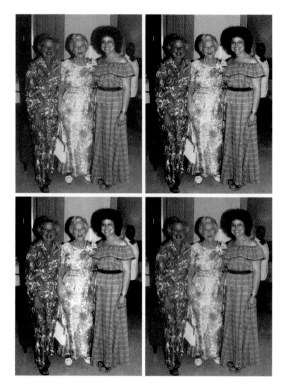

How to use layers to correct color separately from luminosity

First, I opened a copy of Figure 6-10 (remember, always work on copies, never on the original files) and I pasted the Auto Color image from Figure 6-13 into it. That made the original scan the background layer and the Auto Color version Layer 1. I set Layer 1's blend option to Color. That superimposed the color changes onto the original but threw away the tonal changes, giving me Figure 6-16. The composite is now very washed out, like the original, but I can fix this with a Curves adjustment layer (Figure 6-17). The settings for that layer are shown in Figure 6-18.

The most important change is the huge contrast boost in the RGB curve, where I pulled the black end point way in to produce a much wider range of tones in the photograph. I also made moderate adjustments to the red, green, and blue curves to get more neutral whites and blacks. This is a much better result than I got from Auto Color alone, and it's a vast improvement over Figure 6-10.

To correct the photograph in Figure 6-15, I started with the uncorrected image as the background layer and pasted in two copies of the DIGITAL ROC-altered photograph (Figure 6-20) as Layers 1 and 2. I set the blend mode on Layer 1 to Color. I changed the blend mode on Layer 2 to Luminosity and dropped its opacity to 32%. These layers retained all the color alterations that DIGITAL ROC had made to the original photograph but only about one-third of the tone and brightness changes.

Fig. 6-16 Layers are a great tool for controlling color and tonality separately. This photograph is based on Figure 6-13. Auto-Color does a good job of bringing back some of the color to that photograph, but it produces a photograph that's far too dark. In this photograph, I've copied Figure 6-13 into a new layer on top of the original photograph. Setting the blend mode for that layer to Color applies the color changes wrought by Auto-Color but not the brightness and contrast changes.

Fig. 6-17 A Curves adjustment layer improves Figure 6-16. Note that this layer is above the other two layers, since I want it to work its changes on the photograph after the Auto-Color corrections have been applied. The Curves settings are shown in Figure 6-18.

Fig. 6-18 This is the Curves adjustment that produced Figure 6-17. The most important change is in the RGB channel, where I moved the black point in to a value of about 100. The other control points produce more than a five-fold boost In contrast in the shadows and open up the midtones and highlights. The three color channel curves are set to keep the overall color balance neutral. I moved in the end points for each curve until the dark suits and the bright washed-out areas had little residual color cast.

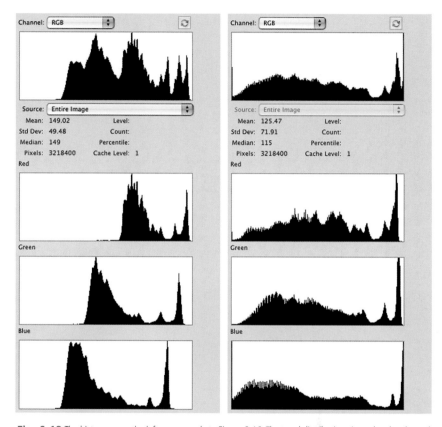

Fig. 6-19 The histogram on the left corresponds to Figure 6-16. The tonal distributions in each color channel are narrow, and they're displaced horizontally with respect to each other. That says that the photograph is low in contrast and has a pronounced color cast. The histogram on the right represents Figure 6-17; it shows the beneficial effect of the Curves adjustment layer on this photograph's tone and color distribution.

It is still undersaturated, though, and the color is mediocre. Hue/Saturation and Curves adjustment layers, used with the right blending modes, fixed it up nicely. Being able to correct color and luminosity separately, as described in the next sidebar, makes controlling your work a lot easier and usually yields better-looking photographs.

How to improve color with Curves and Vibrance or Hue/Saturation adjustment layers

I added a Hue/Saturation adjustment layer to Figure 6-21 and set the saturation level to +35 (Figure 6-22). (In this situation, the new Vibrance adjustment in Photoshop CS4 would have produced similar results.) That got me to the middle photograph in Figure 6-21. I felt the tonality could use some further improvement: The midtones and highlights were too harsh and contrasty, while the shadows were washed out. So I created a Curves adjustment layer between Layer 2 and the Hue/Saturation adjustment layer (Figure 6-23). I set the blend mode to Luminosity so that it would alter the tones but not the colors. The curve increased the contrast in the shadows and made the darkest tones much closer to true black while slightly lightening and lowering the contrast in the midtones and highlights. That produced the right-hand photograph in Figure 6-21.

Fixing the overall color of Figure 6-21 isn't hard. In Figure 6-24 I added two eyedropper

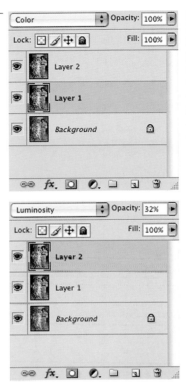

Fig. 6-20 Layers make Digital ROC work a lot better. ROC does a great job of restoring color, but it tends to increase contrast too much, blowing out the near-whites and near-blacks in a photograph. I fix that by applying ROC to two duplicate layers instead of the original background layer. I set Layer 1 to Color blend and leave the opacity at 100%, so I get the full benefit of the color correction. I set Layer 2 to Luminosity blend and drop the opacity on that layer until the contrast looks right, as shown on the left in Figure 6-21. This has the same color as Figure 6-15, lower left, but the layered version has much better contrast and doesn't look nearly as harsh.

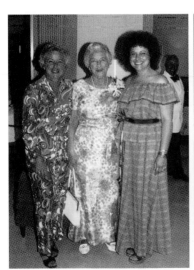
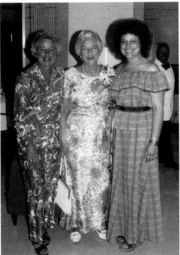
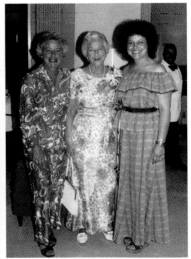

Fig. 6-21 The photograph on the left shows how Digital ROC, applied in Color and Luminosity layers, substantially improves on the original photograph. The middle figure shows the photograph after applying the Hue/Saturation adjustment layer shown in Figure 6-22. The figure on the right has better shadows and blacks because I inserted a Curves adjustment layer into the layers stack, as I've shown in Figure 6-23.

Fig. 6-22 This Hue/Saturation adjustment layer substantially boosts the saturation shown at center in Figure 6-21.

Fig. 6-23 This Curves adjustment layer produced the image on the right in Figure 6-21. It creates better blacks without altering the midtones and highlights. The blend mode is set to Luminosity so that it doesn't alter the saturation of the photograph; that's the job of the Hue/Saturation layer above it.

readouts to the photograph to show the color errors in the highlights and the shadows that I talked about. I opened up the Curves tool (Figure 6-25) and adjusted the end points for the red and blue curves to make the highlight and shadow readouts neutral.

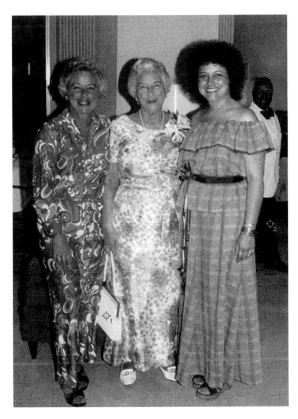

Fig. 6-24 This photograph still needs some color correction, so I've added two sample points by shift-clicking with the eyedropper on the photograph. Those sample points, in the white purse and the black pants of the waiter, will guide me as I adjust the curves of a Curves adjustment layer in Figure 6-25.

Fig. 6-25 To make the sample points in Figure 6-24 neutral, I adjusted the end points on the red curve to darken the whites and lighten the "blacks," so that the red values in the sample points matched the green values (Info window on right). I made similar adjustments to the end points of the blue curve so that all three values were approximately the same, resulting in neutral blacks and whites. This Curves adjustment layer produces better and more accurate colors in most of the photograph, but the skin tones lost their healthy richness (image at left in Figure 6-26).

Fig. 6-26 The photograph on the left, the result of applying a Curves adjustment layer with the curves shown in Figure 6-25, has a more correct overall color balance, but the skin tones were better without this adjustment. To fix that, I created a mask for the adjustment layer (Figure 6-27) that blocks the effect of the adjustment layer on the women's skin. The result, right, combines the good skin tones of the earlier version with the more neutral and correct overall color produced by the Curves adjustment layer.

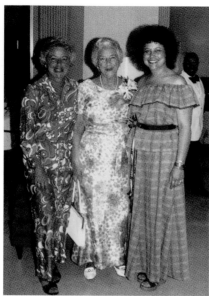 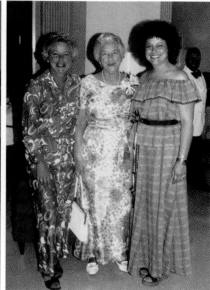

We're well on our way. The adroit use of blended adjustment layers has greatly improved the overall color, which is now considerably more accurate in the clothes and the room furnishings. The shadows and highlights no longer have a bad color cast, but there are some color distortions that should be corrected—the highlights are pink, while the shadows have gone a bit cyan. The skin tones look even worse (Figure 6-26, left), mostly because there's way too much contrast in the faces. While that was probably a result of the on-camera flash and might be an entirely "accurate" restoration, it's not attractive!

Getting Better Skin Tones

This photograph needs a lot more work before it will be a good restoration. Fortunately, there are solutions.

The Layered Approach

I had applied the curves in Figure 6-25 as a Curves adjustment layer. Because of that, I can now alter where those curves get applied to the photograph by adding a mask. In this case, I decided to paint the mask in by hand because the areas that needed to be masked were pretty simple. I could just as easily have used a tool such as Mask Pro or Fluid Mask, and for a more complex masking job that's what I would do.

Fig. 6-27 This mask separates the skin tones from everything else in the photograph. By using this mask (and its inverse) I can create adjustment layers for the photograph that worked separately on the skin tones and the rest of the photograph, as I do in Figures 6-26 and 6-29.

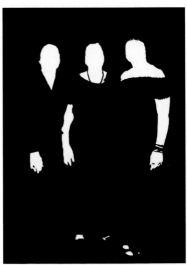

Fig. 6-28 This is the basis for another Curves adjustment layer to be used with Luminosity blend. The mask for this layer, at left, restricts the adjustment to working only on the skin tones. The RGB curve reduces contrast and substantially tones down the bright hot spots in the women's complexions caused by the on-camera flash.

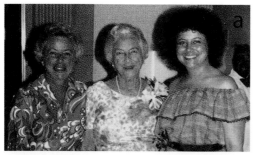

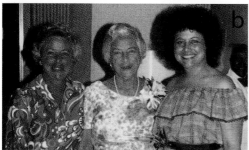

Fig. 6-29 Masked adjustment layers make a big improvement in skin tones. (a) is a section from the right of Figure 6-26. It shows the background image with Digital ROC applied in a masked layer. This photograph corresponds to the bottom two layers, "background" and "roc," in the layer stack shown in Figure 6-32. (b) shows how the harsh highlights are softened by the Curves adjustment layer from Figure 6-28 (the Women 0 layer in Figure 6-32). (c) Skin tones still look blotchy, with uneven yellowish and pinkish patches. Another Curves adjustment layer, Women 1, using the settings in Figure 6-31, fixes that. Finally, a Hue/Saturation layer using the settings in Figure 6-32 improves the saturation and refines the brightness to produce the natural-looking results in (d).

There are no irreversible mistakes when creating a layer mask. I started off with a large-radius black brush and painted over the faces and arms of the women. Then I shrank the radius of the brush and filled in the edges. If I painted out too far, I switched the brush to white and corrected my errors. Pressing the Q key turns the Quickmask view on and off in Photoshop, so I could inspect the mask directly while cleaning it up. I checked it frequently to make sure I didn't miss a spot.

In about half an hour I had the mask shown in Figure 6-27. That mask blocked the effect of the Curves adjustment on the faces and arms, producing the photograph on the right in Figure 6-26.

I'm not finished with that mask. Masks are just grayscale images and they can be copied and pasted and modified with all the usual Photoshop tools. Inverted, this mask would help me correct the skin tones.

Skin tones in old color photographs commonly have two problems. The first is high overall contrast: Tones are usually too harsh, and highlights tend to be blown out, with lines and shadows accentuated. The second problem is blotchy color; high contrast in each of the individual color channels exaggerates what should be more subtle differences in skin hues. Instead of having a healthy range of colors, you see faces with some patches that look flushed and others that look jaundiced.

I can fix problems like these with adjustment layers or with careful hand work. First I'll show you some adjustment layer approaches. In this example

I apply the same corrections to all three women's faces, which won't be optimal for any of them. For high-quality work, I'd make individual masks for each woman and correct each one's skin tones separately.

I copied the mask from Figure 6-27, inverted it, and used it to create a Curves adjustment layer (Figure 6-28). I set the blend mode on that layer to Luminosity so that it would alter tonal values but not colors. What that curve did was reduce contrast in the midtones and highlights and drop the maximum density in the highlights.

Figure 6-29 shows successive improvements I made to the women's complexions. Figure 6-29a is the same as in Figure 6-26, just repeated here for easy comparison. The second photo (Figure 6-29b) shows the effect of the luminosity Curves adjustment layer I just created. There's no change in the color balance, but the harsh effects of the on-camera flash are tamed.

With lower contrast, it's easier to see the blotchy color problem I described. To understand what's behind that, look at Figure 6-30. From top to bottom, this shows the red, green, and blue channels of the aforementioned photograph. The red channel looks great. The contrast in the faces in the green channel (the magenta hues) is a little bit high, and the contrast in the blue channel (corresponding to yellow) looks very harsh. It's that excess contrast in the magenta and especially the yellow hues that causes the blotchy skin colors.

How to make skin tones smoother with Curves adjustment layers

I described in Chapter 5 how to use a reversed-S curve to tame midtone contrast. That's just what I did here. Figure 6-31 shows green and blue curves that will substantially soften those problematic colors. I created a second Curves adjustment layer using the mask for the women, this time with the blend mode set to Color. I applied the curves to Figure 6-26, which produced Figure 6-29c.

The reversed-S curve described in the sidebar makes the skin tones look pretty natural, but I felt they were a little bit undersaturated. There's a flat and pasty quality to them, typical of insufficient saturation. So, I created a third masked adjustment layer, this time for Hue/Saturation, and applied the settings in Figure 6-32. That produced Figure 6-29d. The complete stack of layers for these corrections is shown on the right in Figure 6-32.

The Airbrushed Layers Approach

When a photograph has too much contrast in the faces but the color is pretty good, a little handwork often does the trick. Consider Figure 6-33. The original photograph is on the left, my improved scan on the right. I used the scan Levels

Fig. 6-31 These inverted-S curves, applied in the masked adjustment layer, Women 1, even out the skin color because they reduce the contrast in the midtones of the green and blue channels. Lower contrast means smaller color differences, so excessive variations in skin color are suppressed.

Fig. 6-30 These individual channel images show why the skin tones in Figure 6-29b look blotchy. The red channel has smooth, low contrast, but the magenta channel is harsher, and the blue channel shows large variations in brightness in the skin areas. The curves in Figure 6-31 fix this.

Fig. 6-32 A Hue/Saturation adjustment layer completes the layer stack that fixes the skin tones in Figure 6-29d. Increasing the saturation removes the pasty look from the faces, and darkening the tones a little bit makes them blend in better with the rest of the photograph. Like the two underlying Curves layers, this layer uses the mask from Figure 6-28.

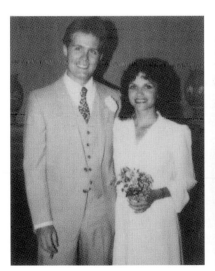

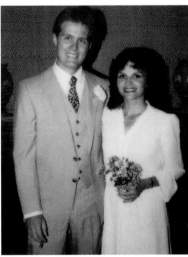

Fig. 6-33 The original photograph (left) is moderately faded and stained, but a good scan fixes most of that (right).

settings in Figure 6-34 to get reasonably neutral highlights and shadows. The other colors and tones pretty much fell into line.

There's a little bit of color crossover, with the highlights being too pink and the shadows too cyan, but the man's suit made it really easy to correct this by eye. All I needed to do was use the eyedropper to look at the colors in various tones in his suit and shirt by clicking/sampling different places on the suit and shirt and adjust some of the curves so that they came out neutral. The curve settings I used are in Figure 6-35. That got me to the image on the left in Figure 6-36.

Fig. 6-34 The scanner software histograms and Levels adjustments for Figure 6-33. As is typically the case, bracketing the range of tones in the histograms with the black and white Levels sliders produces a much-improved photograph.

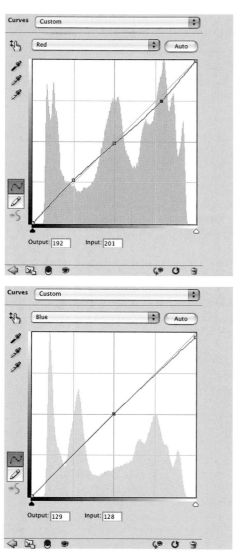

Fig. 6-35 The white dress and gray suit in Figure 6-33 made color correction much easier; they gave me a wide range of neutral tones to aim for. These red and blue curves make the clothes come out neutral (left side of Figure 6-36). I applied these curves in a Curves adjustment layer named Curves 1, as shown in Figure 6-37.

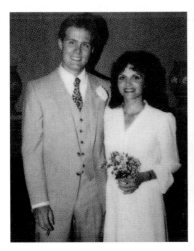 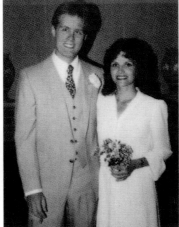 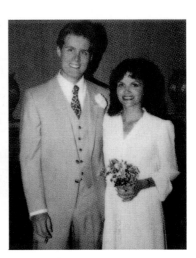

Fig. 6-36 The photograph on the left shows how the Curves adjustment layer from Figure 6-35 improves this photograph. Although the color is quite good, the skin tones have that harsh, "on-flash" look. The middle photograph shows how an airbrush darkening layer eliminates the hotspots on the couple's faces. A lightening airbrush layer softens the shadows on their faces and hands (right). The lighting in the photograph now looks much more professional and natural than it did in the original.

I was happy with the color balance, but not with the contrast; there were lots of blown-out highlights in the faces, and the shadows were pretty harsh. I decided to airbrush away these problems. Instead of attacking the problems directly, though, I created some special retouching layers to make the work much easier and less error prone.

How to retouch skin tones with an airbrush layer

I added two layers to the photograph (Figure 6-37) and set Layer 1 to Darken blend and Layer 2 to Lighten blend. Note that these are not adjustment layers; they're ordinary image layers.

Next I selected the airbrush tool and set its opacity to a very low level: 9%. I activated Layer 1, sampled the color in the man's face next to the highlight on his forehead, and started airbrushing over his forehead. Because I had the opacity set to such a low level, I could build up tone very, very gradually and blend it in smoothly with the surrounding skin tones.

With this layer set to Darken mode and such a light tone in the airbrush, I didn't have to worry about accidentally airbrushing over any of the other parts of his face. Sloppy brushwork won't mess up tones that I don't want to change. Should I slip with the brush and run it across his hair or a darker midtone, it would have no effect on the blended image, because the color I was painting with would be lighter than those background layer colors. When I did occasionally overextend

Fig. 6-37 The layer stack that fixes Figure 6-36. Layer 1 is an airbrush layer set to Darken blend, and it removes the hot spots from the photograph. Layer 2 is set to Lighten blend; airbrushing in that layer opens up the shadows.

my retouching, I airbrushed away the excess retouching by switching the color of the brush to white. Alternately, I could've used a white eraser to remove my mistakes from the layer.

I airbrushed any part of his face where I thought the highlights were too bright and shiny. Wherever I airbrushed a highlight, I used color sampled from a nearby area. For example, when I airbrushed his cheeks I sampled a spot of color right under his eye. When I was toning down the highlight on his chin, I sampled the color between his lower lip and the chin.

To deal with the shadows, especially those in the woman's face and hand, I switched to Layer 2, which was set to Lighten blend. I worked the same way I had in Layer 1, using the airbrush at very low opacity and setting its color to one that was adjacent to the shadows I wanted to lighten.

I didn't try to remove much of the shadowing; shadows define the shape and three-dimensional structure of the faces and hand. Flatten out those tones too much and you'll get a very strange look, as if people were wearing flat cardboard masks with pictures of their faces on them. You don't want to go that far! I made the background black in this illustration so that the airbrushing would be visible as lighter brush strokes against the background. The background of that layer is actually transparent, but that makes it too hard to see the airbrush work, which is pretty subtle. The combined highlight and shadow retouching produced the photograph on the right in Figure 6-36.

This kind of retouching is really easy; it took me longer to write about it than it did to do the work. You'll probably find that it's much simpler to do it than to understand my explanation of it.

The darkening retouching I did is shown on the left in Figure 6-38. The shadow work that I did is shown in the right half of Figure 6-38. As you can

Fig. 6-38 Here's what I painted into the airbrush layers of Figure 6-36. The figure on the left shows the Darken airbrush work that reduces glare and reflections from the skin tones. The mostly black figure on the right represents the contents of the lightening airbrush layer; this is what softens the shadows. This layer is actually mostly transparent; I made the background black for clarity's sake.

see, I didn't follow the outlines of the face or highlights very closely at all. The results, shown in the center of Figure 6-36, look entirely professional. Blending in light-toned airbrushing like this really does produce a seamless-looking photograph.

In truth, I overdid the retouching in this example to make sure the changes would show up clearly in the illustration for this book. But my efforts weren't wasted. A nice thing about having done this work in layers is that I can dial back the strength of my retouching. Dropping the opacity in the two retouching layers to a strength of about 60% gets me a photograph that looks great as a finished print.

The Hue/Saturation adjustment is a powerful tool for modifying ranges of colors in subtle ways that are difficult to achieve by other means such as Curves. Used in a masked adjustment layer, Hue/Saturation works amazingly well for smoothing out blotchy skin tones.

The key to understanding this approach is to realize that blotchy skin tones look that way because they have some patches that are too pink or red and other patches that are too yellow. If one were to make the yellows a little ruddier, they'd look a lot more like a proper skin tone. Similarly, making reds and pinks a little yellower would suppress that flushed look.

How to refine skin tones with a Hue/Saturation adjustment layer

Create a Hue/Saturation adjustment layer and set the channel sliders for the red and yellow channels, as shown in Figure 6-39. Moving the Hue slider to the left or right shifts the whole spectrum. By moving it to the left for the red channel, we've shifted the yellow colors into the red and the reds into the pinks. For the yellow channel, move the slider to the right, which moves redder colors into the yellow range.

It doesn't take a lot of hue shift to get the desired effect. Be careful not to overdo it, though, or you'll wipe out most of the color variations in the face and it will look like the subject is wearing way too much pancake makeup. Of course, the nice thing about doing this in an adjustment layer is that you can fiddle with it as much as you like and go back and revise it later if you change your mind.

The other reason for doing this in an adjustment layer is that usually you won't want to change all the colors in the photograph, just the skin tones. So, the final step is to fill the mask channel with black and use a white paintbrush to paint in the areas of skin that you want to alter. Figure 6-40 shows the results.

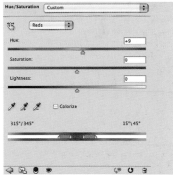

Fig. 6-39 The Hue/Saturation adjustment provides a simple and powerful way to even out skin color. Shift the Hue of the Yellows channel to the negative (ruddier) until the jaundiced look disappears from the overly yellow parts of the skin. This will leave the face looking flushed overall, so switch to the Reds channel and shift the Hue to the positive (more yellow) until the overall skin color looks good. Blotchiness will magically disappear.

Fig. 6-40 Before (top, left) and after (bottom, left) the Hue/Saturation adjustment (Figure 6-39) that evened out the skin tones. Note the mask in the adjustment layer, which limits the changes to the faces and necks.

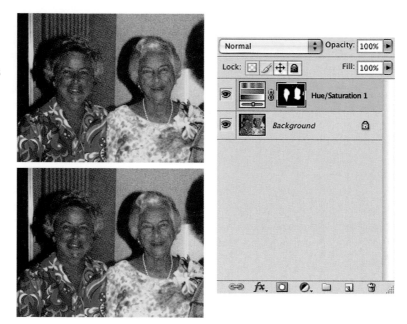

How to refine skin tones with SkinTune 2

Getting skin tones perfect is difficult. It's not especially surprising that we humans are particularly sensitive to how we look. Unfortunately, it means you can be 95% of the way to perfect color correction in a photograph and people's faces are still going to look, well, wrong.

There's a Photoshop plug-in that will help a lot with this: the SkinTune component of PhotoTune 2 from OnOne software (Chapter 3, page 77). It's a bit pricey as a one-trick pony, but if you work on lots of photos where people's faces matter and you find refining those flesh tones a tricky business, it will be worth it.

SkinTune works like a very sophisticated kind of color picker (Figure 6-41) combined with color-specific selections. Pick the ethnicity of the subject and the program presents you with a palette of subtly different, appropriate skin tones to choose from. Select the skin color of your choice. Once you've settled on a reasonable skin tone, you can adjust sliders that will alter its hue and saturation to make it look exactly the way you want. SkinTune then applies that correction to any colors that are close to the targeted skin tone in the photograph.

You may not want the same skin tone applied to everyone in the photograph (not to mention nonhuman parts of the photo that just happen to share the same color as human skin). In that case, apply SkinTune to a copy of the photograph in a separate layer and paint in a mask for the parts you want changed. You can use multiple layers to assign different skin tones to different people this way.

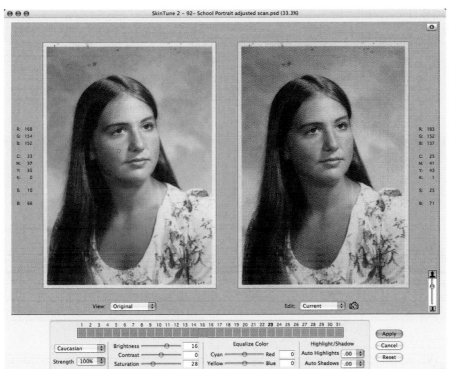

Fig. 6-41 SkinTune is a fast, easy way to get pleasing and accurate skin tones in a photograph. It starts with skin tone-specific color pickers that will get you close to the right color and finishes up with customizing sliders that let you precisely tune the result to your taste.

Correcting Skin Tones with Color Airbrushing

A nice, painterly tool for correcting blotchy skin colors is the color airbrush. In fact, the color airbrush is good for correcting all kinds of color aberrations when pleasing color is more important than technically accurate results. Like the previously described airbrush techniques, it's fast, flexible, and reversible, and it doesn't require you to be a great artist to use it effectively.

The school portrait on the left in Figure 6-42 was extremely faded. To the eye, it seemed to have only two colors: a washed-out green and a reddish purple. I made a good scan of the print, following the methods I've used with the other color photos, carefully bracketing the tones in the scanner software color histograms with the black and white Levels sliders. This scan (Figure 6-42, right) showed there was more to the photo, but it was in very bad shape.

The very first thing I did was to substantially increase the saturation (Figure 6-43) because there was so little color differentiation between the parts of the photograph. That produced Figure 6-44a. Now I needed to do something about the overall color. I made the curve changes shown in Figure 6-45. They are pretty complex, so I'll spend a little time describing what they do.

Fig. 6-42 This old school portrait (left) is very badly faded, with little color apparent save for pale greens and purples. A good scan (right) reveals a lot more detail in the photograph, but the color is still extremely anemic.

Fig. 6-43 A substantial (+49) increase in Saturation makes a big difference to the photograph in Figure 6-42. The results, in Figure 6-44a, show that better color is possible for this photograph.

The RGB curve leaves the whites untouched, but it darkens the midtones and highlights and increases their contrast and detail. I left the moderate shadow tones alone, but I made the very darkest tones darker and closer to true black, which also increased the contrast in the deep shadows, bringing out their detail. The highlights were a little bit reddish, but the rest of the tones had a cyan cast. I lowered the maximum value of the red curve but added an adjustment point that raised all the other values, thereby adding a bit of cyan to the highlights but removing it from everything else.

The shadows had a very strong magenta/purple cast to them, so I raised the shadow values in the green curve (subtracting magenta) and lowered them in the blue curve (adding yellow). I also removed a little bit of magenta and added a little bit of yellow to the midtones, but I made sure that the highlights didn't change because they were pretty neutral. That got me to Figure 6-44b. That was good enough for me to start working with color airbrushing, as described in the sidebar.

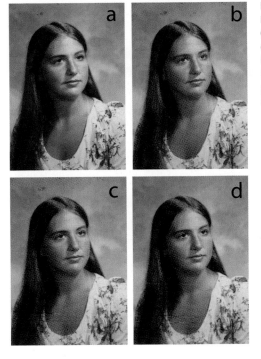

Fig. 6-44 (a) is the result of applying the Hue/Saturation correction from Figure 6-43 to Figure 6-42. The color balance is poor, but at least there is color. (b) The curves in Figure 6-45 restored the overall color balance but left many details to be corrected. (c) The same photograph after skin colors are repaired by the color airbrushing in Figure 6-46c, applied via a layer set for Color blend mode. See the main text for a full description of this technique. (d) This photograph now looks excellent after the complete color airbrushing shown in Figure 6-46f.

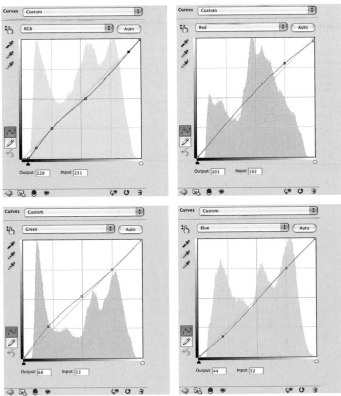

Fig. 6-45 These curves correct the overall color and tonality in Figure 6-44a, producing Figure 6-44b. See the main text for an explanation of how each curve affects the photograph.

195

How to fix a faded school portrait with airbrush layers

I added a new empty layer to the photograph in Figure 6-44b and set the blend mode to Color—anything I painted into that layer would alter the color of the underlying photograph, but it wouldn't change its brightness or tonality.

I set the opacity of the Brush to 15%. Note that I used the tool in its Normal mode: The layer blend setting is taking care of how the airbrushing gets merged. If I wanted to paint directly on the original photograph, I'd select Color as the airbrush mode, but then I wouldn't have the ability to easily revise my work.

Figure 6-46 shows successive stages of color airbrushing from start to finish. First, I decided to remove the cyan cast that was still present in the highlights on the face and neck. I set the airbrush color to the pink hue of the cheek and brushed over the woman's forehead, around her eye sockets, across the bridge of her nose and her upper lip and chin, and along her neck (Figure 6-46a). Her skin was now more uniform in color but too pink. I used a broad airbrush at very low opacity, selected some brown from her hair, and ran the brush over her skin to produce a flesh tone that I liked (Figure 6-46b).

The shadows on the woman's neck and hair were very magenta, so I selected a yellow-brown tone from her hair and painted over her neck at moderate strength and her hair at high strength to correct those colors (Figures 6-46c and d). That gave me the photograph in Figure 6-44c. Her hair and skin color now looked very good, with the magenta shadows obliterated and the cyan highlights converted to healthier skin tones.

Fig. 6-46 Color airbrushing is done by painting into an empty layer whose blend mode has been set to Color. This shifts the hue of the underlying layers without altering their density or contrast. The frames here show successive stages in the process of airbrushing Figure 6-44. Restoration starts with airbrushing the highlights in the woman's face to eliminate their cyan cast. The airbrushing in (b) and (c) evens out the skin color over the rest of her face and eliminates greenish highlights on her hair. The effect of this intermediate stage of airbrushing is shown in Figure 6-44c. (d) corrects the color in the woman's hair, and (e) removes the yellow stains from the background. (f) makes the excessively cyan shadows and folds in her blouse more neutral, with the finished result shown in Figure 6-44d.

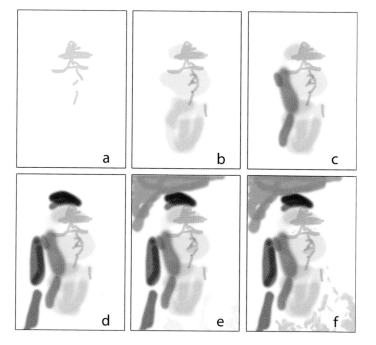

The upper-left part of the photograph was stained yellow, so I sampled the background on the right and used the airbrush at about 50% strength to change the color of the stained areas to match the rest of the background (Figure 6-46e). That got me almost to where I wanted to be.

The whites of her eyes and the folds of her dress were too cyan. I sampled a gray tone and used a small-radius brush at 30% opacity to dot in the whites of her eyes, erasing the cyan there. I then ran the brush over the folds of her dress, taking care to avoid the red pattern, making the folds in the fabric much more realistically neutral. The finished color airbrush layer is shown in Figure 6-46f.

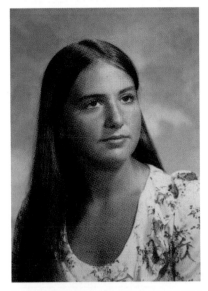

That airbrushed color layer gave me the photograph in Figure 6-44d, which looks awfully good. But it's not the only way to achieve some of these corrections. Instead of painting gray over the whites to make them more neutral, I can do the same thing with a masked Hue/Saturation adjustment layer. This is a great way to eliminate residual color casts in shirts and blouses or white hair or to make distracting backgrounds less obtrusive.

How to create neutral tones with a Hue/Saturation layer

The top image in Figure 6-47 shows what the high school portrait looks like after the color airbrushing shown in Figure 6-46e. Instead of correcting the whites of the eyes and the blouse with more airbrushing, I'm going to do it by adding a Hue/Saturation adjustment layer with the settings shown in Figure 6-48.

This layer leaves brightness unchanged, but it greatly reduces color casts. I didn't turn the saturation all the way down, because that would leave those tones exactly neutral gray. Most pictures aren't truly neutral gray; if I had done that to some areas the results would look strange. I increased the saturation in the Reds to counter the overall desaturation and leave the pattern on the dress unchanged. That made the next step (the mask painting) go a lot faster because I could paint over the whole dress instead of working around the pattern.

I filled the mask channel with black and painted white into the areas that I wanted to make more neutral. The bottom image in Figure 6-47 shows the effect of this adjustment layer on the photograph.

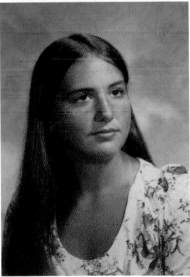

Fig. 6-47 The top photograph has a cyan cast in the whites of the eyes and the dress. A Hue/Saturation adjustment layer (Figure 6-48) can remove that cast easily, as the bottom photograph shows.

Hand-Tinting Photographs
Using Masked Layers to Hand-Tint Photographs

Adjustment layers are a great way to repair hand-tinted B&W photographs. Figure 6-49 shows a 60-year-old photograph that has turned brown and faded. It also has a little bit of physical damage, some cracks and stains, but mostly it's the poor tonality and color that are the problem.

As with any restoration, the first step is making a good scan. The scan I made is shown on the right in Figure 6-49. The purpose of the scan was not to produce good color but to get a good range of tones from near-black to near-white. The color was something I'd take care of with masked adjustment layers. You can create such masks with the magic wand in Photoshop, the mask range selection tools in Picture Window, or any of the masking plug-ins I recommended in Chapter 3, or you can draw the selection by hand with the Lasso or edge-selection tool. It doesn't really matter which method you use in a situation like this.

Fig. 6-48 This Hue/Saturation adjustment layer neutralizes the color cast in the whites. The saturation increase in the Reds counteracts the overall reduction in saturation, so the mask could be painted in broad strokes over the entire dress.

How to hand-tint a photograph with masked layers

I constructed a set of masks, one for each area that was to be tinted (see Chapter 7, "Making Masks," page 236, for details). It's not critical that the mask be perfect, because you can rework the masks at any time, adding or subtracting from them with the Brush tool. I made masks for the dress, the background, the bare skin, the shoes, the hair ribbons, and the hair. I saved each selection in a separate channel and named it (left image in Figure 6-50).

Next I created Hue/Saturation adjustment layers using each of those masks (right image in Figure 6-50). Figure 6-51 shows the mask for the skin adjustment layer along with the Hue/Saturation settings that I used. In the master channel, I entered −7 for the hue to make the skin tones more pink (notice how the rainbow scale at the bottom of the control panel shifted). I increased the saturation significantly and also lightened the tones until they looked right to my eye. The shadowed areas in the skin tones were still sallow, so I went to the yellow channel, shifted the yellows toward the red, and increased their saturation. That warmed up the shadows sufficiently to give me the skin tones in Figure 6-52, left.

Next I corrected the background adjustment layer, using the mask and Hue/Saturation settings given in Figure 6-53. The adjustments I made improved the whites, lightened the background, and gave it a slightly warm

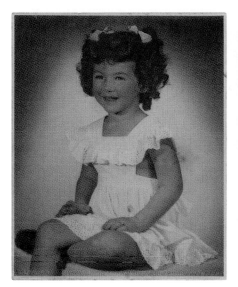 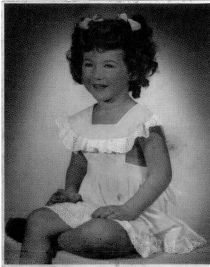

Fig. 6-49 On the left is a faded and stained hand-tinted photograph. On the right is the scan I made from it. The goal of the scan was only to get a full range of tones from black to white. The color balance of the scan isn't too important because I'm going to retint the photograph.

Fig. 6-50 On the left are the masking channels I created to hand-tint the photograph. (See Chapter 7 for techniques for making these masks.) On the right is the stack of Hue/Saturation adjustment layers I created from those masks. Each layer corrects the tint in a different part of the photograph.

tone (center image in Figure 6-52). I made comparable corrections, judging by eye and my taste, to all the Hue/Saturation adjustment layers. Because everything was being corrected in layers, if I decided I didn't like an earlier adjustment I could go back and correct it by changing the settings in that layer's control panel.

Fig. 6-51 These are the adjustments in the Skin adjustment layer. On the left is the mask for the layer, which restricts its effect to bare skin only. The Master Hue/Saturation adjustment (center) increases the saturation and lightness of those tones and makes them redder because I've shifted the Hue by −7 points. I also modified Yellows, shifting their Hue even farther toward the red and increasing saturation by +15 points. This layer converts the scan in Figure 6-50 to the photograph at left in Figure 6-52. Observe how this changes the rainbow scale at the bottom of the control panel.

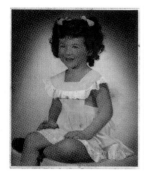
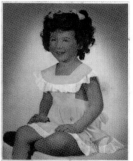
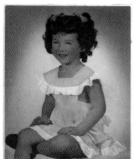

Fig. 6-52 Successive stages of hand-tinting. The figure on the left shows the changes produced by the Skin adjustment layer only. The middle figure shows how the photograph changes after I tinted the background using the settings in Figure 6-53. The figure on the right shows the finished retinted photograph. See the main text for full details.

Fig. 6-53 The adjustments for the Background adjustment layer. On the left is the mask that selects the background and the white trim on the dress. The Hue/Saturation adjustment shifts the Hue by −7 points, eliminating the greenish cast and lightening the tones by a substantial +23 points. That whitens the lace on the dress and makes the shadows in the background softer and more attractive. The result is shown as the middle photograph in Figure 6-52.

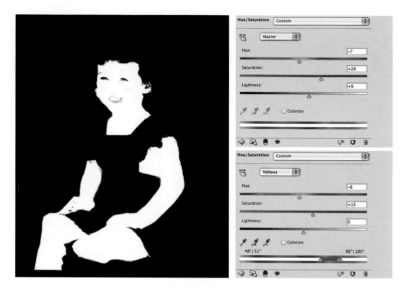

I discovered in many cases that my masks weren't perfect. For example, the skin mask overlapped the background in a couple of places. Fixing that was easy. I highlighted the skin adjustment layer, which automatically activated the mask in that layer, set the Brush tool to a small radius, and painted with black or white to add or subtract from the mask. Mask changes were instantly reflected in the photograph's tone and color, so it was very easy for me to fix up the masks by eye. Periodically I turned on the Quickmask (Q) view to make sure I had not missed any spots.

Once I was completely happy with the colors, I went back to the base layer to clean up the stains and damage. That's another good thing about layers; I can repair physical damage without messing up any of the color corrections I've done.

I used the Dust & Scratches filter and the Clone tool to clean up the stains and cracks in the background, and I blurred the background overall to smooth out the tones. The finished result is shown on the right in Figure 6-52.

This is not a very sophisticated job of tinting, because the original hand tinting was crude and hastily done. Look along the border between the blue dress and a white lace; the studio didn't even make much of an effort to follow the contours of the dress and lace. It would have been easy for me to do a much nicer job of hand-tinting, but I wanted to preserve the charm of the original.

On the other hand, should I change my mind about this, my options are preserved in the channels and adjustment layers. I can go back and refine the masks, even add new selections and masks if I want to do more detailed tinting and color corrections; there's really no limit. My decision to stop here is not irrevocable.

Hand-Tinting with Coloriage

Hue/Saturation layers work great for hand-tinting when the original color's still intact, albeit faded. It's not as useful for badly damaged photographs, since a lot of the time the original tint will be gone, in whole or in part. There will also be times when the client will want you to hand-tint a photograph that was black-and-white to give it a "period" look.

In cases like these, or if creating your own tinting masks is too onerous, a plug-in like AKVIS Coloriage is just the ticket. Coloriage will do most of the hard work. As I explained in Chapter 3, page 79, it only demands that you crudely outline the region to be tinted and Coloriage will automatically find the boundaries and fill in the region with the selected tint. There are only a few tricks to using it well that I need to impart, so let's pick up with the photograph as I left it in Chapter 3.

How to hand-tint a photograph with AKVIS Coloriage

As I described In Chapter 3, page 79, using Coloriage is extremely simple. Pick the color and tone you want from the selection on the right side of the control panel (image on left in Figure 3-15) and use the blue Pencil tool to draw it into the region to be tinted. If you overshoot your mark, the eraser removes penciling you don't want.

In a badly faded or low-contrast photograph, Coloriage isn't going to do a perfect job of finding the edges, and the colors that result may not be quite what you expected (image at right in Figure 3-15). In this photograph, the colors in the blanket, the background, and the white dress have bled together in the lower right part of the photograph. The shoes are unpleasantly bright, and there's a bit of color leakage from the dress into her left arm and from her right arm into the dress. I neglected to isolate her ring, mouth, and eyes, so they've all been tinted pink. Let's fix those mistakes.

I opened up the original photograph and duplicated the background layer to make a layer to hand-tint. Then I launched Coloriage and loaded the previously saved pen strokes that produced the image on the right in Figure 3-15. I began by fixing the shoes. Using the "magic tube" tool, I assigned a different color to those pencil strokes. Next I used the eyedropper to assign the color in the skin-tone pencil strokes to the blue pencil tool and carefully circled the eyes, mouth, and ring to exclude them from the skin-color region. In the same manner, picking up previous pencil strokes' colors and assigning them to the pencil, I drew more careful borders along the edges where colors had inappropriately leaked.

Zooming in, I added silver to the ring, white to the teeth and the whites of the eyes, brown to the pupils, and pink to the lips and tongue (Figure 6-54). I got the appropriate colors for the eyes and the mouth from the library. Applying these revisions gave me a plausible hand-tinted image.

Fig. 6-54 AKVIS Coloriage produces precise hand-tinting from a freeform sketch of the regions and colors you want applied to the photograph. This is a big improvement on Figure 3-15 that I executed days later, starting from a saved sketch.

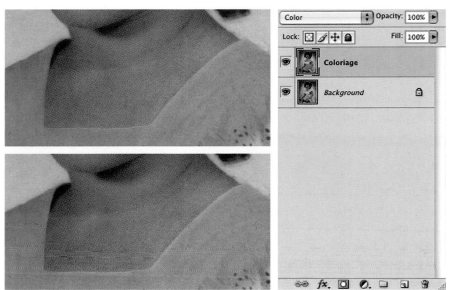

Fig. 6-55 Coloriage can do too precise a job of tinting, producing boundaries between colors that look unrealistically sharp (upper left). Soften the results by changing the tint layer's Blend mode to Color and apply a 2- or 3-pixel radius Gaussian Blur to it (lower left).

On close inspection, the tinting doesn't look entirely natural, because Coloriage creates pixel-perfect margins and hand-tinting just isn't that sharp and precise. To make the results look more natural, I changed the blend for the tinted layer to Color and blurred the layer slightly. A Gaussian Blur of 2 or 3 pixels made the results look just as though they had been done by hand instead of computer (Figure 6-55).

Fixing Chromatic Aberration with Picture Window

Old amateur color photographs frequently suffer from a bit of lateral chromatic aberration (color fringing at the edges of the photograph) because the lenses on the cameras weren't very good. Some modern digital cameras also have color fringing problems that you may have to deal with if you're rephotographing the original instead of scanning it. A little fringing isn't a big deal, but it is so easy to fix that it's worth repairing. If you're working on a small photograph that is going to be enlarged, eliminating the problem helps the enlargement look sharp.

Figure 6-56 is a typical 1950s photograph with a case of chromatic aberration. Photoshop has a tool (the Lens Correction filter) for eliminating it, but I don't like it very much. It's a coarse adjustment that I feel is too hard to use precisely.

When I need to eliminate chromatic aberration, I prefer to use Picture Window.

203

Fig. 6-56 Lateral chromatic aberration (color fringing at the edges of a photograph) frequently shows up in old amateur color photographs because lenses weren't very good. It's not a serious problem, but it's easy to fix, and doing so makes the photograph sharper.

How to remove color fringes from a photograph

Figure 6-57 shows how Picture Window corrects chromatic aberrations. The window in the upper left displays a 300% view of the corner of the photograph that I corrected. Chromatic aberration gets stronger the farther you get from the center of the photograph, so a corner or edge with sharp detail like this is where to look to judge your corrections.

The window at the upper right shows what the corrected photograph will look like. The long rectangular window at the bottom is the Chromatic Aberration correction control panel. Picture Window lets me change the size and shape of the control panel, so I stretched it out horizontally to expand the correction scales. That way I could make very fine adjustments.

I moved the red shift slider back and forth until I minimized the cyan and red fringes around the fine detail in the Preview window. Then I did the same for the blue shift slider. It's harder to see the blue correction, because the fringing will be yellow versus blue, which doesn't have very good visual contrast. The user must do the best she can. Once I had the sliders set, I clicked Apply to create a new, corrected photograph.

If you're unsure whether you've gotten the degree of correction just right, reposition the sliders and click Apply again. Each time you do this, you'll create a new window with the new version of the corrected photograph. Once you're finished, click OK and you can pick the version that looks best and save it.

Fig. 6-57 The Chromatic Aberration transformation in Picture Window does a more controllable and precise job of fixing this problem than the Lens Correction filter in Photoshop. This screenshot shows the transformation at work. The window on the left shows the lower-right corner of the photograph from Figure 6-56 at 3X magnification. The color fringing is quite clear at this scale. At the bottom is the Chromatic Aberration control panel, stretched out horizontally to give me very precise control over the position of the Red Shift and Blue Shift sliders. On the right is the Preview window showing how the transformation will change the image.

Repairing chromatic aberration should be the second thing that you do in the restoration process. The very first thing is to clean up the scan, eliminating all dust, dirt, and physical damage from the photograph. To illustrate why it's necessary, I didn't do that in this case. Look at the circled area with the dirt speck in the before and after photographs, enlarged in Figure 6-58. Because dirt's not part of the image, it doesn't have any color fringes. Correcting the chromatic aberration for the photograph smears out the speck into a rainbow smear that will be a lot harder to retouch. That's why you want to do all your cleanup first.

Fixing Color Stains and Development Marks

Sometimes photofinishers misprocess film. The top image in Figure 6-59 shows a photograph from a 35 mm negative that received improper agitation. There are pink and green bands along the edges where the developer flowed unevenly around the sprocket holes in the film. This ruined an otherwise good-looking photograph. Fortunately, I can fix that digitally (bottom of Figure 6-59). Often the best way to tackle a color stain problem like this is to convert the photograph from RGB to Lab color, as described in the first edition of this book. You can read the details at http://photo-repair.com/dr1.htm.

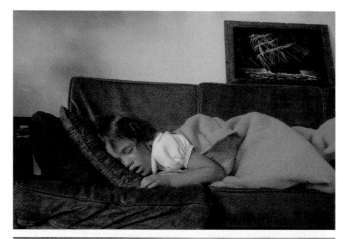

Fig. 6-58 This is a greatly magnified dust speck, showing what happens to it after chromatic aberration correction. Since the speck didn't have any color fringes to begin with, the correction turns it into a rainbow-colored smear. This will be much harder to clean up than the original sharp speck. Make sure you repair all dust, dirt, and physical damage before correcting chromatic aberration in a photographic image.

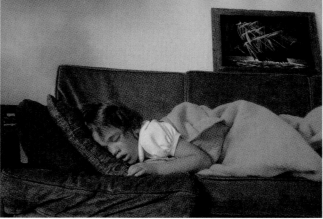

Fig. 6-59 This color negative (top) was poorly processed by the photofinisher; the pink and green bands at the top were caused by uneven developer flow around the film's sprocket holes. The color bands (bottom) have been cleaned up, but the photograph still needs careful color balancing.

When you're done cleaning up in Lab space, you can convert the photograph back to RGB color to continue your restoration. That was what I did to finish up the photograph at bottom in Figure 6-59. First, I blurred the wall to smooth out the distracting shadows. Next I corrected the color.

Just by looking at it, it's not difficult to see what's wrong with the color in the image at the bottom of Figure 6-59. The walls are an unlikely shade of green, the sleeve isn't white, the girl's hair looks too red, and her skin tones are sallow. Being able to correct all that with just a handful of Curves adjustment points (Figure 6-61) is another matter. Years of experience and a certain amount

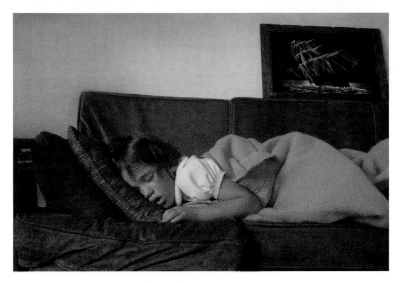

Fig. 6-60 The photograph from the bottom of Figure 6-59 after applying the Curves adjustment from Figure 6-61. Overall color balance is restored by those curves, and this photograph is now ready for the finishing touches that will make the color perfect.

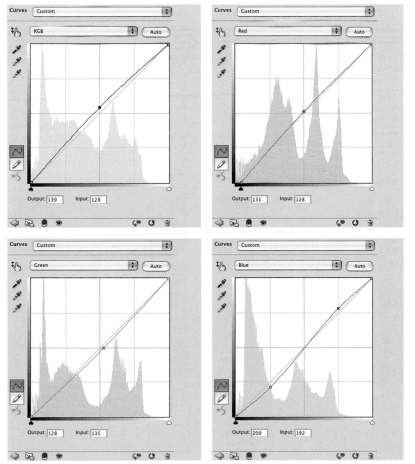

Fig. 6-61 These curves correct the color and tonality of the image at bottom in Figure 6-59. The RGB curve slightly lightens the photograph. The red curve fixes some minor color crossover, eliminating a cyan cast from the highlights and taking excess red out of the shadows. The green curve makes the photograph overall more neutral by adding magenta (reducing green). The blue curve eliminates a substantial amount of color crossover, making the shadows considerably yellower and highlights significantly bluer.

Fig. 6-62 The Color Mechanic plug-in is another way to correct the color of the image at bottom in Figure 6-59. In the first step, pictured in this screenshot, I selected a point on the wall and dragged it toward the neutral center point, clearing out much of the overall greenish color cast of the photograph.

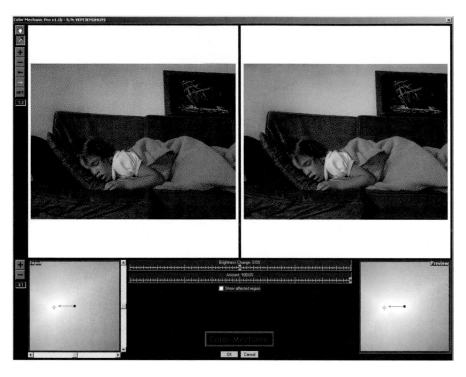

Fig. 6-63 Successive stages of Color Mechanic correction. On the left I've set a control point in the little girl's skin and dragged it to a more saturated, slightly pink hue. The center figure corrects the color of the girl's hair, eliminating an unlikely pinkish tinge by making it yellower (browner). In the final adjustments on the right, I added fixed control points for the green blanket, red pillow, and brown sofa to lock those colors to their original hues.

of intuition guided my hand. It's not a skill I can teach you in a couple of pages; it's something you'll develop on your own after much practice.

Fortunately, there's another, much more artistically intuitive way to correct the color. The Color Mechanic plug-in (reviewed online at http://photo-repair .com/dr1.htm) did an even better job than my curve corrections. Color Mechanic is also built into Picture Window.

How to improve color with Color Mechanic

Figure 6-62 shows the full control panel for Color Mechanic with my first correction. I wanted to make that wall neutral, so I clicked on it, which set the light-green control point in the color map at the lower left. I dragged the arrow from that point to just slightly on the warm side of the neutral center marker. The Preview window in the upper right shows what happened to the color; the color map on the lower right shows how all the colors were altered to accommodate this adjustment.

The wall and the sleeve were now neutral, and I wanted to fix the skin tones next, so I clicked on the girl's arm. I dragged the new control point's arrow away from the center and a little toward the red, which warmed the color and increased its saturation (image at left in Figure 6-63). I removed the excess red from her hair by clicking on a highlight in it to create the red control point shown at center in Figure 6-63. I dragged that arrow toward the yellow, which made the hair browner.

I added three more control points by clicking on the green blanket, the bright red pillow, and the brown sofa. The new red, green, and orange points on the right in Figure 6-63 pinned those colors to their original values. I also made slight refinements to the control arrows for the girl's skin and hair. This got me the final version of the photograph you can see in Figure 6-64.

Fig. 6-64 This is the photograph from the bottom of Figure 6-59, as corrected with Color Mechanic. This is even better than the Curves-corrected version in Figure 6-60. Of course, there's nothing to keep you from using both of these tools on the same photograph.

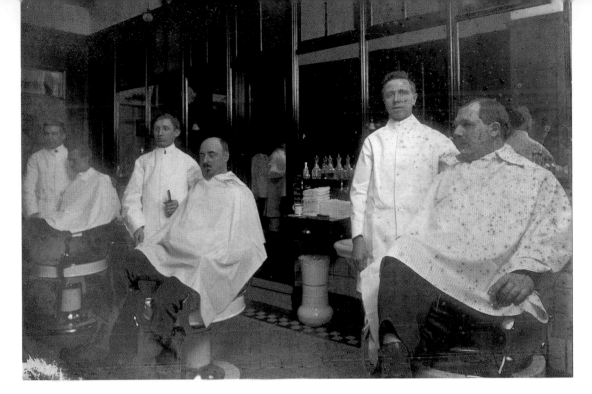

Chapter 7

Making Masks

How-To's in This Chapter

How to eliminate tarnish from a photograph
How to select cracks with the Find Edges filter to make a mask
How to select cracks with the Picture Window Edge tool
How to enhance cracks for selection
How to select cracks with the help of a noise reduction program
How to select tarnished parts of a photograph
How to use Channel Mixer to emphasize damage for masks
How to select damage by color with Image Calculations
How to select cellophane tape damage by color range
How to use Mask Pro to select cellophane tape damage
How to create a damage selection mask from a single color channel

Why Mask?

You can do restoration without masks, but mask making is an essential skill if you want to do really good restoration work. Masks let you apply changes to parts of photographs so that you can control precisely where and how strongly an adjustment changes the photo. A mask has no direct effect on a photograph; it merely governs the adjustment. In other words, a mask is a means to an end, not an end in itself.

A mask is nothing more than a grayscale image that is the same size as the photograph. Black areas in the mask completely block whatever change you're making to the photograph; white parts of the mask permit the change to work at 100% strength. Gray values in a mask produce intermediate-strength changes—the lighter the tone in the mask, the stronger the effect your adjustment has on the photograph.

Masks are portable. You can save masks as standalone grayscale image files, as Alpha channels in a Photoshop layer, or as separate layers. You can copy a mask from one image to another; you can even make masks with one application and use them in a different one. For example, I use some of the mask-making tools in Picture Window to create masks for use in Photoshop.

Saving and using masks is very simple. Once you've composed the grayscale mask image, create a new channel in the photo you'll be masking. It's a good idea to give the channel an identifying name, like "face," so you can pick it out in the channel stack easily when you need it. Copy the grayscale mask image, and paste it into that new channel. When you want to use the mask as a selection, go to Select/Load Selection, pick that channel from the drop-down menu of choices in the control panel, and click OK. The mask becomes a selection.

A mask can be as simple as a B&W outline or silhouette, like the ones I used for hand-tinting a photograph in Chapter 6, "Restoring Color," page 199, one of which is reproduced here (Figure 7-1). Near the end of this chapter, I show you how to make these masks.

Every adjustment layer in Photoshop automatically has a mask channel. Much of the time you don't pay attention to it because the mask is, by default, white everywhere. In that case the layer adjustments change the whole photograph uniformly at full strength. Replacing the white with a carefully constructed mask is a very useful way of controlling how the photograph looks. The instructions for eliminating tarnish from a photo demonstrate that. I essentially eliminated the tarnish in a single operation. That's the power of a good mask!

Fig. 7-1 A mask is nothing more than a grayscale image that is the same size as the photograph that you want to mask. It can be a simple B&W silhouette, as shown here. This mask selects for the background and the white lace trim on the little girl's dress and blocks everything else.

How to eliminate tarnish from a photograph

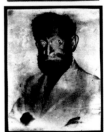

For the photograph at the top in Figure 7-2, I created the continuous-tone mask shown to select for the tarnished areas in the photograph, as described on page 227. I used that mask in a Curves adjustment layer with the settings shown in Figure 7-3. I made the Curves adjustments by eye in this case, but this would have been a good place to use the middle gray eyedropper. Clicking the eyedropper on a point where the tarnish was worst would have corrected the color balance to make it neutral.

Even after correcting the color, the tarnish will still be lighter than the surrounding photograph, so the final step is to adjust the RGB channel to darken the tarnish until it's no different in brightness from the unaffected parts of the photograph. I did that by adding a point to the RGB Curve at a mid-dark gray level and dragged the point down until the tarnish disappeared (Figure 7-2, bottom).

A mask doesn't even have to portray the content of the photograph. I use such masks to manually control the strength of an alteration and where it gets applied to the photograph. In Chapter 5, I used a gradient mask (Figure 5-39) in a Curves adjustment layer to correct uneven exposure and contrast in the photograph shown in Figure 5-37. For the photograph shown in Figure 5-43, I used hand-painted masks in Figures 5-45 through 5-51 to burn in parts of the photograph to

Fig. 7-2 Continuous-tone masks are powerful correction aids. The top photograph is badly tarnished. The mask in the middle selects for that tarnish, using techniques explained later in this chapter. When that mask is used in combination with the Curves adjustment in Figure 7-3, the tarnish is almost completely eliminated in a single step (bottom).

Fig. 7-3 This Curves adjustment, used in conjunction with the mask from Figure 7-2, repairs the pale-blue tarnish. The RGB curve makes the tones darker, the green curve makes them more magenta, and the blue curve makes them much more yellow. This is an extremely effective tarnish-repair technique.

correct tones and repair the damage caused by light fog in the original negative. In Figure 5-69, I used a very simple hand-painted mask to dodge and retouch a face, eliminating hard shadows and lines.

This chapter won't teach you all about masking. In fact, it will only teach a small fraction of what there is to know on the subject. Real masters of masking (don't count me among them) can work wonders that go far beyond what I offer up in this chapter. You may be amazed at what I accomplish with masks, but I can assure you it's just the tip of the iceberg.

If masking proves to be your cup of tea, I strongly recommend you pick up a copy of *Photoshop CS4 Channels & Masks One-on-One,* by Deke McClelland, published by Deke Press/O'Reilly. It's the best book I've found on the subject so far, plus it has great explanations of different blending modes and how they work (another difficult-to-absorb subject).

Many Ways to the Same Goal

Just as there are many kinds of masks, there are many ways to create them. At the end of this chapter, I show you five different ways to mask the same photograph. Different masking tools appeal to different people and have different strengths and weaknesses. Simple masks can simply be drawn or painted in, as I did with the photograph of the three women in Figure 6-26. In most situations, though, manually constructing a mask is very time consuming and tedious. I much prefer tools and techniques that let the software do the work for me. I use a lot of different tools for making masks. I discuss my favorite tools in this section.

The simplest tool is the Magic Wand in Photoshop. I know many professionals who think it's too crude a tool to be very useful, but I'm pretty fond of it. I use it a lot when I need to make a purely B&W mask. The key to using it with some precision is to keep the tolerance low and use the wand in Add mode so that you can build up your selection from carefully selected colors and tones. If I select too much, the Subtract mode comes in handy, along with Undo and History reversions. The big limitation of this tool is that it's no good for creating a continuous-tone grayscale mask, which is important for most masking work.

Fig. 7-4 This screenshot shows how well Picture Window's masking tools work to find edges (the unmasked photograph can be seen in Figure 7-6). The bright green area is the selected area. I painted in that selection using the Mask Paint tool, set to track "similar pixels." Painting that tool along the border between the baby and the background selects pixels in the background but rejects those in the baby and highchair.

Conversely, I know professionals who are very fond of the Color Range Select tool in Photoshop, but I've had trouble warming up to it. I think it's great for selecting highlights and pretty good for selecting shadows, but when it comes to using it in the Sampled Colors mode, I usually have difficulty getting exactly what I want. On the other hand, it does generate a continuous-tone mask.

There are several Photoshop plug-ins that I'm fond of: Fluid Mask, Mask Pro, and Asiva Selection. The first two are especially useful when I need to construct a complicated mask and I don't have strong image characteristics such as contrasting tone or color that easily define a mask. When I can define a mask in terms of tone, saturation, and color, Asiva can create it for me very quickly, and it does a much better job than Photoshop's Color Range tool.

Picture Window has several mask tools that work well for me. The one I like best of all is the Paint tool with the Similar Pixels option selected. Figure 7-4 shows a mask under construction (the bright green areas are selected areas) that uses the brush settings of Figure 7-5. The brush makes the pixel values at its center point the selection reference; it selects any other pixels within its radius that

Fig. 7-5 A close-up of the Mask tool control panel in Picture Window. The Paint tool is selected; note the large number of controls at one's disposal for this tool. Other tools include Color Range and Brightness Curve selection tools as well as an assortment of geometric shapes and spines, plus combinatorial tools for adding and subtracting from mask selections.

215

are similar to the target pixel. As you paint with the brush, it finds such pixels and adds them to the selection.

This is a great tool for masking complicated and subtle boundaries. Paint along the perimeter of the area you want to mask, keeping the center of the brush in the selected area. The brush will automatically include the pixels that are similar and mask out the pixels on the other side of the border because they're different. You can set the threshold to be as narrow or as inclusive as you like, so you can mask some very subtle boundaries automatically. I used a tight threshold in Figure 7-4, and I was able to selectively mask the legs of the highchair without masking the background. In the photograph I can barely tell them apart visually, but the low-threshold masking brush picked up on the difference. With Add, Subtract, and Difference options available for the masking tools, plus an Undo button, it's not difficult to refine a selection.

Figure 7-6 shows the original photograph and the mask I created this way. It's still a crude mask: There are lots of pinholes in the white areas because of the tight threshold I used, and the baby and highchair aren't masked off perfectly in a few places. Since the mask is just a grayscale image, I can use the normal Brush and Eraser tools to clean up those mistakes. Meanwhile, creating the basic mask took me only a couple of minutes to get 95% of what I need.

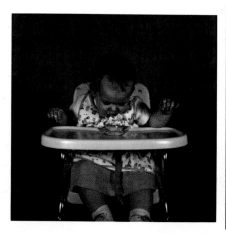

Fig. 7-6 The unmasked photograph of the baby and the mask created with the similar-pixels Paint tool in Picture Window. The mask needs cleaning up and refinement, but the Paint tool has done a remarkable job of automatically finding the boundaries between the foreground and the background.

Picture Window also has a Brightness Curve tool at the right end of the row of masking tools. The Color Range Select tool in Photoshop works like a crude version of that when you choose the Highlights, Midtones, or Shadows range for masking. In Picture Window's tool, you can control in detail which brightness values get masked by drawing a curve. You can select a broad or narrow range

of tones or even a complicated combination of light and dark tones. Whatever you can draw in a curve, you can mask for.

How do I decide which tool to use in a particular situation? I look at the photograph to figure out what is distinctive about the area that I want to mask. That's the key to masking: All these tools work by finding some difference between the part of the photo you want to mask and the part you don't. The areas I want to mask might differ in terms of brightness, color, or sharpness from the ones I don't. The approach I use to getting a good mask is to emphasize the difference that best defines my intended selection and then pick the masking tool that works best with that kind of a difference. Let's look at some examples of how that works.

Isolating Cracks

You may not have thought of masking according to sharpness, because none of the tools you normally use for masking distinguishes between sharp and unsharp parts of the photograph. Photoshop, though, has filters that can do just that.

Figure 7-7 is in surprisingly good shape, color-wise, for a 35-year-old color photograph. The problem is one of physical damage—it's riddled with cracks, creases, and missing chunks of emulsion, as the close-up view at left in Figure 7-8 shows. Frankly, I could paint the whole

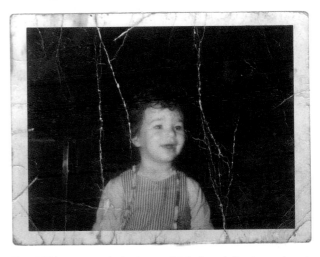

Fig. 7-7 This 35-year-old color photograph is badly cracked and creased. Manual damage repair would work just fine, but a mask that selects the damaged areas will make repairs go much faster.

Fig. 7-8 A close-up of Figure 7-7 shows just how extensive the cracking is. The much-improved photograph on the right is a close-up of Figure 7-12, the result of the masking and repair methods shown in the next four figures.

217

background charcoal gray and nobody would notice. Instead, let's treat it as a challenge: What can I do to clean up that damage without changing anything else in the photograph? The answer is to create a clever mask that selects only the damaged areas.

How to make a mask by selecting cracks with the Find Edges filter

I scanned this 3 × 4-inch photograph at very high resolution: 1200 ppi. As you can see in Figure 7-8, the photograph isn't anywhere near sharp enough to justify that detailed a scan. I did it because I wanted to make the physical damage as sharp and distinct from the photographic image as possible.

I made a copy of the image and ran the Find Edges filter on it. That produced the image at the top in Figure 7-9. The blue channel did the best job of showing the cracks without showing any

Fig. 7-9 The Find Edges filter in Photoshop can pick out fine cracks. The top figure shows the full-color image produced by applying this filter to a copy of Figure 7-7. The bottom figure shows the blue channel only, which does the best job of picking up the cracks while ignoring the real photographic detail.

of the photographic detail, so I copied that as a grayscale image and threw away the other two channels (Figure 7-9, bottom).

Next, I manipulated that filtered image to turn it into an effective mask. A highly enlarged section of the blue channel appears at the upper left in Figure 7-10, with successive alterations shown clockwise. First I applied a Gaussian Blur to the mask, to widen the edges, and then I used Curves to make the features much darker and more contrasty. The blur and curve settings are shown in Figure 7-11. Lastly, I inverted the image so that when used as a mask it would select for the cracks instead of everything else.

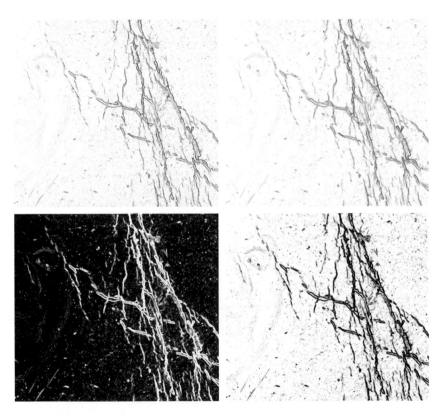

Fig. 7-10 Successive stages in making a crack-selection mask. Starting from the upper left, this is an enlarged view of the blue channel from Figure 7-9. I applied a Gaussian Blur to that channel to broaden the edges of the cracks. Then I used the Curves tool to increase contrast and make the cracks much blacker. The settings for these adjustments are in Figure 7-11. Lastly, I inverted the image so that the cracks were selected (white).

I copied the mask I devised in the sidebar and pasted it into an Alpha channel I created in the original photograph (Figure 7-12, bottom). Next I loaded the Alpha channel as a selection to use the mask as a selection by going to Select Load Selection, picking that channel from the drop-down menu of choices in the control panel, and clicking OK. I applied a Median filter with a 20-pixel radius, which got me the image at the top in Figure 7-12. I enlarged a small section of

Fig. 7-11 A Gaussian Blur with a 1.2-pixel radius broadens the edges of the cracks and smooths them out. The Curves adjustment makes the background white and the crack edges solid black so that the mask strongly distinguishes between them. This makes a much better mask for doing crack repair.

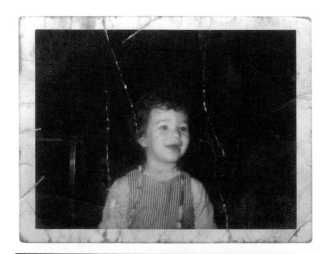

Fig. 7-12 The full mask from Figure 7-10 is shown at the bottom. Above it is the photograph after being filtered with a Median filter with a 20-pixel radius. The mask limits the effect of the filter to the crack edges, so it eliminates a majority of them while having very little effect on the photographic image. An enlarged section of this photograph appears in Figure 7-8, right.

the photograph at the right in Figure 7-8 to show how much garbage I eliminated in a single operation by using this mask.

How to select cracks with the Picture Window Edge tool

If you're intrigued by the idea of using filters to select cracks from which to build masks but you would like more flexibility when creating your edge masks, consider using Picture Window's Edge

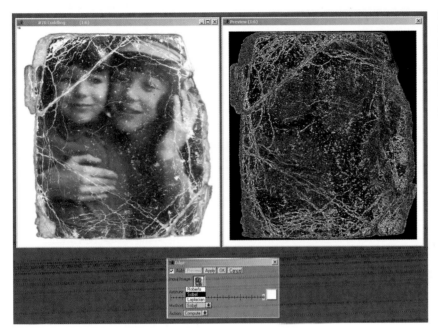

Fig. 7-13 Picture Window's Edge tool has several different mathematical methods for computing edges that produce different results. This screenshot shows the Sobel method.

transformation tool (Figure 7-13). This tool has three different mathematical methods for finding edges that produce different results. It also has adjustable strength and two special Action modes: Darken and Lighten.

The Darken action can minimize a lot of damage directly, as you can see at the center in Figure 7-14. You can set how much it darkens the edges with an adjustment slider. Lighten (Figure 7-14, bottom) makes cracks and light spots stand out even more strongly. This mode is not something you would use for repairing cracks directly, but emphasizing them can make it easier to select them using other masking tools.

While I'm on the subject of emphasizing features to make them easier to mask, here's another way to make it easier to select fine cracks and other damage for repair. Sharpen a copy of the photograph to enhance the edges of the cracks before using the Find Edges filter or Picture Window's Edge tool.

How to enhance cracks for selection

Figure 7-15a shows a portion of a photograph that is covered with very fine emulsion cracks. (The inset boxes in the upper-left corners of Figures 7-15a and 7-15b show magnified views of some of those cracks.) The cracks all have well-defined edges and are very small, which makes them ideal

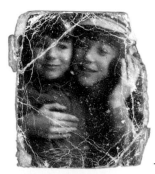

candidates for an edge-selection mask. Figure 7-15b shows what happened after I applied an Unsharp Mask (Figure 7-16) filter: The fine cracks are greatly enhanced in contrast and sharpness.

I followed this with the Find Edges filter (Figure 7-15c). Looking at the three color channels, the blue channel again did the best job of bringing out the edges of the cracks without emphasizing the edges of the photographic detail. I copied the blue channel (Figure 7-15d) and pasted it into an Alpha channel in the original photograph. In Chapter 8, "Damage Control," page 268, I show you how I used this mask to almost totally eliminate the cracks and crazing in a few easy steps.

Fig. 7-14 The Picture Window Edge tool has options for lightening or darkening the edges it finds. You can use this tool to enhance cracks (bottom) to make it easier to make masks from them or to suppress cracks (center) to repair damage.

The Glowing Edges filter in Photoshop has some benefits that the Find Edges filter lacks (Figure 7-17). You can vary the edge width to encompass wider or narrower cracks; in many cases you won't even need to apply a Gaussian Blur to the results. The smoothness adjustment works more like a fine-detail finder; at lower settings it selects for smaller and sharper edges, while higher settings pick out grosser detail. You can produce a fairly sophisticated mask in a single step with this filter. Note that the Glowing Edges filter only works on 8-bit files, so you need to convert a copy of the file from 16 bits to 8 to use it.

Here's another approach that produces similar results but doesn't require conversion to 8 bits. Run the Find Edges filter, convert the image to grayscale, invert it, and use the Lens Blur filter to increase the width of the edges to fill in the gaps. This method is very effective and gives you a lot of control. I use this method in the how-to on page 224 in combination with noise reduction.

Odd as it sounds, a noise reduction program can help when you need to emphasize and select major damage in a photograph. Noise reduction programs have to walk a fine line between eliminating noise from a photograph and erasing real image detail. To successfully do that, their filters have thresholds built into them that keep them from working too aggressively; the filter does its best to ignore any features that are larger or more contrasty than the thresholds.

What that means for you, the restorer, is that you can use these tools to suppress a great deal of photographic detail while leaving damage alone, since damage is usually sharp and contrasty. Cleaning up the photograph that way while leaving the damage intact makes it a lot easier for filters like Find Edges to lock onto the real damage without being fooled as much by dirt or fine detail in the photograph.

222

Fig. 7-15 The photograph in (a) is riddled with fine cracks that need to be repaired. (b) shows how the cracks are accentuated by Unsharp Masking, using the settings in Figure 7-16. This makes it easier for the Find Edges filter to pick out the cracks, as shown in (c). The blue channel (d) displays the cracks most clearly without including much photographic detail, so it will work best for a mask.

Fig. 7-16 These Unsharp Mask settings do a good job of highlighting the cracks and their edges without picking up extraneous detail in the photograph. Setting the Threshold above 0 keeps the filter from accentuating noise and low-contrast detail. This helps the filter work selectively on the cracks.

Fig. 7-17 The Glowing Edges filter has controls for Edge Width, Brightness, and Smoothness. For mask making you'll usually leave the Brightness at 20 to produce maximum contrast. Adjust the Width and Smoothness sliders until the filter does a good job of selecting cracks and little else.

The photograph in Figure 7-14 is a good candidate for this technique because the photograph itself is soft and lacking in fine detail, while the damage is sharp and extensive. Unfortunately, the photograph is covered with fine nicks and flaws that make it hard to produce a mask that selects only for the very worst damage. Attacking the fine garbage with a noise reduction program (in this case, Noise Ninja) lets me generate a much better mask more quickly.

The Reduce Noise filter built into Photoshop is not an especially good tool for this purpose. It doesn't suppress noise nearly as aggressively as the dedicated programs I recommend, nor is it as good at preserving edges and details that we want to retain. It's also extremely slow. Don't imagine that it is a satisfactory substitute for a dedicated noise reduction program.

How to select cracks with the help of a noise reduction program

I made a copy of Figure 7-14 and launched Noise Ninja from the Filters menu in Photoshop. After having Noise Ninja profile the image, I moved all six Strength, Smoothness, and Contrast sliders up

Fig. 7-18 Noise reduction plug-ins, when "misused," can be powerful tools for isolating cracks and damage. For example, maximizing the filter settings in Noise Ninja wipes out most image detail but retains the most extreme damage. The resulting photo can be filtered to extract the damage for a mask.

to their maximum values (Figure 7-18). This clobbered all but the most substantial and contrasty detail, namely the cracks. To further emphasize the cracks I set the USM (unsharp masking) slider at 200%.

The image that resulted from this process had no fine detail except where major damage was. I converted this to grayscale, applied the Find Edges filter, and inverted the resulting image to produce Figure 7-19.

To smooth out the mask and fill in the cracks, I applied the Lens Blur filter. I set the Radius to 6, the Curvature and Brightness to 100, and the Threshold to 135 (Figure 7-20). This produced an excellent mask that needs very little cleaning up before it can be used to attack the scratches.

This trick will work with just about any noise reduction plug-in or standalone program, but different programs have

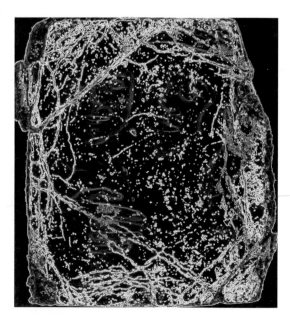

Fig. 7-19 Applying Find Edges to the noise-reduced photograph from Figure 7-18 and inverting the results highlights cracks and other damage.

Fig. 7-20 The Lens Blur filter does a very good job of filling in the broadening crack outlines from Figure 7-19, which creates a very useful mask for damage isolation going into the repair stage.

different kinds of adjustments. Fiddle around with the program of your choice until you find the settings that most suppress the photograph while emphasizing the damage. Usually, as with Noise Ninja, those will be either maximum or minimum settings on the various controls.

Making Masks from Colors

Color is a great way to distinguish between various parts of a photograph that need different kinds of correction, especially if the photograph is in B&W. That's not a paradox. A B&W photograph in good condition has no color differences between parts of the photograph. It's only when you get damage like differential fading, staining, bleaching, or tarnishing that you'll see different colors in different parts of the image. Color changes are a reliable sign of damage that needs to be fixed.

I used Color differences to construct the continuous-tone mask in Figure 7-2. That mask worked so well that it gave me in one step almost complete correction of a serious tarnish problem. The following how-to describes how I did it.

How to select tarnished parts of a photograph

Figure 7-21, top, shows the original photograph, which is yellowed, faded, and tarnished. I made the adjusted scan on the bottom in Figure 7-21 by using the scan level settings shown in Figure 7-22. This gave me a much better range of tones to work with and removed most of the yellow stain. It may not be obvious in the reproduction here, but I left the image slightly yellow, just enough so that it would be easy to distinguish the bluish tarnish from the proper photographic image.

I used Asiva Selection (Figure 7-23) to build this mask, but any of several masking tools would have worked. I set the Hue range to restrict the mask to shades of blue, which corresponded to tarnish. I adjusted the Saturation curve so that areas with very little or no saturation would

Fig. 7-21 The top photograph (also seen in Figure 7-2) is badly tarnished. The tarnish is lighter and bluer than the rest of the image. The scan settings in Figure 7-22 restore much of the photo's neutrality at the same time that they accentuate the tarnish's blue color. That makes it easier to select the tarnish with a mask.

Fig. 7-22 The scan settings for Figure 7-21. The black and white sliders in each color channel are adjusted to closely bracket the highlights in the photograph while leaving the shadow tones well above 0. That leaves the true blacks in the photograph as dark grays, but it ensures good tonal separation between the dark tarnish and the darker underlying tones.

227

Fig. 7-23 Asiva Selection is a good tool for creating masks selected by color and tonality. The mask is shown in orange in the preview window. To select for the tarnish color, I restricted the Hue range to shades of blue. In addition, I set the Saturation slider to reject the parts of the photo that had no saturation (were near-neutral in color) and the Intensity slider to middle-dark tones because the tarnish is dark but not black. The mask this plug-in produced is shown in Figure 7-2, center.

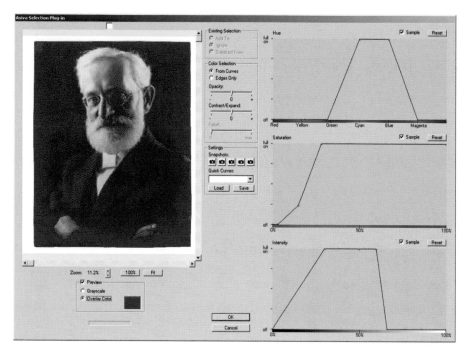

be excluded from the mask. In the Value curve, I rejected the lighter tones because I could see they had very little tarnish. I also reduced the mask selection as the tones neared black because anything in the photograph that exhibited high density couldn't be badly tarnished. The orange overlay shows the areas that would be selected. This is what got me the mask in Figure 7-2.

I applied that mask to the photograph and used the curve settings in Figure 7-3 in a Curves adjustment layer. These curves moderately darkened the midtones and shadows, made them slightly more magenta, and made them much more yellow. Remarkably, this simple Curves adjustment produced the very uniform-looking photograph in the Figure 7-2, bottom. This is not a B&W conversion; it is still a full-color RGB image; the curves did that good a job of correcting the tonality and color everywhere.

Exaggerating Color to Select Tarnish
Sometimes the color differences are too subtle to select for directly. Accentuate them and they make an excellent basis for a mask. The photograph at the top in Figure 7-24 has widespread, silvery tarnish. The color difference between the

tarnish and the yellowed photograph is not very strong, so I couldn't make a selection mask directly. The image at the center of Figure 7-24 shows the scan I made with the scan settings in Figure 7-25. I increased the tonal range, whitened the whites, and made the photograph overall more neutral, but I didn't do as complete a job of scan correction as I normally would. By intent there are no tones close to black, and I left enough residual warm hue in the photograph to let me separate the tarnish by hue. In fact, I chose scan settings by trial and error to make the tarnish go bluish while leaving the photograph brown.

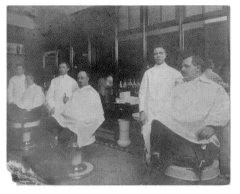

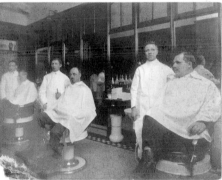

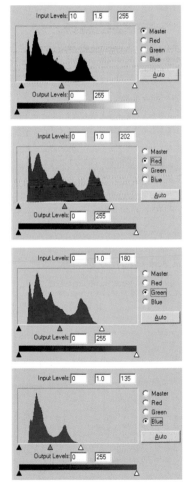

Fig. 7-25 These are the scanner Levels settings I used to create Figure 7-24, center. I let the blacks remain gray to get good tonal separation between the tarnish and the photograph. I didn't fully color-correct the photograph. Leaving the photograph reddish and the tarnish bluish makes it easier to create a selection mask.

Fig. 7-24 The original photograph (top) is yellowed, faded, and tarnished. I scanned this photo using the settings in Figure 7-25 to produce the middle figure. I intentionally did not make the photographic image neutral; by leaving it warm-toned, I got a more clear-cut color difference between the tarnish (which now looks bluish) and the photograph (reddish). I used that to create a tarnish-selecting mask, with which I eliminated most of the tarnish, as shown in the bottom figure.

Fig. 7-26 Applying a Saturation increase of +72 points to the scan from Figure 7-24 produces this image. The colors in the tarnish and the photograph are greatly exaggerated, making it very easy to see where the tarnish is. This exaggerated color makes mask making much easier.

My next step was to enhance those colors in a copy of the scan with the Hue/Saturation control set to +72 saturation. This produced Figure 7-26. Now I had something I could sink my selection tools into. The untarnished image is reddish-orange, while the tarnish is intense blue. The color distinctions are clearly visible when you compare the red channel (Figure 7-24, top) and the blue channel (Figure 7-24, middle). I used Channel Mixer to exaggerate the differences.

How to use Channel Mixer to emphasize damage for masks

Photoshop's Channel Mixer is a good tool for emphasizing flaws in a photograph when there is a color difference between the damaged areas and the rest of the photograph. As I discussed in Chapter 4, "Getting the Photo into the Computer," when that color difference exists, the damage will be more visible in one channel than another. You can use Channel Mixer to "subtract" the clean channel from the dirty one.

In general, the way to do this is to crank up the percentage of the dirty channel in the Channel Mixer to 200% and adjust the clean channel to a negative percentage (start with −100%, but it can wind up being considerably more or less) until the combination shows the damage the best.

Starting with the saturation-enhanced copy of the photograph (Figure 7-26), I brought up the Channel Mixer (Figure 7-28), turned on the Monochrome option, and set the Blue channel slider to +200%. I slid the Red channel slider into the negative percentages to create a new B&W image

that would be the difference between the red and the blue channels. At a red value of −155%, I got a mask that did a good job of highlighting most of the tarnish without including much of the undamaged photograph (Figure 7-27, bottom). I converted this image to grayscale and copied it into an Alpha channel in the original scan.

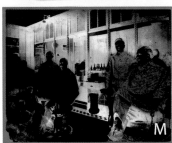

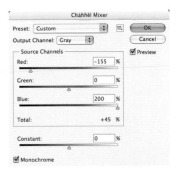

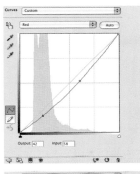

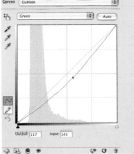

Fig. 7-27 The top two figures show the red and blue channels from Figure 7-26. The red channel shows the least tarnish, while the blue channel shows the most; this isn't surprising given the colors in the photograph. I used the Channel Mixer settings in Figure 7-25 to "subtract" the red channel from the blue channel, leaving only the tarnish behind. The bottom figure shows the resulting mask.

Fig. 7-28 These are the Channel Mixer settings that produce the mask at the bottom in Figure 7-27. I set Blue to 200% for maximum strength. I adjusted the Red slider until I got the photograph to fade out as much as possible (a setting of −155%). Monochrome is selected so that the output of the Mixer is a grayscale image.

Fig. 7-29 This is the Curves adjustment I used in combination with the tarnish mask in Figure 7-27 to produce the repaired photograph at the bottom of Figure 7-24. Much like the Curves adjustment in Figure 7-3, these curves make the tarnish darker, a little more magenta, and much more yellow. That blends it in well with the background photograph.

231

I loaded my mask as a new selection and created a Curves adjustment layer with the settings shown in Figure 7-29. That darkened most of the tarnished areas and eliminated the blue cast to produce the photograph at the bottom of Figure 7-24.

Exaggerating Color to Select Scratches

Sometimes you can take advantage of enhanced color tricks to isolate scratches for repair. Figure 7-30 is an ideal case. This badly faded and yellowed photograph is covered with dark stains, spots, and thousands upon thousands of fine scratches. The scratches are very small and neutral in color, but they're so prevalent that they almost bury the image in places. Fortunately the damage is neutral and the image is yellow, so I can create a color-based mask that selects for the damage.

The scan in Figure 7-31 has improved image contrast and color; now you can see the damage very clearly. The scan settings in Figure 7-32 produced the better, more detailed scan by expanding its tonal range and making it more neutral. The enlarged section from the center of the photograph gives you some

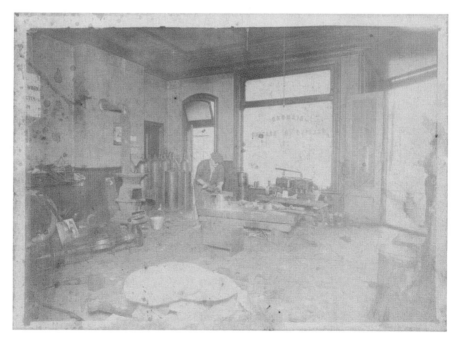

Fig. 7-30 This photograph is almost obscured by damage. It has faded very badly and is almost completely covered with fine scratches, dirt, and stains.

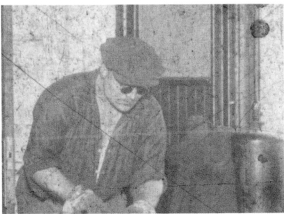

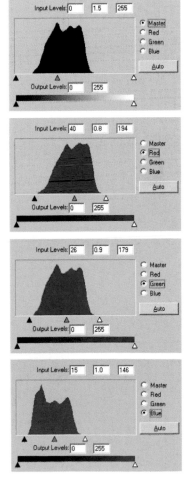

Fig. 7-31 The first step in repairing this photograph is making a good scan, using the scanner Levels settings in Figure 7-32. This scan shows that there's a great deal of detail in the photograph, hidden underneath all the garbage. The enlargement in the lower figure shows just how pervasive the dirty scratches are.

Fig. 7-32 The scanner Levels settings I used to produce Figure 7-31. As with Figure 7-24, these settings leave some residual color in the photograph, rendering it slightly yellowish. In contrast, the dirt and scratches come out blue, making them easier to select for.

idea of just how bad the scratches are, but even at this enlargement it's much worse than what you see on this page.

Making the image more neutral made all the scratches distinctly blue in hue. So I started out with the same trick I used on the barbershop photograph. A saturation increase of +70 points produced Figure 7-33. Instead of creating the mask with Channel Mixer, as I did in the previous example, I used the Image Calculations tool.

Calculations combines two layers or channels in more complicated ways than the Channel Mixer. It's a complicated tool with a mildly scary-looking set of controls, and mastering it requires serious study. Fortunately, we're not going to try to do that. To the extent I use it in this book, you can ignore most of the settings. The only ones you really need concern yourself with are the two Channel settings, the Invert box and the Blending settings. Ignore all the other options.

The tricky part to making this work is the Blending mode. Photoshop has 20 different modes, most of which are difficult to describe in words and many of which have uninformative names. The blends most likely to be of interest are the subset that starts with Overlay and ends with Hard Mix. These blends accentuate the results of combining two channels.

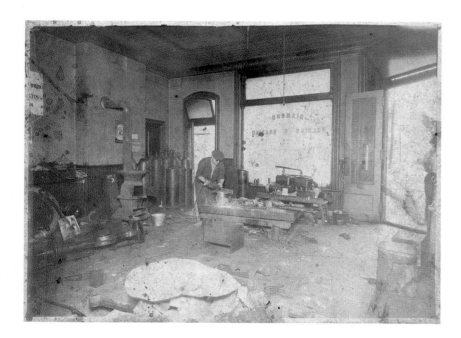

Fig. 7-33 Applying a Saturation increase of +70 points to Figure 7-31 produces this image. Now the photograph and the dirt and scratches are clearly differentiated by color. This photograph gets turned into a mask in Figure 7-35.

If I combine one channel with another channel's inverse, I don't simply end up with a new channel that is the simple difference, the way I would with Channel Mixer; the Blending mode will exaggerate that difference. Some Blending modes' exaggerations are extremely useful for mask making. I haven't managed to internalize what all the Blending modes do, so I don't try to visualize in my head how well a particular mode will work; I just try them all out. Very often I'm surprised.

If you manage to master Calculations, you'll discover that it can solve a large fraction of your masking problems almost by itself. Should you decide you really want to get into this tool (and masking in general), I suggest you pick up a copy of Deke McClelland's book, mentioned earlier in this chapter.

How to select damage by color with Image Calculations

Just as with the barbershop photograph, I decided to use the difference between the red and the blue channels to isolate the damage, since they showed the most and least damage, respectively. Figure 7-34 shows the Calculations control panel settings I used. All that's of import here are the two Channel settings and the Blending mode. I checked the Invert box next to the red channel; it has the same effect as entering a negative percentage did with Channel Mixer.

For this particular image, the Linear Light and Hard Light blending modes worked spectacularly well. Both produced masks with almost no real photographic detail in them; they're nearly perfectly isolated images of the damage. The results for those two calculations are shown in Figure 7-35. The top mask was produced by Linear Light blending, the bottom by Hard Light blending.

It's a toss-up as to which one would do the best job for repairing this photograph; both could be useful. The Linear Light blend has better contrast characteristics for a mask, with stronger differences between the scratches and the rest of the photograph. The Hard Light mask has poorer contrast, but it does a better job of suppressing photographic detail.

I chose the Linear Light mask because it needed less adjustment (Figure 7-36) to turn it into a really good mask with strong whites and real blacks. In Chapter 8, "Damage Control," pages 260–266, I use this mask in combination with the original and saturation-enhanced versions of the scan to make some amazing repairs.

Fig. 7-34 Image Calculations works something like Channel Mixer, but it offers more complicated blending options for the channels being combined. The mask I'll create from Figure 7-33 involves subtracting the red channel from the blue channel because the red channel shows the damage most clearly, while the blue channel shows it hardly at all. The Linear Light (top) and Hard Light (bottom) blend modes exaggerate and enhance the differences between the two channels, producing a much stronger and more selective mask than Channel Mixer could. The results of these two blends are shown in Figure 7-35.

Fig. 7-36 This Curves adjustment pushes the tones in the Linear Light mask from Figure 7-35 toward stronger blacks and whites. That isolates the scratches more strongly for correction in Chapter 8.

Fig. 7-35 The masks that result from Linear Light (top) and Hard Light (bottom) blending of Figure 7-33 in Image Calculations have different strengths and weaknesses. The Linear Light mask has better contrast between the damage and the photograph, but more of the photograph is visible (selected). The Hard Light mask does a better job of rejecting the photograph, but the contrast between the damage and the photograph isn't as strong.

Exaggerating Color for Hand-Tinting Masks

Exaggerated color is a good way to prepare hand-tinted photos like the one in Figure 7-1 for masking prior to repair work. In the image at left in Figure 7-37, I added a Hue/Saturation adjustment layer that was set to a saturation level of +75 to the original scan.

I inserted a Curves layer between the original and the Hue/Saturation layer so I could adjust the color balance to make it more neutral overall. It wasn't necessary, but it let me create brighter and more distinct colors with the Hue/Saturation layer (Figure 7-37, right). I didn't do anything particularly sophisticated with the curves; I merely adjusted the end points of the individual

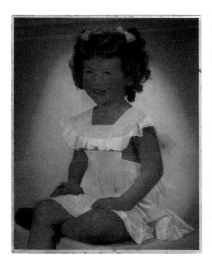

Fig. 7-37 Exaggerated color makes it easier to create masks for hand-tinted photographs. I increased the saturation of Figure 7-1 by +75 points in the photograph on the left. I used Curves to make the image overall more neutral in the photograph on the right so that it would be easier to select regions for hand-tinting by their colors.

Fig. 7-38 This screenshot shows the photograph from the right in Figure 7-37, with its layer stack. The Magic Wand selects just the blue of the dress to make a hand-tinting mask, shown in Figure 7-39.

Fig. 7-39 This is the finished hand-tinting mask for the dress. I expanded the selection in Figure 7-38 by 3 pixels and contracted by 3 pixels. That filled in any "pinholes" in the selection. I've feathered the edge of that selection by 2 pixels to soften the border so that the tinting will blend better into the photograph.

color channels so that whites and blacks both came out modestly neutral. This was not a finely tuned color adjustment.

To create my masks, I used the Magic Wand in Contiguous mode (Figure 7-38). I started with the dress, making a few clicks in each area with the brush set to a large tolerance of 30, and then narrowed down to 5 to fill in near the

edges of the selections. Once I thought I had a good selection, I expanded it by 3 pixels and contracted it by 3 pixels. The reason for doing that was to fill in any "pinholes" (missing pixels) in the selected area. Finally, I feathered the selection with a radius of 2 pixels to slightly soften the edges of the affected area and make it look more like painted-on color.

I clicked Select Save Selection and saved in a new channel that I named "dress" (Figure 7-39). Creating this mask took only a few minutes' work. Creating all the masks that I used to hand-tint this photograph in Chapter 6 took me less time than did writing this description of my methods.

Five Ways to Mask Cellophane Tape Damage

In this chapter I've described several different ways to create selection masks. The methods aren't mutually exclusive; more often than not you can make a good mask any number of ways. In this last section I'll show you five different methods, all of which have merits, for selecting the same area for repair.

Figure 7-40, left, shows an old faded photograph that was taped together with cellophane tape, brittle and brown with age. There's no way to remove the tape without destroying the photo. The photograph looks very different where the tape is; to do a good restoration will require a mask that selects the taped region so that it can be repaired separately from the rest of the photograph.

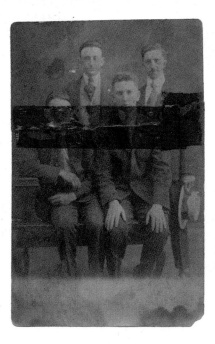 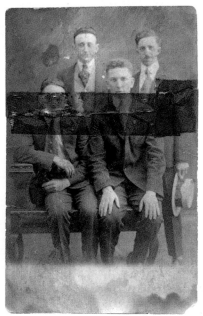

Fig. 7-40 This stained and faded photograph was taped together with cellophane tape that has turned brown with age (left). The scan made with the scanner settings from Figure 7-41 improves contrast and density. It also makes the photographic image almost neutral while leaving the tape marks orange (right). I can use that color difference to create a tape-selecting mask in several different ways.

My first step was to make a scan that exaggerated the difference in color between the tape and the rest of the photograph, using the settings in Figure 7-41. As you can see at the right in Figure 7-40, I was able to make the photograph more neutral and contrasty without losing the distinctive orange color of the tape. That gives the masking tools a pronounced color difference to grab onto.

How to select cellophane tape damage by color range

This is one of the rare (for me) cases where Photoshop's Color Range tool is up to the task. To make the Color Range tool's work easier, I increased the photograph's saturation by +40 before I opened the tool. I sampled three points—one bright point in the collar under the tape, one middle tone, and one dark tone on a lapel. Then I adjusted the Fuzziness slider until most of the tape (but little else) was well selected (Figure 7-42).

The color range masking tools in Picture Window did an equally good job (Figure 7-43). By themselves the range adjustments didn't completely select the tape (purple overlay on the photograph at right). They decently roughed it in, though, so I followed up by switching to the masking brush with the "Similar Pixels" setting and painted over the tape area. That efficiently filled in the gaps to produce the mask on the left.

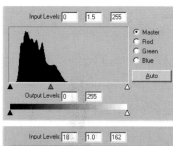
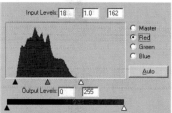

The Asiva Selection plug-in produced the mask in Figure 7-44. I simply swept the eyedropper over the square piece of tape on the right of the photograph, and Asiva automatically generated the curves settings and the mask shown.

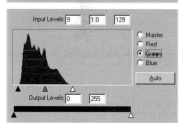

How to use Mask Pro to select cellophane tape damage

Mask Pro took a bit more work, but it produced the most complete and accurate selection of the taped area (although it selected some extraneous matter as well). After I created a copy of the photograph for Mask Pro to work on, I used the Keep and Drop eyedropper tools to create palettes of colors that I wanted included and excluded from the selection (Figure 7-45). Then I activated the Magic Brush tool and ran it over the photograph. That produced the partial mask that you can see in green in the illustration. Satisfied that my color selections were appropriate, I applied the Apply Everywhere command, and Mask Pro generated the full mask shown on the right in Figure 7-45.

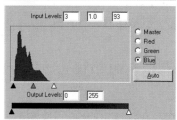

Fig. 7-41 The scanner software histograms and Levels settings for Figure 7-40. This scan improves the density and contrast of the original photograph and makes the photographic image almost neutral in color.

Fig. 7-42 Because there's a clear-cut difference in color between the tape and the photograph, the Color Range tool can do a pretty good job of creating a mask that selects for the tape. Before sampling the taped region, I increased the saturation of the photograph by +40 points to make the color difference even more pronounced.

Fig. 7-43 Picture Window's Color Range masking tool selects for the tape by its distinctive hue and saturation. In this screenshot, note how I've adjusted the selection ranges on the Hue, Saturation, and Values sliders to include the tape as completely as possible while excluding the rest of the photograph. The mask on the left was created with Color Range followed by the Similar Pixel Brush tool.

Fig. 7-44 Asiva Selection easily finds the tape in the photograph. Restricting the hues to reds and oranges and the saturation to moderate levels excludes most of the photograph while retaining the tape.

Fig. 7-45 Mask Pro is able to select the tape very completely because its Drop and Keep sample palettes permit me to specify the tape color very completely from multiple sample points. In the window on the left, I'm using the Magic Brush with the colors from the palettes to paint in the mask. Mask Pro also includes some extraneous areas, seen in the mask on the right, but those can easily be erased with a black eraser.

How to create a damage selection mask from a single color channel

To make my fifth mask, I didn't use any special tools, just a simple trick. When looking at the damage to this photograph in the separate RGB channels (Figure 7-46, top row), I saw that the red channel showed the tape the least (making it a good candidate on which to do the actual restoration work), but the blue channel on the right showed it very clearly. When I increased the saturation of the photograph, this difference became even more pronounced. At +60 saturation, the entire taped area was distinctly darker than the rest of the photograph (Figure 7-46, bottom row).

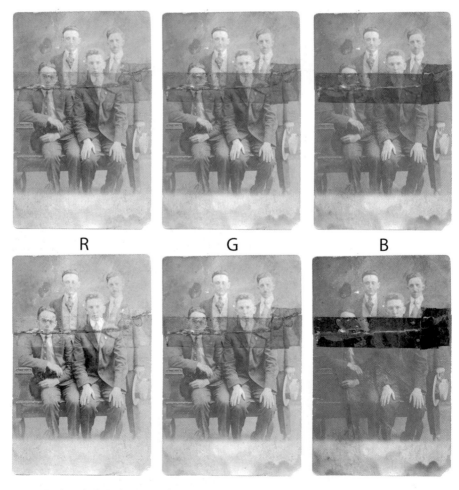

Fig. 7-46 The individual color channels for the top row of Figure 7-40 show that the tape is most visible in the blue channel. Increasing the saturation of the photograph by +60 points exaggerates this difference and makes the taped area stand out very clearly in the blue channel (bottom row).

I copied the saturated blue channel into a new Alpha channel and inverted it (Figure 7-47). I applied the Curves settings in Figure 7-48 to turn that grayish image into a mask that strongly selected for the taped area.

All five masks will require some manual white and black brushwork to completely block out the areas I don't want to alter and select small parts of the tape that the mask tools missed. That's part of the beauty of a mask channel— you don't have to spend hours getting it perfect with your masking tools and software. A little manual labor can turn a pretty good mask into a perfect one.

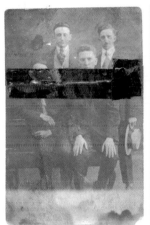
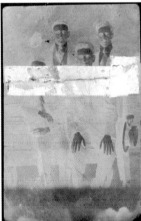
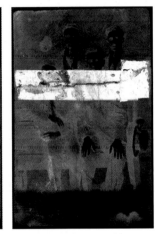

Fig. 7-47 The figure on the left is the saturated blue channel from Figure 7-46. Inverting that image produces the center figure. Applying the Curves adjustment from Figure 7-48 produces a strong, contrasty mask.

Fig. 7-48 This curve converts the middle figure in Figure 7-47 into a good, strong mask. The contrast is greatly enhanced, especially in the highlights and midtones, forcing the tones in the areas surrounding the taped region close to black.

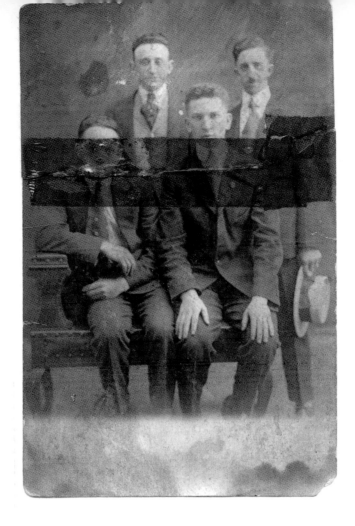

Damage Control

How-To's in This Chapter

How to clean up dust and scratches from a scan using the History Brush
How to clean up dust and scratches from a scan with masked layers
How to repair a badly scratched slide
How to minimize scratches using noise reduction and blended layers
How to minimize scratches in a print with Curves
How to minimize scratches in a print with multiple Curves adjustment layers

Introduction

Every restoration job involves repairing dirt and damage. The work can be as minimal as cleaning up residual dust specks and scratches in a scan, but usually the problems are more extensive. I've restored many photographs that had very good tone and color but had suffered some kind of physical damage.

In this book I emphasize getting the computer to do as much of the work of photo restoration as I can, to minimize pixel-by-pixel manual retouching. Wherever possible I use software filters, tools, and special programs to repair damage, because they are faster and more efficient than manual retouching and are very effective. Whether you're restoring professionally or for personal joy, you still only have so many hours a day that you can devote to photo restoration. If a bit of computer code saves you hours restoring a photograph, that is time you can spend doing something else you enjoy (even if that "something else" is restoring more photographs).

Clever code will only take you so far, though; repair work requires manual labor, and there's no way around it. There are no ways to totally avoid pushing pixels around; some damage just can't be eliminated except pixel by pixel. Still, virtually all damage can be reduced with a smart application of software, making your manual repair labors less onerous.

Simple Spotting

Every scan you do will need some spotting. Scans accentuate minor scratches and other occasional defects. Even if your technique is meticulously antiseptic, you will still find bits of dirt or dust embedded in the photograph. As I explained

in Chapter 4, "Getting the Photo into the Computer," it's much safer to leave that dust alone than to try to remove it, so you'll have to do some cleanup work to get rid of those lingering specks and scratches.

The old copy negative in Figure 8-1 can use plenty of spotting. Most of the specks are white in the positive image (Figure 8-2), but there's a scattering of dark specks that also need to be erased. The best and fastest way to clean a scan is to use

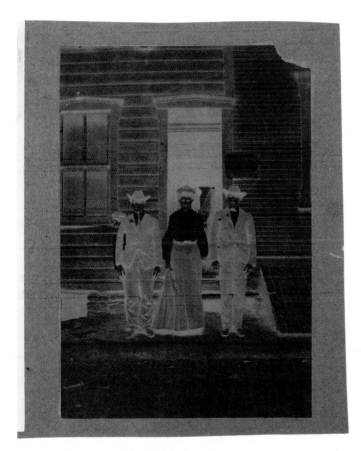

Fig. 8-1 This old copy negative has lots of dust and dirt specks that need to be cleaned up. The original photograph had dirt on it that was copied over when the negative was made. Since then the negative has acquired its own layer of grime.

Photoshop's Dust & Scratches filter in conjunction with the History Brush. I reserve the Clone tool or the Spot Healing Brush for only the larger flaws.

I applied the Dust & Scratches tool using the settings shown in Figure 8-3. I used the smallest radius that still eliminated almost all the specks. The smaller you can keep the radius, the less damage it will do to the fine detail in the photograph. I raised the threshold to 15 to preserve the grain and texture of the

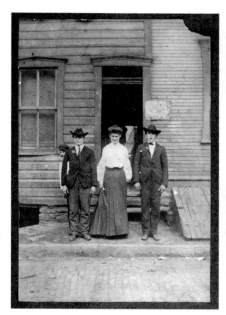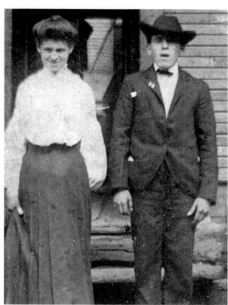

Fig. 8-2 The positive image of Figure 8-1, enlarged on the right. The tonality is pretty good, but the snowstorm of white and black specks makes clear how much cleanup needs to be done to restore this photograph.

Fig. 8-3 Photoshop's Dust & Scratches filter, selectively applied with a History Brush, is the fastest and most accurate way to clean up specks manually. I set the Threshold to 15 so that the filter preserves the grain and fine detail in the photograph (see Figure 8-4). That makes the History Brush strokes less visible.

original photograph while still eliminating dust specks. That's important if you want your repairs to be invisible. The enlargement at the top in Figure 8-4 shows what this filter did; the bottom of Figure 8-4 shows what would have happened if I had applied the same filter with the threshold set to 0.

The how-to's explain how I use the Dust & Scratches filter in conjunction with the History Brush or masked layers to apply the filtering effect only where I want it to have an effect. The reason I don't just use the brush in Normal mode is that the Dust & Scratches filter has much less effect on photographic detail in the Lighten or Darken mode than it does in the Normal mode.

You can use the History Brush very aggressively without obliterating the photograph. If you run the brush over a sharp edge in the photograph that blurs out as the brush passes over it, just undo that brush stroke. Reset the History Brush to a smaller radius, and carefully work it up to the edge of the boundary. Working this way allows me to be even more casual (translation: to work faster) as I apply the brush to the photograph.

Fig. 8-4 This shows the effect of the Threshold setting on the behavior of the Dust & Scratches filter. With a Threshold of 15, as in Figure 8-3, there's relatively little loss of fine detail and grain in the photograph (top), although almost all the dust and dirt are filtered out. A Threshold of 0 (bottom) catches every last bit of dust and dirt, but it also destroys the fine detail and texture of the photograph.

How to clean up dust and scratches from a scan with the History Brush

I set the History Brush to the Dust & Scratches history state by clicking the little box to the left of that history state. The History Brush icon will appear in the box to let you know that you've assigned the brush to that state. I then reverted to the state just before I filtered the image by clicking on the history state just above the Dust & Scratches state (Figure 8-5). I set the brush to Darken mode with a radius of 20 pixels. That's much, much larger than individual dust specks but small in terms of the scan, which was made at 600 ppi.

All I needed to do to clean up the white specks was to paint the brush over any part of the picture where there was dust. I didn't necessarily pick them off one by one with single mouse clicks; often I used long brush strokes that took out dozens of the specks at one time.

Once I'd finished removing all the white specks, I changed the History Brush mode to Lighten and brushed out all the dark specks. When the photograph has a mix of light and dark dust and scratches, you'll usually find it faster to go over the entire picture with the brush in one mode and then go over it again with the brush in the other mode instead of constantly switching back and forth between modes.

Fig. 8-5 You can selectively apply an adjustment or filter using the History panel and the History Brush. I clicked the check box next to Dust & Scratches to attach the History Brush to that state. Then I clicked the History state preceding that, Select Canvas, which undid the overall filtration. Now I can paint in the filter just where I want it.

The masked layer approach is better than using the History Brush to paint in a filter effect, because the work on a masked layer is completely reversible. With the history brush, if you decide you don't like some of the work you did, you can only step back as many history states as you have available (and making lots of little brush strokes, you're going to use up your history states pretty fast). Also, when you back up like that, you lose any intermediate work, so if you don't discover your mistakes pretty quickly you can end up throwing away a lot of interim changes.

With the masked layer approach, you can undo your corrections at any time or add other ones in the later work session. The History Brush only maintains its utility so long as you keep that image open; end your work session and the history states evaporate. Masked layers stay with your file when you save it; they are available to work on any time you open that file, now or in the future.

If masked layers are so good, why didn't I use (and recommend) them over the History Brush in the previous edition of this book? The answer is that adding layers to files increases their size substantially. For example, an image file with two additional Dust & Scratches filter layers, one for lightening and one for darkening, is three times the size of a single-layer file that you applied the Dust & Scratches filter to directly. Working on the larger file uses up a lot more RAM and a lot more CPU power. Although history states also consume RAM, you can purge them if Photoshop starts to bog down. The extra resource requirements of layered files cannot be so dismissed; they will always be with the file.

With my old computer system (the one I used when writing the previous edition) and a 2-GB RAM limit, the performance penalties associated with masked layers could be severe, so I relied much more on the History Brush to apply my alterations selectively. If you're working on a similarly old system, you might also prefer to stay with the History Brush. If you're running on a newer machine with plenty of RAM, masked layers are the better way to go.

How to clean up dust and scratches from a scan with masked layers

To clean up the photograph in Figure 8-2 with masked layers, I first made a duplicate layer of the photograph. I applied the Dust & Scratches filter to that duplicate layer. Next, I added a mask to the filtered layer. There are two ways to do that. For one, you can go to the Layer/Layer Mask… menu item and select Hide All. That creates a mask filled with black that hides the effect of the filter. The other way to do it in Photoshop CS4 is to click the small Add a Pixel Mask button at the top of the Masks panel and then click Invert.

I duplicated the masked, filtered layer and set the blending mode to Lighten for one of the copies and Darken for the other copy (Figure 8-6). I set the paintbrush color to white and used the Brush tool to paint into the mask layer wherever I wanted to apply the filter effect to the original photograph. I worked on the lightening layer to get rid of dark scratches and dust and the darkening layer to get rid of light scratches and dust. I prefer to finish all the lightening and darkening work in separate passes over the image. The way my brain works, it's easier for me to see the damage I'm trying to correct if I'm focusing my attention on just one kind of damage.

You may prefer working on light and dark scratches at the same time; that can be faster when only a small amount of the damage is light or dark. If that's the case, you can speed up your History Brush work considerably by memorizing just two keystroke shortcuts: Alt-Shift-K switches the brush to Darken mode; Alt-Shift-G switches it to Lighten mode. That's a lot faster than moving the mouse up to the mode drop-down menu and selecting the lighten or darken mode from there.

Similarly, if you're using the mask layer approach, Alt-[moves the focus to the layer below the one you're currently working with, and Alt-] moves the focus up one layer. That's the speedy way to switch between the Darken and Lighten filtered layers.

It only took a few minutes to produce Figure 8-7. All but the largest white and black spots are gone. To get rid of those, I selected the Spot Healing Brush tool with a radius of 20 pixels. For the two white spots on the jacket, I set the tool to Darken and dabbed the brush over each spot; the tool filled them in perfectly. Then I switched the tool to Lighten and eliminated the few black spots the same way.

Not so incidentally, you can use the Spot Healing Brush (or Clone stamp) in layers, too! Begin by creating a new empty layer (Figure 8-8). If you're using the Spot Healing Brush, be sure the Sample All Layers box is checked in the options bar. If you're using the Clone tool, choose All layers from the drop-down Sample menu in the options bar.

Use Healing or Clone tools just as you always would. What's different is that the changes they create will be painted into the new layer you created, instead of replacing parts of the original photograph (Figure 8-9). Leaving your original photograph unchanged leaves you free to undo any changes you've made at any time by simply erasing those details from the new layer.

Fig. 8-6 Masked layers let you apply an adjustment selectively and reversibly. Here I applied the Dust & Scratches filter to a duplicate of the Background layer. Then I clicked the Add Mask button in the Mask Panel and the Invert button (both circled in the top figure). I duplicated this layer and set one filtered layer to Darken blend and the other to Lighten. Painting white into the masks in those layers applies the Dust & Scratches filter selectively to the photograph.

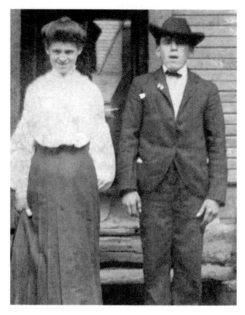

Fig. 8-8 Use the Spot Healing Brush or Clone tool in an empty layer and you'll be able to add or erase corrections at any time. Just make sure that Sample All Layers is checked, and the Brush will fix the underlying image and place the changes in the new empty layer.

Fig. 8-7 A few minutes' work with the History Brush, applying the Dust & Scratches filter, cleans up most of the garbage. A few large spots and many fine scratches remain, but this is a big improvement over Figure 8-2.

Fig. 8-9 The left figure shows the Background layer from Figure 8-8. In the center is the layer containing the Spot Healing Brush repairs. On the right is the combined result of those two layers.

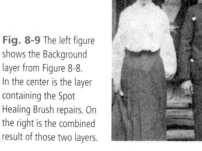

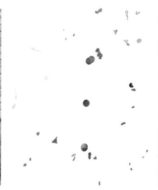

Polishing out the Scratches

Scratches and scuff marks can be a restoration nightmare. Sometimes they're obvious from the moment you look at the original, as with the Kodachrome slide in Figure 8-10. Often, however, they lurk in wait to surprise you when you enhance the tone and contrast in a badly faded photograph, like the one

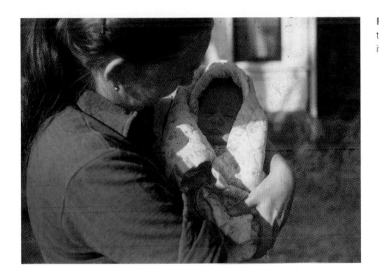

Fig. 8-10 This Kodachrome slide has color and tonality nearly as good as the day it was made, but it's very, very badly scratched.

in Chapter 7, Figure 7-31. Regardless, once scratches become evident, eliminating them with manual retouching is a very time-consuming activity.

The History Brush trick doesn't work as well on pervasive scratches and scuff marks as it does on dust specks. You'll need to increase the radius of the Dust & Scratches filter because long scratches cover more adjacent pixels. You'll have to set the radius of the History Brush much smaller because the eye is very good at picking out even subtle brushwork artifacts when they appear as long lines. I have repaired badly scratched photographs this way, so it's not impossible, but it is assuredly a lot of work.

Your best defense is a scratch-free scan. Figure 8-11 shows enlarged portions of the Kodachrome slide of Figure 8-10 scanned normally and with DIGITAL ICE turned on. ICE couldn't remove the scratches completely, because the dyes used in Kodachrome film interfere with the way the scan detects scratches. Still, it did a pretty good job and saved immense amounts of labor. This is why I so strongly recommended in the hardware chapter that you buy a film scanner that includes DIGITAL ICE. DIGITAL ICE won't work on B&W silver film, though, and the really effective version of it isn't available in flatbed scanners. (I haven't tried it myself, but other people have reported that the version of DIGITAL ICE built into flatbed scanners performs poorly.)

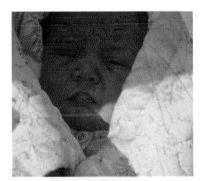

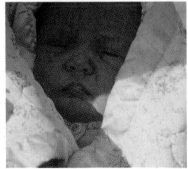

Fig. 8-11 This enlargement of Figure 8-10 shows how extensively the original slide is scratched (top). The bottom figure demonstrates what a good job Digital ICE does suppressing scratches, even when scanning this Kodachrome slide (with which it is much less effective than with other color films).

Many Kodachrome slides won't be so cooperative; DIGITAL ICE won't work well with a lot of them. And it's useless with silver-based B&W films. In cases like those (or if you don't have DIGITAL ICE at all), try the Polaroid Dust & Scratches Removal program (reviewed in Chapter 3). It's a standalone program, so you can use its results with any image processing program.

As I explained in that review, sometimes it isn't very careful about what it removes and what it keeps, but you can make it a lot more useful by applying it in conjunction with a Photoshop layer. Save a copy of the photograph you've been working on, have the Polaroid program work its magic on that copy, and save the results. Open the filtered file in Photoshop, copy the image, and paste it into the photograph you have been working on. Photoshop will create a new layer with the filtered image in it. Now you can use the same masked layer approach I described using with the History Brush to control where the Polaroid Dust & Scratches Removal filter alters the original photograph by painting the mask with a white brush. This makes it a much more useful program!

A refinement of this approach is to construct a damage-selecting mask using one of the many methods described in Chapter 7 or in this chapter. Once you've created such a mask, copy the resulting grayscale image. Switch to the mask channel in the filtered layer, select All, and click Paste. That will replace the existing mask channel in the Polaroid Dust & Scratches Removal layer with your custom-built mask. If there's a lot of pervasive damage to be repaired, as there is with this Kodachrome slide, you'll find that this is much, much faster than painting the correction regions into the mask by hand.

Finding Scratches with the Find Edges Filter

So your scan, for better or for worse, has scratches. Now what? In many cases you can obliterate them successfully with filtering if you can keep the filter from attacking the rest of the photograph. That's what I was doing manually when I used the History Brush with the Dust & Scratches filter. A good mask can make this almost automatic.

How to repair a badly scratched slide

For the slide from Figure 8-10, I used the Find Edges filter. I made a copy of the original photograph and applied the filter to that. The upper part of Figure 8-12 shows what the scan looked like after applying this filter. The lower part of the figure shows the mask I created by inverting that, converting it to grayscale, and using Curves to give it the strong blacks and whites that make for a good mask.

Back in the original photograph, I created a new channel named Alpha. It provides a place to store the mask image I just created. I copied the grayscale image I created in Figure 8-12, switched

to my Alpha channel in the original photograph, selected All, and pasted the mask image into that channel. Next I loaded that mask as a selection (Figure 8-13) with the Select/Load Selection… command. This brings up a dialog box where you can select the channel that will be used to create the selection, if you've created multiple masks. Clicking OK loads the mask in that channel as a selection.

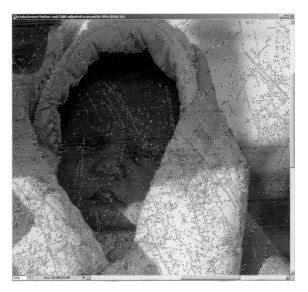

Fig. 8-13 The mask from Figure 8-12 does a pretty good job of selecting for the scratches, as this screenshot shows. Applying the Dust & Scratches filter to this image produces Figure 8-14b.

Fig. 8-12 The Find Edges filter turns Figure 8-10 into the upper figure here. Inverting that figure, converting it to grayscale, and increasing the contrast produces a good scratch-selection mask.

Applying the Dust & Scratches filter with a radius of 12 and a threshold of 0 erased a lot of the scratches. It also erased some of the fine detail; look closely at the printed flowers on the blanket and the bubbles on the baby's lips in Figure 8-14b.

Just like the History Brush, I can apply the filter in the Lighten or Darken mode to reduce its impact on photographic detail. I did that by using the Fade command with the strength at 100% and the mode changed to Lighten (Figure 8-14c). The scratches aren't eliminated quite as well, but there's a lot less damage to photographic detail.

Fig. 8-14 The original scratched slide is shown in (a). (b) results from applying a Dust & Scratches filter to the masked photograph in Figure 8-13. It has erased some fine detail, like the bubbles on the baby's lips. To restore much of that detail (c), use the Fade command set to Lighten blend after running the Dust & Scratches filter. (d) If I set the Dust & Scratches filter threshold to 15, it doesn't do a complete job of removing the scratches, but it also doesn't erase any real photographic detail.

What do you do about that "collateral damage"? There are several possibilities. One is to use the History Brush. I assigned the brush to the history state just before the filter and set the brush radius to a very small value of 5 pixels. I used that to brush the unfiltered photograph back into the fine detail and edges in the photograph that had been obliterated. There wasn't a lot to brush back; the mask had ensured that the filter worked mostly on the areas that I wanted to correct.

Another way to minimize unwanted side effects is to make the corrections in gradual stages instead of trying to eliminate all the scratches in one step. I went back to the original, masked photograph and applied the Dust & Scratches filter, but instead of setting the threshold at 0, I set it at the fairly high level of 15. Now the filter had almost no effect on the photograph at all. It missed the finer scratches, but it wiped out the darkest and worst of them (Figure 8-14d), and I had to do almost no History Brush work to restore lost details.

A third approach is to use masked layers once again. Before starting on the procedures in the how-to, make a duplicate layer of the photograph with a mask

channel, as I described on page 250. Then add another channel to that layer and name it Alpha. Follow the procedures in the how-to to create a filtered image in the duplicate layer. You'll get the same filtering results you did in the how-to, but they'll be confined to the duplicate layer instead of directly affecting the original photograph. Now you can use the Brush tool to paint the masked channel in that layer black or white to apply that filter precisely as you want to the original photograph.

Minimizing Scratches with Noise Reduction and Layer Blends

While writing the second edition of this book, I received a restoration job that presented me with an interesting problem. The client submitted a JPEG of a grayscale scan of the original photograph (Figure 8-15). The scan was of very high quality, although it was too low in contrast; that was easily fixed with a Curves adjustment layer (Figure 8-16). Except for the contrast issue, though, it's the kind of scan I'm happy to work from; the original was scanned at 1200 ppi, a good resolution for a small original where one doesn't know what one will encounter, and the client used a JPEG compression ratio that was low enough to avoid any artifacts (the JPEG itself was 3 MB in size).

Fig. 8-15 This scan is highly detailed, but it lacks contrast. A Curves adjustment layer (Figure 8-16) fixes that, as Figure 8-17 shows.

Fig. 8-16 The Curves adjustment layer corrects the contrast of Figure 8-15 but reveals a great deal of dirt and noise in the photograph.

The problem can be seen in Figure 8-17; there is some nice delicate highlight detail in this photograph that is swamped by dust, dirt, scratches, and the paper texture. Normally I'd tackle this by looking for color differences between the damage and the original image and emphasizing those to help me select the garbage for removal. There's no opportunity for that with a grayscale scan.

Since most of the damage is also delicate and light, I decided on a different approach, described in full in the following how-to. First I used Noise Ninja to reduce the level of garbage without significantly damaging photographic detail. Next I duplicated the noise-filtered layer and blended the two layers together using the Soft Light blending mode.

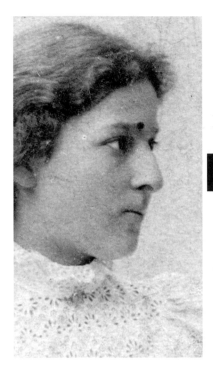

Fig. 8-17 This enlargement shows that there is considerable delicate fine highlight detail in the photograph, but it's almost lost in all the garbage.

How to minimize scratches using noise reduction and blended layers

This photograph (Figure 8-17) is badly in need of cleaning because the pervasive fine damage and paper texture obscure much lovely delicate detail in the photograph. Simple filtering, even in combination with a masked layer, won't work, because the garbage is so extensive and much of the real detail is so faint.

I first used noise reduction software to suppress as much of this intrusive texture as I could. Noise reduction programs have different strengths and weaknesses; the one that was most effective in this case was Noise Ninja, using the settings shown in Figure 8-18. Noise Ninja automatically profiled

Fig. 8-18 Noise Ninja is a good first step toward cleaning up Figure 8-17. The plug-in's default selections and settings worked well for this photograph.

the photograph; I tried manual selection of the target areas to be profiled, but it didn't produce visibly better results. After filtering, the noise was less intrusive (Figure 8-19), but what was more important for my purposes is that it was also lighter, pushing closer to paper-white.

To enhance the photograph over that softened noise, I used layer blends. I duplicated the noise-reduced layer and chose blending modes for the duplicate layer that strengthen darker tones and/or push lighter tones toward the whites. Several blend modes improved the photograph, as shown in Figure 8-20. Overlay, with an Opacity of 50%, darkened the midtones and shadows while lightening damage in the highlights. A Soft Light blend at 80% opacity did a slightly better job of preserving smooth midtones.

The more intense Hard Light blend, at an opacity of 65%, substantially eliminated the noise, but it bleached out the highlights and blocked up the shadows just a bit. That would likely be acceptable for a less-than-perfect restoration. For better results, we could add a mask channel to this layer and darken it locally with the Brush tool where the effect of this blend should be suppressed to retain real highlight detail.

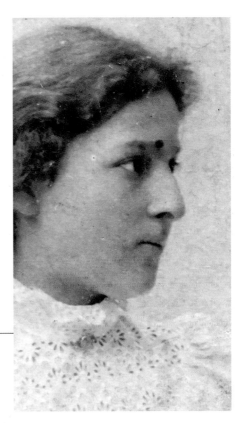

Fig. 8-19 Noise Ninja cleaned up a lot of the damage to Figure 8-17, as this figure shows. By blending this photo with itself, I can suppress the noise even more.

 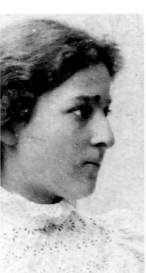 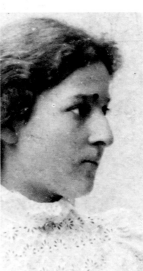

Fig. 8-20 Several Photoshop blending modes lighten highlights and intensify midtones and shadows. Blending a photo, such as Figure 8-19, that has light-toned noise with itself can make that noise lighter and less visible. From left to right, the Blend modes are Overlay at 50% opacity, Soft Light blend at 80% opacity, and Hard Light at 65%. I like the Soft Light blend the best.

Fig. 8-21 Here's the photo from Figure 8-15 after contrast enhancement, noise reduction, and blending. The photograph now has much more contrast and visible detail, without a commensurate increase in the visibility of the damage.

This solution proved to be most successful (Figure 8-21); the blend didn't entirely eliminate the low-level noise, but it attenuated it considerably. The photographic image is now clearly visible above the level of the damage, even in the elder sister's delicate, lacy blouse. Much work remains to be done, but this is a very good first step toward a clean restoration.

Minimizing Scratches with Masks and Curves

In Chapter 7, "Making Masks," pages 232–236, I used color tools to create masks that selected for scratches and dirt and nothing else. Here's where I put them to work. I converted Figure 7-30 to grayscale, shown here as Figure 8-22a. I loaded a scratch-selecting mask as a selection (the previous how-to tells you how to do this if you don't already know how) and made most of the scratches go away with a simple Curves adjustment.

How to minimize scratches in a print with Curves

I loaded the mask I created with the Linear Light blend (Figure 7-35, upper) as a selection on the photograph in Figure 8-22a. I applied the Curves adjustment in Figure 8-23 to that selection. The intent was to lighten up all the dust and scratches, since they were darker than almost everything else in the photograph. Figure 8-22b shows the improvement this made to the photograph.

It's usually impossible for a single curve to make the damage completely disappear. A curve that makes the damage invisible against the middle-gray background will make it look too dark against a light part of the photograph and too light when it's over shadow tones. Aim for one that on average minimizes the overall visible impact of the damage, even if for some tones and for some parts of the photograph it makes it worse.

Fig. 8-22 (a) is a grayscale version of the photograph in Figure 7-30. (b) shows how much this photograph is improved by applying the mask from Figure 7-35, top, as a selection and making the Curves adjustment shown in Figure 8-23. That curve lightens up the dirt and scratches without altering the rest of the photograph. (c) and (d) are improved-contrast versions of these photographs. They make it much clearer how well the masked Curves adjustment works.

To better see how much this improved things, I've made an overall Curves adjustment to Figures 8-22a and 8-22b to give these photographs a good range of tones and proper contrast. In the normal-contrast version, the original dirty photo (Figure 8-22c) looks even worse. It's very clear now that the dirt and scratches degrade much of the image. The photograph at the lower right (Figure 8-22d) is remarkably clean considering how simple the masked correction was.

Figure 8-24 shows an enlarged portion of Figure 8-22. The upper, uncorrected photograph shows how badly the dirt and scratches obscured the photograph. The middle illustration demonstrates how much applying that lightening curve to the mask-selected scratches improved the appearance. Using Curves this way is a very important part of doing restorations, because it reduces the visible differences between damaged areas and the photograph. That makes that damage much more amenable to filtering and other software tools that can fill in the bad spots with good image data from the surrounding pixels.

If you use this approach in an adjustment layer instead of applying directly to the original photograph, you can achieve a much higher degree of scratch removal with multiple adjustment layers, as the how-to explains.

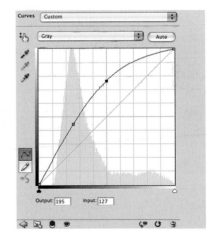

Fig. 8-23 This Curves adjustment lightens up the dirt and scratches in Figure 8-22c, making them much less visible in the photograph.

Fig. 8-24 These enlargements illustrate the benefits of masked scratch removal. The top figure is the original photograph from Figure 8-22c. The middle figure shows how much the Curves adjustment from Figure 8-23 reduces the visibility of the mask-selected scratches and dirt. I created the improved photograph on the bottom by applying the Dust & Scratches filter in Figure 8-30 to the masked photograph. Minimizing the scratches with the Curves adjustment first allows the Dust & Scratches filter to work more effectively.

How to minimize scratches in a print with multiple Curves adjustment layers

There's no reason you need stop with one Curve adjustment. You can use masked adjustment layers to apply several different Curves to the problem. Begin by creating a Curves adjustment layer and paste the Linear Light blend mask into the mask channel for that layer. Adjust the curve in that layer to look like the one in Figure 8-23. This produces the same results as the procedure described in the main text except that the correction is all in an adjustment layer instead of being applied to the original photograph.

There will be some damage this average curve didn't eliminate. There will be other damage where it went too far (dark scratches will appear lighter than the background). Both of those issues can be fixed with additional layers. Duplicate the Curves adjustment layer you just created, and adjust the curve in that layer to look like Figure 8-25. That will remove most of the residual damage the first Curves adjustment layer didn't catch, but it will also make almost all the scratch removal too strong. Use a black Brush tool to paint over the areas of the mask channel (Figure 8-26) where you don't want this new, stronger curve to have an effect (Figure 8-27).

Similarly, you can create yet another duplicate Curves adjustment layer that darkens the scratches that the first "average" curve left too light (Figures 8-28 and 8-29).

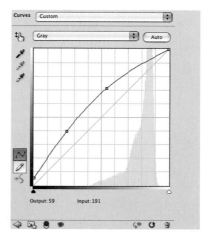

Fig. 8-25 This Curves adjustment layer works in combination with the mask shown in Figure 8-26 to eliminate many scratches that remained in Figure 8-22d, as shown in Figure 8-27. It has a strong effect on midtone and dark-area scratches. I painted portions of the mask solid black where I didn't want this layer to take effect.

Fig. 8-26 This mask works with the Curves adjustment layer from Figure 8-25 to produce Figure 8-27.

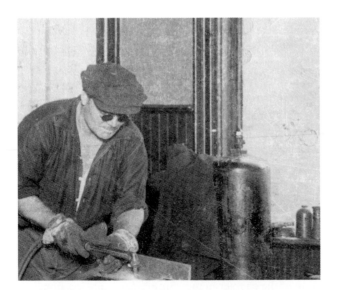

Fig. 8-27 Multiple Curves adjustment layers work well on different areas of damage. Adding the masked Curves adjustment layer from Figures 8-25 and 8-26 gets rid of a lot of the scratches a single Curves adjustment layer missed. (Compare this with the middle photo in Figure 8-24.)

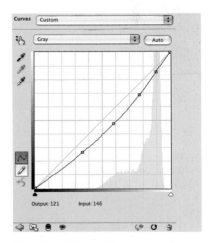

Fig. 8-28 This Curves adjustment layer darkens scratches that were made too light by the previous Curves adjustment layers. Figure 8-29 shows its effect.

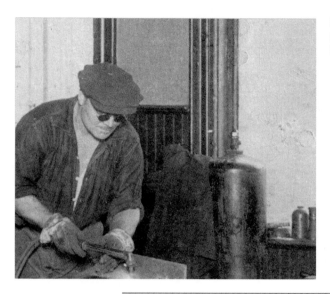

Fig. 8-29 Stacked Curves adjustment layers cleaned up most of the damage to the original photos. Compare this with Figures 8-27 and 8-24, top and center.

Fig. 8-30 This Dust & Scratches filter almost erases the scratches and dirt from the photograph (Figure 8-24, bottom). The high threshold value of 16 ensures that no fine photographic detail is affected by the filter.

What little damage remains after you've used these masked Curves methods will be much more amenable to filtering. Before I applied the Curves correction, the scratches were so strong and pervasive that they would have prevented the Dust & Scratches filter from working properly. The filter would have filled in the scratches with a combination of the photograph and the dirt I was trying to eliminate. Once the damage no longer dominated the photograph, I could apply the filter.

I used the Dust & Scratches filter on Figure 8-22d, the photograph I cleaned up with just a single Curves correction, to show how well the filter worked with even a partially cleaned-up photograph. The results would have been even better had I applied it to the multiple-curves version. Using the filter settings from Figure 8-30 produced the results you see at the bottom of Figure 8-24. As I did when working on the Kodachrome slide, I used a high threshold with the filter so that it would remove some of the scratches but none of the true photographic detail.

I attacked the very last of the damage the same way I did at the beginning of the chapter in the "Simple Spotting" section. I set the Dust & Scratches filter so that it would eliminate just about all the residual damage without attacking the photographic image too badly. Used in combination with the History Brush or applied in a masked layer to limit the effect to just the residual damage, this final filtering gave me a completely clean photograph.

Enhancing Color to Attack Scratches

Sometimes enhancing and exaggerating the color in a monochrome photograph actually eliminates most of the scuffs and scratches. This trick doesn't work very often, but when it does it's practically like magic. When damage has a different hue from the original photograph, the individual color channels will show more or less of that damage. In Chapter 7, page 233, I used the channel to emphasize damage to create masks. Here I'll use color to de-emphasize the damage.

In the badly scratched photograph of the welder (at left in Figure 8-31), the scratches are substantially more evident in the red and green channels than in the blue channel (Figure 8-32). The photograph was a faded yellow, which meant that most of the density for the photograph was in the blue channels. The scratches and scuff marks were fairly neutral in color; when I scanned the photograph to shift the image tone from yellow to more neutral, it shifted the scratches from neutral to bluish. Being blue meant they didn't have a lot of density in the blue channel. That's why the blue channel in Figure 8-32 looks so much better.

If I were going to use conventional techniques for eliminating the scratches, the blue channel would be the best one to work on, and the red would be the best one from which to create a scratch-selecting mask. But I'm not going to use conventional techniques; instead, I turned to the Hue/Saturation tool for further corrections, as I explain in the next how-to. The image at right in Figure 8-34 shows the channel-mixed photograph. It's even better than the blue channel

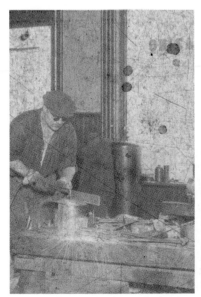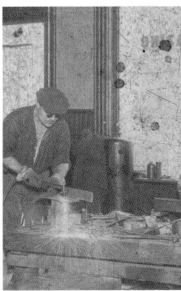

Fig. 8-31 The figure on the left is a portion of the original scan enlarged to show the dirt and scratches more clearly. On the right is that same photograph after a saturation increase of +70 points. As subsequent figures illustrate, this makes it easier to extract a clean photograph from the scan.

Fig. 8-32 The individual color channels from Figure 8-31, left, show that the blue-cyan dirt and scratches are most obvious in the red channel and least visible in the blue.

Fig. 8-33 The color channels from Figure 8-31, right, show that increasing the saturation of the photograph increases the differences between the channels. Because the color of the dirt and scratches is purer, they are even more visible in the red channel, since they are nearly eliminated from the blue channel.

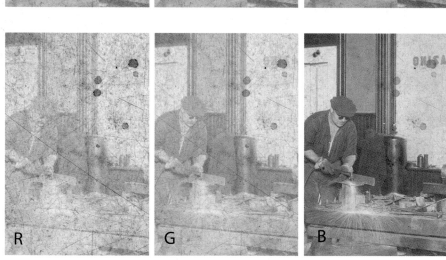

alone, an amazing recovery for such a damaged photograph. I'm well on my way to a clean restoration.

How to minimize scratches with color channels and channel mixing

I boosted the saturation of the photograph by +70 points (Figure 8-31, right); the individual color channels are shown in Figure 8-33. Exaggerating the saturation exaggerated those characteristics of the channels that were apparent in Figure 8-32. Now the red channel is extremely noisy, with almost no image visible, which would be a great starting point for creating a damage mask. But I don't need to do that, because the blue channel is, remarkably, almost damage-free. Even the large stains have been bleached.

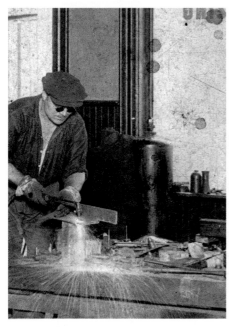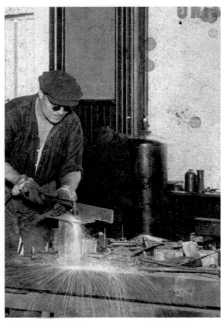

Fig. 8-34 The figure on the left portrays the saturation-increased blue channel of Figure 8-33 after I've corrected the tone and contrast. There's much less visible damage than in the original scan (Figure 8-31). The photograph on the right looks even better because I subtracted a bit of the noise-laden red channel from the blue channel, using the Channel Mixer settings from Figure 8-35.

The image at the left in Figure 8-34 reproduces that blue channel with the contrast and brightness adjusted for a normal-looking print. This is so much better than the original that it's hard to believe, and I achieved it with no handwork.

There's more I can do with this photograph. The blue channel doesn't entirely suppress the damage, but the red channel shows almost nothing else. So, if I were to subtract some of the red channel from the blue channel, I could remove more of the damage without diminishing the photograph much. That's what the Channel Mixer settings in Figure 8-35 do. The negative percentage in the Red Source Channel works like inversion does. Instead of adding some red to the image, I'm subtracting one-fifth of the red channel from the blue channel. The total still adds up to about 100%, so there won't be an overall brightness change. Note that this is the counterpart to the channel mixing trick I used in Chapter 7 to create the masks that selected for the scratches and dirt. Here I'm using it to suppress rather than enhance.

Why did this solution work so well? Look at Figure 8-31 and you'll see that saturation boost made the (false) colors in both the photograph and the scratches pretty intense. The photograph is now a very strong yellow, while the damage

Fig. 8-35 The Channel Mixer settings here produce a grayscale image by combining the red and blue channels from Figure 8-31, right. Subtracting a small amount of the red channel from the blue channel eliminates most of the residual garbage without much affecting the photographic image. This works because the red channel is almost entirely noise with very little image, so it doesn't subtract much from the underlying photograph.

is blue-cyan. Strong colors always have very high densities in some channels and very low densities in others. A perfectly saturated color, like a pure red, will have no density at all in one channel (the red one). Any time you can manipulate the tones and colors in a photograph to produce a very strong color difference, you'll be able to create an image where one color channel will have a very strong rendering of the photograph and a very weak impression of the damage you're trying to fix.

Filling in the Cracks

Filling in cracks is similar to erasing scratches and dust specks, but it's a tougher job because cracks are fatter. A typical scratch is only a couple of pixels wide, so it doesn't take a very wide-radius filter to cover it. Small features like scratches are also easily picked up in their entirety by simple filters like Find Edges. Find Edges easily selects the edges of cracks, but selecting the interiors as well takes more cleverness.

Cracks are also harder to repair because they're often not uniform in density, the way dust specks and scratches are. Cracks can have dark edges and light interiors, and if the cracks are large, the interiors may be mottled or dirty. Just as when dealing with scratches and specks, you can fill in cracks with handwork, but it's harder. If you use the Dust & Scratches filter, you'll have to set it to a very wide radius, and that will increase the amount of damage to real photographic detail. That makes it harder to use the History Brush to paint in the filter, so masking becomes even more helpful.

Curve tricks like the one I used in Figure 8-24 are very useful for suppressing cracks before doing serious work on them. In part that's because cracks, being larger, occupy a greater percentage of pixels than simple scratches, so it's more important to reduce their influence on filters. Another reason is that cracks usually expose bare white paper, which is always brighter than any other part of the photograph, so using darkening curves works everywhere in the photograph, regardless of the surrounding tones.

Removing Fine Cracks with a Mask and Median Filtering

In Chapter 7, "Making Masks," page 223, I showed how the Unsharp Mask filter made it easier to create a crack-selection mask for a badly damaged photograph (Figure 8-36) with the Find Edges filter (Figure 7-15d). To complete that mask, I took that blue channel and inverted it (Figure 8-37b). Next I applied a Gaussian Blur of 1.2-pixel radius; this filled in the outlines created by the filter so that

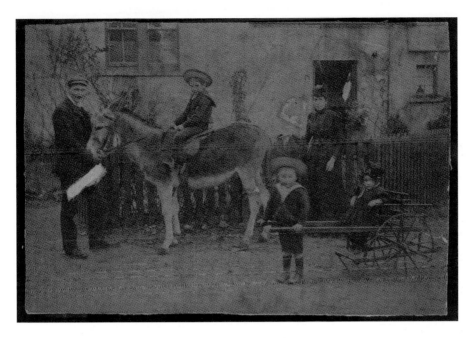

Fig. 8-36 This photograph is faded and yellowed, but its worst problem is that it is covered with a network of fine cracks, shown enlarged in Figure 7-15.

Fig. 8-37 (a) shows a portion of the sharpened photograph from Figure 7-15b. (b) is the inverted version of the masking image I created in Figure 7-15d. In (c), I blurred this mask with a Gaussian Blur of 1.2-pixel radius to fill in the crack outlines. I turned that into a strong mask (d) with good blacks and whites by applying the Curves adjustment in Figure 8-38.

the mask would select whole cracks and not just their perimeters (Figure 8-37c). Blurring lowered the contrast of the mask, so I applied the curve shown in Figure 8-38 to get the finished mask in Figure 8-37d.

Figure 8-41 shows a tone- and color-corrected enlargement of a portion of Figure 8-19; improving the color and contrast makes the cracks even more

Fig. 8-38 This Curves adjustment produces a strong, contrasty mask from the image in Figure 8-37c. It both lightens and increases contrast, producing Figure 8-37d.

obvious in the unrepaired photo on the left. See how effective this combination of mask, Curves, and Median filter described in the following how-to is at cleaning up the damage in the photograph on the right? The cracks are almost gone, and I achieved this without losing fine detail in the photograph.

How to fill in cracks in a print with a mask

The top image in Figure 8-39 shows an enlargement of another portion of the photograph from Figure 8-36. I repaired the cracks in that photograph in two stages. First, I loaded the mask as a selection and applied the Curves setting shown in Figure 8-40 to the cracks. That darkened them so that there would be less difference between the cracks' brightness and the surrounding, undamaged photograph.

That lets me better use the Median filter to fill in the cracks. The Median filter fills a pixel with the average of the surrounding pixels.

In photographs like this, where a high percentage of the pixels are in damaged areas, the average would get thrown off by those light-colored cracks. Darkening them kept them from distorting the tonal values of the filtered photograph so badly.

I applied the Median filter in Figure 8-40 to produce the photograph at the bottom in Figure 8-39. The 6-pixel radius worked well; if I'd set the radius too small, the filter wouldn't have sampled enough good pixels to fill in the cracks adequately. If the radius were too large, the filter would sample pixels from far away, and I'd not get the average of only those colors close to the pixel being fixed.

Removing Fine Cracks in Stages with Repeated Median Filtering

The photograph in Figure 8-42 was originally very low in contrast. Making a good scan of it (see Chapter 4, page 91) meant increasing its contrast considerably. That brought out an extensive network of cracks and emulsion damage.

Figure 8-43 shows the central portion of this photograph and two masks I generated using Photoshop filters. The Find Edges filter (center) produced a mask that did a good job of picking out the heaviest cracks, but it didn't create much distinction between the finest ones and the lighter background. The Glowing Edges filter (right) was a better choice for finding all the cracks; they're much more clearly emphasized, especially against the light background and skin tones.

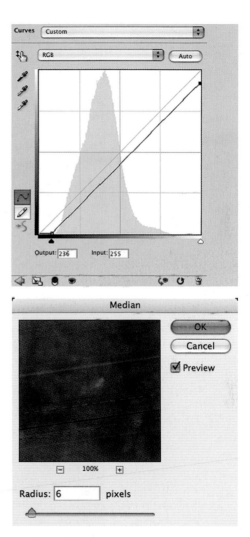

Fig. 8-40 The Curves adjustment, top, applied to the masked photograph in Figure 8-39, top, darkens the white cracks in the photograph so that they're closer in tone to the surrounding image. Making this adjustment lets the Median filter, bottom, do a better job because the muted tones in the cracks don't throw off the average tone as much.

Fig. 8-39 Crack repair on this photograph is a two-stage process. At top is the original photograph. In the center is the photograph after applying the Curves adjustment from Figure 8-40 to the masked photograph. That reduces the visibility of the cracks and gives them tones more like the surrounding photograph. This lets the Median filter in Figure 8-40 work more accurately as it fills in the cracks with surrounding tones (bottom).

Fig. 8-41 The figure on the left is an enlargement from Figure 8-36 corrected for tone and color to produce a good B&W photograph. With the contrast improved and the stains removed, the cracking problem is glaringly obvious. The figure on the right is the result of masking for the cracks and applying the Curves adjustment and Median filter from Figure 8-40. The cracks are nearly gone, and there is almost no loss of real photographic detail.

Fig. 8-42 This photograph is badly scratched and marked up. Fortunately, many scratches can be removed with proper masking and filtering.

I tackled these cracks in stages with repeated use of the Median filter, applied via the Glowing Edges mask, as I explain in the how-to. Repeated filtering improved the picture because each pass averaged more of the good surrounding photographic image into the cracks. Had I used a large-radius filter, it would have been more aggressive at filling the cracks, but it also would have attacked real detail and caused problems with dark areas bleeding into light, and vice versa. Keeping the filter radius small ensured that the filling in was based only on neighboring tones.

In this example I made extensive use of the history brush to control how the different filter passes got applied to the original image. Alternately, I could have done the various filterings on duplicate layers masked with the Glowing Edges mask and then brushed black into those layers' mask channels to restore the prefilter detail where I needed it and to restrict the effects of subsequent filtrations.

How to repair cracks in stages with Median filtering

I loaded the mask shown in Figure 8-43, right, as a selection and applied the curve at the top in Figure 8-44. That subdued the cracks in the midtones and highlights, although it didn't accomplish much in the shadows (Figure 8-45b). Then I applied the Median filter with a radius of 1 to get Figure 8-45c. I applied the Median filter three more times with the same radius, which took me to Figure 8-45d.

I did a final Median filtering with a radius of 7 pixels (Figure 8-45e). That did a very good job of filling in all the cracks in the midtones. It also erased photographic detail in a couple of small places, but I restored that detail with the History Brush assigned to the prefilter history state. Even at this larger radius, though, the Median filter couldn't fill in the very light, closely spaced cracks in the shadows.

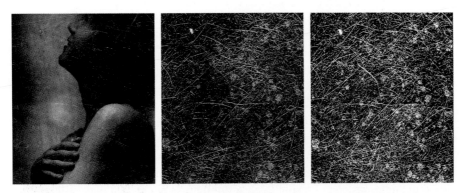

Fig. 8-43 This enlargement from Figure 8-42 shows how extensive the scratches are. Photoshop's Fine Edges filter did well at isolating the heavier cracks, but it didn't pick up the finer ones (center). The Glowing Edges filter found even the finest cracks, producing the superior mask on the right.

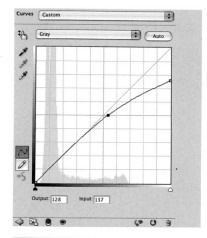

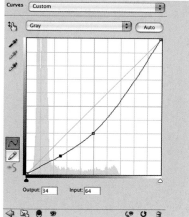

I went after them with a second pass. First I used the History Brush to erase the effect of the 7-pixel Median filter in the shadows (Figure 8-46a), and then I applied the curve to achieve the image at the bottom in Figure 8-44. That substantially darkened the cracks in the shadows so that the Median filter could work more effectively there. You can see the results in Figure 8-46b. This curve messed up the midtones and highlights, but that wasn't going to be a problem because I was planning to use the History Brush to paint in the new round of corrections only where I wanted them.

Because I was working in the shadows, where there was little image detail or difference in tones, I could use a Median filter of large radius (13 pixels) to fill in the cracks with a single pass. That produced Figure 8-46c—which looks great in the shadows but has distorted midtones and highlights. Out came the History Brush! I assigned this new Median filter history state to the brush and reverted the photograph to the state corresponding to Figure 8-46a. I used the brush to paint the Median filtration into the shadows and midtones that hadn't been properly corrected on the first pass.

You can see the result of these multiple filter passes in close-up in Figure 8-46d. Figure 8-47 shows the full before and after photographs. There's a lot of work to be done to turn this into a good photograph, mostly dodging and burning in with masked layers as described in Chapter 5, page 148, but the majority of the fine-detail physical damage is gone.

Whittling away at Wide Cracks

When cracks get more than several pixels wide, single-pass fill-ins are hard because it's difficult to make selections that grab the entire crack. In Chapter 7, "Making Masks," page 224, I talk about how a combined use of noise reduction software, the Find Edges filter, and the Lens Blur filter can often produce a useful mask for making such a selection. With large selections, though, the filters I apply will be influenced as much by the cracks as by the surrounding photograph with which I'm trying to fill them in. When I worked on the image at the top in Figure 8-48, in Chapter 7, I emphasized masking methods that would grab the damaged areas as completely as possible. Now I'm going to approach it from a different angle. Instead of trying to clear out the whole crack at once, I'll whittle away at it, peeling off its pixels like layers from an onion. The following how-to explains how that works.

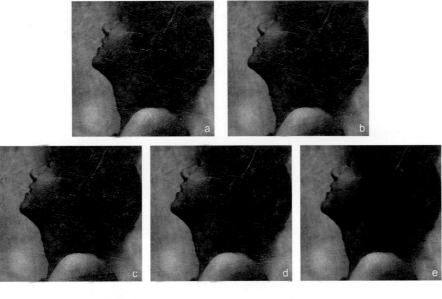

Fig. 8-45 The original photograph, (a), has many white scratches defacing the image. Masking it with the mask from Figure 8-43, right, and applying the Curves adjustment from Figure 8-44, top, reduces the visibility of scratches in the midtones and highlights (b). Applying a Median filter with a one-pixel radius produces (c); repeated applications of the Median filter generate (d) and (e), as described in the main text.

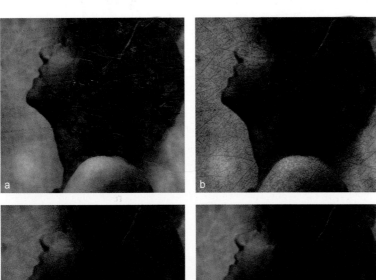

Fig. 8-46 (a) This photograph is the same as Figure 8-45b except that I used the History Brush to undo the effects of the Median filter in the shadows. (b) Applying the Curves adjustment from Figure 8-44, right, darkens the scratches in the shadows very effectively. Applying the Median filter then produces (c), which has great shadows but messed-up midtones and highlights. I assigned this state to the History Brush, reverted to Figure 8-46a, and used the Brush to paint the scratch-filtering into the shadows of (d). The full photograph of these results is shown in Figure 8-47, right.

275

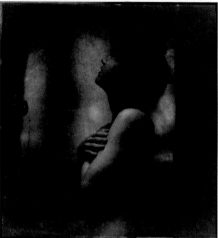

Fig. 8-47 The original photograph, left, had way too many fine scratches to make manual retouching feasible. I substantially repaired it by masking and repeated Median filtering, right.

How to repair large cracks with repeated masking and filtering

I made a copy of the file and used the Find Edges filter to pick up the small specks and the edges of the large cracks (Figure 8-48, center). I copied the blue channel from that image, inverted it, and increased the contrast to make the background black and all the edges of the cracks solid white so that it would make a good mask (Figure 8-48, bottom).

I loaded this mask as a selection and applied the Dust & Scratches filter shown in Figure 8-49. I set the radius on the filter large because I wanted to sample lots of surrounding pixels. I relied on the mask to limit the area that the filter affected. This eliminated most of the small cracks and specks and substantially reduced the extent of the large cracks, as you can see at the top in Figure 8-50 and enlarged in Figure 8-51b.

To peel off the next layer of the cracks, I needed to create a new selection mask. First I made a copy of the cleaned-up image and aggressively sharpened it (Figure 8-51c) with the Unsharp Mask filter shown in Figure 8-52. I did that to create new sharp edges on the cracks that the Find Edges filter could grab onto. Then I made a new edge-selection mask the same way I did the first one: I applied the Find Edges filter, inverted the results, and increased the contrast so that the mask had true blacks and whites. I loaded this new mask onto the photograph, used the same Dust & Scratches filter I had previously, and got the results you see at the bottom of Figure 8-50 and in Figure 8-51d.

You can run this kind of mask-and-filter cycle repeatedly until you fill in the cracks. After the second or third pass, you'll have filtered all the small cracks and only have the remnants of the largest ones left. If you do this for too many cycles, though, you'll start to degrade the photograph because the mask doesn't

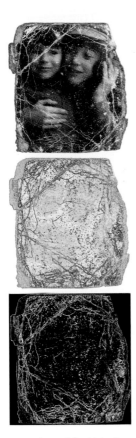

Fig. 8-48 I created a mask for this badly cracked photograph by using Photoshop's Find Edges filter. That filter (center) picks up the edges of the cracks well. The blue channel from that image, inverted and contrast-enhanced, makes a good crack-selection mask (bottom).

Fig. 8-50 The photograph on top illustrates how the Dust & Scratches filter from Figure 8-49 improves Figure 8-48. The enlargements in Figure 8-51 show that the mask restricted the effect of the filter so that it whittled away at the cracks without destroying real photographic detail. Additional edge-selection masking and Dust & Scratches filtering eliminates even more of the cracks (bottom).

Fig. 8-49 I applied this Dust & Scratches filter to the masked photograph in Figure 8-48 to produce Figure 8-50, left. Note the large filter radius; I'm using the mask to restrict the spread of the filter's effects instead of the radius setting.

Fig. 8-51 (a) shows an enlargement of Figure 8-48, left. (b) shows an enlargement of Figure 8-50, left, illustrating how much damage can be cleaned up by masking plus the Dust & Scratches filter. (c) is an intermediate work image I created by aggressively sharpening (b) with the Unsharp Mask filter settings shown in Figure 8-52. I created a new edge-selection mask from (c), applied it to (b), and ran the Dust & Scratches filter again, as shown in (d).

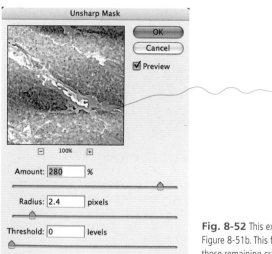

Fig. 8-52 This extremely strong Unsharp Mask filter enhances the edges of the cracks left in Figure 8-51b. This facilitates the Find Edges filter in making a new edge-selection mask from those remaining cracks.

perfectly distinguish between the photograph and the damage; the filtering will "leak" into the photograph a little bit with each pass. To prevent that, I use the History Brush to paint in the later filtering passes just where I want them, or I do that filtering in duplicate masked layers and paint the mask white where I want the filtering. Since I've already eliminated 99% of the defects, this task isn't too onerous and time consuming.

Paving over Tears and Holes

Tears and small holes, though catastrophic to original photographs, are really not all that hard to repair. Clean tears, especially, produce damage that is localized and well defined. In principle, you can repair it with nothing more than judicious use of the Clone tool, but there are lots of ways to make the job go faster.

Figure 8-53 shows a negative with a tear along its lower edge. I repaired it using Image Doctor 2's Smart Fill function and Photoshop's Healing Brush and Patch tool. You can read the details at http://photo-repair.com/dr1.htm.

Using the Spot Healing Brush

The Spot Healing Brush comes in handy when I'm trying to clean up isolated holes or spots. Take its name at face value; it works a lot better when you "dab" it on a bad spot than when you try to paint an extended line with it.

Fig. 8-53 This negative has a tear at the bottom that makes it impossible to print conventionally without a lot of print retouching. I used Photoshop's Spot Healing Brush to accomplish the repair in the middle figure. I repaired the bottom figure with the Patch tool. Each tool has its strengths and weaknesses.

How to remove chemical and water spots

The enlargement at the lower left of Figure 8-54 shows a film scan of a photograph that has a bunch of chemical or water spots in the middle of it. When you're only clearing out a few isolated spots, using the brush directly on the photograph works fine. However, when there are lots of blemishes to be cleaned up, as there are here, it's safer if your cleanup efforts go into a layer of their own.

I created a new empty layer above the photograph. I selected the Spot Healing brush tool and set it to Sample All Layers. The new empty layer is the active one, so that's where the tool's results will be rendered, but Sample All Layers directs the Brush to create those results from the underlying photograph.

Working my way over the photograph, clicking the Spot Healing Brush wherever there was a water spot removed 90% of them with very little trouble.

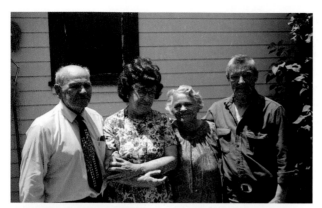

Fig. 8-54 Water spots deface this negative, seen enlarged at lower left. The Spot Healing Brush is the ideal tool for repairing this damage. It removes 90% of the spots perfectly (lower right).

Every so often the brush introduced an odd or inappropriate element into the photograph. Usually clicking again on the same spot or near its edge would get rid of the blemish the brush had introduced with the first click. Occasionally it made it worse. Don't sweat it; just plan on making a second pass with the Clone tool to manually repair the few blemishes that the brush couldn't take care of or created. Remember that the Clone tool can also sample underlying layers and place its results in the same layer used with the Spot Healing Brush. If you wind up with results that are unacceptable from either the Spot Healing Brush or the Clone tool, simply use the eraser to wipe them out and try again. It's impossible to make a bad mistake with these tools this way.

Clearing the Debris
Eliminating Tarnish

Old silver photographs are prone to tarnish and bronzing—shiny or iridescent metallic-looking spots on the surface of the print, especially in the shadows.

Tarnish is a vexing problem in restoration because it casts a veil over everything, but with the right techniques it is remarkably easy to fix.

The image at the top in Figure 8-55 shows a B&W photograph that's tarnishing out. There's a bluish sheen to the blacks, and much of the print has a low-contrast, milky haze over it. The reduced contrast was easy to fix with a good scan (middle photograph); I got rid of some of the yellow in the highlights and improved the density in the shadows. It didn't get rid of the tarnish, but it did make it clearer.

How to eliminate tarnish and silvered-out spots

The way to attack the tarnish in Figure 8-55 is to isolate it with a mask. The tarnish had a bluish sheen, so I applied the Hue/Saturation settings in Figure 8-56. This exaggerated the color of the tarnish so that it would be easier to pick out, as shown at the bottom of Figure 8-55.

Many Photoshop tools can create a mask out of color distinctions: the Color Range selection, the Channel Mixer, or Image Calculations (see Chapter 7, "Making Masks"). The Asiva Selection plug-in is a favorite of mine. Figure 8-57 shows the Asiva Selection control panel with the curves I used to isolate the tarnish. The top curve restricted the selection to colors in the blue part of the spectrum, excluding undamaged parts of the photograph that were yellowish. I set the saturation curve to reject areas that had very little or no saturation, since those were untarnished. The resulting selection is shown in Figure 8-58.

I created a Curves adjustment layer with that selection. It would be just as effective to apply the curves directly to the selection, but the adjustment layer left me free to try out different curves that I could revise later. Knowing that the tarnish was greenish blue and lighter than the surrounding areas, I developed my curves by trial and error (Figure 8-59). The RGB curve doesn't have a big effect; it darkens the shadows some and ensures that the darkest tones really are near-black. The green curve shifts the color substantially to the magenta, having the least effect in the highlights and the greatest effect in the shadows. The really big change occurs in the blue curve. I dragged the black point way in and added another control point, which pulled the whole curve down so that everything except for the very whitest tones was shifted very strongly to the yellow.

The method I present in the how-to produced the photograph on the left in Figure 8-60, which is tarnish-free. The details in the hair and the texture of the moiré silk blouse are once again rich and clear. The restoration isn't complete, however; there are yellow stains and marks on

Fig. 8-55 The photograph on the top is not badly faded, but it is yellowed and severely tarnished. The middle figure shows the scan I made of this photograph that eliminated the stain and made the photographic image less yellow. This made the tarnish bluer. I accentuated the color of the tarnish with the Hue/Saturation settings in Figure 8-56 to produce the figure on the bottom.

Fig. 8-56 These Hue/Saturation settings exaggerate the color difference between the tarnish and the underlying photograph, so that it will be easier to prepare a tarnish-selecting mask. The Master adjustment of +40 points exaggerates both the slightly yellow tone of the photograph and the blue color of the tarnish. The Cyan adjustment of +59 points kicks up the saturation in the tarnish even more.

the surface of the print, and the paper texture is distracting, but I've fixed the worst problem. In the next section, I get rid of the stains and marks. On page 286 I subdue the annoying paper texture, which will finish up this restoration.

Picking the Right Color for B&W

In Chapter 7, page 230, I created masks using channels and the Channel Mixer to exploit color differences between B&W photographs and the damage inflicted on them. I used the Hue/Saturation tool to exaggerate those differences, making those channel manipulations even more effective. I took advantage of colors or combinations of colors that especially emphasized the damage over the photograph.

Those same tricks can be inverted to minimize the damage using complementary colors. For example, damage that is especially visible in the green channel will have a strong magenta component. That means it will not be very visible in

Fig. 8-57 This screenshot of the Asiva Selection plug-in at work shows the settings I used to create the tarnish-selecting mask in Figure 8-58. I restricted the range of selected colors to the blue tones characteristic of the tarnish. I also adjusted the Saturation curve to reject any tones that were not at least moderately saturated. This did a good job of isolating the tarnish for repair.

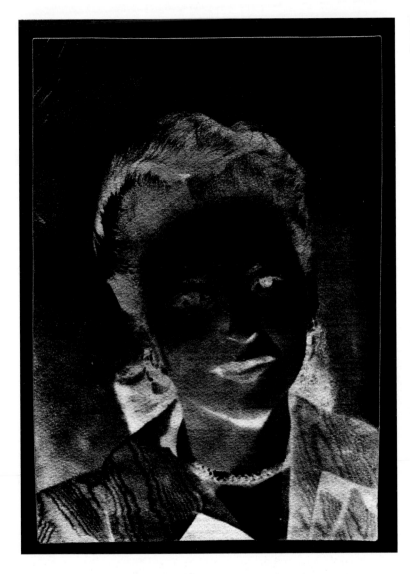

Fig. 8-58 This is the finished mask that I used to repair the photograph in Figure 8-60.

the "magenta" (red + blue) channel. I would use the green channel to build a mask from because it shows the damage so clearly. Conversely, if I wanted to suppress that damage, I would use the Channel Mixer to combine the red and blue channels and exclude the green channel.

I used the colors green and magenta merely as examples. The precise color that works best will depend on the photograph and the damage. If the damage

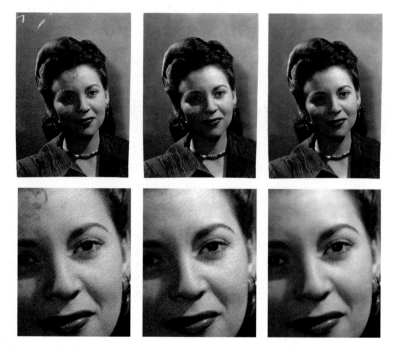

Fig. 8-59 This Curves adjustment eliminates the tarnish from Figure 8-55 when it's used in conjunction with the tarnish-selecting mask from Figure 8-44. The RGB curve slightly darkens the shadows, the green curve makes the tarnish more magenta, and the blue curve makes it much yellower. That eliminates the light blue/cyan cast that the tarnish had and makes it blend in perfectly with the photograph (Figure 8-60, left).

Fig. 8-60 The figure on the left shows the photograph from Figure 8-55 after tarnish repair. Tone and contrast are good, but there's some yellow-orange stain, and the paper texture is distracting. The stain is least visible in the red channel, so I copied that into the middle figure and used the Clone tool to repair the minimal amount of residual damage. The figure on the right shows the fully restored photograph after I removed the paper texture with Neat Image (Figure 8-63).

looks reddish compared to the photograph, check out the red channel; if it looks cyan, check out the green and blue channels. What you can usually count on when restoring a B&W photograph is that one channel will show the damage and stains on the photograph less than the other channels.

That's especially true when you've done a good full-color scan that produces a reasonably neutral-toned photograph. Stains and other defects usually have a

Fig. 8-61 The tape stain in this photograph has a strong red-orange color, which means that it is least visible in the red channel (see Figure 7-46).

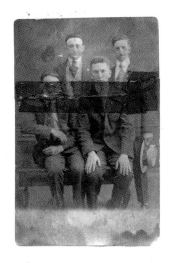

different color from the photograph proper. Once you've finished with the kinds of repairs that require a full-color image, like the tarnish-reducing work I did in the previous section, look at the individual color channels for the photograph and select the one that looks the cleanest for further restoration work.

In the portrait in Figure 8-60 the stains are yellow-orange in color. When I inspected each color channel, I saw that the red channel displayed hardly any of the stains. I copied that channel into a new file that is shown in the middle column of Figure 8-60. I used the Clone tool to clear out the white marks of the top and remove a couple of small dark spots from the picture; it literally took just a few minutes' work to make it look this good.

How to minimize tape stains

In Chapter 7, starting on page 238, I demonstrated several ways to mask Figure 8-61 to select the tape for repair. In preparation for that repair, I wanted to reduce the discoloration in the taped area. I did that by manipulating the Hue/Saturation control. The tape was least visible in the red channel, hardly a surprise given the color of the stain, so I went to the Channels palette and clicked off the "eyes" for the green and blue channels (Figure 8-62) so that I was viewing only the red channel. The RGB channel was still highlighted, so all the channels were active.

I launched the Hue/Saturation control and began moving the Saturation slider up. That changed the intensity of the red in the tape stain and varied its appearance in the red channel. By watching how the appearance of the tape changed in the preview, I could choose the right saturation setting to minimize its impact. Normal saturation showed the tape darker than the surrounding area. Moving the saturation up to around +40 did a good job of lightening it.

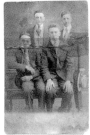

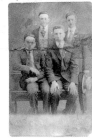

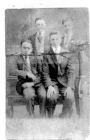

Fig. 8-62 I can make strongly colored stains less visible with an appropriate saturation increase. The screenshot at the top shows the red channel from Figure 8-61 along with the Hue/Saturation control panel. The tape stain is modestly darker than the rest of the photograph. Increasing the saturation by +42 points makes the typical density of the stain in the red channel the same as the unstained photograph. That reduces the amount of work needed to repair this photograph. Increasing the saturation too much makes the stain look lighter than the rest of the photograph (bottom).

Dealing with Textured Prints

Paper texture isn't really damage, because it was an intentional part of the original print. Print textures, though, usually look bad when they are reproduced on a flat-finish paper. If you want to restore an original, textured photograph to a fresh textured print, you will get a much better-looking print if you print a clean image on textured paper than if you try to print the illusion of texture. Consequently, I treat texture as though it were widespread damage—something I want to erase from the prints while doing as little destruction of photographic detail as possible.

Like tarnish and other surface blemishes, texture tends to get enhanced in scans. In Chapter 4, "Getting the Photo into the Computer," page 117, I talked about rephotographing textured prints on a copy stand as one way to get around the paper texture problem. Here I deal with getting rid of paper texture in scans.

The print in Figure 8-60 cleaned up nicely with the tarnish mask. To get rid of its texture I used Neat Image, a powerful noise reduction plug-in.

How to remove print surface textures using Neat Image

Neat Image profiled a section of the background in Figure 8-60 to create a filter that could cancel out the texture just as though it were noise (Figure 8-63). The filter was so effective that it completely eliminated the paper texture at its default settings, but it also softened the finest detail in the photograph.

I wanted to retain the fine detail. I did that by using the noise reduction sliders. I set the sliders' high-frequency Noise Reduction Amount to 0%. I left the mid- and low-frequency settings at 100%. That meant that the filter still had full effect on the coarse paper texture but left fine detail (and texture) alone.

Applying the filter produced the photograph at the right in Figure 8-60. All the image detail is still there, but almost all the paper texture was removed. There's a very fine "tooth" to the photograph from the high-frequency texture I allowed to get through, but it's not distracting or intrusive.

Figure 8-64 was a tougher case. This school portrait was printed on that "honeycomb" paper that was commonly used for inexpensive portraits. It created some real restoration problems for me. Because this photograph wasn't very faded, overall color and tone correction was pretty easy. I made a good scan and some modest curve corrections to get the photo shown at the left in Figure 8-65. Unfortunately, as the lower enlargement makes clear, the honeycomb texture really messed up the photograph's appearance.

Fig. 8-63 The Neat Image plug-in for Photoshop can clean up paper texture in a scan just as well as noise. I eliminated the texture from Figure 8-60 without compromising fine photographic detail by adjusting the high-frequency Noise Reduction Amount. Turning this all way down to 0% ensured that fine details like the catch lights in the eyes wouldn't be filtered out. Most of the paper texture was still eliminated, resulting in a very good restoration (Figure 8-60, right).

I turned to Neat Image once again and, sure enough, it did great job of extracting a texture profile from a background area that completely eliminated the honeycomb. Because this texture was sharp and well defined, I couldn't turn down the high-frequency noise filtering and still remove it. In fact, I had to turn up the noise-level detection for the high and middle frequencies to successfully grab all the pattern (Figure 8-66). I was able to turn the low-frequency noise filter and noise reduction all the way down, and that helped a little to preserve detail. The center image in Figure 8-65 is the result. The enlargement shows that the filter completely eliminated the paper texture and didn't blur the print detail very much—but the print wasn't that sharp to begin with. I'd like to fix that.

I turned to Focus Magic. Focus Magic restores sharpness to every part of the photograph, not just edges,

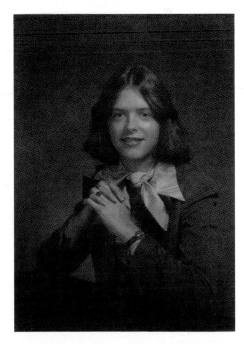

Fig. 8-64 This 30-year-old high school portrait is printed on honeycomb-textured paper. Once the color and contrast are restored, the paper texture is very intrusive because of the increased contrast (Figure 8-65, left).

Fig. 8-65
The photograph and enlargement on the left show the color-restored version of Figure 8-64. This photograph looks great except for the annoying paper texture. Neat Image, using the settings in Figure 8-66, eliminates the paper texture entirely, but it also loses some of the fine detail in the photograph. Focus Magic (Figure 8-67) not only restores that lost sharpness, it actually brings out a bit more detail in the photograph than was visible in the original (right).

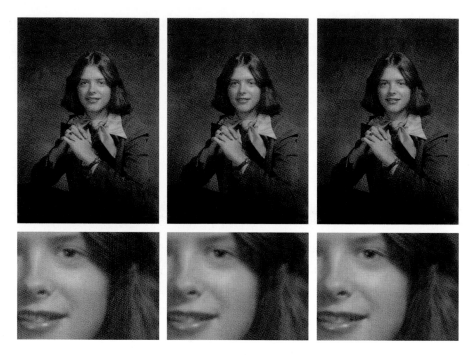

Fig. 8-66 These Neat Image settings eliminated the paper texture in Figure 8-65. The texture is very fine and sharp-edged, so the high-frequency Noise Filter and Noise Reduction settings were turned up to maximum. Since the texture contains no low-frequency components, I turned that Noise Reduction setting off.

Fig. 8-67 Focus Magic effectively sharpens up the photograph in Figure 8-65, right. It did more than simply restore detail that was removed by Neat Image; it made the photograph sharper and more detailed than it was originally.

so you don't want to use it on a noisy image because it will enhance the noise along with everything else. But Neat Image had done such a good job of removing the paper texture that there was little of it left for Focus Magic to exaggerate. I set the blur width to 9 pixels, as shown in Figure 8-67, and let Focus Magic do its work. The final photograph, at the right in Figure 8-65, is both sharper and smoother toned than the original.

How to remove print surface textures using Picture Window

Picture Window has a built-in tool called Advanced Sharpen that works pretty well on paper texture. What makes it useful for texture removal is that it has three stages of operation: noise reduction, speck removal, and sharpening. To attack the paper texture, I used the first two operations and didn't do any sharpening.

In Figure 8-68, I applied the Advanced Sharpen tool to the school portrait. Under noise reduction, I set a blur radius of about 2.5

Fig. 8-68 Picture Window's Advanced Sharpen transformation includes Noise Reduction and Speck Removal tools that can minimize paper textures. In the top screenshot, I've set the Noise Reduction sliders to include most of the detail in the paper texture without compromising real photographic information too badly. That produces the results seen on the right. I can further improve that result in the Speck Removal stage by instructing the tool to remove only the light specks. That picks out the highlights from the texture that wasn't eliminated by Noise Reduction.

pixels and adjusted the noise detection sliders at the bottom of the control panel until they did a good job of picking up most of the paper texture without starting to eat away at the detail in the photograph. The preview window in the upper right showed that this stage would suppress (but not entirely eliminate) the paper texture without damaging fine detail too much.

After I applied noise reduction, I advanced to the speck removal stage. Because the texture was significant, I set the speck size to 10×10 pixels and told the filter to remove only light specks (the highlights from the texture). I moved the threshold slider up to almost 100% so that it would find low-contrast texture, and I set the detail detection histogram slider so that the filter grabbed the texture but not too much else. As you can see in the preview window, the results are not as perfect as with Neat Image, but I've eliminated most of the paper texture without compromising the detail in the photograph.

When the paper texture is finer than the image detail in the photograph, sometimes Photoshop's filters can handle it. The Dust & Scratches filter will do the job without costing you too much detail. Figure 8-69 shows before (left) and after (middle) close-ups of a textured print scan. The "after" version was generated by the Dust & Scratches filter with a radius of 2 pixels and a threshold of 4.

The Median filter does an extremely good job of suppressing fine paper texture, but it strongly attacks real image detail, so use it carefully. I filtered the photograph at the right in Figure 8-69 with the Median filter at a radius of 2 pixels. All the paper texture wasn't suppressed at this radius, but increasing the radius to 3 visibly blurred the photograph.

Repairing Mildew

Mildew damage is a serious problem for original photographs. Mildew spots and filaments are composed of microorganisms that eat the photographic emulsion

Fig. 8-69 Very fine paper texture, as in the photograph on the left, can be attacked with Photoshop's own filters. The Dust & Scratches filter, with a 2-pixel radius and a threshold of 4, produced the middle figure. The paper texture is finer than the finest detail in the photograph, so it is eliminated, while photographic information isn't. Median filtering can also reduce or eliminate paper texture (right), but it has to be used very carefully to avoid blurring the photograph.

and grow. Mildew will expand just like bacteria in a culture dish. Photos that are starting to suffer mildew damage will only get worse, so they should get priority for treatment (or digital restoration).

Moderate mildew damage takes the form of long dark filaments or clusters of small dark spots, like closely spaced freckles. The long mildew filaments look like fine squiggly scratches in a scan, and you can treat them as you would other scratches. Because mildew spreads from single spores that take hold, the filaments grow out like the roots of a plant, so they are very close together. Throughout this and the preceding chapter I introduced techniques for dealing with dense networks of fine cracks, and those methods will work just as well on mildew.

Dense groups of mildew "freckles" cause many restorers problems because they aren't as well defined as the filaments and they can cover enough of a photograph to seriously distort average tonal values. That makes them harder to remove with simple filtering, and they are far too numerous to remove by cloning. This how-to describes a multiple-pass filtering approach that works well when mildew attacks a broad uniform area of the image, which is where it is most visible. If two passes aren't sufficient, you can repeat this Median filter lightening process as many times as needed to get a clean image. In recent versions of Photoshop, you can implement this approach in any of several ways.

How to erase mildew spots using the History Brush

Figure 8-70a shows the corner of a slide that is developing mildew freckles. (This figure is heavily sharpened to make it easier to see the mildew spots, so ignore white halos around edges, because those are just sharpening artifacts.) The sky along the left side and upper part of the photograph is filled with numerous dark spots. You could simply blur them out, but it wouldn't work well. Because the average tone, including the mildew, is darker, if you just blurred them out there would be a broad dark blemish in the sky. In Figure 8-70b, I applied a Median filter with a 10-pixel radius to the photograph. The freckles were obliterated, but that faint dark blemish I warned about showed up.

The way to fix that is to paint in the effect of the filter using the History Brush set to Lighten mode. I assigned the History Brush to the Median filter state, reverted to the previous state, and painted over the mildew with the History Brush. It lightened the mildew spots but didn't have any effect on the sky in between.

I did that on Figure 8-70c, and most of the mildew is gone. There's still a faint impression of it because the filter isn't painting in undamaged blue sky but an average of blue sky and dark mildew. The way to completely eliminate the mildew is to repeat the process. In Figure 8-70d, I applied the Median filter again and used the History Brush in Lighten mode to paint over the mildewed area a second time. This completely eliminated all evidence of the mildew and restored perfect sky color.

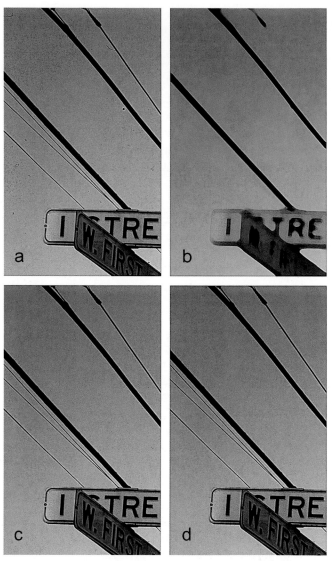

Fig. 8-70 Dark mildew specks and spots, like those afflicting the photograph in (a), can be filtered out in stages. A 10-pixel Median filter produced (b). There are broad, faint dark areas in the sky because the Median filter averaged the dark mildew into the blue sky. To get rid of those, I assigned the Median filtering to the History Brush, reverted to the previous state, and used the Brush in Lighten mode to paint over the mildew in the sky (c). This has no effect on the blue sky, but it lightens the mildew considerably. I applied the filter a second time and History-Brushed it over the residual mildew in (c). The result, (d), is free from mildew blemishes, and the sky is restored to its natural tones.

Fig. 8-71 Apply filtration in masked layers to control where it affects the photograph. The top photo shows mildew damage. I used the median filter on a Lighten-blended duplicate layer (Figure 8-72) to suppress the mildew. I hand-painted a layer mask (middle figure) to restrict the filter's scope. The combination of layers (bottom) has a much cleaner sky.

How to erase mildew spots using masked layers and Smart Filters

In the previous how-to, I used the History Brush in lighten mode to paint in the Median filtration. You could also do this with masked layers. Duplicate the original photograph, apply the Median filter to the duplicate, set the blend mode for that layer to Lighten, and paint white into the layer's mask channel wherever you want to filter to take effect (Figure 8-71).

To apply the filter repeatedly, as I do in the how-to, you'll need to merge the work you've done into a single layer so that the next filter pass can build on the first. The way to do that is with the following incredibly obscure keystroke combination: Command-Alt-Shift-E (if you're working on a PC, that would be Control-Alt-Shift-E). That creates a brand-new layer on top of the stack that merges together all the existing layers (Figure 8-72). Duplicate that layer; then filter, blend, and mask the duplicate as I described in the preceding paragraph.

Fig. 8-72 The layer stack I used in Figure 8-71. The Command-Alt-Shift-E key combination creates a merged layer (highlighted) from the original photo and the masked, filtered layer.

Fig. 8-73 Use smart objects and filters when you want to stack filter effects and be able to go back and change your filter settings later.

Smart Filters are ideal for this situation. First you'll need to convert the photograph to what Photoshop calls a smart object so that you can apply Smart Filters to it. Select Filter | Convert for Smart Filters from the menus to transform the photograph. Now when you select Median filtration from the filter menu, Photoshop will apply it as a Smart Filter. You use Smart Filters much like adjustment layers. You can change the parameters and blend modes for the filter at any time and you paint into its mask layer to control where it affects the photograph (Figure 8-73).

Each Smart Filter you add applies its effect to the cumulative effect of all the preceding Smart Filters. You don't have to merge your filter results before applying another stage of filtering. All your preceding work is changeable and the changes will propagate up the filter stack.

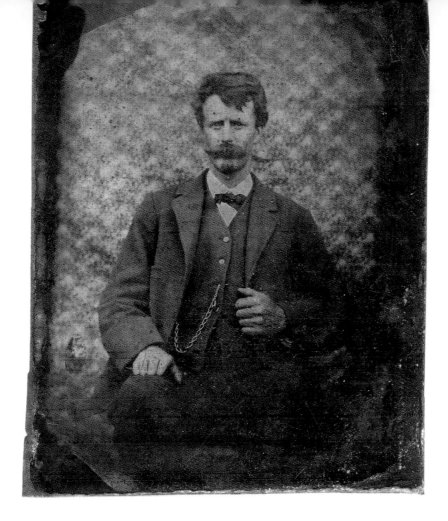

Tips, Tricks, and Enhancements

How-To's in This Chapter

How to scan very contrasty photographs
How to eliminate the dots from newspaper photographs
How to increase sharpness and fine detail in a photograph
How to make a photograph look like a tintype
How to combine scans to make one large photograph

Introduction

Every photograph is unique, and so is every photo restoration job. Many photographs have common characteristics, though, so I've concentrated my instruction to this point on the tasks that benefit the greatest number of photographs. I've grouped those tasks into broad categories and chapters of shared purpose, like color correction.

Still, I can't ignore the inherent uniqueness that makes every restoration job an interesting and stimulating challenge, nor can you. For your part, you want to be flexible and versatile if you're going to restore photographs effectively and efficiently. For my part, I want to introduce you to a bunch of specific tricks and techniques that I've found especially useful but that don't fit neatly into one of those broad categories that I laid out.

Save Time by Using Your Keyboard and Mouse

I've noticed that most people who work on the computer have deeply ingrained mouse and keyboard work habits. Some people are very mouse and menu oriented. When they need to save a file in Photoshop, their instinct is to go to the File menu, click on it, scroll down to Save, and click that. Okay, that works, but simply pressing Command S (CTRL-S in Windows) does exactly the same thing, and you don't have to move your mouse (or even let go of it). Not having to navigate a hierarchy of menus is a lot less disruptive to your thought processes.

Frankly, I'm more mouse oriented than not. I'm not the person to lecture you on not knowing how to play the keyboard like a virtuoso. I don't seem to be able to remember many more than six keyboard shortcuts at one time, a small fraction of the number available. But knowing only that handful saves me a huge amount of time. I can remember that Control-Shift-S activates Save As, so I can save a file with a new name; Y switches to the History Brush and S to the Clone tool when I'm retouching; and the Spacebar activates the Hand tool when I'm lassoing a large area. D sets the foreground and background colors to the default black and white. X swaps those colors. Those are handy when you're using the Brush tool, especially when you're painting masks. The [and] keys expand or contract my brush; the { and } make it harder or softer. Each of these shortcuts is just a tiny little time saver, but together they add up to a lot of minutes each day.

I have a few more keystroke shortcuts that are not so easy to remember, but they're so useful that it's worth giving it a try. Alt-Shift, in combination with certain letters, changes the blending mode of tools. With almost all the tools, Alt-Shift-G switches the mode to Lighten and Alt-Shift-K switches it to Darken. And not too surprisingly, Alt-Shift-N sets the blend mode back to normal. When you're using something like Clone or History Brush tools, where you frequently want to be working in Lighten or Darken mode, these keystroke shortcuts can

save you a lot of time by saving you having to move the cursor away from the part of the photograph you're working on.

One last keystroke combination, which isn't exactly a shortcut, does something so very useful that you'll want to make note of it somewhere so you don't forget it. Command-Alt-Shift-E (on a PC, that would be Control-Alt-Shift-E) creates a new layer at the top of the layer stack that is the merged combination of all the visible layers. Unlike the normal Merge Layers command in the menu, this doesn't destroy all the individual layers that went into the merged layer. The preceding layers are preserved, so you can go back and modify them at a later time, should you feel the need.

With so much control being available in adjustment layers and the like, you'd think there'd be no reason to create such a merged layer. The need arises because some of Photoshop's tools, such as filters and plug-ins, work directly on a single image layer; they can't work on the combined elements of a layer stack. So, for example, if you've done a lot of dust and scratch removal using layers, as I've described in the preceding chapters, and you want to filter the finished result in some way or apply a plug-in to it, you'll need to merge all that work into a single layer.

I'm not going to prescribe which keyboard commands you should learn. Learn to pay attention to yourself. Notice when you're doing an operation repetitively. When you do, check out the menus and help files to see whether there's a keyboard shortcut. Some shortcuts will show up if you move the cursor over the item and wait for a helpful little pop-up box to appear. Those are great memory-joggers (like when I forget that the Clone tool is S because the Crop tool is C).

While I'm talking about speeding up your Photoshop workflow, let me remind you to do two things: Go into your preferences. Set them to add central crosshairs to the brush tip cursor and assign the mouse scroll wheel to zoom the image. These are little changes, but they mean big improvements.

Capturing a Long Density Range in a Scan by Stacking Images

As I've said in other chapters, some kinds of originals present real scanning problems. Old B&W films and plates can have such a high density range that a single scan can't capture it all. Transparencies that are severely faded in one channel can throw off a film scanner's exposure control and make it difficult to get good density information in all three channels from a single scan. Even with my film scanner set for maximum-density-range capture and using Wide Gamut RGB color space, I sometimes can't get a single scan that holds detail in both highlights and shadows.

Picture Window's Stack Images Transformation can blend up to five images together. Photographers use it to combine bracketed exposures from

a digital camera to produce one extended-range photograph. I use it to extend the dynamic range of my scanner. I think it's much better for this purpose than Photoshop's Merge to HDR operation, which I rarely use.

How to scan very contrasty photographs with Picture Window

Figure 9-1 shows a badly faded slide of Richard Nixon from the early 1950s. The combination of extreme fading in the slide and very uneven lighting in the photograph made for a very difficult scan. I adjusted my scanner's exposure settings to favor the capture of highlight, midtone, and shadow detail in separate scans.

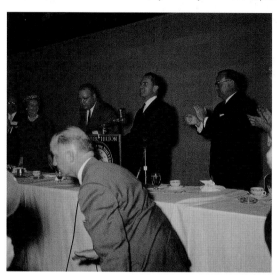

I saved those three scans as 16-bit TIFF files and opened in them in Picture Window (Figure 9-2). The Stack Images Transformation control panel is visible in the upper right. I assigned the dark TIFF to Image 1, the intermediate file to Image 2, and the light file to Image 3. In many cases you'll get a good result from combining just light and dark scans.

Click the Apply button and Stack Images creates a default blend, shown at the top in Figure 9-3. This looks like the medium-exposure TIFF but with substantially better highlight and shadow detail. Customizing the blending curves is better still. Each image in the stack has its own density mask curve. That curve controls how different tones in that image will be blended into the mix.

Image 1 had excellent highlight detail and no shadow detail, so I wanted the blend to use its highlight detail. I adjusted its curve so that it is 0% in the shadows and 100% in the highlights. Density Mask 2 pulled in 100% of the midtone information from the medium scan but tapered off in the highlights and shadows. Density Mask 3 used all the shadow detail from Image 3, which had the most shadow information of the three files. It used almost none of the highlight information because that was blown out in the scan.

Fig. 9-1 This slide of then-Vice President Richard Nixon is 50 years old. It's lost most of its cyan dye but almost none of its yellow. This combination of extreme fading and color shift makes it difficult to make a scan that captures the full density range of the slide.

The blend preview is the lower right photograph in Figure 9-2 in the quartet shown on screen; the other three are the original scan TIFFs. The finished blend is shown in Figure 9-3, bottom. It holds all the detail that was in the original slide and substantially reduces the harsh contrast produced by the on-camera flash.

With a high-quality composite image at my disposal, good restoration became possible. Figure 9-4 shows what I achieved by applying the DIGITAL

Fig. 9-2 Picture Window's Stack Image transformation is a superior tool for combining multiple scans into a single long density range image. This screenshot shows me combining three scans made with different exposures (upper left) into a single merged image, visible in the Preview window. At the upper right is the Stack Images control panel. Below that are the curves I created to control how the densities of the different scans get blended together. Mask 1 is for the darkest scan. I don't want to use any shadow detail from that scan, but I want all its highlight detail. So I set the mask curve to 0% in the shadows and 100% in the highlights. The intermediate scan has good midtones but worse highlights and shadows than the other two scans, so Mask 2's curve picks up 100% of the midtones and drops off to 0% at both ends of the curve. The lightest scan has great shadow detail and no highlight detail; Mask 3 has a curve that uses 100% of the shadow detail and falls to 0% in the whites.

ROC plug-in to the blended image, making some Curves adjustments and doing a bit of dodging and burning in.

Descreening a Halftone

Photographs in newspapers and magazines are not continuous-tone images; they are halftones. Halftones are made up of a fine pattern of dots that, from a distance, looks like continuous tones. In Chapter 4, "Getting the Photo into the Computer," page 103, I discussed the best way to scan halftones. Now it's time to talk about how to remove the dot pattern; this is called *descreening*.

Your scanner software probably has a descreening filter built into it. Figure 9-5 shows a halftone photograph I scanned at 1200 ppi. The greatly enlarged section on the left in Figure 9-6 shows the individual dots that make up the photograph. On the right is the scan I got when I turned that filter on. It reduced the dot pattern but didn't eliminate it entirely. Turn to Photoshop filters, which will do a better job than this.

Several different Photoshop (or Picture Window) filters can remove the halftone screen entirely, but choose wisely. Figure 9-7a shows the effect of applying the Dust & Scratches filter to the photograph. It completely eliminated the screen pattern, but it cost me some sharpness and it made the contrast much worse. Dark areas became completely black, losing shadow detail; highlights

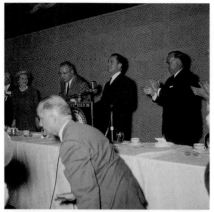

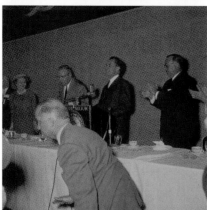

Fig. 9-3 The top figure is the best single scan I could make of the slide in Figure 9-1. It's too contrasty, with blown-out highlights and shadow detail that is too dark. The bottom figure shows the merged image I created with Stack Image in Figure 9-2. I applied color and tone corrections to produce Figure 9-4.

got blown out. The sidebar provides some much better filtering choices.

How to eliminate the dots from newspaper photographs

Good old Gaussian Blur worked surprisingly well (Figure 9-7b). A radius setting for the blur filter of about 40% of the dot spacing will usually work best. In this case, the spacing between dots was 12 pixels, so I set the Gaussian Blur radius to 4.5 pixels. The photograph is dot free, sharp, and has good tonal detail in both the highlights and the shadows.

The Lens Blur filter, with a radius of 11 pixels (just a bit less than the spacing between the dots) and a Blade Curvature of 100% (a round aperture), didn't entirely eliminate the dot pattern but it came very close (Figure 9-7c). It retained fine image detail much better than Gaussian Blur did. The Box Blur (Figure 9-7d) filter, with a radius of 6 pixels (50% of the dot spacing), completely eliminates the dot pattern and is almost as sharp as the Lens Blur filter. It also runs considerably faster than Lens Blur.

There are further improvements to be had! FocusFixer, reviewed in Chapter 3, "Software for Restoration," can extract additional detail from the filtered image without exaggerating the dot pattern. I set it to a radius of 12 and a threshold of 0, and FocusFixer produced an extraordinary amount of real subject detail, even more than was visible in the original halftone (Figure 9-8).

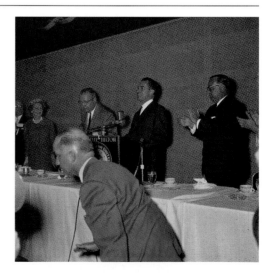

Fig. 9-4 Applying Digital ROC and some Curves adjustments to Figure 9-3, bottom, gets me this photograph. The color and tones are now approximately correct, and I've retained the full range of detail that was visible in the slide.

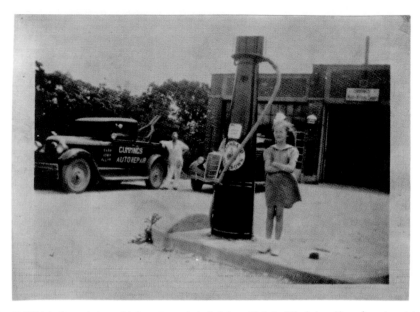

Fig. 9-5 This halftone photograph is in pretty good physical shape. It's just a little dark and has a few minor stains. The big challenge is getting rid of the halftone screen, shown enlarged in Figure 9-6.

Fig. 9-6 The figure on the left is enlarged from Figure 9-5, to show the halftone dots that make up the print. One way to reduce the visibility of those dots is to turn on the descreen option in your scanner software (right). This doesn't eliminate the dots, but it softens them. Other software tools (Figure 9-7) can eliminate them entirely.

Fig. 9-7 Here are four different ways to get rid of halftone dots. (a) uses the Dust & Scratches filter. That method loses sharpness and quite a bit of shadow detail. Gaussian Blur (b) works much better, and the Lens Blur filter (c) better still. Both of these preserve the detail and tonality of the original photograph. (d), using the Box Blur, is possibly the best balance between retaining detail and eliminating the dot pattern.

Fig. 9-8 The FocusFixer plug-in does an amazing job of recovering fine detail in descreened halftones. Here I applied it to Figures 9-7c and 9-7d.

Getting the Most Detail out of Your Photograph

Many photographs hold a wealth of hidden detail that can be revealed by the right tools. Good software techniques can do more than simply sharpen edges; they can bring out fine details that were invisible in the original print. In some cases they can rescue unacceptably blurry photographs; in others they take an inadequately

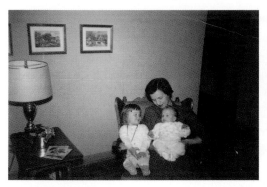
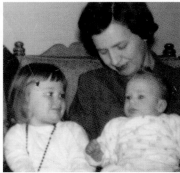

Fig. 9-9 This photograph has some physical damage, but it's otherwise in great shape. It has excellent tonality and no noise or grain. As the enlargement on the right shows, it could be sharper. There are ways to achieve that!

sharp photograph and improve the detail enough to let you enlarge it substantially.

The ideal candidate for detail enhancement is a photograph that has good tonality and little visual noise: no heavy texturing, visible grain, or extensive scratches or cracks. Minimal noise is important because all these techniques enhance fine noise along with fine detail. The best of them work mostly on the photographic detail and don't enhance noise too much, but there will always be some increase. If you start out with a visually noisy original, you will not have a good-looking photograph after you've sharpened it.

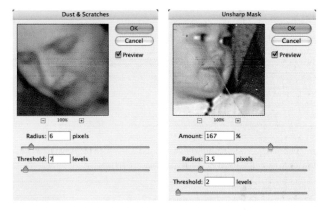

Fig. 9-10 I used the Dust & Scratches filter in conjunction with the History Brush to get rid of the dust and cracks in Figure 9-9, prepping it for sharpening. Photoshop's standard tool, Unsharp Masking (right), isn't the best choice for that (see Figure 9-11a).

Figure 9-9 is a great candidate for detail enhancement. As the enlargement on the right shows, the photograph has some cracks and scratches and a scattering of dirt and dust, but there's no film grain, paper texture, or unevenness to the tones. The original photograph was only 2 × 3 inches, so I scanned it at 1200 ppi with the intention of enlarging it. I cleaned up the specks and cracks with the Dust & Scratches filter, using the settings shown in Figure 9-10. Assigning that filter to the History Brush, I painted out the flaws.

There are several good ways to bring out detail in this photograph. A poor way is to use Photoshop's Unsharp Mask, which I did using the filter settings shown in Figure 9-10 to produce Figure 9-11a. That emphasized edges, but it didn't actually bring out any new detail. Several much better methods are described in the following how–to.

Fig. 9-11 There are different ways to sharpen up Figure 9-9. Unsharp Masking (a), using the settings from Figure 9-10, doesn't really improve fine detail. It just exaggerates edges and produces the well-known "oversharpened" look. Photoshop's Smart Sharpen filter works much better. I used Lens Blur to create (b). It's just as sharp as (a), but it looks much more natural. (c) is the product of FocusFixer running with a 7-pixel radius. This filter produces a real increase in fine detail and sharpness, not just the illusion of one. Lastly, (d) are PixelGenius' PhotoKit Sharpener utilities, a collection of useful automated scripts that do sharpening in multiple layers that you can modify to suit the particular photograph.

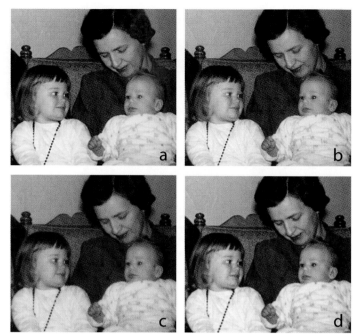

Fig. 9-12 Here are the Smart Sharpen settings I used to create Figure 9-11b. I've selected Lens Blur as the filter method I want to use and checked More Accurate because it produces better-looking results.

How to increase sharpness and fine detail in a photograph

Photoshop's Smart Sharpen filter, with Lens Blur selected, does much nicer filtering than Photoshop's simpler sharpening tools. Be sure to check More Accurate to get the best results (Figure 9-12). Figure 9-11b shows what this filter accomplished. It's much more natural looking than the photograph created with the Unsharp Mask filter; even delicate detail in the couch and the baby's clothing was brought out. There's a slight increase in overall image noise (likely not visible in reproduction), but it's not enough to be bothersome; it just looks like very fine film grain.

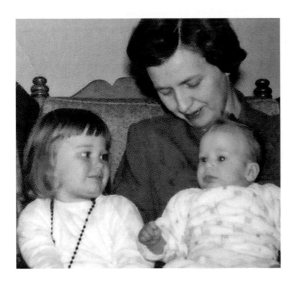

Fig. 9-13 The Shadow/Highlight tool improves the detail in Figure 9-11c. Using this tool with the settings from Figure 9-14 makes both highlight and shadow details clearer.

Fig. 9-14 The Shadow/Highlight settings that produced Figure 9-13. I'm doing just a small amount of shadow enhancement but a moderate amount of highlight enhancement. I kicked up the Midtone Contrast a little bit to ensure that the photograph didn't look too flat.

More natural still are the results produced by FocusFixer, which I reviewed in Chapter 3. FocusFixer makes exceedingly complex calculations that do a very good job of recovering the very subtlest fine detail. I used it with a radius of seven pixels to produce Figure 9-11c. Although this doesn't have the dramatic edge contrast increases produced by Unsharp Masking or Smart Sharpen, there is a real increase in fine detail. This photograph doesn't merely look sharper, it actually *is* sharper. The downside to using this filter is that it took many, many minutes to process this photograph; that's the price of truly superior sharpening.

The final enhancement tool I used was PixelGenius's PhotoKit Sharpener utilities. This large collection of automated routines provides myriad ways to sharpen a photograph with minimal increases in noise and other kinds of visual garbage. For Figure 9-11d, I used the Creative Sharpener module and ran the Super Sharpener option.

Sharpening isn't the only way to bring out detail. I created Figure 9-13 by taking the photograph I sharpened with FocusFixer and running it through the Shadow/Highlight filter using the settings shown in Figure 9-14. (See Chapter 5, "Restoring Tone," page 134, for complete instructions on how to use this filter; it has a lot of different options!) This opened up shadows and tamed highlights in a fashion that made detail in those parts of the photograph much clearer. The results are not actually one bit sharper than Figure 9-11c, but the improved contrast reveals the details much more clearly.

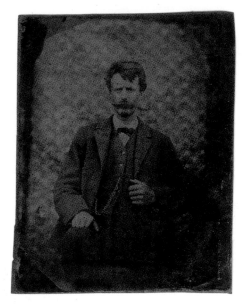

Fig. 9-16 This histogram for Figure 9-15 is typical of tintypes. All the tones are compressed into the dark end of the scale. I've moved the scanner software Levels sliders in to bracket that narrow range, to capture as much information as possible. It's a good idea to scan tintypes in 16-bit mode. The result is shown in Figure 9-17.

Fig. 9-15 Tintypes are naturally very dark. The "positive" image is the result of laying a dark-gray silver negative image on top of a black substrate. The scanner software histogram in Figure 9-16 shows how dark the original is.

What Do You Do with a Tintype?

Tintypes raise interesting questions about your goals in performing a restoration. Is your objective to make the photograph look the way it did originally or to make it look like a good photograph by today's standards?

A tintype by its very nature is extremely dark. It's a B&W silver negative on a piece of black-enameled metal (usually iron). The silver image looks lighter gray than the black enamel, so the photo appears as a positive. The range of tones runs not from white to black but from dark gray to black. It's not what we expect to see in modern photographs.

Figure 9-15 shows an old tintype. Figure 9-16 shows the histogram my scanner software generated for that tintype, as well as the level settings I used to make a full-range scan. You can see from the histogram that the tintype's extremely dark; this is certainly a case in which you'd want to scan in 16-bit mode.

Figure 9-17 is the scan I made that extracted the maximum tonal information from the tintype. The red channel showed the clearest image with the least dirt and scratches, so I used it to do the partial restoration you see the in Figure 9-18, top. At this point, I'm very close to having a good-looking photograph; I still have to remove some scratches and dust specks and make some final adjustments to the tones in the shadows and the background.

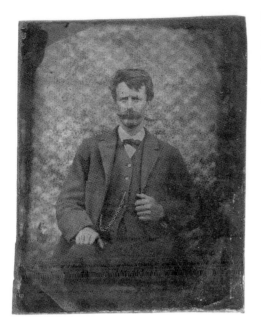

Fig. 9-17 The scan I made of Figure 9-15 using scanner settings from Figure 9-16. This doesn't look at all like a proper tintype, but it provides maximum information to work with for restoration.

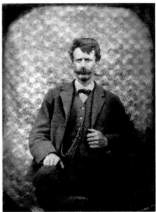

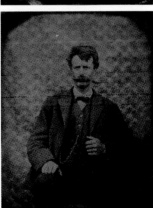

How to make a photograph look like a tintype

Figure 9-18, top, doesn't look anything like the original tintype. It looks like a modern photograph, with modern-photograph tonality. The image on the bottom in Figure 9-18 shows my simulation of the tintype "look." I got that by applying the curves in Figure 9-19 to darken the restored image. So, which version is "correct"? That will depend on your objectives—on whether this is supposed be an aesthetically pleasing restoration or a historically accurate one.

Stitching Scans Together

Sometimes you'll want to restore a photograph that is larger than your scanner can accommodate. Scanning a photograph in sections is not difficult, but there are two problems to address when you're stitching sectional scans together: Some misregistration and slight differences in exposure might exist between the separate scans.

You won't want the scanner making different exposure and contrast adjustments for each section of the photograph, so turn off as much of the scanner's automatic exposure control as you can. Ideally, the exposures for all the sections should be absolutely identical. In practice, this doesn't always happen. The internal scanner calibration from scan to scan may not be identical. You should expect to see some slight exposure mismatches between the sections.

Fig. 9-18 What's the right way to restore a tintype? The figure on the top is the restoration I did from Figure 9-17, treating the image as though it were a conventional photograph. Consequently, I aimed for a photograph with good contrast and a full range of tones from black to white. On the bottom is the new "tintype" I created by adding a Curves adjustment layer that used the settings in Figure 9-19. This preserves the look of the original for a more historically correct restoration.

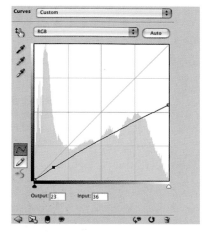

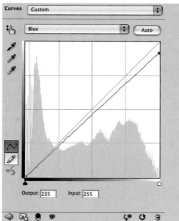

Fig. 9-19 A simple Curves adjustment turns a normal-looking photograph into one that looks like a tintype. The top curve darkens all the tones and lowers the contrast so that the "whites" become grays, just as they are in a real tintype. The curve on the bottom adds a bit of yellow to the photograph because silver negative images are usually a little bit warm in hue. The result, shown in Figure 9-18, bottom, is a faithful reconstruction.

In the previous edition of this book, I described how to align, warp, and manually tone- and color-balance the component scans of a large photograph to produce a seamless whole. Those instructions are now on the Web. For me, Photoshop CS3 made them obsolete. Photoshop's Photomerge automation, which was nearly useless in CS2, came into its own in Photoshop CS3. These days I use Photomerge for almost all my stitching work, and most of the time it produces flawless results. It really is a wonder. If you tried Photomerge in its earlier incarnation and abandoned it in disgust, take another look at it. You'll be very pleasantly surprised. The how-to explains how Photoshop automatically turned the scans in Figure 9-20 into the photograph in Figure 9-21. In Chapter 11, "Examples," I demonstrate a complete restoration of this photograph.

How to combine scans to make one large photograph

Photomerge is a wonder tool that makes stitching together scans nearly trouble-free. I launched Photomerge from the File | Automate... submenu. It presented me with a control panel where I chose the layout scheme that Photoshop would use to merge the photographs and an empty window for the names of the files that I wanted to merge (Figure 9-22). I clicked the Reposition layout option; that's the only one that will work well in this situation. I clicked the Browse... button and selected the files that I wanted to merge; then I clicked OK.

Photoshop opened up the component files I selected, analyzed them, aligned them and warped them to overlap seamlessly where they don't fit together perfectly, and adjusted tone and color to eliminate slight mismatches between scans. After a suitable number of CPU cycles, Photoshop presented me with a single image file with each component scan in its own separate layer with its own mask (Figure 9-23). All this was automatic!

On rare occasions, Photomerge won't correctly align the scan components. When that happens, you'll want to use the Interactive Layout option in the Photomerge control panel. You don't see that option on your system? That's because Adobe removed that option from Photomerge in Photoshop CS4 for technical reasons. It's an important feature, and there are times when you will need it. Fortunately, you can get it back by

installing the legacy plug-in, PhotomergeUI.plugin, into the Automate folder that resides inside your Photoshop Plug-ins folder. You'll find that plug-in available online at http://kb2.adobe.com/cps/404/kb404900.html.

Also on rare occasions, Photomerge might not get the color and tone perfectly balanced between the segments. If that's the case, follow the part of the instructions on the Web (at http://photo-repair.com/dr1.htm) for stitching together scans that explains how to make Curves adjustments. That will just about perfectly match the tone and color between segments.

I do have one refinement to offer: Make those corrections with Curves adjustment layers attached to each scan segment layer. Here's how you do that: Click the scan segment layer to which you want to attach the adjustment layer. Then tell Photoshop to create a new Curves adjustment layer. A New Layer dialog box will come up; click the box that says Use Previous Layer to Create Clipping Mask (Figure 9-24).

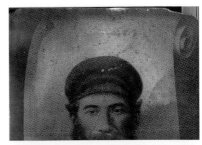

Fig. 9-20 This photograph was too large to scan in a single pass or even two. It took three scans to capture all of it on my scanner.

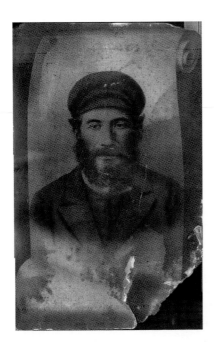

Fig. 9-21 Photomerge, in recent versions of Photoshop and Elements, has become a very capable tool for merging piecemeal scans, as this photograph shows.

Fig. 9-22 The Photomerge control panel offers many layout choices. For stitching scans, Reposition works best.

Fig. 9-23 Photomerge creates an image with each component in its own layer with its own cut mask. If you don't like where Photomerge placed the cuts, you can edit the masks by painting on them with the Brush tool.

Fig. 9-24 Click the Use Previous Layer to Create Clipping Mask option when you create an adjustment layer if you want to limit that adjustment's influence to a single layer. This is a good way to correct individual components of a composite image, such as merged scans.

That will attach the Curves adjustment layer to the scans segment layer you'd selected, and it will affect only that layer (Figure 9-25). Now you can fiddle with the Curves in the different scan segment layers, as per the online instructions, to color-match your scans.

Improving the Original

Just what do I mean by "improving the original"? A recurring theme throughout this book has been my admittedly perfectionist quest to create the best possible print of a photograph. What do I think makes for a better print?

- Richer and more accurate color
- More accurate tonal rendition
- Better density range in the print
- Better and sharper detail

Many original photographs weren't all that great to begin with, even before they started to deteriorate. Your typical amateur photograph is not usually perfectly composed, perfectly exposed, perfectly in focus, and perfectly printed. Professionally made photographs may have an overall higher level of quality

(although many don't), but the photographer can only do so much. Photographic films and papers don't have perfect color and tonal rendition. Even the most skilled photographers are limited by the materials with which they work.

As long as I don't need to produce a historically accurate restoration, I can't resist making little improvements. It could be sharpening up the photograph and bringing out fine detail that wasn't apparent, or perhaps correcting the color and exposure so that they're exactly right instead of merely being close to what they should be. Sometimes I'll bring out highlight and shadow detail in a previously too-contrasty photograph or eliminate excessive film grain and an annoying paper texture. I can even dodge, burn in, and crop to improve composition.

Do not misunderstand; I am not saying the originals were bad photographs! By and large they're very good photographs. They're just not *perfect* photographs, and what is not perfect can often be improved, especially with the power of digital manipulation. Review the many restorations I present throughout this book, especially the complete restorations that I present in Chapter 11, "Examples." You'll see that I often go beyond the limitations of the original to produce a better photograph than existed before. This is where the "Art" I talk about in the Introduction and Chapter 1 comes in—this is where you think like an artist and a photographer, not like a technician. Here are two examples to illustrate this idea.

In my review of DIGITAL ROC (online at http://photo-repair.com/dr1.htm), I used a self-portrait by noted photographer Tee Corinne (Figure 9-26a) to introduce the power of this Photoshop plug-in. It's just the kind of problem that ROC was designed to solve. Figure 9-26b is a very faithful

Fig. 9-25 This layer stack shows a Curves adjustment that has been created to affect only the middle segment of the merged scans.

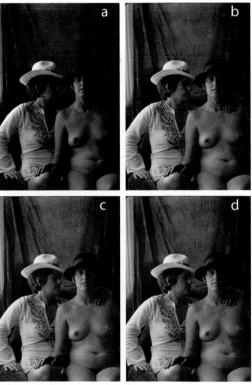

Fig. 9-26 This self-portrait by noted photographer Tee Corinne is barely 30 years old, but it only exists as an impermanent duplicate slide that has faded badly. Digital ROC does an amazing job of restoring the color in faded slides (b). This is faithful to the original, but I can make it better. (c) shows the results of applying an inverted-S curve to improve highlight and shadow detail and moderate contrast in the midtones. In (d) I increased the saturation by +20 points. This is almost perfect. (Photograph copyright by Tee Corinne.)

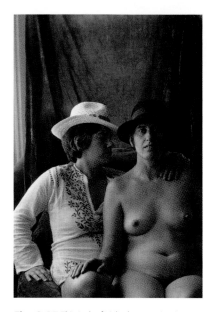

Fig. 9-27 This is the finished restoration, just as Tee and I would have it. It is a slightly warmed-up version of Figure 9-26d; a modest Curves adjustment did the trick. This looks better than the original photograph. (Photograph copyright by Tee Corinne.)

rendition of the original photograph and is indeed almost entirely the plug-in's doing.

Consulting with Tee on this matter, we both agreed that while this image might accurately portray what the color film recorded 30 years ago, that didn't make it the best possible interpretation of this photograph. Films of that era tended to be a little contrasty and low in color saturation. The color rendition was a bit cool for Tee's taste because the portrait was photographed by bluish sky light. We agreed to improve on the original.

First I reduced the excessive contrast in the midtones to bring out more highlight and shadow detail. When I did this restoration, I used an "inverted-S" curve, as I discuss in Chapter 5, "Restoring Tone," page 134–136, to get Figure 9-26c; today I'd probably use the Shadow/Highlight adjustment. The tonal rendition is much nicer, but lowering the midtone contrast made the saturation worse. I increased the saturation by 20 points with the Hue/Saturation adjustment and made a slight Curves adjustment to brighten the midtones a bit. That produced Figure 9-26d, which I think is a much better version of the photograph than the "original." If it were my photograph, I'd probably stop here. But Tee wanted slightly warmer hues, so after a little more work with Curves, we got to Figure 9-27.

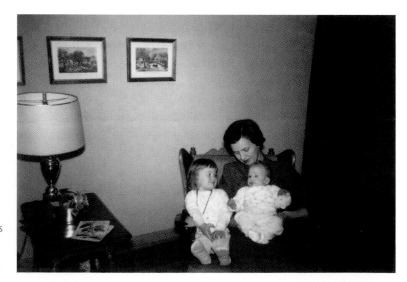

Fig. 9-28 This is the nearly restored version of Figure 9-9. It's been sharpened and cleaned up, except for a few faint folds in the paper. It's a good restoration of the original photograph, but that photograph can be improved (see Figure 9-29)!

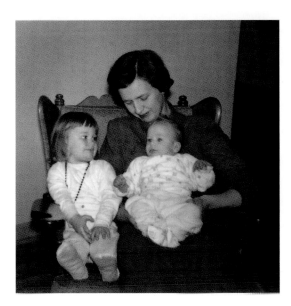

Fig. 9-29 Here's the new and improved version of Figure 9-28. I cropped away the extraneous and distracting material to produce a composition that focused on the mother and children. Next I dodged the mother's left side to even out the lighting and improve the detail. Finally, I burned in the upper-left corner to remove a hot spot on the wall. What was previously an acceptable snapshot is now a really great one. I could have eliminated the "on-flash" look in the skin tones, but I wanted to preserve the snapshot feel of the original rather than make this look like a professionally done portrait.

That is now the final and definitive version of this photograph, one that Tee and I both feel is better than the original she made 30 years ago.

Figure 9-28 is the cleaned-up version of the photograph I sharpened earlier in this chapter (page 304). As a straight restoration, it's almost finished. A couple of faint folds in the paper are visible in the background, but once I erase those, it will be a pristine version of the original photograph. But I think it could be a much better photograph than this!

Since I had already determined that I could sharpen and extract considerably more fine detail from the photograph, I decided to crop it to produce a much better composition (Figure 9-29). That wouldn't have been possible without the sharpening techniques I used; the original was only 2 × 3 inches and it wasn't very crisp. But Focus Magic pulled up all sorts of fine detail for me (these days, I'd be using FocusFixer instead). The Shadow/Highlight adjustment brought out the details in the children's clothing and the mother's hair and dress very nicely.

To finish off this photograph, I did a little dodging and burning in, evening out the lighting on the walls so that there wasn't a distracting bright spot in the upper left and dodging the mother's left side so that you could better see her arm and clothing. That was it!

I intentionally left the "on-flash look" alone. I could've retouched the faces and the clothing to get rid of the hot spots, thus making this look like a very professional photograph. I didn't because I wanted to preserve the snapshot feel of the photograph. I simply made it look like an exceptionally good one.

Up to this point in the book, I've been instructing you in myriad specific techniques for doing restorations. In the last section of this chapter, we started to pay more attention to the overall purpose and ultimate results of restoration. That's what Chapter 11, "Examples," is entirely about: how all these specific methodologies work together to produce complete and finished restorations. Before that, though, let's talk about what it takes to make a restoration look *really* good. The next chapter's about beautifying your results.

Chapter 10

Beautification

How-To's in This Chapter
How to create a merged "finished restoration" layer
How to improve tonality with Unsharp Masking
How to use Dust & Scratches to shave off the worst noise

Introduction

In the first sections of this book, I made it a point to remind you that photo restoration was about more than mere data recovery. At the very least, you'd like a restoration that accurately reflects the source photograph and doesn't merely wind up looking like a copy many times removed from "originality." At the best, and especially when an historically accurate, technical rendering is less important, a successful restoration should stand on its own as an attractive and appealing photograph.

That latter goal veers well into the domain of photography and printing as art or at least high craft. Obviously I'm not going to try to teach you how to be an artist in a couple of dozen pages. What I will do is suggest some approaches that will help you teach yourself and make it easier for you to evaluate just how good your work is. Part of that approach is psychological and perceptual.

Most of it, though, is craftwork: knowing the tricks and techniques that can polish a photograph and make it shine. It seems to me that the routines I go through to make my digital prints sing are a lot like detailing a car. For those of you more familiar with camera bodies than automotive ones, detailing is the business of making the car sparkle and look special: vacuuming out all those nooks and crannies in the interior, giving the chrome one extra coat of wax, touching up the pinstripes, and so on. It's those little, almost subliminal, touches, those details that make an auto look like something out of the ordinary.

A lot of my photographic refinement techniques serve the same function. They don't fundamentally change the photograph, but they get me a much, much better print of it. I use them so regularly that I don't ever make a print that hasn't benefited from several of these rituals. These routines are, indeed, well, routine. But that doesn't make the results any less special. Most of this chapter is devoted to these techniques. First, though, let's talk about the psychological component.

Viewing Your Restorations at Arm's Length

Learning how to see your restorations from that artistic perspective means distancing yourself a bit from the work you're doing. Photo restoration is, all by itself, an amazing thing. I'm still delighted and astounded each time I create a clean and clear photographic print (or monitor image) that was born from barely legible smudges on a bedraggled piece of paper. It's exciting, and I love it! But in large part I'm loving it for what the process is: the still seemingly miraculous recreation of lost images. I'm not loving it for what it looks like.

The real test is viewing that photograph without acknowledging that it's been resurrected from unviewable garbage. Does it look good to someone who knows nothing about its origins? That someone can be you, if you can distance yourself enough from the process you went through to get there. Getting yourself into that headspace at will takes practice. Sometimes putting the photo aside for days or weeks is the best approach. When you pull the restoration out to look at again, don't look at the unrestored original. Try to concentrate on the photograph that's in your hands (or on your screen) and don't think about where it came from. Forget all the work you went through to make the restoration photograph; look at it as though you're seeing it for the first time.

If you have trouble adjusting your perspective that way and you make and print your own photographs for work or pleasure, try working on some of your own photographs for a little bit. You'll quickly find yourself settling into your normal work habits and perceptions, and those are ones that are directed at making a nice photograph that people enjoy looking at. Once you feel like you're settled into that emotional and intellectual state, pull up the restoration photograph (again, without the original) and see if it meets your standards for a good-looking photograph.

Believe me, I know that this is easier said than done. Sometimes it's better to get an external reality check by showing the photograph to someone else. I do that regularly with my housemate, Paula. I show her a finished print and just ask her what she thinks of it. I don't tell her what work I've done, I don't show her the original until after she's made her judgment. All I want is for her to try to evaluate the quality of the print the same way she would if it were one of my own photographs. Her take on the photograph helps me a lot when I'm trying to decide whether what I've done is merely a good restoration or something that is genuinely nice to look at.

If you feel that your restoration is a genuinely nice photograph, you're ready to move on to the final stages of the restoration process: printing out the photograph (if that's your goal) and archiving the restoration. Chapters 12 and 13 will give you some pointers on those important tasks.

More likely, you've looked at the restoration and have this feeling that it doesn't quite "sing." The techniques in the remainder of this chapter may be just what you need to give the photo voice.

Improving Tonality and Making the Photo More Lively

Many folks have noted that digital prints usually lack the subtle tonality and fine gradation of traditional prints. I've observed that digital prints, from many

different image sources and printed many different ways, routinely have a slightly flat aspect to them; subtle variations in tone and color, "texture" or "snap" if you will, seem to get suppressed.

Photographic restoration makes the situation worse. Always you are working with copies of originals. Sometimes you're working with copies several generations removed. Every generation seems to flatten tones and make the photographs less engaging (see Chapter 5, "How to Improve a Copy Print," page 139). The virtual cleaning that we give photographs when we're eliminating the noise and dirt and degradation can wipe away some of the total subtleties as well. Sometimes the results make the subjects of the photographs look a little too much like they're cut out of construction paper instead of rendered from real-life, three-dimensional objects.

Although the methods in this chapter don't necessarily require Photoshop, they can work more flexibly and controllably in Photoshop CS4. Layers and Smart Objects let you apply the methods nondestructively so that the restoration work you've done isn't irreversibly altered. That's an awfully good idea when you're doing the kinds of finishing touches I'm talking about in this chapter. The degree and kind of fine-tuning that looks exactly right depends on your final presentation: whether you're making prints or viewing the photo on a monitor, the size of the print or monitor, and the kind of printer you use.

Hence, the smart thing to do is to make these corrections on a duplicate copy of the photograph or, in Photoshop, on a separate layer. Create an output layer in Photoshop that merges all the existing layers and adjustments you've made into a single flat image and work on that instead of the original.

How to create a merged "finished restoration" layer

Start by clicking the layer on the top of the layer stack to make it the active layer. Press the following four-key combination: Command (or Control)-Alt-Shift-E. Photoshop automatically creates a new layer at the top of the stack that merges everything underneath. That preserves all your original work while letting you apply changes to the new layer.

If you plan to use a filter or a plug-in that can work as a Smart Filter, you may want to convert the new layer to a Smart Object by selecting Convert for Smart Filters from the Filters menu.

Smart Filters work like adjustment layers; you can go in and mess with their settings to change the effect they have on the photograph. That's awfully useful when you're trying to refine a photograph for various kinds of outputs or you just need to experiment with a bunch of different settings.

Sometimes all it takes to make a photograph look a lot livelier is to add some contrast to the midtones using Curves (or a Curves adjustment layer), as I describe in Chapter 5, "Restoring Tone" (see "How to Add Contrast to Midtones with Curves," page 131). This is an easy, quick fix, so it's always worth giving it a try. Many times, though, you'll find that it doesn't enliven the photograph as much as you'd like. Then it's time to move on to stronger measures. Remember that these stronger measures can be used in combination with a Curves adjustment. The two approaches complement; a Curves adjustment is more about making overall changes to the placement of tones, while these more specialized tools are for enhancing local tonal differences.

Unsharp Masking

Bill Atkinson taught me how to use Unsharp Masking to reduce that "flat" feeling. Frequently referred to as *local contrast enhancement*, this technique works so well and it's so easy to do that I use it on most photographs I print. This technique works in any image processing program that has Unsharp Masking.

How to improve tonality with Unsharp Masking

Pull up Unsharp Masking. Set the Amount for somewhere between 8% and 25%, depending on your taste, subject, and printer. Set the Radius for around 60 pixels (Figure 10-1). This value isn't critical, although for very small originals you'll find that a smaller radius, as little as 20, will work better. Set the Threshold to 0. Let 'er rip!

You'll find that subtle tonal and color separation has been improved and increased without a commensurate increase in overall contrast (Figure 10-2). It's a real miracle worker.

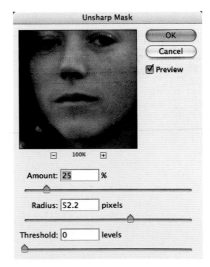

Fig. 10-1 Unsharp Masking does a good job of increasing local tone separation and snap without changing the overall contrast of a photograph. Use it at a low percentage and a large radius to get this result.

In case you're curious about how the filter works its magic, it's like this: Unsharp Masking increases the difference between the target pixel and the surrounding pixels. Used normally with a small radius, it has little effect on areas of uniform tone. It's only when it hits a boundary, where there are both bright and dark pixels, that it has a noticeable effect. There it makes the bright pixels brighter and the dark pixels darker than the average. Consequently, there's an edge enhancement that makes the picture look sharper (chemical film developers do the same thing, by the way).

Fig. 10-2 The same photo, before and after the Unsharp Masking filter shown in Figure 10-1. The tonal range from black to white hasn't changed, but the filtered picture looks a lot snappier.

When you apply Unsharp Masking with a very large radius, it doesn't see edges; instead it sees the average tonality over a broad area. If the target pixel differs from that average, it increases the difference by a small amount. Slight local variations in tone, color, and texture get amplified. The resulting print looks livelier and has better tonality and gradation.

There may be a small increase in the total value range of the photograph because highlights are frequently small areas that fall within the 60-pixel radius. Consequently, you want to apply this filter before you do your last bit of curves fine-tuning to the image tone and contrast. Other than that, it doesn't really matter when you do it.

ContrastMaster

The ContrastMaster plug-in that I described in Chapter 3, "Software for Restoration," is a very powerful tool for enhancing local tones in any image processing program that can use Photoshop plug-ins. As I've pointed out, it is dauntingly complicated. Used properly, it can give flat, dull photographs an almost three-dimensional sense of vividness (Figure 10-3). Used poorly, the tool produces results that look harsh and unbelievable, even surreal.

I think this plug-in may be a must-have for the serious printer because it works so much better and more controllably than Unsharp Masking. Unsharp Masking, though, is a very simple tool to use; if you follow the instructions I've given, you're almost guaranteed an attractive result. ContrastMaster, on the other hand, will require a lot of experience and trial and error before you'll be any good at it, and there's not much I can tell you that will guide you to a good result other than practice, practice, practice.

Detexturing the Photo
Dust & Scratches Filter

Generally people aren't bothered too much by uniform film grain or digital image noise. What grabs viewers' attention in an unpleasant way are the sharp fluctuations caused by dust and dirt, clumps of grain, and electronic noise. It's these extremes that stand out from the background and look most unpleasant and distracting. To put it another way, most people don't mind grain that looks like fine sand; what they don't want is grain that looks like a bed of jagged, crushed stone.

Photographic restoration often produces noisy-looking images. If you're starting with an original that is faded or very flat, the boosts you give to contrast and color saturation also enhance any dirt or grime on the print as well as bringing out grain and noise that were in the original photograph. If you're repairing extensive cracking or crazing, it's difficult to remove it without leaving a little bit of residual noise, a pale ghost image of the original damage. Of course, the results look a lot better than what you started with, but the photograph will look even more attractive if you can get rid of that residual distraction.

The Dust & Scratches filter can be a valuable tool for smoothing out grain and image noise if it is used with delicacy. Appropriately applied, it will "shave off" those highs and lows in parts of the image that have little or no sharp-edged detail.

Fig. 10-3 ContrastMaster created all three of these variants on Figure 10-2, left. It's a powerful tool for altering local contrast, once you climb a long learning curve.

How to use Dust & Scratches to shave off the worst noise

You'll want to apply the Dust & Scratches filter to a duplicate image layer or as a Smart Filter. The reason for this is that a filter strength that is appropriate for shaving off the worst of the noise and grain will probably also obliterate some fine detail in the photograph. You don't want that to happen, so using the filter in this way lets you paint on a mask afterward, to select only the areas you want to work on.

I set the filter controls for a radius that would obliterate the small dust specks but not the large ones (Figure 10-4) with a threshold setting just at the point where the grain was slightly smoothed out.

Use a very light touch on the setting; don't set the threshold so low that the smoothing is obvious. As I said, you just want to trim off the extremes. If you smooth out the grain/noise too much, the difference in texture between the filtered and unfiltered portions of the photograph, when you're done masking the effect, will lead viewers to notice that you were messing around.

After I applied the filter, I set the on-screen image magnification for 50% or 100% and switched the filter effect on and off by clicking on the eyeball next to the Dust & Scratches Smart

Fig. 10-4 A light touch with the Dust & Scratches filter can trim off the worst of the noise and smallest dust specks from a photo without damaging most of the true photographic detail.

Fig. 10-5 Toggle between the filtered and unfiltered photographs by clicking the eyeball next to the filtered layer. This will make it easy to spot unintended changes, which you can then block with a hand-brushed mask, as shown here.

Filter or filtered layer in the Layers palette (Figure 10-5). What I looked for were fine details that blinked in and out of existence as I toggled the view.

If you've made your filter settings correctly and this is an appropriate image for using the filter, only a small portion of the photograph will show damaged detail. I set the Brush tool to black and painted into the Smart Filter or filtered layer mask channel to kill the effect of the filter where desired detail had been obliterated (Figure 10-6).

Sharpen and Smooth … or Vice Versa

Restored photos don't simply tend toward noisiness, they also tend toward softness. Scans, no matter how high the resolution, always seem to lose a little bit of crispness in edge detail. Frankly, many of the originals you're restoring won't be that sharp to begin with. Despite the fact that older photographs were often made on much larger format films, more primitive films, lenses, and printing methods combined to make many of them somewhat fuzzy.

This might not be too noticeable in the original photograph, but it will become a lot more obvious in the restoration. Subconsciously, we expect a contrasty, vividly colored photograph to also be crisp. If you're also hoping to enlarge the restoration, even by a modest amount like 50%, you'll often discover that the original was just adequately sharp for the size at which it was printed but won't really stand any enlargement.

Fig. 10-6 The top photograph is unfiltered. The middle photograph shows the layer where I applied the Dust & Scratches filter from Figure 10-5. It eliminates a lot of paper texture and the dark and white specks, but it also blurs out details in the hair, eyes, and mouth. The bottom figure shows the result I got by brushing black into the filtered-layer mask in those areas. The resulting photograph is much cleaner and still retains the important facial details.

There are many good sharpening tools available, such as Photoshop's own Smart Sharpen and FocusFixer V2, which I reviewed in Chapter 3. Unfortunately, sharpening a photograph has the side effect of increasing its grain and noise; conversely, filtering out noise can compromise sharpness and fine detail. With the proper mix of the two, you can sharpen an image without increasing its noise or reduce the noise in a photograph without losing sharpness. Or, as I often do, you can split the difference and get a photograph that is both sharper and less noisy. In more than a few cases, I've produced a restoration that I am positive looks better and shows better detail than the original photograph ever did.

Applied with restraint and modest strength, these two tools balance each other nicely. Restraint is the key word. Excessive noise reduction tends to filter

out subtle differences in tone and color. A heavy dose of noise reduction can produce a grainless image, but the subtle texturing that makes surfaces look real instead of looking like molded vinyl also gets filtered out. Sharpening doesn't restore missing tonality, it simply makes edges very well defined. That makes the whole photograph look even more plastic, with broad and featureless areas of tone bounded by razor-sharp edges.

Understand that this is not sharpening for output, although it can reduce any need for that final step (in fact, I hardly ever sharpen specifically for printing). This is just a bit more of the detailing that brings out the most information in the photograph while minimizing the noise. You will want to apply these adjustments to duplicate layers or as Smart Filters. There is often considerable trial and error involved in balancing the smoothing and the sharpening operations to produce the ideal result. Don't lock yourself in with irreversible changes.

Remember, too, that these are successive operations. You want to sharpen the smoothed image (or vice versa). For example, if you're going to sharpen first and then smooth using duplicate layers, you'd duplicate the photograph, apply the sharpening tool to the duplicate, duplicate that layer, and apply the noise reduction filter to the sharpened duplicate.

So, should you do sharpening first and then reduce noise, or vice versa? It seems to be six of one and half a dozen of the other. Some photographs look slightly better if the sharpening is done first. Others look better if the smoothing is done first. Most of the time there doesn't appear to be a big difference. I wouldn't get too involved in trying to optimize this factor; it will quickly become a case of diminishing returns for the amount of energy and time you're spending. I tend toward sharpening first, but that's just my habit.

The Smart Sharpen filter works well with this technique, especially at very small radii, 1–2 pixels or less. When I'm not using the Smart Sharpen filter, I'm likely to use FocusFixer, reviewed in Chapter 3. It works especially well if it looks like the photograph is going to benefit from sharpening with a larger radius. You will rarely go beyond 3–4 pixels, even in a very high-resolution scan. If you do, you'll usually see ringing effects at the edges, those bright and dark halos that announce to the world that you've done digital sharpening badly. FocusFixer is less likely to produce such artifacts than Smart Sharpen.

Increasing sharpness can exaggerate chroma noise and create little colored sparkles along edges. If you're working with a particularly noisy and uncooperative photograph, try sharpening only the luminosity. If you're using the sharpening program as a Smart Filter or applying the sharpening to a duplicate layer of the image, change the Blend mode on that filter or layer to Luminosity. That will suppress the distracting sparkles.

The resulting image will have improved detail but also increased grain and noise. The next step is to suppress that enhanced noise. For that I usually turn to Noise Ninja, but any of the programs I wrote about in Chapter 3 will do the job. Do not use Photoshop's own noise reduction filter; it is a most inferior tool.

For slight noise/grain suppression, I've found that most noise reduction programs' default settings work very well, with one exception. The Noise Reduction Amount typically defaults to a value that almost completely eliminates grain and noise, and that level of noise reduction tends toward that plastic look I try to avoid. For 1-pixel sharpening, a 25% reduction setting seems to work best. For 2-pixel sharpening, 30–35% works best. This produces the balance I mentioned between somewhat improved sharpness and somewhat reduced grain/noise. In the example illustrations in Figures 10-7 and 10-8, I've used extremely strong sharpening and noise reduction to make the illustrations clearer. In real life, you'd rarely use levels so high.

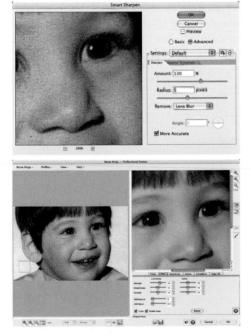

Fig. 10-7 Combining sharpening and noise reduction can produce a photograph that has less noise and better sharpness than the original. In this example, the noise reduction and sharpening settings are abnormally high in order to produce a clear difference in Figure 10-8.

Fig. 10-8 This photograph (top) went through a two-stage adjustment. First I sharpened it using Smart Sharpen (Figure 10-7, top) and then I reduced its noise with Noise Ninja (Figure 10-7, bottom). The combination produced a photograph with better detail and less noise (bottom) than the original.

You can choose to favor one quality over the other. If I want to emphasize sharpness over noiselessness, I'll sharpen with a 2-pixel radius and use the 25% noise reduction setting. If, on the other hand, I want to suppress noise without noticeably altering sharpness, I'll use a 1-pixel sharpening radius and a 30–35% noise reduction level. It all depends on the photograph and the look I'm going for.

Applying these tools to separate layers or as Smart Filters allows you to tailor these effects to different parts of the photograph. For large sky areas, you might want more noise suppression; for sharply defined subjects in the foreground, increased sharpness may be more important. Use the Brush tool to paint black or white into the masking channels of the smoothing and sharpening layers to control the impact they have on the photograph. Set the brush opacity to around 25%, so you can paint in the changes gradually; it's unlikely you'll want to completely suppress sharpening or smoothing anywhere. The nice thing about working with masks, of course, is that if you decide you overdid the brushwork, you can switch the brush from black to white (or vice versa) and undo what you overdid. Since the changes you're making to the restored photograph are subtle, you don't have to worry that applying different balances of these effects to different parts of the picture will be obvious. The local variations won't be apparent to the viewer, just the total aesthetic effect.

Examples

Introduction

The examples in this chapter are case studies in restoration. Each example takes a photograph, step by step, from its original form to its fully restored glory. Within the limits of space I've left nothing out. No magic takes place behind the curtain.

As I said back in Chapter 1, what I enjoy most about doing photo restoration is going for "the best of all possible prints" from a damaged photograph. I love to take the restoration process to its limits and see just how perfect a photograph I can get. The examples in this chapter are precisely these kinds of perfectionist performances. They aren't necessarily complicated, but they are all as masterful and complete as I know how to make them.

What I want to convey in this chapter is not a set of marching orders but some understanding of how one gets from A to Z. It's about more than noting

the specific tools that I use to solve each problem in the restoration; it's as much about the order in which I tackle the problems and how I decide what path to follow to get to my goal.

This doesn't mean you have to be a perfectionist! You needn't travel all the way from A to Z to get great results; you can stop at P and have restorations that are more than good enough to make most people very happy. Chapters 5 through 9 are filled with examples that don't go to the ultimate limit of the restoration art, but they still look good.

Always remember that these are examples, not prescriptions. Give the same photograph to 10 different restorers and they will take as many different approaches to fixing it. When you read these examples, I hope you'll sometimes find yourself thinking, "Wouldn't it have made as much sense for Ctein to address this problem this other way?" The answer is very likely "Yes!" There is never one right answer, and the more right answers you can come up with, with the more tools you'll have at your disposal when you encounter a new problem.

Examples 1 through 8, from the first edition of this book, have been moved to the Website in order to make room for new material. You can find them at http://photo-repair.com/dr1.htm.

Here are short descriptions of those examples, along with the original and restored photographs.

Example 1: Repairing an Old Glass Plate

This 4 × 6-inch glass plate negative was made in the 1920s in Italy. It's tarnished, but otherwise the silver image is in great shape. Although the negative is very dense—typical for photographs of the time—the edges of the plate are clear and only slightly yellowed. The only thing that prevents me from printing this plate conventionally on a Grade 0 paper is that it's broken in two!

Example 2: Repairing Color with a Good Scan

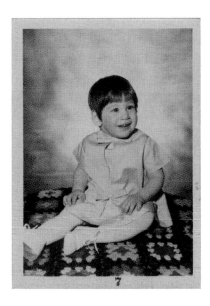 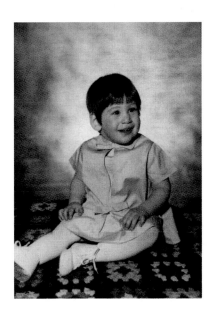

Throughout this book I've emphasized the importance of getting a good scan to make your restoration job easier and better. Getting the scan right in this case got me 90% of the way to great tone and color (see also Chapter 6, "Restoring Color," page 167).

The original was a 3 × 5-inch color snapshot made in 1966. It was in very good shape for a 40-year-old color photograph. It was little bit dirty and slightly cracked, and there were some paper fibers stuck to the surface but little physical decay. The print had a moderate amount of yellow staining and overall had faded considerably but uniformly.

The restored photograph is sharp enough to take up to 6 × 10 inches and still stand up to close inspection.

Example 3: Mother and Child—A "Legacy" Restoration Job

This was the first professional-quality restoration I ever did, in 1998. The computer was slow and had little memory, I could only work with 8-bit files, and all the work was done under Photoshop 4. That meant no adjustment layers, no History States, no Healing Brushes, and no clever third-party plug-ins. The methods and tools I used to restore this photograph are available in just about any image processing program; this is as close to "generic" technique as you can get.

The photo was made by a chain department store's portrait studio 30 years ago. Poorly processed and taped into a cheap cardboard matte, the print hung on a wall in the family's home for two decades. Although it looks like a nearly monochrome red image, there was enough color information left to do an excellent digital restoration.

Example 4: A Faded E-1 Slide

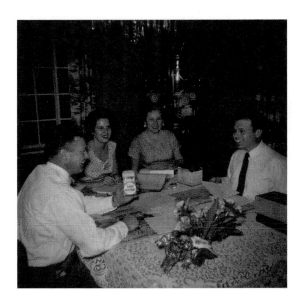 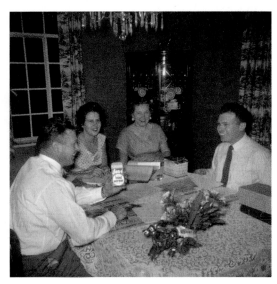

This 1950s medium-format Ektachrome slide is very badly faded. Process
E-1 slide films were very unstable. This slide has lost about two-thirds of its
cyan dye; the maximum density of the cyan image is only 1.0 density units—a
terribly low number!

To make matters worse, the slide is pockmarked with orange-speckle
"measles" damage, regions where the cyan dye image has faded even more,
and serious yellow stain has occurred. And if that were not enough, the amateur
camera and flash that made this photograph produced severe vignetting and
chromatic aberration (color fringing).

Example 5: Reassembling an Astronomical Glass Plate

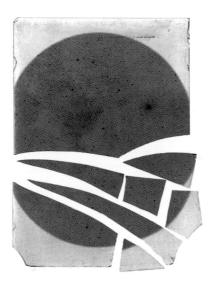 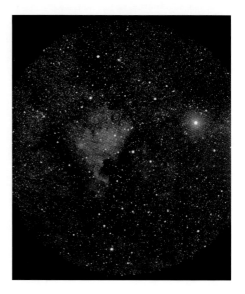

I made this photograph, my first astrophotograph, in high school in 1966. Back then all serious astrophotography was done on special glass plates that were only about half the thickness of the old pictorial photography glass plates. Twenty years ago my photograph got broken into eight fragments during a move. Finally, thanks to digital restoration technology, I got to fix it.

Example 6: A Rare and Historic Old Polaroid

I made this Polaroid photograph as a teenager more than 40 years ago. Where the lacquer didn't sufficiently protect the silver from oxidation, the Polaroid had turned yellowish. What makes it historically interesting is that it's a portrait of the world-famous physicist, Dr. Richard P. Feynman. What makes it rare is that it shows him with a mustache, a short-lived "look" for the brilliant scientist. For those reasons, I wanted to make minimal changes to this photograph when I restored it. I did not want to obscure or alter some detail that might be of importance to a future viewer.

Example 7: Fixing a Photocopied Halftone

This is a clipping from a memorial service pamphlet that was printed in the late 1990s. It was not very good to begin with; the original photograph, presumably a color snapshot, was screened and poorly photocopied for the leaflet. During its short life it's gotten much worse because the nonarchival paper started developing brown spots and freckles, which are easily seen in the enlargement on the right.

Example 8: Restoring an Almost-Blank Photo

Back in Chapter 5, "Restoring Tone," on page 152, I introduced you to the most badly faded photograph I've restored to date. The finished photograph truly amazes me with how much photographic information turned out to be buried in it. I never guessed I'd be able to do this much with that photograph when I first looked at the nearly blank square of paper.

Example 9: Restoring a Very Old and Large Print

This photograph was too large to scan in a single scan. In fact, because of its size, 12 × 19 feet, I had to split it into three scans (Figure 11-9a). As I explain in Chapter 9, Tips, Tricks, and Enhancements, page 307, successfully reassembling the complete photograph from individual scans involves aligning detail and matching tone and color rendition between scan segments.

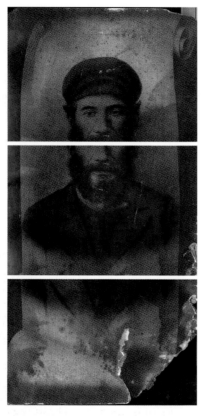

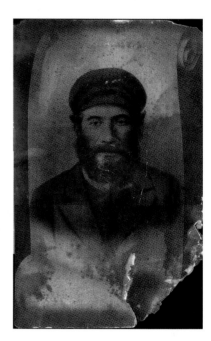

Fig. 11-9b As this overlay of the three scans shows, their tones don't match perfectly; repeated scans from moderately priced scanners often come out slightly different.

Fig. 11-9a This 12 × 19-foot photograph was too large to scan in a single pass; it was necessary to scan it in three sections to get it all.

Simply overlapping the scans (Figure 11-9b) won't do the job. Affordably priced flatbed scanners simply aren't that precise; there will usually be slight geometric distortions (probably not visible here) and small differences in tonal rendition. This is all fixable by hand, as I explain online at http://photo-repair .com/dr1.htm, but it's much faster to use the Photomerge operation in Photoshop (Figure 11-9c), which works *very* well in versions CS3 and CS4 (and in Elements 6 and up).

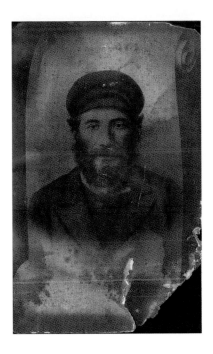

Fig. 11-9c The Photomerge operation in Photoshop produces a perfectly aligned and tone-matched composite from the three scans in Figure 11-9a.

Fig. 11-9d Photomerge puts each component scanned into a separate layer, so you can make adjustments to individual components or the cut lines before merging them.

Since Photomerge places each scan component in a separate layer, you can still do individual tone color adjustments to the scans, should that be necessary. Use attached adjustment layers (Figure 11-9d), as I explain in Chapter 9.

Once you are satisfied with the scan merge, there's no reason to keep them in separate layers, so flatten the image into a single layer and save it as a new file.

In Chapter 4, page 96, I described how Channel Mixer produced the cleanest, most defect-free grayscale image from this full-color scan by mixing 150% red with –50% blue. Figure 11-9e shows the converted image. Now it's time to go in and clean up the remaining damage.

It's apparent that the portrait was heavily and crudely retouched, most obviously in the facial hair and the eyes, and there's not a lot of fine detail in the original photo. In fact, this is as much a drawing as it is a photograph. That's going to make it a lot easier to clean up the damage, which is mostly small-scale.

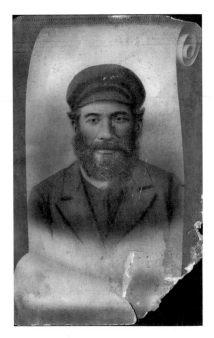

Fig. 11-9e I used Channel Mixer to combine the red and blue channels of Figure 11-9c to get a grayscale image that's much cleaner than the original scans.

Fig. 11-9g Clicking the Color Range… eyedropper on one of the white areas and setting the Fuzziness to 130 produces a good selection of the most badly damaged parts of the photograph.

Fig. 11-9f This close-up shows that the parts of the photograph with the emulsion entirely missing are much lighter than the rest of the photograph. That makes it easy to select these areas using the Color Range… selection tool.

Fig. 11-9h The Color Range… settings in Figure 11-9g produced this mask that selects for the worst damage in the photograph.

I duplicated the base layer containing the photograph so that I could apply filtration in a separate layer. I began with the parts where the image was entirely missing because they were white, much lighter than any part of the photograph proper (Figure 11-9f). I made a selection of the white areas using Color Range…, clicking the eyedropper on one of the pure white areas and setting the Fuzziness to 130, as shown in Figure 11-9g. This produced the selection shown in Figure 11-9h.

I applied the Median filter with a radius of 14 pixels to the selected regions. That filled in the damaged areas with surrounding pixel values (Figure 11-9i).

To separate out some of the remaining damage, I used the noise reduction/Lens Blur method that I describe in detail in Chapter 7, page 224. I made a copy of the photograph and applied very aggressive noise reduction to it, using the settings shown in Figure 11-9j. This produced a blurry photograph where only the strongest edges were preserved. In this case, that mostly corresponded to damaged areas.

I applied the Find Edges filter to that blurry photograph, inverted the results, and increased the brightness and contrast of the image with the Curves adjustment shown in Figure 11-9k. I called up the Lens Blur filter (Figure 11-9l), which turned that image into a mask that would select for the worst of the remaining damage while ignoring most of the real image detail. I copied that mask and pasted it into a new channel in the original photograph so that I could load it as a selection.

Fig. 11-9i Median filtering of the parts of the photograph selected by the Color Range… tool has eliminated a great deal of the damage from Figure 11-9e in a single step.

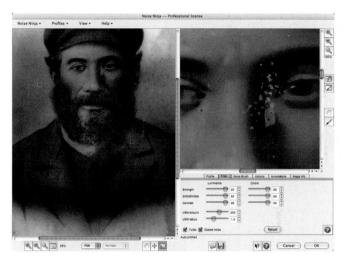

Fig. 11-9j The extreme noise reduction settings shown here blur out everything except the hardest-edged details in the photograph, which include many damaged areas.

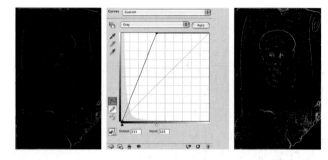

Fig. 11-9k The Noise Ninja plug-in, the Find Edges filter, and an inversion got me to the mask image on the left. Applying the Curves adjustment in the center brought out the edges of the damaged areas more clearly, as shown on the right.

Fig. 11-9l The Lens Blur filter turns the mask in Figure 11-9k, right, into one that selects for entire damaged areas and not just their edges.

339

This mask is not perfect; it also selects a bit of the detail in the photograph. I used a black brush to paint over the mask channel where it had included real edges, resulting in Figure 11-9m.

I duplicated the photographic layer that I cleaned up with the Median filter so that I could apply the next stage of filtration separately from that one. I loaded the mask I had just created as a selection and applied the Dust & Scratches filter (Figure 11-9n).

The newly filtered image layer looked really great, but by clicking the eyeball next to that layer to turn it on and off I could see that there were spots I had missed when retouching the mask. A few bits of real photographic detail had been obliterated by the Dust & Scratches filter. I expected that would happen, which is why I did the filtration in a separate layer. By adding a mask to that layer and painting into it with black wherever I didn't want Dust & Branches filtering, I could undo that loss of detail (Figure 11-9o). The mask and the filtered photograph are shown in Figure 11-9p.

Fig. 11-9m Here's the mask image that Lens Blur produced after a little handwork to black out edges and real details that the mask undesirably also selected for.

Fig. 11-9n This Dust & Scratches filter, apply selectively through the mask from Figure 11-9m, eliminates a lot of the remaining damage.

Fig. 11-9o The Dust & Scratches filter in Figure 11-9n did its work on a duplicate of the Median-filtered layer that I masked with Figure 11-9m. I added a mask layer to the newly filtered layer so that I could paint out the Dust & Scratches effect where it obliterated real photographic detail instead of damage. The painted mask is shown in Figure 11-9p, along with the resulting photograph.

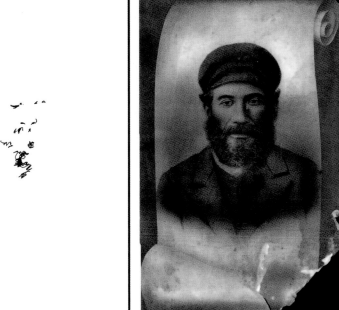

Fig. 11-9p Here's the mask that modified the Dust & Scratches filter, along with the now twice-filtered photograph.

Aside from the large rips and tears, almost all the remaining damage is small in size and sharp-edged (Figure 11-9q). One more pass with a masked filter ought to take care of it. Because the damage already has clear edges, I don't need to use Noise Ninja to isolate it; the Find Edges filter will work just fine all by itself.

Fig. 11-9q A close inspection of the twice-filtered photograph shows that most of the remaining damage is small and sharp—an ideal candidate for removal by masked filtering.

341

Once again I made a copy of the photograph, applied the Find Edges filter, inverted the result, and applied the Lens Blur filter with the settings shown in Figure 11-9r. To capture the finer detail and extract it from the background, I used a smaller radius and a much higher threshold. The resulting mask image included a lot of low-level background from the photograph, so I used a Curves adjustment (Figure 11-9s) to make the white (selected) stronger and to push the background closer to black. This got me the mask shown in Figure 11-9t.

Fig. 11-9r The Lens Blur filter with these settings produced a good candidate for a mask, although it was somewhat low in contrast, as shown in Figure 11-9t, top.

Fig. 11-9s This Curves adjustment turns the mask image at the top of Figure 11-9t into the one at the bottom.

I'm sure you know the routine by now: I copied the mask image into a new channel in the photograph, loaded it as a selection, and applied the Dust & Scratches filter (Figure 11-9u,) to get Figure 11-9v. Compare that to Figure 11-9q to see the improvement.

Almost all the damage has been eliminated, and we're down to the routine (and tedious) handwork. There's a bunch of small stuff to clean up, but nothing that the Spot Healing brush can't handle in short order. The lion's share of the work lies in the dark stains and light fade marks that cover much of the print.

To fix those, I turned to the masked dodging and burning-in layer approach I described in detail in Chapter 5, page 146. I created two masked curves

Fig. 11-9t The new image mask before (top) and after (bottom) the Curves adjustment from Figure 11-9s. Some edges are still visible and need to be painted out by hand, but this is only a few minutes' work. The resulting mask does a very good job of selecting only damage.

Fig. 11-9u Applying this Dust & Scratches filter to the masked photograph produced Figure 11-9v.

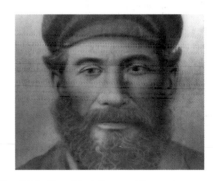

Fig. 11-9v The original photograph is now almost damage free except for large tears and a few isolated spots that selective filtration couldn't catch. The main work left to do is to clean up all the stains and faded spots that practically blanket the photograph.

adjustment layers, as shown in Figure 11-9w. The top curve creates a dodging layer; by airbrushing white into the layers mask (left), I can lighten up the photograph. Similarly, the bottom curve creates a burn-in layer that locally darkens the image.

It took a couple of hours, work to dodge and burn in the corrections to this photograph; it was pretty messed up. But finally I'm getting close to a clean photograph!

Figures 11-9x (a) and (c) show the photograph before and after my mask work.

Fig. 11-9w These masked dodging (left) and burning-in (right) adjustment layers let me controllably paint out dark and light blotches that remain in the photograph.

Fig. 11-9x (a) The photograph before dodging and burning in. (b) The same photograph after applying the dodging adjustment layer from Figure 11-9w, left. (c) The result of applying both dodging and burning-in masked layers. (d) The photograph after median filtering to smooth out the background and some cloning to fill in missing portions.

I created a new flattened layer with the magic key sequence Command-Option-Shift-E and used the Magic Wand and Lasso tools to create some masks that isolated the outer border, the background, and the scrolls at the top and bottom of the photo, as illustrated in Figure 11-9y.

I used those various selection masks in combination with Median filters of differing radii to clean up the most of the remaining irregularities. A 30-pixel radius worked well in the outer border and 50 pixels was best for the background and scroll regions. I faded the filtration by 50% to retain some of the structure and texture in the photograph so that the blends didn't look too artificial. Then I used the Clone stamp to paint over the large tears and recreate the missing pieces of the print, which got me to Figure 11-9x(d).

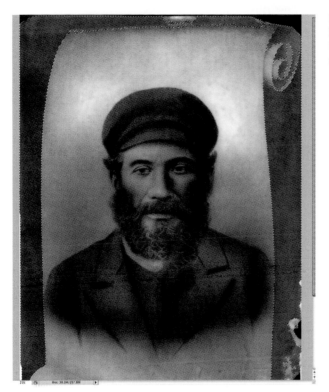

Fig. 11-9y The Magic Wand and Lasso tools work quickly in a photo of this type to select portions of the background for median filtering, because the areas to be filtered are well defined.

Fig. 11-9z Two more masked adjustment layers provide the final touches.

345

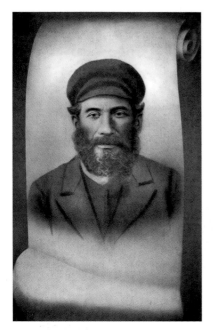

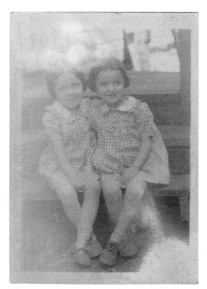

Fig. 11-9aa The finished photograph prints very nicely at its original size. It looks a lot more like a drawing than a photo, but it's an attractive and recognizable likeness of the subject. Compare this to the original in Figure 11-9c.

Looking at that result, I felt there were still some large, shadowy stains in the middle of the photograph. It was a judgment call; that might have been the way the original looked, but it looked odd to me. Since this photograph isn't anything close to a literal rendition of the subject, I decided to go with my artistic instincts and not worry about the historical veracity.

I created another hand-masked dodging layer (Figure 11-9z) to eliminate those shadows. Finally I added a darkening layer with an oval gradient to darken up the borders and direct attention to the portrait (more artistic judgment rather than original intent). This, plus some minor overall Curves adjustments to brighten up the whites and increase contrast, got me to the photograph in Figure 11-9aa.

Example 10: Restoring a Very Yellowed B&W Snapshot

This mid-20th-century 3.5 × 5-inch snapshot is so badly faded that the girls are almost unrecognizable (Figure 11-10a). Part of the image, in the lower-right corner, is entirely missing, and the left side of the photograph is so light that it's hard to tell if there's any detail there at all.

As always in cases like this, a good scan is the first order of business. Although there wasn't any particularly fine photographic detail in this print, I chose to scan it at 1200 ppi to make it easier to use filters to separate the dirt and damage from the image itself. I clicked the black eyedropper in my scanner's levels/histogram software on a point right under the steps where the image was darkest (Figure 11-10b). Similarly, I clicked the white eyedropper on the lightest point I could find in the photograph. That got me to Figure 11-10c.

The scan showed that along with severe and uneven fading, the photograph was plagued with a lot of fine dirt, which came out bluish in the scan. When I looked at the individual color channels, the dirt was most visible in the red channel (Figure 11-10d, left). The blue channel (Figure 11-10d, right) showed

Fig. 11-10a This photograph is so badly yellowed that it's difficult to tell which parts of the image have faded and which have been lost entirely.

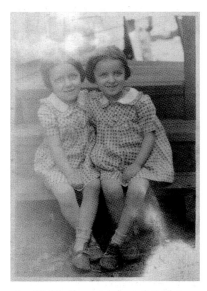

Fig. 11-10b My scanner software's eyedropper tools set the brightest and darkest parts of Figure 11-10a to near-black and near-white, producing the much improved scan in Figure 11-10c.

Fig. 11-10c The corrected scan shows that there is usable detail in most of the photograph, especially in both girls. Some dirt and debris overlie the left side of the photo.

Fig. 11-10d Here are the individual color channels that make up Figure 11-10c. The red channel on the left shows the least image detail and the worst dirt. The blue channel on the right shows the most image detail and the least dirt. Using Channel Mixer to subtract some of the red channel from the blue channel will eliminate a great deal of the dirt while retaining maximum image detail.

the best image detail—not at all surprising considering how yellow the photograph was.

Given that, I decided to use the blue channel as the primary image for restoration and subtract a little bit of the red channel from that to cancel out most of the dirt. I created a Channel Mixer adjustment layer with the settings shown in Figure 11-10e, which produced Figure 11-10f.

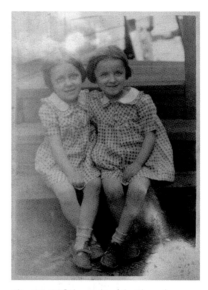

Fig. 11-10e The Channel Mixer settings that produce Figure 11-10f from Figure 11-10c. I subtracted 40% of the red channel from the blue channel to cancel out most of the dirt, but I increased the blue channel so that the total of all three channels still added up to 100%. This way the overall brightness isn't changed.

Fig. 11-10f The results of the Channel Mixer are an image with greatly improved detail over the original photograph. There's still a lot of work to do, though!

The tone and contrast in this B&W conversion are tolerable on the right side of the photograph, but the left side is still way too light. To fix that, I added a masked Curves adjustment layer (Figure 11-10g). I created a curve that made the girl on the left look good. This made most of the photograph way too dark, but that's what the mask layer is for. I painted in the mask to apply that curve only where I wanted it, which got me to Figure 11-10h.

To proceed, I needed a single image that combined the adjustments I had made so far, so I created a merged layer with the key sequence Command-Option-Shift-E. The resulting layer stack looked like Figure 11-10i. I copied

Fig. 11-10g A masked Curves adjustment layer increases the contrast and darkens the parts of the photograph that are pale and washed out. On the left is the curve I used in that layer; on the right is the mask I painted to control where that curve took effect. The results can be seen in Figure 11-10h.

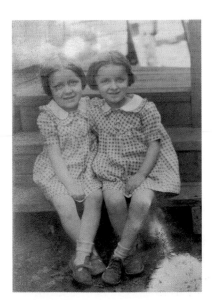

Fig. 11-10h The Curves adjustment layer from Figure 11-10g produced a photograph that is now fairly even in tone, but there's a great deal of dirt and noise on the left half of the photograph that needs to be eliminated.

Fig. 11-10i Here's what the layer stack that produced Figure 11-10h looked like. At the top of the stack is a layer I created using the keystroke combination Command-Option-Shift-E that merges the background image and the two adjustment layers.

the merged layer into a new file so that I wouldn't be carrying the computational overhead from all the individual layers in the later steps.

To grab the worst of the remaining noise for filtering, I used the noise reduction/Lens Blur method that I describe in detail in Chapter 7, page 224. First I applied Noise Ninja to the photograph, as in Figure 11-10j. Then, just as in

Fig. 11-10j A noise reduction tool like Noise Ninja can be used to isolate hard-edged dirt and damage in a photograph. With the filter settings set to maximum, Noise Ninja blurs out everything but the damaged areas.

Example 9, I applied the Find Edges filter to that blurry photograph, inverted the results, and brought up the Lens Blur filter (Figure 11-10k), which turned that image into a mask that would select for the worst of the remaining damage while ignoring most of the real image detail. I copied that mask onto the clipboard, reverted to the History State before I did the noise filtering, and pasted the mask into a new channel so that I could load it as a selection.

I duplicated the photograph layer, loaded the mask I had just created as a selection (that's under Select | Load Selection… in the menus), and applied a Median filter (Figure 11-10l). That wiped out the worst noise, but by clicking the eyeball next to that filtered layer to turn it on and off I could see that there were a few real details that the filter had erased in the eyes and the shoelaces. I brushed black into the mask channel of the filtered layer in those areas so that the unfiltered (lower) layer would show, getting me to Figure 11-10m.

Fig. 11-10k Lens Blur emphasized and expanded the edges that the Find Edges filter isolated from the noise-reduced photograph.

Fig. 11-10l Applying this Median filter to the photograph masked with the image produced by the Lens Blur filter wiped out a great deal of the dirt and damage in the photograph without affecting surrounding areas, as shown in Figure 11-10m.

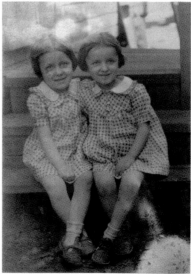

Fig. 11-10m Media filtering the masked photograph cleaned up a lot of the dirt.

My next step was to reduce the overall noise level in the photograph. I duplicated the photographic layer and applied Noise Ninja to that image without limiting it via a selection mask (Figure 11-10n). These noise reduction settings

Fig. 11-10n Noise Ninja, applied to the entire photograph using the settings shown here, eliminated most of the remaining dirt and distracting paper texture.

are, in fact, too strong for most of the photograph. No problem! I added a mask to the noise-reduced layer and filled it with a 50% gray. That reduced the strength of the noise reduction enough that it didn't compromise the fine detail in the girls' faces or dresses.

Many parts of the photograph needed stronger noise reduction than that—their arms, legs, and faces as well as the background and most of the left side of the photograph. I used a white brush to paint those areas in the mask where the photograph needed stronger noise reduction. The finished mask is shown in Figure 11-10o; the resulting photograph appears in Figure 11-10p. The right two-thirds of the photograph is looking pretty good, save for the missing portions at the bottom; the left third still needs more overall cleaning up.

Once again I applied Noise Ninja (Figure 11-10q) to a duplicate layer. This time I hand-selected the regions for Noise Ninja to analyze, concentrating on the background. That did a very effective job of wiping out the background texture noise using the filter's default settings. I added a mask channel to that layer,

Fig. 11-10o Noise Ninja did too good a job in some parts of the photograph, eliminating real image detail along with noise. Incorporating this mask in the layer where Noise Ninja was applied let me reduce its effect to an appropriate level in the parts of the photograph where it worked too aggressively.

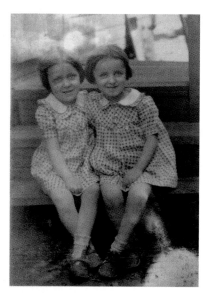

Fig. 11-10p The photograph is a lot cleaner as a result of the selective application of Noise Ninja.

Fig. 11-10q A further application of Noise Ninja using hand-selected analysis regions (the yellow squares) was used to eliminate most of the noise in the background and on the girls' skin.

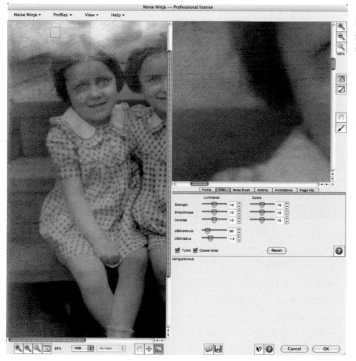

filled it with black, and used the white brush to paint in the filter effect wherever I needed it, mostly on the background and the girls' bare skin.

I decided it was time to adjust the overall tone and contrast and roughly fill in the missing parts of the photo before cleaning up the residual dirt and damage. I filled in the lower-right corner in two stages. In the first stage, I used the Brush tool to paint in the white areas with a dark gray tone that was typical of the foreground (Figure 11-10r, left). In the second stage, I used the Patch and Clone tools to fill in those missing areas with similar textures from the ground (Figure 11-10r, right).

Fig. 11-10r Before filling in the missing corner of the photograph with the Patch tool, I painted the white area dark gray (left). That let the Patch tool do a better job of matching the surrounding tones when it filled in the area with textures sampled from other parts of the photograph (right).

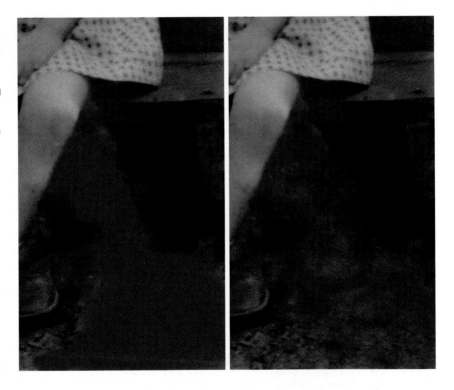

The reason for doing this in two stages is that the Patch tool takes texture and detail from the source and combines it with the overall brightness of the destination. If I had tried to patch the missing foreground areas while they were still white, I would've had ground-like detail there, but it would've been very light. Brushing in the area with the approximate tone I wanted beforehand produced a much better result.

Next I applied the Curves Adjustment layer shown in Figure 11-10s, which improved overall contrast, especially in the highlights, and added a little more snap to the midtones. I added a burn-in layer (Figure 11-10t) and hand-painted the mask to darken the parts of the photographs that were too light. The result, seen in Figure 11-10u, is pretty even. The lower-right foreground needs some more patchwork to make it look realistic, and it's now apparent that there's a big faded area just above the girls' heads, intruding into their hair, which will require burning in along with cloning and patching. Finally, though, we're within shooting distance of a nice-looking restoration.

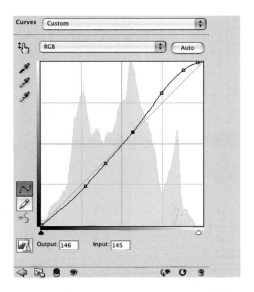

Fig. 11-10s This Curves adjustment layer improved the contrast and snap of the photograph, giving it more midtone brilliance.

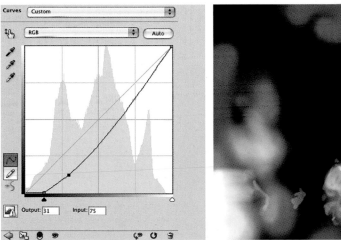

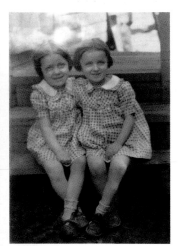

Fig. 11-10t The Curves adjustment layer pictured here burned in the parts of the photograph that were too light and low in contrast, using the hand-painted mask on the right.

Fig. 11-10u The photograph looked pretty uniform after applying the Curves adjustment layer from Figure 11-10t, but there remained a big light patch in the upper left. The Curves adjustment layers in Figure 11-10v fixed that.

To correct the remaining unevenness in tone and get rid of light and dark spots that marred the print, I created a pair of masked Curves adjustment layers. The one on the left in Figure 11-10v burns in areas that are too light; the one on the right dodges areas that are too dark. Figure 11-10w shows the effect of these adjustment layers on the photograph.

Fig. 11-10v The Curves adjustment layers shown here worked to burn in (left) and dodge (right) the photograph from Figure 11-10u. The broad strokes in the masks evened out the tones and eliminated the white spot in the upper left. The small, fine dots and strokes erased residual noise and irregularities that the noise filters hadn't caught.

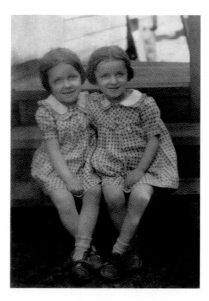

Fig. 11-10w After applying the adjustment layers from Figure 11-10v, the photograph was nearly complete. I needed to restore some detail to the girl's hair on the left and fix the leg of the girl on the right, which I did using the Patch and Clone tools.

My penultimate step was to repair the damage and missing detail in the hair of the girl on the left and the leg of the girl on the right. I used the Patch tool at 50% strength to copy pieces of the other girl's hair to provide believable texture. I did a certain amount of dodging and burning in on the hair so that it would be

less obvious that I had copied from one head to the other. To fix the leg, I used the Clone stamp to sample the middle of the leg and extend the edges.

Finally I added a Curves adjustment layer (Figure 11-10x) to give the photograph more snap and produce a good-looking print. Figure 11-10y shows the finished restoration.

Fig. 11-10x This Curves adjustment layer produced a photograph with good overall brilliance and a nice tonal range from black to white, leading to the final results shown in Figure 11-10y.

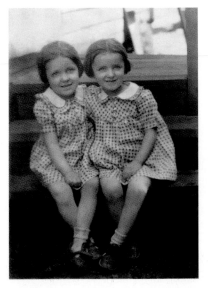

Fig. 11-10y The finished restoration is free of visible dirt and damage, with every recoverable bit of image detail fully restored.

Example 11: Restoring Faded Color Snapshots

Both of the snapshots in Figure 11-11a were made around 1980 on the same brand of paper, and they were even stored together. Nonetheless, they've aged very differently. The photograph on the top (which is, in fact, the newer one) has lost a great deal of cyan dye density, turning the print brick red. The snapshot on the bottom was badly underexposed, so the print is pale and poor in contrast, but what fading has occurred is much more neutral in hue.

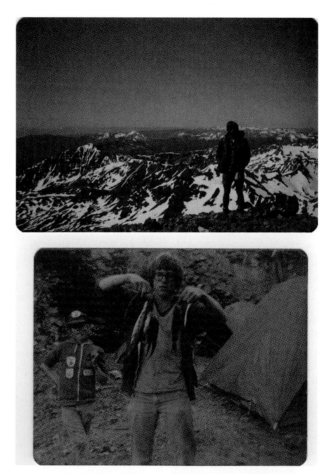

Fig. 11-11a Fading is not always a predictable thing. These two snapshots were made only a few years apart. In fact, the more badly faded photograph on the top is the newer one.

These two snapshots don't look much alike, but similar restoration techniques worked on both of them. I started with better scans, as usual.

Figure 11-11b shows the scanner software settings I used to make the scans in Figure 11-11c. I got to those settings simply by clicking the black eyedropper on the darkest part of each photograph and the white eyedropper on the lightest part.

Fig. 11-11c The adjusted scans had better color and contrast than the original photographs did, but they were still far from having correct color.

Fig. 11-11b I used the black and white eyedroppers in the scanner software to select the brightest and darkest points in both snapshots. Those settings produced the improved scans shown in Figure 11-11c.

Both of the resulting scans are good candidates for Digital ROC color correction, but I decided they needed some cleaning up before doing that. As Figure 11-11d illustrates, both photographs are very grainy, which means there's a lot of chroma noise. Those

Fig. 11-11d Enlarged
sections of both snapshot scans
showed that the photographs
were grainy and had a high
level of chroma noise. That
noise could throw off my color
correction tools, so I eliminated it
using the filters shown in Figures
11-11e and 11-11f.

Fig. 11-11e Noise Ninja, used with the setting shown here, did a good job of reducing
chroma noise. Note that I dialed back the Luminous Strength to minimize the filter's impact
on fine detail.

random fluctuations in color can
throw Digital ROC off the track;
when they are too severe, the
software has trouble ignoring
the noise and working its color-
correction magic based solely on the
image.

I ran each photograph through
noise reduction before I did color
correction. The first snapshot did not
have an extraordinarily high degree
of noise and Noise Ninja, with the
settings shown in Figure 11-11e,
was able to satisfactorily suppress it
without losing real detail.

The second snapshot was a
much tougher case, and so I turned
to Noiseware for a fix. Figure 11-11f
is not a straight screenshot; it's
a composite I constructed to show all the Noiseware control palettes I used to
attack the grain in this photograph. In particular, I ran the color noise detection
and reduction up to near maximum while minimizing the color detail protection
settings. This very effectively suppressed chroma noise without sacrificing detail.

Fig. 11-11f I used a lot of controls in Noiseware to minimize the chroma noise in this snapshot without badly compromising fine detail. This composite screenshot shows all the custom settings I used. I chose settings that emphasized color noise reduction over luminance noise reduction and high spatial frequencies over low.

I ran both photographs through the Digital ROC filter with the settings shown in Figure 11-11g. Digital ROC does a good job of restoring color, but in my judgment it increases contrast by too much, so I usually split its effect into two duplicate layers (Figure 11-11h). The first layer is set to Color blend and left at 100% strength. I typically set the second layer to Luminosity blend and dial back the Opacity until I like the overall contrast. Usually that falls somewhere between 40% and 60%. When I'm happy with the result, I merge the effects into a single layer and proceed from there (Figure 11-11i).

At this point, the stories of the two photographs go their separate ways. I went to work on the mountain photograph first. Digital ROC isn't perfect; the photograph had some color crossover, with the highlights being too ruddy and the shadows too yellowish, although the midtones were close to correct.

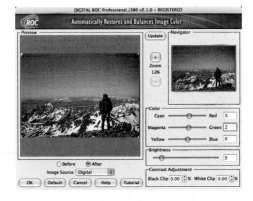

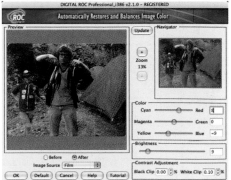

Fig. 11-11g Digital ROC did a very good job of restoring the overall color on both noise-reduced snapshots.

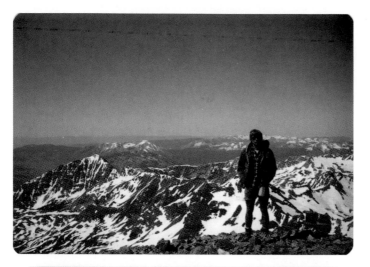

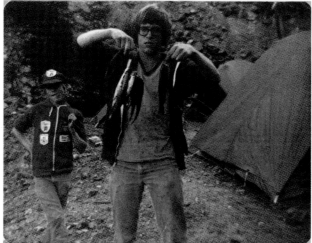

Fig. 11-11h I have found that Digital ROC does a good job of correcting color, but it increases contrast too much. By applying Digital ROC to a separate layer and then duplicating the results, I can split the filter's effect on color from its effect on luminosity. I set the blend mode on the lower layer to color and left the opacity at 100%. Setting the blend mode on the second filter layer to Luminosity and dialing back the opacity kept the contrast from getting out of hand.

Fig. 11-11i Here are the results of the work so far: a carefully adjusted scan, a chroma noise reduction pass, and color restoration with Digital ROC.

It also lacked a bit of saturation. I added two adjustment layers, one for Curves and one for Vibrance, and made the correction shown in Figure 11-11j. That got me to Figure 11-11k.

There was so little dust and dirt in this photograph that I didn't even bother with clever filtering tricks to clean it up. I just used the Spot Healing brush to eliminate those few dozen defects.

Fig. 11-11j Here are the curves I used in a Curves adjustment layer to fix the color in the first snapshot. These curves settings cool down the highlights, which were too red in color, and make the shadows less blue. The result is shown in Figure 11-11k.

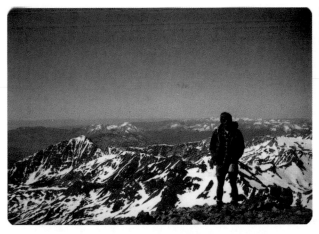

Fig. 11-11k A dose of Curves adjustment (Figure 11-11j) made the color in this photograph a lot better. The red cast is gone from the highlights and the sky is much bluer.

I could see that the cyan dye fading wasn't uniform (Figure 11-11l, left), so I created a pair of dodging and burning-in masked layers (Figure 11-11m) to correct the problem. I hand-painted the masks with a white brush until the color looked uniform, as shown at right in Figure 11-11l and in Figure 11-11n.

Fig. 11-11l (left) The red channel from Figure 11-11k has light and dark patches that throw off the color in the sky. The dodging and burning-in Curves adjustment layers from Figure 11-11m fixed that, as seen on the right, making the sky a much more uniform blue.

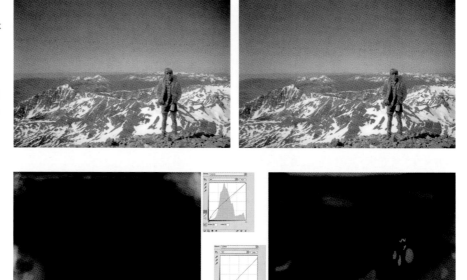

Fig. 11-11m I used these dodging (left) and burning-in (right) Curves adjustment layers to fix problems with the red channel in Figure 11-11k. Along with eliminating the irregularities in the sky, I cleaned up excessive cyan tints in the lower-left corner and some reddish areas on the right. Figure 11-11n shows the improved photograph.

Fig. 11-11n The Curves adjustment layers from Figure 11-11m corrected the colors in Figure 11-11k, as this figure shows. I also used the Spot Healing brush to eliminate the small numbers of specks and defects in the photograph.

I thought that the boy looked dark and flat, so I added a masked Curves adjustment layer (Figure 11-11o) to correct the problem. He also looked overly yellow, so I made a color correction as well. Lightening the figure and making it a bit bluer made the photograph look a lot better, but it remained a bit desaturated and washed out overall. A Hue/Saturation adjustment layer (Figure 11-11p) fixed that, giving me the finished photograph in Figure 11-11q.

Fig. 11-11o The boy in Figure 11-11n looked dark and flat, so I increased his brightness and contrast and eliminated a slight yellow cast with this masked Curves adjustment layer.

Fig. 11-11p A Hue/Saturation adjustment layer with these settings improved the overall color saturation in the photograph and made the sky a more realistic deep blue, as shown in Figure 11-11q.

Fig. 11–11q The finished snapshot looks as good as the day it was made, thanks to Digital ROC and many adjustment layers.

I could have played further games with this photograph, getting rid of the slight vignetting with a masked Curves adjustment layer and using some of the local tone adjustment controls such as Shadows/Highlights or ContrastMaster to produce richer and more detailed gradation. I decided not to because I wanted to retain the look of a snapshot.

The second snapshot presented me with a different set of problems. There were large areas that were lighter and redder in color, and some faint reddish bands streaked the print. I corrected this with a dodging layer applied to the red channel. Figure 11-11r shows what that layer looked like after I got done working over the mask with the white Brush tool.

Fig. 11-11r The campground snapshot from Figure 11-11i had a lot of problems with irregular faded reddish areas and streaks, so I created this burn-in Curves adjustment layer to repair the red channel.

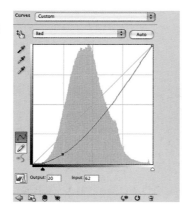
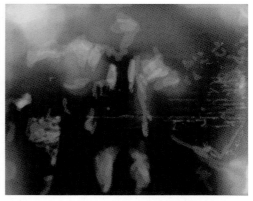

To make the subtle color differences more visible while I did my mask work, I added a Hue/Saturation layer (Figure 11-11s), which functioned as a kind of magnifying glass: It amplified color differences and made it easier to correct the red channel. After I finished painting in the mask, I discarded the Hue/Saturation layer. Figure 11-11t shows the improved photograph; compare this with the version in Figure 11-11i. As with the previous snapshot, there wasn't a lot of dust or dirt on the print, so I just used the Spot Healing tool to clean it up instead of using filters and masked layers.

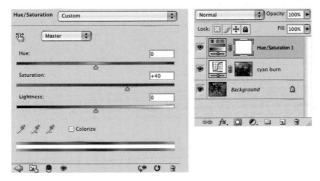

Fig. 11-11s To make it easier to see the effects of my work while I was creating Figure 11-11r, I added this Hue/Saturation adjustment layer, which acted as a kind of magnifying glass: It amplified slight color differences in the original photograph. After I finished creating the mask, I discarded this layer.

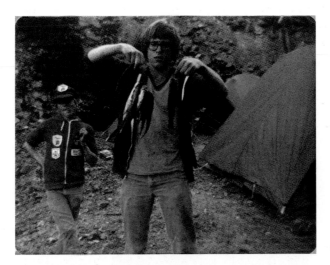

Fig. 11-11t The adjustment layer from Figure 11-11r turned Figure 11-11i into this version. The photograph was dull and low in contrast, but the color was uniform and pretty decent.

I decided it was time to get rid of some more film grain. Looking at the individual color channels (Figure 11-11u) I could see that there was a huge difference in graininess between them. That told me that most of the remaining noise was going to appear as chroma noise, so I applied Noise Ninja to the image with the settings shown in Figure 11-11v. Those settings maximally reduced chroma noise while only modestly reducing luminance noise, which greatly improved the photograph without costing me any detail (Figure 11-11w).

Fig. 11-11u Figure 11-11t is a very grainy photograph, but this figure shows that most of the grain is chroma noise, not luminance noise. By far the noisiest channel is the red channel (left), while the blue channel (right) is almost noise-free. Luminance noise would be much more evenly distributed between the three channels.

Fig. 11-11v I attacked the chroma noise in Figure 11-11t with Noise Ninja. I adjusted the control sliders to strongly reduce chroma noise but only slightly reduce luminance noise. These settings nearly wiped out the chroma noise without losing any detail in the photograph.

Fig. 11-11w This enlargement shows the photograph before and after applying Noise Ninja. The chroma noise is almost gone, but the subject detail remains intact.

The print looked good enough overall that I felt I was ready to finish up adjusting the tone and color. I did that with a couple of Curves adjustment layers and a Hue/Saturation adjustment layer. The first Curves layer (Figure 11-11x, left) mostly had the effect of burning in the washed-out edges of the photograph. I also used it to clean up the last of the pale streaks in the photograph. The second Curves layer (Figure 11-11x, right) increased midtone contrast, giving

Fig. 11-11x I used this pair of Curves adjustment layers to burn in parts of the photographs that were too light and to increase the overall contrast and brilliance in the midtones, to make the photograph more lively.

the picture more snap and better color saturation. The Hue/Saturation adjustment was a modest 12-point increase in both vibrance and saturation, which improved the overall color rendition, as shown in Figure 11-11y.

Fig. 11-11y After a 12-point increase in vibrance and saturation, here's what the photograph looked like. I wasn't entirely happy with the contrast, but I liked the overall brightness and color.

Fig. 11-11z The Shadows/Highlights adjustment got me to Figure 11-11aa, which had better detail in the faces without compromising the blacks and deepest shadow tones.

I felt the contrast was a little bit harsh, so I used the Shadows/Highlights tool, with the settings shown in Figure 11-11z, to bring out a bit more shadow detail. It opened up the shaded side of the faces very nicely without making the image look washed out (Figure 11-11aa).

At this point the restoration is essentially complete. As a very last step, I decided to do a bit more grain smoothing and subsequent sharpening in the fashion I describe in Chapter 10, Beautification, on page 322, to produce a better-looking output print. For this I used Noise Ninja and FocusFixer with the settings shown in Figures 11-11bb and 11-11cc.

Fig. 11-11aa The Shadows/Highlights adjustment turned Figure 11-11y into this much nicer-looking photograph. This restoration is complete except for some fine-tuning of the grain and sharpness that will produce a nicer-looking print.

Fig. 11-11bb These Noise Ninja settings softened up the grain in the image but also took away a bit of sharpness that this photograph could ill afford to lose.

Fig. 11-11cc FocusFixer restored the sharpness that Noise Ninja had taken from the photograph. The combination of noise reduction and sharpness enhancement produced a photograph that was both finer-grained and sharper than it was before I applied these plug-ins.

Chapter 12

Printing Tips

What's the Right Printer?

In case you're looking here to see what printer I recommend, let me repeat what I said back in Chapter 2: There is no one printer I'd recommend. These days every high-end consumer and low-end professional printer produces really good prints. Several hundred bucks will get you a printer that will produce excellent photographs.

What you want to do determines your choice of printer. Will you want to make prints bigger than 8.5 × 11 inches? Do you prefer glossy, semigloss, or matte paper? Will a high percentage of your printing be B&W? Is print speed important to you? If you're thinking about starting a full-service restoration business, the answers to these questions will be "Yes," "All of these," "Yes," and "Yes." If it's relatively recent personal family photos you'll be restoring, the answers are more likely to be "No," "Whatever," "No," and "No."

I have my personal favorites among printers, but I want to emphasize that those are *personal* favorites. I'm suppressing my penchant for laying down The Word because I really think this has to be your decision, not mine.

Choosing Your Print Media for Permanence

Ideally we would like the prints of our restorations to be permanent. After all, impermanent film and prints forced us into restoration in the first place. A digital file can be printed out again and again, but that doesn't make permanent prints any less desirable. Having to go back and reprint your earlier work is a waste of your time and your money and, if you're performing restorations for others, not at all good for your reputation. Better to get it right the first time.

In the world of digital print permanence, there's good news and there's bad news. The good news is that pretty much any current printer on the market will produce permanent prints (we hope, and I'll get back to that). Epson, HP, Canon—they're all good. Oh, yes, people argue about the different longevity numbers for the various makes and models and print media, but all the numbers look very, very good. The most reliable source for longevity data is still Henry Wilhelm's Website (www.wilhelm-research.com). Henry won't be right 100% of the time; no one in the conservation business is. But in my experience Henry is right more often than anybody else, and his objectivity is unimpeachable and impeccable. He doesn't favor one manufacturer or medium over another, and his life goal is to provide us with the best, most accurate, and most objective information on print permanence that he can.

Even less permanent digital prints today get display ratings of half a century—far better than that of conventional color photographs from the 1980s. The best test out as having display lives of centuries. In the dark, in storage boxes or albums, the print life will be even better, according to the tests.

That's the good news. The bad news is that none of these new digital print materials has been around long enough for us to be positive that the accelerated tests are good predictors of print life under normal conditions. Not that we really have any choice in the matter if we're doing digital restoration, but it's worth being a little cautious in our choices.

Start with the printer manufacturer's recommended inks and papers. Mixing and matching inks and papers might get you the look you want, but it could compromise print permanence. Some combinations of third-party papers and inks perform just as well or even better than the printer manufacturer's materials, but most don't; many perform much worse. Look at Henry's tests before jumping into something new.

If you're going the third-party ink route, consider only the folks who sell complete, quality inking systems, like piezography. You're much less likely to get burned by them. Beware of the folks who just want to sell you replacement cartridges for your existing inks that are supposed to be as good as the manufacturers' inks while costing a fraction of the price. These third-party inks are almost always bad news in the permanence department. Henry has some

data about third-party materials on his Website, but it's impossible to test every combination of materials out there. Do not trust the manufacturers of third-party inks and papers to tell you how they will perform; few of them run good longevity tests, and they all have a vested interest in selling you their product.

Beware of extreme bargains. By carefully shopping around I can get original equipment manufacturer (OEM) ink for 25% to 30% less than list price. If you see someone offering ink for your printer at one-half or one-third of list price, read the fine print; it will almost always turn out to be third-party ink that is "compatible" with your printer. That means it won't hurt your printer (no matter what some printer manufacturers claim), but don't expect good print life.

While I'm on the subject of longevity, I'd like to warn you against a common practice of digital photographers who are looking for the most permanent prints. Don't try to test your prints' display life by sticking prints in your window and exposing them to bright daylight and sunlight. This is a pointless exercise unless you're actually planning on displaying your prints that way. Indoor illumination is 100 times less intense and much less actinic than direct sunlight; the way prints react to direct sunlight is no predictor of how they will react under normal indoor lighting. It's not even a good relative measure. In some cases Paper A will fade much more quickly than Paper B in direct sunlight, but under normal light levels, Paper B will turn out to fade faster than Paper A.

Profiling the Printer

Anyone who does digital printing pretty quickly discovers that what you see on the monitor screen isn't exactly what you'll get in the print. Some of the discrepancies are due to inherent differences between the two forms of output. Monitors, which display colors as combinations of red, green, and blue light, portray a different color range than printers, which generate tones and colors as combinations of cyan, magenta, yellow, and black inks. There are colors that can be seen in a monitor's RGB space that simply can't be printed; it's a physical impossibility. Even six- and eight-color printers don't match the range of colors that you see on a display.

Slide photographers have known for years that a projected slide looks more brilliant than a print of the same photograph. Similarly, whites on a display look brighter than on paper because our eyes see the luminous display as being the brightest object in the field of view. In a print, other objects in our field of vision compete with the print for the sensation of pure white.

Within these limits, though, we would like the tones and colors in the print to be as close as possible to what we see on the monitor. For that we need a translation program that converts RGB data (what you see) to the right CMYK data (what you print). That's where the printer profile comes in. The profile is a

set of instructions that correct the color and tonal values in the output data when that data is sent to the printer. Printer profiles don't affect what you see on the monitor or change anything in the image data. They only translate that data as it goes to the printer.

The profile minimizes the color errors produced by your printer. For example, suppose that the printer produces greens that are too yellow and too dark. A printer profile will correct for that by adjusting greens to be lighter and bluer before passing that information on to the printer. The changes the profile makes to the data counterbalance the errors of the printer, so the printer produces a green that looks much more like what you saw on your monitor.

Because every printer needs corrections like this to match what's on the display, why isn't that correction just built in to the computer software so that we don't have to worry about it? The answer is that no two printers produce the same kinds of errors, so no one universal set of corrections will fix things. That's inherent in the nature of printers. Let's look at an example that I hope will make this clear.

Imagine that you want to print pure red on your printer. On the monitor, that's the red that would correspond to the RGB values of (255, 0, 0). On your printer, that maximum pure red corresponds to 100% magenta and yellow dyes and no cyan or black dye. Logically, a 50% red with RGB values of (255, 128, 128) should be half-strength magenta and yellow inks.

I printed those 100% and 50% reds on my decade-old HP DeskJet 970 and an Epson Stylus R2400 (Figure 12-1). The former is a four-color dye printer; the latter is an eight-color pigment printer. The reds on the two printers don't look anything alike. That's a good thing; it shows that printers are getting better. The much newer Epson printer produces much richer color than the HP printer does.

So, how do we get consistent and accurate reds? The printer and ink manufacturers can't do it, not unless they all agree to use exactly the same inks and papers, to lay them down exactly the same way, and to never, ever make improvements on the print quality. No one has yet invented the perfect printer and inks; there's still reason to improve the purity of color and to make the inks richer and more saturated. Manufacturers are not going to stop doing so any time soon. Instead, we turn to software to solve the problem: printer-specific profiles that are designed to correct the differences that are particular to your printer.

Figure 12-2 was printed using custom profiles for my two printers that were created by Cathy's Profiles (see below). The

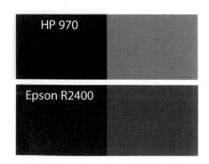

Fig. 12-1 Different inkjet printers use different inks, so inevitably they portray colors differently. The patches on the left are 100% reds (maximum amounts of magenta and yellow ink) produced by an HP 970 and an Epson R2400 printer. The patches on the right are 50% reds.

reds don't match perfectly between the two printers—the Epson printer is always going to produce purer and richer colors—but they're close to each other, and they're both producing colors that are close to the correct shades of red. That is a whole point of color management: to get consistency and accuracy.

Unless your printer is more than a few years old, you are already using a profile, even if you don't know it. Uncorrected output from a printer (Figure 12-3) is always a far cry from what you see on the monitor. The reason that current printers produce pretty good color right out of the box is that the printer driver that the manufacturer supplied with the printer includes a profile for that printer.

In that case, why do we need to worry about a custom profile at all? The reason is that the "canned" profile the printer manufacturer provides is correct for an average printer of that make, but every individual printer behaves differently. A custom profile, created for your own printer and ink and paper combinations, will correct your printer's unique errors and produce an even more accurate rendering.

Printer profiles are specific for each printer/paper/ink/ operating system combination. Ideally one wants a profile for every combination, but a good custom profile often works better with several papers than the canned profile the printer manufacturer provides. Changing to a different brand of ink or a different operating system almost always means you'll need a new profile.

On the positive side, though, printers don't drift as monitors do. Once you've settled on a particular printer, paper, and ink combination, your profile should be good for the life of that printer.

Cathy's Profiles

A half dozen years back, I asked both Jonathan Sachs (author of the Profile Mechanic and Picture Window programs) and Michael Reichmann (owner of www.luminous-landscape.com) what package I should buy to make printer profiles. Both recommended that I not do it myself and instead go to an outside service such as Cathy's Profiles (www.cathysprofiles.com). They told me that I would not be able to produce results as good unless I was willing to spend several thousand dollars on a real

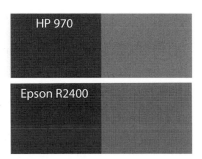

Fig. 12-2 The same 100% and 50% reds as in Figure 12-1 look very different after they've been corrected by custom color profiles for each printer. The two printers produce much more similar (and more accurate) results after profiling.

Fig. 12-3 The top print comes from an Epson R2400 printer running with no profiles enabled. The bottom print was made using a custom color profile for this printer. The profile makes the Macbeth chart and Kodak grayscale look very close to how they appear on the computer monitor.

spectrophotometer. They both know how good my "lab skills" are; they wouldn't have said this without some justification.

Since talking to them, I think I've found a home package that does rival professional profile makers: X-Rite's ColorMunki, which I review later in the next section. Still, even an inexpensive printer profiling package costs several hundred dollars. Cathy charges only $35 per profile. If three or more profiles are purchased at the same time, the first two profiles cost $35 and all the additional profiles are only $30 each. Furthermore, she provides three different mappings of each profile and will help you troubleshoot your workflow. Check out the details on her Website. I've been recommending and using her for years, and I've never been unhappy or heard of a dissatisfied customer. You'd have to purchase 10 profiles from Cathy before it would cost as much as a home-profiling package.

The Cathy's Profiles Website has clear and straightforward instructions. You print out some standard test charts on your printer and mail them to her. About a week after she receives the test prints she e-mails you your profile. I've found Cathy's custom profile to be consistently better than the printer manufacturer's profile. In some cases the differences were very subtle; in others they were dramatic.

It's important that the test prints be made with printer color management turned off. Every printer's interface and driver are different, and some printer software makes it difficult to figure out how to do this, especially under Windows. Sometimes it takes a bit of work to figure out the right settings to produce proper test prints. If you have any doubts or questions about how to set up your printer, be sure to ask Cathy for advice.

Get a custom profile made sooner rather than later. A good profile means fewer test prints and better-looking final prints.

ColorMunki

Although home monitor profiling is a necessity, I've tended to be skeptical of home printer profiling. The low-cost kits out there rarely do anywhere as good a job as professional profiling hardware and software, like what Cathy works with. But if you plan to work with many different printer/paper combinations and you don't already have the equipment to profile your monitor (I talk about the need for that in Chapter 2, "Hardware for Restoration"), X-Rite's ColorMunki may be the cost-effective answer for you.

Printer profiling is literally a hands-on operation. The ColorMunki prints out a color test target (Figure 12-4). The ColorMunki puck works as a handheld scanner: Place it at the end of each row of color chevrons in the test chart and slide it down the paper. Don't move it too fast; 3–4 seconds to scan a row is

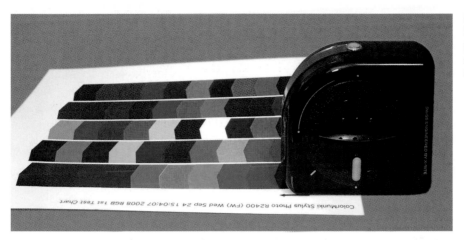

Fig. 12-4 ColorMunki is a hardware/software package that creates custom profiles for displays and printers.

about right. The software reports whether the scan was successful and moves on to the next row. If it wasn't successful, you try again. I'd usually get four out of five rows on the first try. It never took me more than a minute or two to scan a page.

The software analyzes the scans and prints a second color target to fine-tune the data collected from the first target. After you scan that one, the software presents you with a finished profile that you give a custom name. My convention is to use printer model, paper type, and quality setting (e.g., R2400 Harman Gloss FB A1 PhotoRPM). My profiles then appear in selection menus grouped first by printer, then by paper type, and then by print quality.

A most unusual and valuable feature is that you can take an existing profile and further improve it. Select the optimization option, tell ColorMunki which profile you want to improve, and direct it to a TIFF or JPEG image that you'd like it to analyze. The software looks for the important colors in the image and creates a new custom target that concentrates on those portions of the color space. Print and scan the target, and ColorMunki uses that data to reduce residual errors in the initial profile. You can use multiple images via successive optimization runs.

I have to say that the multiply optimized profile I made myself using ColorMunki was superior even to Cathy's for my particular work. Understand that I am really splitting hairs here; they're both excellent, and there's no objective way to choose between them.

What I find remarkable is that I can produce prints that equal or better the ones I made using profiles created with a professional profiling setup by an expert. A gadget that sells for under $500 that can do this in my own home is a remarkable achievement. ColorMunki is an outstanding product.

Toning the B&W Print

As often as not, you'll want to "tone" your B&W restorations before printing them. Many old photographs were never neutral in color. Some processes naturally produced brown or sepia-toned prints, cyanotypes were a strong blue-cyan color, and gold toning could produce a purplish hue. When making modern silver-gelatin prints, photographers and studios often used warm-tone papers and chemicals to produce a print on the warm side of neutral. Even when the original pristine print was completely neutral in color, people have an expectation that old photographs have an antique, brownish look to them. *Care and Identification of 19th-Century Photographic Prints*, which I recommended in the Introduction, is a good guide to original print tone and color.

Several different techniques can be used to tone digital prints. If you're fortunate enough to be printing on one of the Epson printers that use the Ultrachrome K3 inks, the printer control panel has an option called Advanced B&W Photo, which works so well that I don't usually bother with other toning controls.

The Color Toning drop-down menu (Figure 12-5) offers Neutral, Cool, Warm, and Sepia tones. Make your choice and click the Settings button to bring up the Advanced B&W Photo control panel with a color selection wheel (Figure 12-6). You can reposition a setting point in the color wheel to choose exactly the overall hue you want for the print and move it closer to or farther

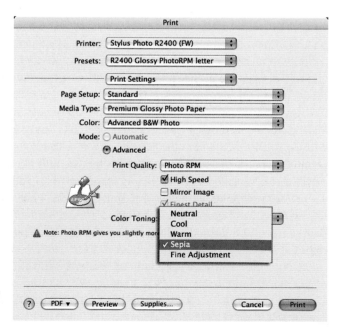

Fig. 12-5 Epson printers using the K3 inks offer excellent B&W print control through the Advanced B&W Photo option. There are preset color tones for Neutral, Cool, Warm, and Sepia, but the real power lies in the Advanced Options, shown in Figure 12-6.

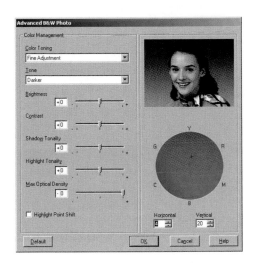

Fig. 12-6 Epson's Advanced B&W Photo options let you precisely adjust print density, contrast, and color in the printer controls. The color wheel at the right lets you pick exactly the tone you want the print to have and how neutral or saturated it will be. Prints come out perfectly monochrome, with no sign of color crossover. This is a great advance in out-of-the-box B&W printing.

from the neutral center points to vary the strength of the tone. There are sliders to selectively fine-tune brightness, contrast, the strength of toning in the shadows, and the strength of toning in the highlights. The Preview window makes using these controls intuitive, and the results look wonderful. The toning has neither undesirable color crossover nor artificial look to it.

If you intend to do strictly B&W printing, a third-party monochrome inking system like Piezography will solve your toning problems; the software drivers that accompany these ink sets include the controls you need to precisely refine the color of your prints. You can also find a huge amount of online expertise among the user groups and forums devoted to the various systems.

There are many great ways to tone prints that don't depend on special ink sets or printer models. For instance, Picture Window has the Tint transformation option. This will produce a monochrome, toned version of any original, B&W or color (Figure 12-7). It is simple to use; launching the transformation opens a control panel with a slider that controls the strength of the effects and a grayscale at the bottom. Shift-clicking on the grayscale adds control points to it. Double-clicking on the number above a point opens the color picture window, and you can assign a hue to the grayscale at that numbered point. For simple toning jobs, you'll probably just assign one point in the middle of the curve, pick a color for it, and be very satisfied. Once you've decided on the color, you can slide that control point to the left or right to change the distribution of tones (it works a lot like the midpoint slider in the Levels tool). All the time the Preview window shows you how your choices will affect the photograph.

Fig. 12-7 Picture Window's Gray/Tint transformation is an excellent and simple-to-use way of producing monochrome prints from any original, B&W or color. Set a control point slider and use the color picker wheel to adjust the color and density of that point. The whole picture will be toned uniformly, as shown in the Preview window at top right.

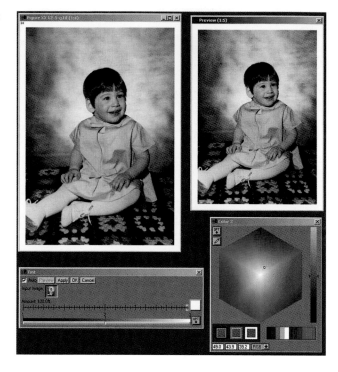

You can simulate more complicated toning, such as split toning (Figure 12-8) or other kinds of combination toning that render different values with different hues. Add two or more control points to the gray scale, assign them individual colors, and reposition them to refine the tonality of the print. It's that easy.

Most of your Photoshop toning needs will probably be satisfied with the Black & White... adjustment in Photoshop CS4. The best way to use this is in an adjustment layer. Convert your grayscale photo to RGB and click the Black & White icon in the Adjustments panel. A set of color adjustment sliders appear; ignore them. Click the Tint check box (Figure 12-9). The color that's going to be applied to the photograph is visible in the square next to the check box. Click that Square to open up the color picker and choose the hue you want. Don't worry if the effect is a bit stronger than you'd like; you can wind that down by adjusting the Opacity control for the layer (Figure 12-10).

You can tone grayscale photographs in Photoshop with more control by adding midpoints to curves and adjusting them up and down. This is a good place to use the gray eyedropper tool (Figure 12-11). Double-click that tool to open the color picture window, assign the hue you want to the eyedropper, and then click with the eyedropper on a gray area of the photograph (it doesn't have

Fig. 12-8 You can set multiple tint points in the Tint transformation to produce more complex toning effects. Here I've set Point 2 one-third of the way up the tonal scale and Point 3 two-thirds of the way. I've assigned them different hues to simulate selenium split-toning. For this illustration shot I exaggerated the toning to make it more visible in reproduction by giving Point 2 a very strong red-brown color and Point 3 a visibly bluish cast. Since these colors are adjustable, along with the total amount of tinting applied via the percentage slider in the control panel, you can produce toning effects as intense or subtle as you like.

Fig. 12-9 Photoshop's Black & White adjustment does a good job of "toning" monochrome photographs. Check tint and double-click the tint box to bring up the color picker panel, and pick the hue you want.

to be a perfect midtone). That sets midpoint values on the curves to create the hue you want (Figure 12-12).

It's best to do this in an adjustment layer and merge the change into the original image by setting the Blend mode to Color, which alters the hue of the image without altering the values. This also lets you use the opacity slider to vary the strength of the toning (Figure 12-13). If you also want to alter

Fig. 12-10 Don't worry if the Black & White adjustment tones the photograph too strongly; you can adjust the intensity of the color with the adjustment layer's Opacity slider.

Fig. 12-11 You can apply tints to B&W photographs in Photoshop using a Curves adjustment layer, as this screenshot illustrates. First select the tone you desire by double-clicking the midtone eyedropper in the Curves control panel and choosing the target color in the color picker. That assigns a custom color to that eyedropper. When you click that eyedropper on a midtone in the photograph, you'll get a set of curves like those in Figure 12-12 and a tinted photograph like that in Figure 12-13.

brightness, create another Curves adjustment layer, set its Blend mode to Luminosity, and make your tonal adjustments there.

For really sophisticated monochrome hue control in Photoshop, look to Duotone mode. The duotone controls are used by B&W photographers who want to be able to have complete and precise control over the color and tonality of their prints, but, honestly, it's a bit of overkill for our needs. Duotone is complicated, so I spend a lot of time on my Website at http://photo-repair.com/dr1.htm explaining how to use it. If duotone is your cup of tea, you'll have to experiment with it for some time before you master it. Don't even think about tackling tritone or quadtone effects until you get the hang of duotone.

An easy way to do superb toning is to use the PixelGenius PhotoKit plug-in (at http://photo-repair.com/dr1.htm). The quality of the results is aesthetically excellent; I doubt that you could create better-looking toning than this yourself.

Display and Storage Conditions for Maximum Print Longevity

The rules for caring for digital prints aren't all that much different from the ones you'd follow for conventional color photographic prints. Broadly put, there are prints you have on display and prints you have stored away. In either situation, the important guiding principle is the same one that doctors follow: "First, do no harm." That means avoiding bad practices and display or storage conditions that shorten print life.

Prints on display should be framed under glass or acrylic. This keeps dirt and grime away from the print. Even ordinary framing glass markedly extends print life by filtering out some of the UV light that would otherwise attack the inks.

If possible, put a spacer matte between the print and the glass so that the surface of the print does not directly touch the glass. Use unbuffered, acid-free archival matte board for the spacer. Avoid buffered boards; many dyes and coloring agents don't like the slightly alkaline environments the buffer creates and so deteriorate more quickly in those conditions.

Also avoid wooden frames. Wood contains compounds called *lignins* that break down over time and release chemicals such as peroxides that can oxidize the colors in prints. They even turn print paper brown (Figure 12-14). The "gas fading" problem of several years back that caused some Epson inkjet prints to fade in days was an oxidation problem.

Considerable argument surrounds whether lacquers and laminates are good ideas. In the short term, lacquer and lamination certainly prevent damaging chemicals, moisture, and some amount of UV from getting to the print surface. The vexing question is what happens in the long term. Many conventional color photographs have had their lives drastically shortened by lacquers made by some of the best companies in the business specifically for the purpose of protecting said photos.

Solvents and plastics in the lacquers and adhesives in the laminates concern me. This could be unwarranted paranoia on my part, but I am inclined to avoid them. There's no good way to run accelerated tests on how these compounds interact with the prints; only time will tell whether, over the long run, they enhance or diminish print life.

For prints that are stored away in albums or boxes, I have a different set of admonitions. If you sleeve individual prints, use Mylar or polyethylene sleeves. Beware of vinyl, which will destroy prints in short order. Even acetate sleeves are not good for long-term preservation; the plastic gradually breaks down and releases acetic acid. It's a slow process, but we are trying to think in time spans of several decades or more.

Avoid "magic" photo albums at all costs! Those are the ones with the sticky pages that have plastics overleaves. You peel back the overleaf and position the picture where you want it on the page. The releasable adhesive holds the photo in place, and the overleaf protects it. That's the theory, but it's not the reality of it.

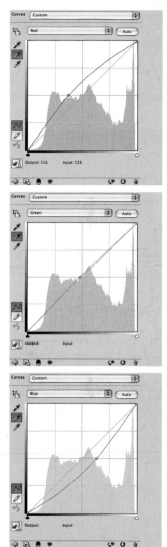

Fig. 12-12 These are the curves that the midtone eyedropper produced for Figure 12-11 when I set the midtone eyedropper to a brown hue with the color picker and clicked the eyedropper on the photograph. I apply these curves in the Curves adjustment layer in Figure 12-13.

Fig. 12-13 Once you've created a tinting Curves adjustment layer like this, you can control the strength of the tint by changing the opacity. I've dialed it back to 53% in this screenshot, which is the right level to make the image look like a brown-tone photograph. Notice that the blend mode has been set to Color, so the Curves adjustment only alters tint and not brightness or darkness.

Fig. 12-14 The front and back sides of this photo have been heavily damaged by prolonged contact with wood. Chemicals released from the wood turned the paper brown and made it brittle. On the back side, the pattern of a knothole is even visible!

The truth is that those albums contain all sorts of nasty compounds that will wreak havoc on your prints (Figure 12-15). The adhesive isn't close to being archival and furthermore can harden and permanently bond to the print over time. Should that happen, when problems start to appear there will be no way to remove the print from the album that won't destroy the print.

Companies like Light Impressions make storage boxes and albums suitable for digital prints. As with matte board, what you're looking for are unbuffered, acid-free materials.

Ultimately, the saving grace of digital restoration and printing is that it's relatively easy to turn out a replacement print that looks just as good as the

Fig. 12-15 Under no circumstances should you store your photographs, conventional or digital, in an album like this! These "magic" albums, with their sticky pages, do more than merely damage photographs. The glue hardens with time, so it becomes impossible to remove the photograph from the album that is ruining it.

original one, as long as the digital file has been properly archived (see the next chapter). "Relatively easy," though, is not the same as "no trouble at all." It will cost you some time and expense to turn out that replacement print, and you may need to make some tone and color adjustments to the digital file to get the new print to look just like the old one did. The best option is to avoid all of that by properly caring for the original print—reprinting is your fallback solution, not your best one.

Archiving and Permanence

The Special Needs of Digital Storage

Once you have successfully restored a photograph, you'll need to preserve that restoration. That digital file is no less important and valuable than the original, deteriorated photograph. In the future it is likely to be the only good or even usable rendition of that image.

Toward that end, we need to think about the long term. The photographs you are restoring range from several decades to more than a century old. If you're taking photographic preservation and restoration seriously, you have to be thinking on the same timescale for your archives. It's not about whether the restored photographs will be viewable 5 years from now, but whether they will be accessible 50 or 100 years from now.

The foremost misconception newcomers to the field have about digital photographs (including digital restorations) is that archiving presents no problems because digital files can be copied perfectly. That is an important difference between physical and electronic photographs: Physical photographs can only be duplicated with some loss of fidelity, but those digital 1 s and 0 s can be replicated indefinitely into the future. Still, there are caveats. Your digital restorations are theoretically immortal, but you'll realize that permanence only if you follow good preservation techniques and maintain ongoing vigilance for deterioration.

Successful archiving means:

- Keeping digital photographs intact
- Being able to read the data
- Understanding the data
- Lastly, being able to find the data!

Fig. 13-1 Film-based photographs, such as the top figure, start deteriorating from the day they're made, but they usually do so in a gradual and predictable way (bottom). This photo developed a pink highlight stain and lost magenta and cyan image density. When deterioration is not too advanced, restoration is feasible—that's the whole point of this book.

This final item is not a problem that is unique to digital files; any archive needs a good filing system. I'm limiting this discussion to problems unique to digital archiving, but I want you to remember that the biggest library in the world is useless if you don't have a good way to find the book you need.

In the remainder of this chapter I talk about the best media for storing your images, suitable data formats for storing them, and how to minimize your chances of losing your files. Before getting into the details, I'd like to explain why this attention to technical minutiae is necessary. It's time to get physical.

In a Material World

There's a widespread and mistaken belief that digital files don't undergo deterioration as film does (Figure 13-1). Digital data may theoretically be immortal, but the real world is not quite so cooperative. Have you ever had a floppy diskette or a CD become unreadable, a hard disk crash, or a backup tape behave unreliably? Digital data obviously isn't impervious to disaster.

In truth, the digital restoration, both the print and the electronic file, can prove less permanent than the original film-based photograph. While digital print deterioration will be immediately visible, just as it is with silver-based photographs, electronic file deterioration won't be. You may see no outward signs that the storage medium (or the data it contains) has deteriorated until you attempt to open the file and it looks like Figure 13-2—and at that point, it's a bit too late.

Digital photographs are binary data: strings of 1s and 0s assembled into bytes, pixels, and finally photographs. One ought not mistake a 1 for a 0, but in the real world it happens. We've all had the experience of finding that we can't read a phone number we wrote down because it became smudged or smeared. Numbers may be fixed and immutable, but their physical manifestations aren't. Even communicating those digits you are sure of may fail. Think about how difficult it can be to tell someone your phone number during a noisy party. These are problems to which data is heir.

No existing storage medium actually records 1s and 0s in digital form; they're recorded as analog signals that are interpreted digitally. Even old-fashioned punched tape and cards are analog signals. It might seem that there is nothing more unambiguous than a hole, but think back to Florida in November 2000 to realize that there can be malformed punch holes in cards

Fig. 13-2 Digital files will show no deterioration initially (top), but beyond a certain point, information will disappear suddenly and often irreversibly. This JPEG (bottom) had some bytes corrupted midfile.

that both machines and human beings have trouble interpreting correctly and unambiguously.

Similarly, magnetic regions on tape or disk and data pits on CDs and DVDs vary in size and intensity. Recordable CDs and DVDs, for example, store data in small regions, whose reflectivity differs from that of the surrounding medium. A laser beam in the disk player scans and measures the reflectivity of the disk, point by point. When this analog measurement changes by more than a certain amount, the electronics in the player interpret it as data and convert it to 1s and 0s.

So, our precise 1s and 0s don't have a physical presence; we extract them from recordings that are actually analog. Ideally, we imagine a digital signal to look much like Figure 13-3a, with nice, sharply defined pulses. Anyone can readily see that this signal starts out with a long pulse, a short pulse, and another long pulse. If I tell you that a long pulse is supposed to represent a 1 and a short pulse a 0, we'd all agree to read this as "101." That's the theory, anyway. In reality, square waves with perfectly sharp sides and flat full-strength tops don't exist. The random vagaries of the real world and normal electronic noise make digital signals look more like the jagged and rounded peaks in Figure 13-3b.

Fig. 13-3 (a) This is how we imagine a digital signal to be: a clear and unambiguous string of 1s and 0s. (b) This is what a digital signal really looks like. (c) As the storage medium degrades, the signal strength weakens (and the noise may increase). The more the signal deviates from the imaginary ideal, the greater the chance that it will be misinterpreted by the computer. Serious and uncorrectable numbers of errors become inevitable.

Here's what's magic about digital processing. As long as the underlying signal is strong enough and the noise isn't too bad, we can figure out which jagged pulses are really 1s and which are 0s. Digital electronics don't merely reproduce the noisy signal of Figure 13-3b; they correctly interpret it and report it as "101." At each and every stage of digital data processing, the electronics take that noisy signal and push it back to being as close to perfect binary data as it can.

This is why we can make perfect copies of digital files ad infinitum and run bits of data back and forth a million times through the innards of our computers without losing any of them. It's not that the digital data is inviolate it's that at every stage we can almost always restore the digital signal to its original form.

Picking up the Pieces

Occasionally data is lost. A hill or valley in the signal could be unusually shallow, or there may be noise spikes. When these things happen, sometimes a 1 gets misinterpreted as a 0, or vice versa. When you're moving around trillions of bits, it's really important to catch all those errors. That's done by adding error-controlling data to the original information. We can design elaborate error

correction schemes that will tell us when bits are misinterpreted and even correct multiple-bit errors.

The most extreme form of error correction exists in ordinary CDs and DVDs. Bits of dust and scratches can obliterate hundreds of bits of data. The disks' data formats use an incredibly complex error correction scheme that can restore dozens upon dozens of errors flawlessly. Most people don't realize it, but almost every time they read data from a disk, there are many, many errors that get fixed invisibly by error correction techniques. Error correction is a necessity; without it all large data files would become corrupted. So why doesn't that make it all okay forever?

It's Just a Matter of Time

All storage media degrade. In a recordable optical disk, the dye layer that actually holds the data gradually fades, just as the dyes in color films do. Random thermal motion of the molecules will gradually demagnetize the domains in magnetic storage. As the dye fades and the domains demagnetize, the signal the playback drive reads gets weaker and weaker. Degradation begins the moment you record data and continues unabated until you rerecord that data. Hardware ages, too. Players can get dirty or go out of alignment after prolonged use.

These are gradual processes that reduce the signal and increase the noise. As the quality of the signal goes down, the error rate goes up. Our archiving problem is that this is all invisible to us as long as error correction codes catch and fix all those errors. When the error rate becomes greater than the correction code can handle, though, the computer system starts reporting that it can't successfully read a file, or it may not even mount a disk at all. From our perspective something has suddenly gone wrong, but it was really a gradual deterioration that was hidden from us until the computer could no longer cope with it. One day you find that uncorrectable errors have "suddenly" popped up (Figure 13-3c).

CD/DVD Diagnostic (www.infinadyne.com) is a Windows-only program that will test CDs and DVDs for read errors, to let you catch them going bad before they become unreadable. It also includes data recovery utilities to help you recover files from bad CDs. CD/DVD Diagnostic (with a 14-day trial download) isn't as thorough or capable as hardware diagnostic systems, but it's about as good as it gets for a home system, and it's a heck of a lot better than just spot-checking your CDs every year or so.

Magnetic media are different. Unlike the dye layers in a CD or DVD, the magnetic recording layer in a hard drive is not likely to physically degrade—it's just that the signal will get weaker over time. That means you can very simply

restore magnetic data to its original pristine state by copying it off the drive and writing it back to the drive. That resets the clock on deterioration. By periodically refreshing your magnetic media, you can maintain the files indefinitely (until the drive fails physically). Which brings me to my next topic: What are the good storage media?

All Storage Is Not Created Equal

Archiving film images is simple: Buy a deep freezer, package the photographs in airtight polyethylene bags, stick them in the freezer, and ignore them. They'll still be good a couple of hundred years from now, assuming someone pays the electric bill. Digital archiving requires an ongoing maintenance plan that allows for the time and expense of periodically rerecording the data. This is where many newcomers mess up. Their strategy is "back up and forget." Down the road this will most certainly cause them grief.

As I've just explained, digital storage usually seems perfect until it is suddenly not. It is most important that we periodically copy old stored data before we actually see bad bits. Also, we need to periodically spot-check our older records or run a program such as CD/DVD Diagnostic so that we don't get caught short by degrading data.

We want to keep the need for maintenance to a minimum, not only to save time and money but to reduce the chances of getting caught by surprise. To some extent that means predicting the future, and we're all prone to make mistakes that way. Figure 13-4 shows a variety of media I own that are no longer readable for one or more of the reasons I'm about to present.

Analog tape is right out. The failure rate for those formats is appalling; look at how often things like QIC-80/Travan backup tapes went bad. The media all come with "lifetime warranties," but that doesn't seem to prevent tape data from going south in a matter of months to years. It's cheap storage, but you'll be lucky if anything is readable in 10 years. Digital tape is better, but it's costly and tape is still physically fragile.

Fig. 13-4 Are you unintentionally committing your photographs to a graveyard of lost data? All these media hold data of mine that is now unreadable for one reason or another.

Flexible magnetic disks are also a very poor choice. Whether they're ordinary floppies or high-density media like Zip disks or Superdisks,

they have poor reliability for archiving. They're also not particularly cheap, and it isn't that hard to run up many gigabytes each year of digital image files. Except for their convenience for swapping small files between friends and computers, these media are obsolete: CDs and DVDs are faster, cheaper, more reliable, and better if you have to move files of any size.

Blu-Ray DVDs have great storage capacity, but they are currently less certain tools for archiving because we have less information on their long-term permanence. That uncertainty will be reduced with time, but at the moment I'm not comfortable with using them for archiving. In addition, I would definitely avoid dual-layer DVD disks. The way these disks get double the capacity of conventional DVDs is by having a second data layer underneath the outer layer. The outer layer is semitransparent, so the underlying one can be seen through it. Therein lies the potential problem; the signal that comes back from a dual-layer DVD can't be as strong as that from a single-layer DVD. A weaker signal means that when the disk deteriorates, the data will reach the point of unreadability sooner than it will for a single-layer DVD.

It may turn out that this is not a practical problem; maybe we will find that single-layer DVDs are good for 150 years, and the dual-layer ones for a "mere" 75. Maybe not, though. As long as the durability of all these media is still under investigation, sacrificing any data life for a modest $2\times$ increase in storage capacity seems very imprudent. It's also not currently cost effective.

It does seem that most drives will support DVD+ and DVD– formats in perpetuity, so we dodged that obsolete-format bullet, but in the future there could be other format-compatibility issues. Remember the recent "Blu vs. HD" DVD format wars.

Removable drive cartridges have good capacities, but unless they are entirely self-contained (sealed units that include the read heads), they're not reliable enough for serious archiving. That precludes using the traditional Syquest/Orb/Iomega varieties of cartridges.

Even sealed cartridge units are unacceptable if they require proprietary hardware support such as special cradles or readers (or software drivers). You can be pretty certain that the company making these devices now will not be making or supporting that model in 20 years; there's a pretty good chance the company won't even be in business. More on this in a few pages; it's the big problem with these formats.

On the other hand, conventional hard drives, whether internal or external, are excellent for archiving. The external ones are best of all because it's easy to have multiple archives (you should always have two copies of anything you really care about) and to add capacity by buying more drives. Hard drives are extremely reliable these days, and data recovery is possible from even heavily

damaged platters, although it's pricey. The odds of losing everything on a hard drive are quite small. The odds of losing anything that's been duplicated onto two hard drives are insignificant.

Hard drive data degrades slowly, but it is easy to refresh the data by reading it off of the drive and writing it back. It costs about $0.16/GB to maintain duplicate external hard drive archives as of mid-2009, and prices are dropping daily. That's less than a penny an image for archiving 50-MB image files, and the process of archiving is as fast and painless as copying files from one hard drive to another. In fact, no other storage device is faster.

If you expect to be amassing large amounts of data, a removable hard drive "bay" or "drawer" is a route to consider. See Chapter 2, "Hardware for Restoration," for further information on this option. Hard drive bays have several advantages. Your storage capabilities are unlimited; every time you need more storage, just buy another hard drive and tray. Regular internal hard drive storage is half the cost or less of a prepackaged external hard drive. Even when you add the cost of a tray, it is still a lot less money per gigabyte than an external hard drive. Removable hard drive trays are ideal when you want to maintain duplicate archives, especially if you want to keep one off-site.

CD-R and DVD-R are also good storage media. High-quality gold archival blanks (don't settle for anything less) are more expensive per megabyte than hard drive storage. Still, duplicate storage will run you only about $0.60/GB and you don't have to commit to a terabyte at a time. It's easy to make duplicate archives as your work proceeds that you can keep off-site in case of fire, theft, or other disaster. High-quality blanks should have a data storage life of decades. Best of all, this storage is permanent; you can't accidentally write over an existing file.

One caution about archiving to CDs and DVDs: Use standard authoring software like Nero or Easy CD Creator for PCs or Toast for Macs. Do not use programs (for example, Direct CD) that let you "drag and drop" files on your disks just as though they were floppy diskettes or hard drives. Disks written in "drag-and-drop" formats can only be read on computers that have special software that can interpret these formats. Such software may not be available in the future. Furthermore, this format turns out to be nowhere as robust as the normal data format. I and other people have had "direct" CDs become unreliable or entirely unreadable on a short timescale, while conventionally authored CDs made on the same batches of media with the same drives have held up just fine.

By the way, many of the standard CD/DVD authoring programs also come with bonus "backup" utilities. *Don't* use those utilities for archiving your work; the backed-up data will be in a proprietary format. Without the backup utility, you'll discover that those files are unreadable.

I don't recommend using online storage for your archive, even though the companies offering the services provide extremely reliable storage. First of all, it's not very feasible when you are generating hundreds of megabytes or even gigabytes of data. Even with a high-speed connection, you're talking about hours to upload your files and then read them back to confirm that they arrived intact.

Furthermore, storing your data with online services has the same problem that archiving on proprietary cartridges does: When the company disappears (and all companies do sooner or later), so may your prospects for retrieving your data.

Can You Hear Me Now?

One of the things that makes digital storage so problematic is that different brands of media have very different levels of reliability and durability. People have long known that about magnetic tape, but it's just as true of floppy diskettes and optical disks. (These days the reliability of hard drives is so high that this isn't really an issue.) Some particularly bad CD blanks have lasted for as little as a few years before starting to develop read errors, even though they were supposed to last for decades.

Folks get into long arguments about how long various media will last; there's even the possibility that all the cautions I've given you aren't necessary. It's prudent to take the precautions because "better safe than sorry" are the watchwords of good archiving. I admit that it could turn out that CDs and other media really will last many decades, as the manufacturers claim. Still, when it comes to archiving my work, I'd rather err on the side of caution and hope that will let me avoid unpleasant repercussions years from now.

What we can be certain of, though, is that data formats will change and old formats and media will become obsolete. Over times measured in decades, the problems of data deterioration pale compared to those of equipment obsolescence. In the year 2050 your highest-quality Zip disks might still be readable (although I doubt it), but it's absolutely certain that Zip drives will be obsolete by then. It's not much use having perfect media if you don't have any way to read it.

Don't be on the cutting edge of a technology. You don't want to be one of the trendsetters; you want to be one of the teeming masses that follow. Security and survival lie in numbers. The more popular and standardized a format is, the more likely you'll be able to read it in the future. It's still not hard or expensive to get drives that read 5¼-inch floppies, although, by today's standards, relatively few people ever used them and relatively little data is stored that way. There are a hundred times as much data stored on 3½-inch floppies, and the drives

will certainly be available for a long time. There are a million times more data archived onto CDs, in both private individuals' and major institutions' collections, than on floppies. Devices that can read CDs will be around for a very long time. IDE and SCSI hard drive interfaces will also endure. There's so much data stored on such drives that the demand for hardware that can read them will exist long after the data formats and media have been superseded by better ones.

Make sure that your storage format is supported by more than one manufacturer. That's the biggest thing that's wrong with proprietary formats and the main reason why most of the removable cartridges on the market—reliability concerns aside —are unacceptable. They are only readable with the manufacturer's hardware, and third-party support is minimal.

This problem isn't limited to cartridges. Many Macintosh users were left with stranded data when Apple abruptly stopped supporting 800-KB Mac-format floppy disks. In most cases one could transfer data or programs to 1.4-MB floppies or network the data between machines, but I had one copy-protected, key-disk program that even Steve Wozniak couldn't tell me how to port over to a newer PowerBook.

Babel Fish

Assuming that you've passed the hurdles of safely recording and retrieving your data, can you figure out what it means? You need software that can interpret the format you used. That means staying away from proprietary file formats as much as possible and using the most popular ones, the same way you did when choosing the physical storage format. Bitmapped formats like BMP and uncompressed TIFF are almost universally readable. TIFF is excellent because it can save both 8-bit and 16-bit images. That means you can save your finished restorations with maximum fidelity. The 16-bit uncompressed TIFF format is widely supported and can be read perfectly by lots of different programs. TIFF also lets you store your color profile with the file.

These uncompressed formats provide some measure of protection against data deterioration; if you lose some bits, only the pixels containing those bits are affected. With the right software you can reconstruct the rest of the image entirely intact, and the formats are simple enough that such software is easy to write. That means it will be available for all sorts of platforms for many years.

Compressed formats are less physically robust; the encoding schemes that shrink the file size make it so that each data byte affects many pixels. A bad byte in a JPEG file can prevent the entire remainder of the image from loading correctly, much as in Figure 13-2. There is software available (for example, www.hketech.com/JPEG-recovery/index.php) that can recover a high percentage of damaged JPEGs by excising the one or two broken bytes and replacing them

with placeholders. Sure, there might be one false pixel or so in the resulting image, but you'll never notice it. JPEG (at very low compression ratios of, say, 1:2 or 1:3) is still a good archiving format for 8-bit data because JPEG readers will be available on just about every platform for the foreseeable future.

Compressed TIFF is also a good format as long as you use one of the most popular programs, like Photoshop, to do the compressing. There are literally dozens of TIFF variants, some of which are so obscure and little used that future support for them is dubious. Translator software such as GraphicConverter (for Macs) and DeBabelizer (for both Macs and PCs) can overcome many of the format hurdles you'll encounter, but why create unnecessary potential problems for yourself?

Don't use Photoshop PSD in preference to TIFF. Even today not all PSD-compatible software can read all PSD files, because Adobe has modified the format over the different versions of Photoshop. Who knows what PSD will look like in 20 years, when Photoshop 15 comes out? If you need to preserve a PSD file because it includes layers or other special Photoshop effects, save a flattened TIFF or JPEG version of the photograph, too—just in case.

A new format being promoted by Adobe is DNG. As of mid-2009, when I'm writing this, the long-term prospects for this format as a common standard look good, but the matter is hardly settled. Adobe will certainly support it for a long time. I think it's safe to use; in fact, I'm using it for archiving my original digital photographs. For restorations, I don't think it has any advantages over 16-bit TIFF, but I don't see any major problems with it.

Final Words

Safely archiving digital photographs is a more demanding task than many realize, but it's not unbearable. Once you've set yourself up well, it won't even feel particularly inconvenient. It only takes a little care and forethought to save your work so that you and your descendants can actually be sure of retrieving it later.

Even in the case of a catastrophe, your archives can probably still be resurrected. Many companies are in the business of retrieving data from storage media that seemed hopelessly damaged. For example, Drive Savers (www .drivesavers.com) can successfully recover data from hard drives that have been drowned, burned, and crushed. Data recovery services aren't cheap, but at least recovery is possible.

But if you do your archiving correctly from the start, you'll probably never be faced with one of those data recovery bills. Here's the short version of what you need to do:

1. Save your files in a common, nonproprietary format. The 16-bit uncompressed TIFF format is ideal, but compressed TIFF is acceptable. For 8-bit color, JPEG

at very low compression ratios is also acceptable. All these formats should remain readable for a very long time.

2. Save your files on media that is durable, in common use, and not likely to be affected by a particular company going out of business or changing its technology. CDs, DVDs, and removable hard drives are ideal. Make a schedule for periodically checking the archived files to make sure that deterioration isn't setting in, and plan to duplicate them on a regular schedule before you see any signs of trouble.

3. For the best security against loss, make two copies of each file and keep one copy off-site. That way, if a disaster hits your home or office, you won't lose your photographs.

4. Finally, have an easily read catalog of what is stored in your archives. A photographic database program is fine for maintaining your archives and making it easy to find files when you need to work on them, but don't expect that database to be readable a few decades from now. Extract all the catalog information and save it as a simple text file or Word document or convert it into an Acrobat PDF file. All those formats will be readable for a very long time; your proprietary cataloging program's format is not likely to be. Save a copy of this catalog document on each archived storage disk.

Safe and sane archiving is neither difficult nor especially much work. A bit of planning now will surely save you a lot of grief years from now.

Index

M